Private Realms of Light

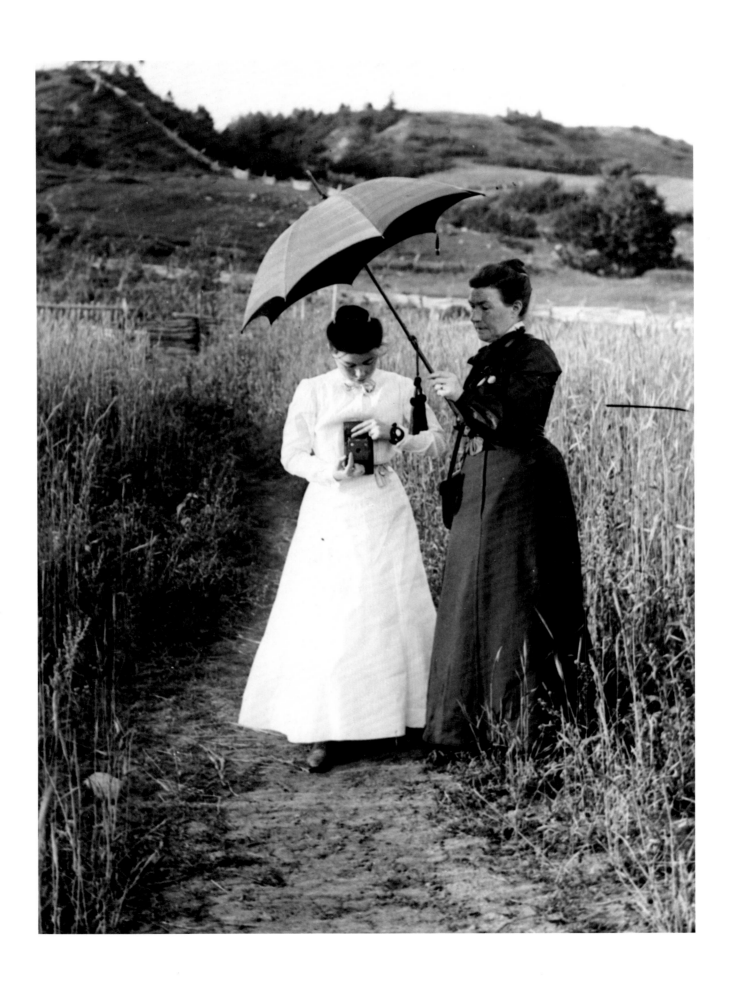

Private Realms of Light

Amateur photography in Canada/1839-1940

edited by

Lilly Koltun

written by members of the National Photography Collection
Public Archives Canada

Andrew J. Birrell
Peter Robertson
Lilly Koltun
Andrew C. Rodger
Joan M. Schwartz

Fitzhenry & Whiteside

Dedicated to
all as yet undiscovered amateurs

This book is based on an exhibition first shown at the
Public Archives Canada, Ottawa, 14 July 1983 - 23 October 1983.

Fitzhenry & Whiteside
195 Allstate Parkway
Markham, Ontario L3R 4T8

Production coordination: Ian Gillen
Design: Sandra Meland, Word & Image
Editing: Olive Koyama
Typesetting: Jay Tee Graphics Ltd.
Duotones and offset film: Rodney-Spencer Graphics Inc.
Colour separations: Praven Graphic Productions Inc.
Printing: Cliff & Walters Lithographing Co. Ltd.
Binding: T.H. Best Printing Company Limited

Printed and bound in Canada

Canadian Cataloguing in Publication Data

Main entry under title:

Private realms of light

Issued also in French under title: Le coeur au métier.
Includes index.
Bibliography: p.
ISBN 0-88902-744-7

1. Photography - Canada - History. 2. Photographers - Canada
- Biography. 3. Photography - Canada - Exhibitions. I. Koltun, Lilly.
II. Birrell, Andrew. III. National Photography Collection (Canada)

TR26.P74 1984 770'.23'30971 C84-099476-1

Frontispiece:

William J. Topley
[Two Women with a camera (detail)] n.d.
From original glass negative 16 x 12.7 cm (broken) *PAC, PA-12938*

Contents

Foreword

It is extraordinary what modern archaeologists can deduce from tantalizing clues uncovered in buried strata. Tiny pottery shards often hold the key to the reconstruction of whole civilizations. But even when the halls of kings are revealed, scientists still know little of the daily lives of those men and women who built them, and who adorned them. Only when a swift catastrophic accident of nature preserves a once-thriving Italian town, such as Pompeii, do we feel a rare kinship over the centuries as we explore homes and streets, and sense activities frozen in time.

The fruits of the monumental task of the recovery of "vanished photographs" by the National Photography Collection is a Canadian modern-day find. The retrieval from neglect of lost and hitherto unknown photographic artists, and the exhibition of their work, *Private Realms of Light, Canadian Amateur Photography, 1839-1940*, is a unique gift of their heritage to all Canadians.

The exhibition covers the period of rich, educated travellers and new immigrants to Canada, who mastered the intricate early photographic techniques, to the time when the ease of hand-held "detective" cameras and celluloid roll film enticed thousands of New Amateurs to become "These modern knights and ladies of the kodak." The camera was an instrument of democratization, bringing together Canadians from all strata of society. Railroad clerks, physicians, scientists and stockholders, many of them with no previous photographic experience, met in camera clubs all over Canada to share with each other theoretical and practical aspects of this exciting new instrument which allowed them to record, in infinite detail, whatever caught their eye. The amateurs' boldness and confidence encouraged them to photograph "just about everything" — most often the near and familiar, such as families, places of work, the landscapes, and the Canadian winter, with a spontaneity and joy unfettered by dogmatic restrictions. These photographs are a rich, artistic source of Canadian social history, evoking the immediacy of a pioneer Saskatchewan homestead, the majesty of the Rocky Mountains, the hi-jinks of turn-of-the-century Toronto medical students, the chores of farm life in the 1880s, a moment's respite in the forging of the railroad; these have remained too long undiscovered.

The "private realms of light" have now become public realms of the rediscovery of our own land, our own history, our own heritage.

Yousuf Karsh

Preface

". . . nearly all the greatest work is being, and has always been done, by those who are following photography for the love of it . . ."

Alfred Stieglitz
1899

I t is seldom that researchers discover a rich and unknown field of study. When they do, the zeal to explore it is matched only by an enthusiasm to communicate it to others. The National Photography Collection has found such a rare pleasure in delving into the history of amateur photography in Canada. After five years of intermittent research, every effort revealing new names and photographs, we feel it is time to offer the results to a wider audience.

The project began in 1977, when Andrew Birrell of the National Photography Collection acted on the belief that had long circulated among photoresearchers, that amateurs were the true innovators of their time, and had produced some impressive work, now lost or unknown. He gathered a team and began delving into long-forgotten photo magazines, dormant camera clubs' records, contemporary illustrated papers, and photo collections in archives or libraries from the period before 1940. The list of names revealed by these sources quickly began to total in the thousands. It was the first warning of the vastness of the project.

Although the likelihood of missing important photographers was substantial, we decided to pursue only a restricted number of key individuals in detail. Yet the next step of the chase — locating surviving family members by tracking through directories, other records and even by word-of-mouth — soon proved its worth, as one collection after another came to light. All doubt that the amateur had played a crucial role in introducing to Canada a variety of technical and stylistic innovations was erased. The earliest stop-action snapshots, colour photography, art photography, and mini-camera work all appeared as the achievements of amateurs. The myth of the bumbler was exploded. Out of the army of mediocre snapshooters emerged a corps of dedicated experts. When their inventiveness flagged, there were always others less technically adept but ready to try anything new, unworried by the possibility of failure.

The definition of "amateur" and the criteria for inclusion in this collection involved intense debate among the team members. Eventually the definition on which all could agree was the simple one of work done "for the love of it," with no eye for a commercial use. This meant that photographers who were professionals in their daily work could appear if represented by their amateur endeavours. A surprising number had made a clear distinction between their paid and unpaid activities. Among them were Arthur Goss and Albert Van, working for the City of Toronto by day, labouring at pictorial fantasies by night. Equally distinctive are Harold Kells'

two personae — a commercial photographer who also, in pursuit of his personal artistic vision, created some of Canada's rare nudes. Did the professional status of these men give them a technical edge over amateurs? On the contrary, the amateurs who admired them were often their technical equals if not superiors. Indeed, two earlier amateurs, Sidney Carter and Harold Mortimer-Lamb, ventured into the professional world, so certain were they of their technical skills and advanced artistic conceptions. There was even a period at the beginning of this century when the amateur disdained the retardataire tendencies and repetitive hack work of most professionals.

Another problem faced the team when considering photographs taken by explorers and scientists. Undoubtedly these men were scientists first, who used photography as a professional tool. In a few cases, however, where the camera was clearly a pastime, rather than a tool, their work was included.

The few score photographers who were finally chosen represent some of the variety of interests and achievements of amateurs in Canada. Yet such a small percentage can only indicate the broad outlines of amateur activity during its first hundred years in this country. Inevitably, the mesh is too wide; even major names will have fallen through it. We are only too aware that this book says the first, not the last word. We console ourselves with the excitement of future discovery which that implies.

Lilly Koltun

Acknowledgements

No project of this size and complexity could ever have been successfully pursued without the help of scores of individuals and institutions who generously contributed their time, knowledge and memories to aid the search for vanished photographs. We must make some small acknowledgement of our gratitude for the pieces of the puzzle that they slipped into place for us.

We were fortunate in contacting many of the photographers represented in the exhibition and it is with special warmth that we thank the late Meyer Barrach and Matilda Barrach, Philip and Edith Croft, Leonard and Elsie Davis, the late Otto Eaton, John Fleetwood-Morrow, Harold and Margaret Kells, the late William E. Lehman and R. Marion Lehman, Arthur and Muriel Lomax, Gordon and Helen McLeod, the late William A. Norfolk, Alfred and Ellen Upton and Brodie Whitelaw.

Invaluable contributions, including the donation or loan of photographs, papers and awards, were made by relatives: J.T. Biller (George P. Allen); S.T. Ballantyne and Bruce Ballantyne (James Ballantyne); Clifford Bastla (Clifford S. Bastla); W.B. Hustwitt, Peter Dunn and Valerie M. Dunn (W.B. Bayley); Jane Palmer and Arthur W. Beales (Arthur Beales); Dr. John E. and Margaret Bethune, the late Roderick O. Bethune and Barberie Bethune (Edith Hallett Bethune); Evelyn Blyth (George Blyth); Pat Boultbee and Richard Boultbee (Horace Boultbee); Peter Brass (Peter Brass); Elsie Brigden and the late Evelyn McGarry (Alfred Brigden); Mr. and Mrs. Duncan Carter, and Mary Elizabeth McTavish (Sidney Carter); Ian C. Stewart (Richard S. Cassels); Pat Martinson (Philip Croft); Mrs. George Driscoll (George Driscoll); Grace E. Leigh, Frances Westman and John J. Ellis (W.H. Ellis); Ewan Evans (Nevil Norton Evans); Prof. G. Wallis Field (G.H. Field); Jean Gates (Grant Gates); Mrs. Charles Mewburn and W.G. Shambrook (William J. Grant); John and Joy Helders, Al Helders and Louise Ross (Johan Helders); Florence Hodges (J.K. Hodges); Herbert Ide and Dr. F.P. Ide (William Ide); Mrs. Henry Welch and Donald C. Johnston (C.M. Johnston); Mrs. A. Brooker Klugh and Hermione Bell (A. Brooker Klugh); Lachlan MacTavish, Q.C. (Newton MacTavish); Gladys Marchell (George Marchell); Lawrence G. McDougall (George K. McDougall); Billie Bridgman (Bruce Metcalfe); Mrs. John Morris and Anne Morris (John Morris); Jane Pearce (George Pearce); the late Frederic H. Peters (James Peters); Mrs. W.B. Piers and Marge Dunning (W.B. Piers); Margaret Pinkerton (B.B. Pinkerton); L. Eric Reford (Robert W. Reford); the late Phyllis McKie (John W. Ross); the late Marion Rogers (Robert Scott); Jessie Saunders (L.G. Saunders); Mrs. Ralph Speiran (Ralph Speiran); Olive Squire (W.H. Squire); Fraser Sweatman (W.A.T. Sweatman); the late Dr. Lois Kent Tweedle (Arthur Tweedle); Julie Trip (Alfred Upton); Mrs. Craig Murphy and Mrs. William Hussey (Albert Van); and the late T. Hartley Hawkins (Henry J. Woodside.)

Together with these individuals, a host of friendly people guided us, answered questions, suggested leads and even kindly gave donations. Although we are unable to list every name, we are grateful for all their efforts on our behalf. A few in particular were: Charles Adkin, Margot Ariss, Nora Britton, Raymond and Blossom Caron, Helen Collinson, Elizabeth Culley, F. Cunningham, David Delaney, Claude Doucet, John Hall, Mr. and Mrs. William Hammond, Joyce Hayes, Mrs. (L.W.) G. Inwood, Francis Kerr, Carolyn R. Kirch, Betty and Kathleen Lawson, John J. Lawson, Robert Legget, Randolph Macdonald, Frank C. Manchee, W.C. Mollington, Richard Panter, William Rattray, G. Perry Robinson, Everett Roseborough, Mr. and Mrs. Alex P. Shearwood, Campbell Tinning, Mr. and Mrs. Nick Turnbull, Walter Turnbull, Edith Verity, M. Weller, Edward C. Walsh, John Warwick and Walter Wood.

We are grateful to the New York City Public Library, the Metropolitan Toronto Library, the National Library of Canada and the Kodak Park Research Library, Rochester, New York, and particularly to Clare Freund, Elizabeth Kraus and Murray Pierson, for making available countless volumes of photographic periodicals. Archivists and curators who made our job much easier include Scott James and his team at the City of Toronto Archives, particularly Linda Price and Victor Russell; Sue Baptie and Ken Young at the Vancouver City Archives; Edward Cavell at the Archives of the Canadian Rockies, Banff, Alberta; Dave Richeson at the National Museum of Man, Ottawa; and George Moppett at the Mendel Art Gallery, Saskatoon. Above all, we wish to thank those individuals and their institutions who have both provided information and made possible the loan of material for the exhibition: William Ormsby, Art Murdoch, Ken Macpherson and the Archives of Ontario, Toronto; Pat Bovey, Janice Ross and the Art Gallery of Greater Victoria; Michael Gilbert, Gary Greenwood and the Canadian Centre of Photography and Film, Toronto; James Borcoman, Ann Thomas and the National Gallery of Canada, Ottawa; Robert W. Bradford, Jim Johnston and the National Museum of Science and Technology, Ottawa; Stanley Triggs and the Notman Photographic Archives, McCord Museum, Montreal; John Bovey, Jerry Mossop and the Provincial Archives of British Columbia, Victoria; Ed McCann and the Royal Canadian Mounted Police Museum, Regina, and the Historical Section of the RCMP, Ottawa; and Daniel O'Neill, Leslie Ross and the Vancouver Public Library. We also wish to express our gratitude to the Beinecke Rare Book and Manuscript Library, Yale University, and to Georgia O'Keeffe for kindly allowing reproduction of the correspondence between Alfred Stieglitz and Sidney Carter.

Too little credit is sometimes given to those closest to home. We therefore want to remember our colleagues Guy Tessier and Brian Carey in the Acquisition and Research Section of the National Photography Collection, and members of the Public Archives Library, Translation and Publication Services, Exhibition Services, Public Relations, Conservation and Reprography Services. Not the least of our debts we owe to the untiring Johanne Simard and Mae Borris who, together with others, typed and processed the manuscript, adapting to endless changes in the text.

We are also very grateful for the consideration and patience shown by the staff at the National Photography Collection, particularly Theresa Rowat who shouldered a greater burden of routine work while we were engaged with the project, and the staff of the Photo Control Section, for whom exhibition preparations represented a major disruption of their work. Above all, we extend our sincere thanks to the administration of the Public Archives, without whose financial and moral support no book and no exhibition would ever have taken shape and life.

Despite our best efforts, we will have made errors, perhaps both of fact and of judgement, and we take entire responsibility for them. However, we hope that they will not diminish too greatly the value and pleasure which you may derive from this exploration into the history of photography.

The authors

[A. Van, attr.]

[Couple with a camera *c.* 1916] Silver 7.5 x 7 cm *PAC, PA-126674*

Private Realms of Light

The Early Years/1839-1885

Andrew J. Birrell

S urprisingly, the name of Canada's first amateur photographer is known and he stands at the very dawn of photographic history. Pierre-Gaspard-Gustave Joly de Lotbinière (1798-1865) was a Swiss-born Canadian, who by marriage had become seigneur of Lotbinière seigneury, about forty miles upriver from Quebec City. In 1839 he was in France preparing for an extended tour of Greece, Egypt and the Holy Land. An educated man, he would have heard the rumours circulating in Paris that Louis-Jacques-Mandé Daguerre had discovered a practical process for permanently fixing the image of the "camera obscura." The announcement of the daguerreotype on 19 August 1839 was made to an audience that was already at a fever pitch of expectancy. In following weeks hundreds rushed to try the slow complex procedure. Like many others, Joly de Lotbinière was seized by the miraculous process and acquired the appropriate apparatus.

Before sailing from Marseilles in September he was approached by the Paris optician and publisher N-P Lerebours, who had conceived of a book of engravings based on the daguerreotypes of travellers. Such illustrations could claim to contain no subjective intervention by an artist and would find a ready audience among the growing numbers who were interested in obtaining accurate information about alien civilizations both past and contemporary. Joly de Lotbinière agreed to participate.

During his stay in Athens in October he made several daguerreotypes, two of which, taken on the Acropolis, appeared as engravings in Lerebours' first volume of *Excursions daguerriennes.* These were undoubtedly the earliest photographic views of the famous ruins. In November he continued on to Egypt. In Alexandria he met the Pasha Mohammed Ali, who invited him to photograph the palace. Then he ascended the Nile, photographing such monuments as the Sphinx and the Colossus of Memnon. Technically he was completely inexperienced and subject to mysterious — occasionally hilarious — failures. At Philae he spent three frustrating days trying to record the area. During the first two days he experienced difficulty because he thought that an over-iodized plate turned purple: ". . . pas du tout; poussée à un haut degré elle se couvre d'un voile blanc. . . ."[1] On another occasion he found his Arab helper opening one of the doors of the box containing a particularly difficult view he had just made. After developing it he found that the second or two of exposure had been enough to wipe it out. Of a second view, he wrote:

[H.J. Cundall, attr.]

Judge Peters' Goose boat, Sidmount, [P.E.I.] 23 August 1860 Albumen 7.3 x 6.8 cm PEI, Acc. No. 3466, DuVernet Album

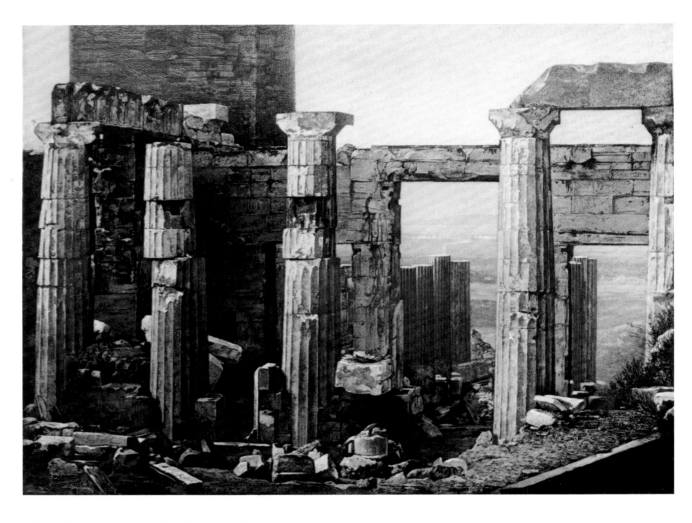

after daguerreotype by Joly de Lotbinière

Grèce. Les Propylées à Athènes in *Excursions daguerriennes* (Paris: N.P. Lerebours), 1842 CCA, unnumbered

Je mets ma vue générale au four, j'allume la lampe, je vois passer mon coquin d'arabe, je lui adresse quelques malédictions et autre chose, j'oublie ma lampe à esprit de vue, la mémoire me revient, j'y cours, j'ouvre le couvert de la boîte et ne reprend mon sang froid qu'en recevant une pluie de mercure bouillant dans la figure, le thermomètre venait de sauter.[2]

Such experiences are telling indications of the frustrations and difficulties encountered by the early photographer.

During his travels in the Middle East, Joly de Lotbinière successfully made more than 35 daguerreotypes, five of which were used by Lerebours. Others were given to the French architect Henri Horeau who was attempting to reconstruct in panorama form the ancient Egyptian monuments. None of the original daguerreotypes have surfaced.[3]

Lamentably, it appears that the seigneur did not continue his photography when he returned to Canada. The skill that is evident in the Lerebours engravings would have provided Canadians an extraordinary photographic record of mid-century Quebec, but it was not to be.

Although the daguerreotype flourished until the mid 1850s there is no record of any other amateur photographer using that charming medium in this country. On the one hand, the business of photography grew rapidly; there were many professional daguerreotypists in the major cities and towns from the early 1840s. On the other hand, evidence of the work of amateurs is lacking. In England, Europe and the United States, amateurs were in the vanguard of photography, forming societies, experimenting, publishing, and, of course, photographing. It was, however, very much the pastime of the affluent and educated. British North America at the time was still a frontier society with a minuscule population, largely rural, separated by vast distances, its cities and its middle class consequently small. Those who did take photographs were frequently travellers, or immigrants who had taken up the camera before coming to Canada. It is not surprising, therefore, that there are no records of photographic societies and scant evidence of individual amateurs even during the 1850s.

Daniel Wilson, a Scot who came to Toronto to teach at the new University of Toronto, commented with pleasure in 1853 that a colleague at Trinity College, the Rev. G.C. Irving, "is a Cambridge man, and an amateur calotypist, so we were friends at once. . ."[4] Irving had come to Canada the year before as professor of mathematics at Trinity, and remained until 1856. In 1853 he delivered a lecture at the Canadian Institute on the principle of the stereoscope, a device that enabled the viewer to see an image in three dimensions.[5] Of the calotypes by Irving and Wilson there remains no trace whatsoever. Such oblique references constitute the present sum of our knowledge of the use of the calotype in Canada during the early 1850s.

In England the form of photography most used by amateurs was the calotype, despite the fact that its inventor, William Henry Fox Talbot, patented his discovery, forcing users to pay fees. The popularity of the calotype was probably due in part to the fact that it yielded a negative from which many prints could be made, unlike the unique image produced by Daguerre's method. However, the use of the daguerreotype was doubtless limited by the fact that it, too, was patented in Britain, the only country where this was so.

Even as Wilson wrote in his diary, both calotype and daguerreotype were on the verge of extinction, for in 1851 the British amateur Frederick Scott Archer had published his wet collodion negative process. This combined the advantages of the calotype negative with the detail and clarity of the daguerreotype. Because it was necessary to coat the glass plate and to perform on the spot all the operations through to developing and fixing, a further complication arose for the photographer who wanted to travel or merely to work away from his studio. In addition to a bulky camera, it was necessary to carry a complete darkroom with him.

It is not surprising that great efforts were made to produce dry plates that could be coated in advance and developed at leisure in the darkroom at home. Photographers in England produced scores of "dry" collodion methods, some quite successful, but for all its difficulties the wet plate remained most popular because it was the most reliable.

Among the rare known practitioners of the dry-plate method in Canada

THE DAGUERREOTYPE

Daguerre's invention required that a copper plate with a thin coating of silver be exposed in an iodizing box to vapourized iodine which deposited itself on the plate, forming light-sensitive silver iodide. It was then exposed in a camera for up to half an hour, depending on the brightness of the light and the aperture of the lens. The exposed plate was placed in a fuming box over a dish of mercury which then was vapourized. The vapour rose, came in contact with the exposed plate, and deposited itself in tiny globules in exact proportion to the amount of exposure each part of the plate had received. The positive image so formed was fixed by immersion in hyposulphite of soda. The result was a highly reflective image with incredible detail and tonal range.

THE CALOTYPE

The calotype was made by coating high quality paper with a light-sensitive solution and then storing it until ready to use. It was exposed in a camera, developed and fixed. Prints were made by exposing the negative to sunlight when in contact with a piece of sensitized paper. The resulting positive image appeared without aid of developing and was fixed. As with the daguerreotype, early calotype exposures were very long, but as the sensitive emulsion was improved the length of exposure was reduced considerably. Fibres in the paper give prints from calotypes a distinctive appearance. Since the negative was not on a transparent medium, the image lacked the sharply distinct detail of the daguerreotype and later glass-based negatives. The result was rather pleasing, however, and provided a chiaroscuro effect.

The collodion process required coating a polished piece of glass with a solution of cellulose nitrate or pyroxylin in ether and alcohol, and then sensitizing the plate in a silver nitrate bath. Still wet, it was exposed immediately, developed in an acidic developer like pyrogallic acid or iron sulphate, then fixed and dried. All the work had to be done while the emulsion was damp. The wet plate method was a complicated process, made even trickier by the number of places where things could go wrong. For example, almost invisible amounts of foreign matter in the silver nitrate bath could result in a blank plate.

COLLODIO-ALBUMEN PROCESS

The collodio-albumen process appears to have been first demonstrated by the French chemist Taupenot about 1853. It was a dry negative process which called for the glass plate to be coated with iodized collodion, then sensitized in a silver nitrate bath, washed and dried. A layer of iodized albumen was then added and the negative was again sensitized in the silver nitrate and dried once more. In this state it was ready for exposure at a later date. The double sensitization seems to have been typical of early collodio-albumen processes. An early improvement reduced sensitization to only one bath.

was Henry J. Cundall, a surveyor and land agent in Charlottetown. In 1859 he ordered equipment, supplies, and a pamphlet of instructions for the "collodio-albumen" method of photography from Horne and Thornwaite of London, England.[6] He seems to have received the equipment late in 1860, and successfully mastered the process. The DuVernet album at the P.E.I. Heritage Foundation, compiled between 1859 and 1867, contains one signed photograph of Government House by Cundall, and other views could be attributed to him. He may not have been alone in his hobby. An intriguing note from April, 1860 asks Horne and Thornwaite to itemize the materials in their invoice as "some of them are for another party."

By far the most outstanding early Canadian amateur to practise the wet-plate method was Alexander Henderson of Montreal.[7] Henderson, a Scot, who came to Montreal in 1855, took up photography in 1856 or 1857 and advanced rapidly, taking many trips to find picturesque views.[8] The earliest extant is a print of Brompton Rapids dated spring, 1858. The following year he became the first North American member of the Stereoscopic Exchange Club of London, England.[9]

Like many other amateurs, Henderson experimented with a variety of processes, though he obviously preferred the wet-plate method. He mentioned using the popular Norris, Fothergill and collodio-albumen dry plate methods, though he was not enamoured of any of them in spite of having "taken a great many negatives with these processes." His experience with them was probably not uncommon: "Fothergill I gave up for the marbling . . . and the collodio-albumen would not work at all. . . . This caused me much disappointment in two excursions into the woods, where I saw fine subjects, and took many, only to find black, dirty glasses on retiring. . . . I very much doubt if I ever take a dry plate again, unless in winter."[10] In the same letter he spoke highly of the turpentine wax paper process as "a decided improvement on the common wax paper." The early photograph entitled *Tanneries Village* (page 121), made from a paper negative, is probably an example of this process.

Henderson's main interest was in landscape views. He travelled widely in Quebec and eastern Ontario, lugging his equipment into the wilderness in search of the scenes that delighted him. Probably more than any of his contemporaries, professional or amateur, Henderson photographed that great natural resource, the Canadian winter. The cold and snow were thought to be obvious reasons for remaining indoors, particularly when one or two photographs might mean enduring hours of freezing discomfort. Furthermore, it was believed at the time that the sensitivity of the collodion plate decreased as the temperature dropped. Henderson was undaunted, and regularly and successfully captured the beauty he saw, even, as in the case of *Valley near Beauport Lake* (page 124), during a snow storm at 0° Fahrenheit. In fact a few years later, as a result of his experience, *The British Journal of Photography* carried out some tests and concluded that temperature had no effect on the sensitivity of a wet collodion plate.[11]

Throughout the first half of the 1860s Henderson devoted himself to his avocation. In 1865 the extent of his ability and dedication was revealed in a publication entitled *Canadian Views and Studies by an Amateur.* The title

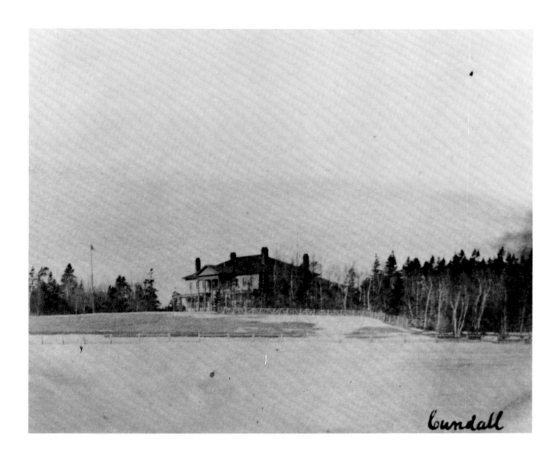

H.J. Cundall

Government House, [Charlottetown 1859-1867] Albumen 6 x 7.2 cm PEI,
Acc. No. 3466, DuVernet Album

page however read *Photographic Views and Studies of Canadian Scenery* and
the volume contained twenty whole-plate views with a letterpress title. Later
editions have a different title page and, of the fifteen known copies, no two
have the same contents, though about half of the photographs appear regu-
larly. From the variety of titles, formats and contents, it is likely that each
volume was made to order according to the wishes of the recipient.

Here was the work of a serious, talented and confident artist. Even after
more than a century the prints in the album retain the deep, rich tones
characteristic of albumen paper toned in gold chloride. From this period in
Canada perhaps only the work of the professional photographers William
Notman and Samuel McLaughlin is consistently as rich. A large proportion of
Henderson's landscapes, like *The Trout Brook* (page 127) for instance, are
intimate, carefully composed views which he presents to the viewer like
jewels discovered in some out-of-the-way place. Since it would have been
easy to concentrate on the grander aspects of Canadian scenery this reveals
the influence of the picturesque style on his work, a style common both in
England and among Montreal artists with whom he was undoubtedly
acquainted.[12]

Typical of Henderson is the painstaking attention to detail to build the

Alexander Henderson

Brompton Rapids. St. Francis River, E[astern] T[ownships Spring, 1858] Albumen 15.2 x 21.2 cm *PAC, PA-28611*

impact of the composition. Yet, as Dennis Reid has noted, one is left less with a sense of being rooted in a particular spot than with a feeling of the atmosphere that suffused the place where the photograph was made.[13] *Spring Inundation* (page 126) exhibits a rare, ethereal quality, the boat seemingly almost freed from the bonds of gravity.

Nevertheless, all photography at this time was anchored in the real, in the world of infinite detail. Henderson's affinity for this aspect of the medium stood him in good stead later when he became a professional and took many photographs of cities and towns. During 1866 or 1867 Henderson opened a studio in Montreal and until his retirement in the 1890s he was one of Montreal's foremost photographers. Initially he took studio portraits as well as landscapes, but he soon dropped portraiture and devoted himself to the views that he loved.

At the time Henderson was finding his feet as a photographer, Vancouver Island was a tiny colony about to be invaded by hordes of goldseekers. The Fraser River rush of 1858 brought thousands of people, among them British

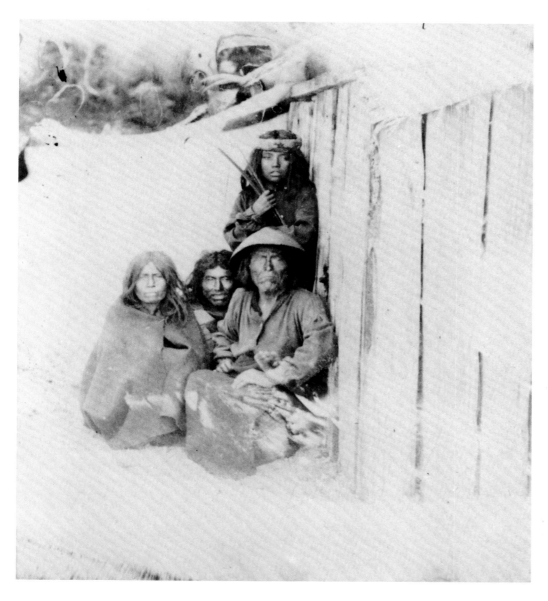

Richard Roche

[British Columbia Coast Indians 1858-1860] Albumen 10.8 x 9.6 cm *PABC, 85593*

officials sent out to form the civil service of Vancouver Island and British Columbia. These, added to the permanent residents, most of them British also, formed a shifting middle class which included numerous amateur and professional photographers.

One of the earliest amateurs to arrive in the colony was Richard Roche, a young lieutenant aboard HMS *Satellite*, one of two ships sent to survey the water boundary through the Gulf of Georgia. Little is known about Roche, but he had obviously learned the wet-plate process before leaving England, since there exist photographs taken in the Falkland Islands and in South American ports where the *Satellite* stopped on its trip to Esquimalt. There are several excellent photographs made aboard the *Satellite* (page 128), but the most interesting historically must be those of the American and British camps on San Juan Island, taken shortly after the Americans occupied the island in July, 1859, following the little skirmish known as the "pig war."

Like most British visitors, Roche was struck by the exotic culture of the native Indians. On several occasions he attempted to photograph the Indians,

*Thomas Fothergill's process,
introduced in 1858, was a
collodio-albumen adaptation
specifying that the albumen layer
be washed off after half a minute.
This left sufficient albumen
impregnated in the pores of the
emulsion to preserve its sensitivity.
Though the preparation seems
tedious, it was claimed that a good
worker could prepare a Fothergill
plate in three minutes. While there
were many enthusiasts, there were
also many complaints, one of the
most persistent being the marbling
of which Henderson complained.*

*In 1856 Richard Hill Norris
patented a dry collodion process
using gelatin in place of albumen
— "the beginning of the
manufacture of dry plates" (Eder,
History of Photography, New
York: Dover Publications Inc.,
1974; 373-374).*

but with indifferent success. The sailor was not among the leading wet-plate practitioners. His manipulations of the tricky liquid were inconsistent and a number of his prints betray evidence of improper fixing. Still, his are among the very earliest photographs of the young colony and the best merit more than passing attention.

Another young Englishman who intended making an extensive record of the Indians was Francis George Claudet, who arrived in Esquimalt in the first half of 1860, having been appointed to the Office of the Assayer in New Westminster. The son of Antoine Claudet, England's foremost portrait photographer, he was no newcomer to the medium. Strangely, he did not bring his equipment with him and he lamented soon after arriving, "The scenery is magnificent . . . I only wish I had my photographic apparatus with me."[14] To his brother he confided, "I intend to make an interesting collection of views & groups of Indians to send home."[15] It is apparent that he and Roche knew each other; Claudet made frequent visits aboard the *Satellite,* and his personal albums contain a considerable number of Roche's prints.

Claudet's extant work is typical of the casual amateur of the time who documented his milieu both for himself and, as he said, to send home. There is nothing to suggest that he made any portraits even though he wrote in good humour, "Poor dear Mammy hopes I am putting by a *deal of money* & making a good little business of my own taking portraits."[16] His talent was used for semi-official purposes in 1861 when British Columbia was preparing its exhibits for the International Exhibition held in London the following year. Captain W.D. Gosset, his superior in the Assay Office, wrote that, official duties permitting, Claudet would make a series of photographs "of the Towns and other interesting places. . . . Persons can . . . greatly aid Mr. C. and save him from much loss of time by selecting points of view prior to his arrival, escorting him . . . and assisting in the transport of his instruments, chemicals, &c."[17]

Not only did Claudet contribute to the exhibition, he won an Honorable Mention for a series of views of New Westminster. This suggests that he might not have had time to tour the colony. The one view of Hope that he mentioned in a letter to his brother is rather pedestrian; he said he went up without leave, suggesting that duty did not see fit to free him for the task. Many of this series in Claudet's own albums were printed at a later date after the negatives had suffered damage. They depict what must have been the cliché of the frontier town (page 131). Buildings rise among a jumble of surrounding stumps while, close behind the town, giant firs seemingly crowd it into the river. "A perfect chaos," Claudet called it and his photographs reflect that viewpoint.[18]

The Hudson's Bay Company had built its fortunes by working beyond the fringe of civilization. Occasionally, as at Fort Garry or Victoria, civilization caught up to it, but for the most part its posts were isolated islands in a vast land. The employees who manned them maintained their British or North American culture as best they could, often co-operating in scientific pursuits. A small group in the Moose, Eastmain and Rupert's River districts adopted photography as a pastime. For a brief period during the 1860s and 1870s there were at least five men who avidly photographed the Company forts,

Francis Claudet

Steamer *Onward* with pic-nic aboard, Fraser River, B.C. [1861-1871] Albumen
21.2 x 26.9 cm *PABC, 88070*

the Inuit and Indians and the surrounding countryside.

The most important was Bernard Rogan Ross, a native of Londonderry who joined the Company at the age of 16 and rose to become Chief Trader. He was well known for his scientific interests, being a corresponding member of several naturalist societies, a founding Fellow of the Anthropological Society of London, and a Fellow of the Royal Geographical Society. He probably began to use the camera to support his anthropological interests at a relatively early date. According to H.G. Deignan he was making "photographic drawings" in the early 1860s to illustrate his investigations of the tribes of the Mackenzie River District.[19] The only ones known today are those taken at Rupert House, where Ross was stationed during the 1860s (pages 138-141). His latest photographs date to 1868, shortly before he left the north. Although a large proportion of Ross' prints reveal his obvious anthropological interests, he also shows a well-developed sense of composition and a superior ability to manipulate the tricky wet collodion process. A sense of humour is evident in the contrived *Shooting a White Bear*.

Ross' name also appears on the four photographs by Charles George Horetzky, accountant at Moose Factory from 1864 to 1869 (pages 142-144.) Three of these carefully indicate in Ross' hand that Horetzky took the photo-

B.R. Ross

Winter Scene. Rupert's River, [Que.] 1868 Albumen 14.5 x 20 cm *PAC, C-75914*

graph but that Ross printed it. We may suppose that Horetzky was simply learning at this point. One of Horetzky's prints, *Moose Factory: From the Flats* (page 142), is not unlike the series he later took at the Elbow of the North Saskatchewan River in 1871, though the best of that series is far more powerful.

Horetzky left Moose Factory in August, 1869, having been transferred to Fort Garry. The disturbances created by Louis Riel prevented him from taking up his duties, and he was given a leave of absence to visit his wife in Ottawa. He never returned to the Company. He did put his photographic hobby to good use in 1871, however, when through Sir Charles Tupper he importuned Sandford Fleming for a position on the newly formed Canadian Pacific Railway surveys. Tupper mentioned Horetzky's ability and produced examples of his work for Fleming to see. On the basis of these Fleming decided to hire him "for the purpose of taking photographic views of objects of interest, illustrative of the physical features of the country . . . to the west of the Forks of the Saskatchewan."[20] Thus Horetzky's pastime led him by chance to a position as a professional photographer and explorer for the next nine years.[21]

Horetzky's replacement at Moose Factory was James L. Cotter, a career Company man who had arrived at the settlement in 1867. He too became interested in photography but, unlike his colleagues, maintained his interest throughout his life.

Charles Horetzky

At elbow of North Saskatchewan [River] Sept. [18]71 Albumen 14.9 x 19.9 cm
PAC, PA-138573

While in the Eastmain District, a region he described as "a land so inhospitable and so sterile . . . [it is] likely at first sight to be pronounced uninteresting," Cotter developed an interest in the Inuit and their methods of survival.[22] He took numerous photographs of igloo building, kayaks and other aspects of Inuit life, in addition to portraits. While much of Cotter's work is valuable only for its documentary content, his best photographs, such as the *Otter* and *Plover* at Moose Factory (page 148), are splendidly evocative. The spare and cryptic *Camp. Shores of Hudson Bay* (page 147) with its modern feel is unusual for the time. Cotter's photos appeared as engravings in *The Illustrated London News* and in several annual reports of the Geological Survey of Canada. The firm of Notman and Son is reported to have complimented him by saying "they had never seen such beautiful and artistic work coming from an amateur."[23] Regrettably, little of Cotter's work remains in the form of original prints, and the negatives are reported to have been lost in a fire many years ago.

William Bell Malloch, a medical doctor, was sent to Moose Factory in 1870. His harrowing walk from Abitibi to Moose in the bitter cold of January, during which he almost froze and starved, was graphically described later to a friend. In the letter he enclosed several photographs to help his friend visualize the town as he described it. A later letter, apparently still before summer had arrived, explained: "I regret not to be able to send you good photographs . . . but it is too early in the season to take good negatives in the

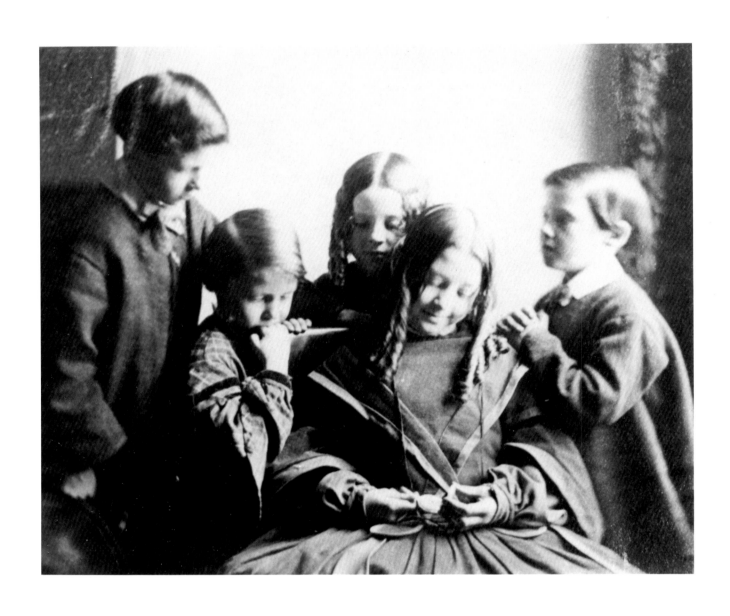

[H.J. Cundall, attr.]

14 Bobbie, Ada, Walter, Louie & Alice DeBlois, Charlottetown 1861 Albumen 8 x 9.4 cm PEI, Acc. No. 3466, DuVernet Album

open air. . . . In a week or two I hope to be able to take a panoramic view from one of the islands."[24] Confronted by dwindling supplies of albumen paper for printing, Malloch made his own using notepaper which, he noted, "is but a poor substitute." Though Malloch was an active photographer during his eight years at Moose Factory, there are almost no photographs which can be definitely attributed to his hand, since he did not sign his work.

There is evidence that other Company employees also photographed. Chief Trader George Simpson McTavish, for example, is represented by the striking photograph of an Inuit beside his catch at Little Whale River (page 145).[25] The varied interests of these Company men and the wide territory which they covered combine to present a fascinating record of life in the region of James and Hudson Bays during the 1860s and 1870s.

Up to the 1870s all the previous photographers used the troublesome wet-collodion process. Repeated efforts were made over the years to reduce the bulk of equipment and to eliminate the necessity of carrying about a complete darkroom. None had more than a limited success. In the 1870s, however, constant experimenting led to the discovery that using gelatin as a base resulted in an emulsion that was dry, kept for long periods, and was ten to twenty times faster than collodion. Although gelatin bromide negatives were commercially produced as early as 1873, the process did not arrive in one step. Continued refinements led to its widespread adoption by the early 1880s.

The advent of the gelatin dry plate set the stage for a vast increase in the number of amateur photographers. The speed of the new plates and the introduction of relatively small hand-held "detective" cameras opened the possibility of casual photography to thousands who would never even have considered the collodion process. *The Philadelphia Photographer* stated in 1885 that "amateurs are insatiable and ubiquitous" while *The New York Times* likened the wave of interest to an epidemic.[26]

One of these new enthusiasts was William Hanson Boorne, a chemist by education, who came to Canada to homestead in Manitoba in 1882. He was already a knowledgeable amateur and the snapshots he made on his farm are typical of the new informal work made possible by the hand-held camera (pages 150, 151). About 1885 he travelled to Calgary. He was apparently impressed by the possibilities for a photographic business there and, returning to England briefly, he persuaded his cousin, Ernest May, to come back with him. Together in 1886 they established the photographic studio of Boorne and May which did a profitable business for seven years. Boorne is today best known for his professional activities and not at all for these souvenirs of his life as a young homesteader.[27]

Boorne has brought us to the edge of the "snapshot" revolution. The style and subject matter of his photographs are vastly different from the work of amateurs of the wet-plate period. Up to this point the amateur market had been a small part of the photographic industry, limited to those with sufficient money, time and ability to learn the complicated procedures of the daguerreotype, calotype, and wet plate. Economically speaking, the amateur was now on the verge of dominating the photography industry.

TURPENTINE WAX PAPER

The turpentine wax paper process was a variation on Gustave LeGray's wax paper process, itself an improvement of the calotype. The turpentine process, ascribed to the Frenchman Tillard, was described in The Photographic News (17 December 1858,) as follows:

"Into about a quart of . . . turpentine is placed the white wax, in small pieces They are left to mix together two or three days and the solution is decanted and filtered. Into this . . . a small quantity of iodine is then placed A very small quantity of palm oil . . . is added The iodide bath, having been prepared and filtered, is placed in a dish or basin, and the paper is soaked . . . then dried rapidly, and laid aside for sensitizing at another time . . . in a bath of nitrate of silver The paper is washed and dried . . . and is then ready for use."

It was claimed that by repeating the iodizing step the speed of the emulsion could be improved by up to a third; otherwise, exposures were the same length as with the ordinary wax paper process — a matter of five to twenty or more minutes. The negative could be kept many hours before it was developed.

The New Amateur/1885-1900

Peter Robertson

An explosion of amateur photographic activity occurred in Canada during the fifteen-year period leading to the twentieth century. Who was the New Amateur? He was Captain James Peters of the Regiment of Canadian Artillery, snapping the defeated Louis Riel in the aftermath of the Northwest Rebellion of 1885 (page 170). He was the young traveller Robert Reford making a portrait of a Chinese woman at Victoria in 1889 (page 172). He was that quintessentially Victorian man of action, Henry J. Woodside, pointing his camera at prospectors in 1899 during the Klondike Gold Rush (page 179). Moreover, the New Amateur was one of hundreds of more obscure men and women, less adventurous than these three, who joined camera clubs or who went quietly about the pastime of photography. Thus the New Amateur was Arthur Beales in the kitchen of his Toronto home, photographing his wife in the act of preparing food (page 175), and May Ballantyne of Ottawa, recording the activities of her sister and brothers in an engagingly candid way (pages 153, 154).

The new amateurs owed their existence to significantly improved equipment, which removed photography from the confines of the professional studio. The mass-produced gelatin dry plate freed the photographer from recourse to a darkroom for sensitization and development every time he exposed a negative. Furthermore, the rapid exposure time of the dry plate made it possible to photograph subjects in motion and, by minimizing the problem of camera shake, enabled the photographer to use a small hand-held camera which was both portable and inconspicuous. Thus, the Marion 'Academy' dry-plate hand camera allowed Peters to cope with the unsettled conditions of the Northwest Rebellion. "It is quite wonderful what the instrument *did* stand. . . . I found that the rebel marksmen of the far West did not give an amateur photographer much time with his 'quickest shutter', and I tremble to think of the fate of the [photographic] artist who would attempt to erect his tripod."[1]

Yet the days of the dry plate were numbered as early as 1888, the year that George Eastman marketed the Kodak system of photography. Reford was one of the first Canadians to own a Kodak and to appreciate the convenience of commercially-processed celluloid roll film, a feature which separated the act of taking a photograph from the task of making a print. The negatives of H.J. Woodside[2] furnish further graphic evidence of the evolution touched off by Eastman within the cameras of most amateurs: the dry plates

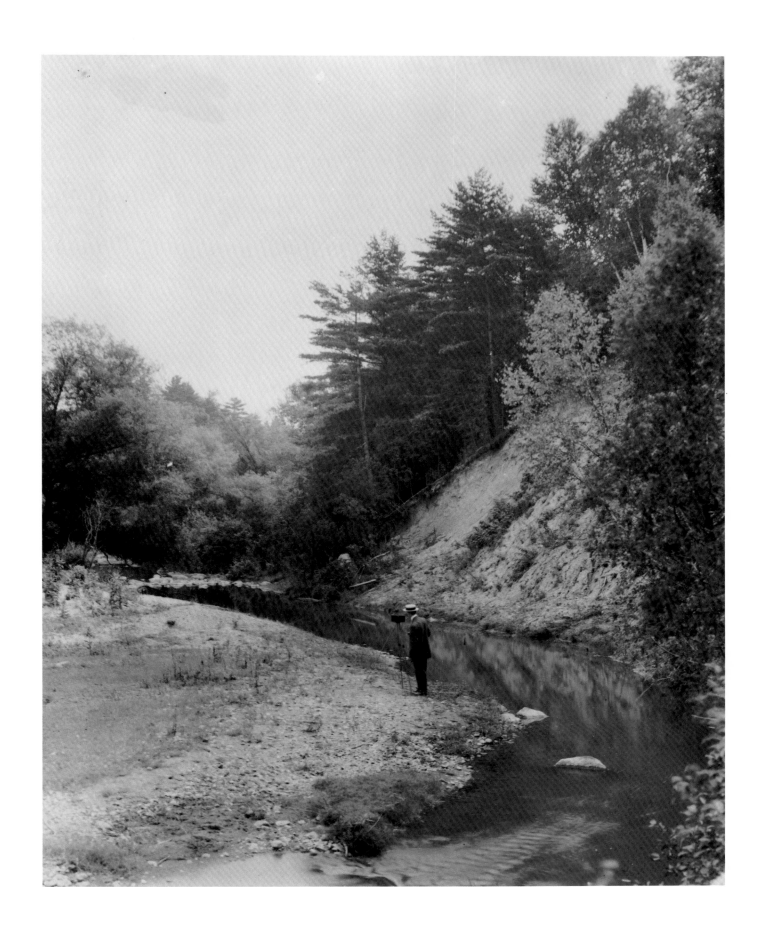

Anonymous

[Arthur Beales ? near Toronto] n.d. From original glass negative 25.1 x 20.1 cm *PAC, PA-800239*

GELATIN DRY PLATE

Commercially available to amateurs by the early 1880s, the gelatin dry plate negative was a sheet of glass coated with an emulsion of light-sensitive silver halides suspended in a layer of gelatin and capable of maintaining its sensitivity to light over long periods in storage. An unexposed plate was loaded into a plate holder in the darkroom for exposure in the camera when needed. The exposed plate was brought back to the darkroom for developing, fixing, washing and drying.

HAND-HELD CAMERAS

One of the greatest boons to the amateur photographer was the development of the hand-held camera during the 1880s, freeing the photographer from the constraints of burdensome equipment. One of the earliest known photos by a hand-held camera in Canada was made by James Peters c. 1884, when he snapped this view of some of his more traditional colleagues using a tripod-mounted camera at the Citadel in Quebec City (PAC, C-15018). Other examples of Peters' work are reproduced on pages 170 and 171, clearly indicating the ability of the improved equipment to capture motion, and to record fleeting historic moments such as the capture of Louis Riel after the Northwest Rebellion of 1885.

of the early 1890s were joined by cut film negatives in mid-decade, and by roll film negatives at the turn of the century. In 1899, the establishment at Toronto of the Canadian Kodak Company[3] was proof that the slogan "You press the button, we do the rest" was influencing significant numbers of Canadians.

To the professional photographers, amateurism posed the threat of lost business. They responded by joining camera clubs, where they could make contacts and influence events. Such well-established men as George Gauvin and Adolph Gentzel of Halifax, Jules-Ernest Livernois of Quebec, Alexander Henderson and Amos Rice of Montreal were active members of the clubs in their cities. Even the renowned William J. Topley of Ottawa and Alex Cunningham of Hamilton, president of the Professional Photographers of Canada in 1895 and 1896, were members of local clubs. Furthermore, there was considerable expansion as well as competition among dealers like David Hogg of Montreal and James G. Ramsey of Toronto, who approached the New Amateur as a growing market for photographic supplies and services. The potentially uneasy relationship turned out to benefit both groups. Whereas amateurs had access to professional expertise and critical judgement, commercial photographers revitalized their outlook and kept abreast of current trends. There was, however, a third group which was unhappy about its exclusion from this relationship. This was the Pharmaceutical Association of the Province of Quebec, whose members were concerned that their business was being undercut by professional photographers who were selling chemicals to amateurs. The Association accordingly instituted a lawsuit on 30 November 1892 against Jules-Ernest Livernois, alleging that he "contrives to sell them [chemicals] as cheap as we buy them." By rendering a decision in favour of Livernois on 6 December, Judge Chauveau of the

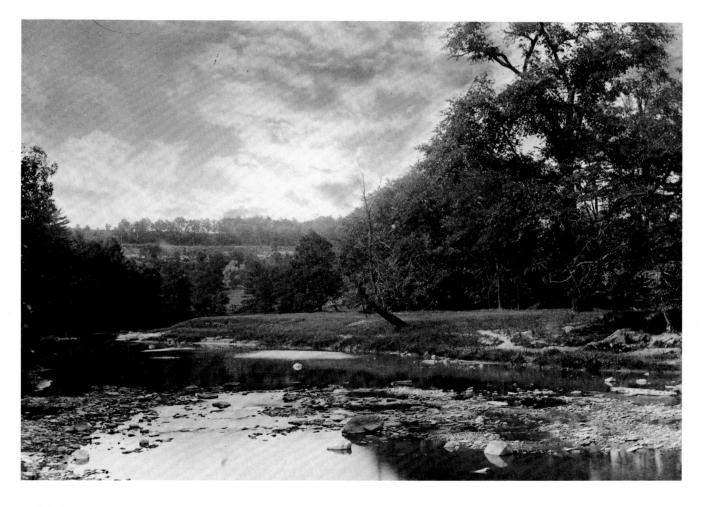

A.M. Ross

On Don River, [Ont.] n.d. Platinum 14 x 19.4 cm PAC, PA-120284

Quebec Police Court removed a possible legal restraint on the photographic supply trade.[4]

The gregarious nature of the New Amateur gave impetus to the formation of camera clubs in the cities and towns of Canada, modelled upon the numerous amateur photographic societies already existing in the United Kingdom and the United States. The first of these was the obscure Quebec Amateur Photographers' Association which existed in Quebec City from 1884 to 1886.[5] Its successor was the Quebec Camera Club, formed on 8 February 1887 by "a certain number of gentlemen interested in photography," including James Peters, the first president and moving spirit.[6] Never consisting of more than ten members, the club met regularly in the quarters of Captain William Imlah at the Citadel until it disbanded in May 1896.

Organized on 5 November 1886, with rooms at 12 McGill College Avenue, the Montreal Amateur Photographic Club initially consisted of just six members, who appointed themselves to every position on the executive except that of president. One year later, the club had a president, member-

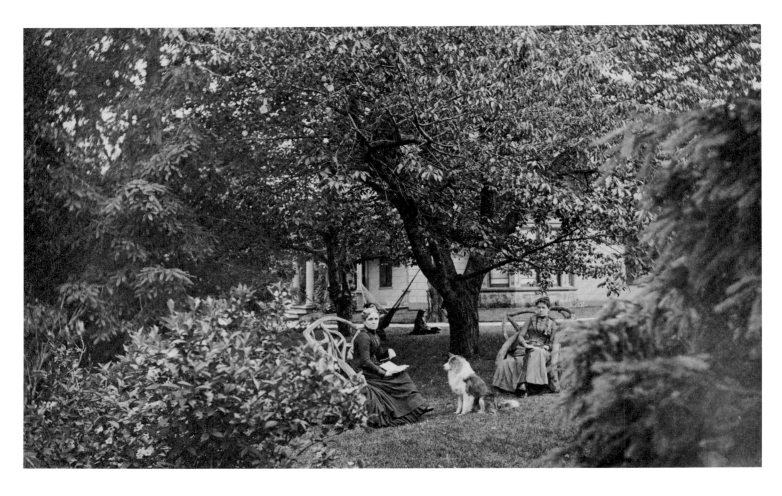

A.M. Ross

Under the Cherry Tree, [Goderich, Ont.] n.d. Silver 11.5 x 13.4 cm *PAC, PA-120266*

ship had risen to 33, and a report stated that "amateur photography is a pursuit that many Montrealers have taken to the last year or so."[7] Following the demise of the club at the end of 1889, the Montreal Camera Club was established in February 1890. At the end of 1899, the membership was 95, and meetings were held at No. 4 Phillips Square.[8]

In Ontario, the first meeting of the Photographic Section of the Canadian Institute in Toronto took place on 23 February 1887. So active were the 33 members that by the spring of 1888 they were anxious to escape from the Institute, whose annual report stated regretfully, "Desiring to extend their work in a more practical manner, [they] resolved to form a Photographic Society having wider scope."[9] This was the Toronto Amateur Photographic Association, the result of a meeting in the Queen's Hotel on 17 March 1888. Meeting at the College of Physicians and Surgeons on Bay Street, the 60 members proclaimed their objectives to be "the promotion of the art-science of photography in its various branches, the exchange of information and ideas by means of papers by members, practical demonstrations of various

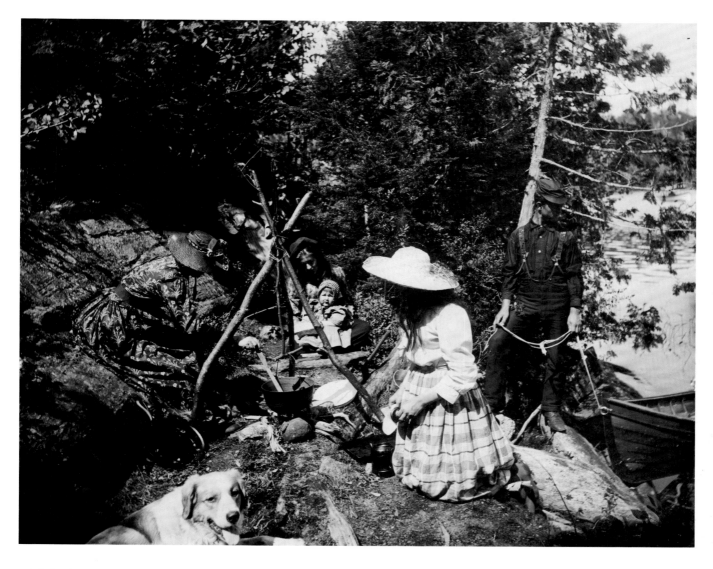

A.M. Ross

Gypsey [*sic*] Camp, Cha[m]plain Island [Ont.] n.d. Gelatin chloride 15.2 x 18.9 cm *PAC, PA-120294*

photographic processes, discussions, and also to provide a headquarters where the different manipulations can be carried out with the assistance of apparatus to be provided by the Association, and where sundry books of reference and current photographic periodicals shall be at all times available."[10] In December 1891, the association became the Toronto Camera Club, but the change of name meant no difference in the nature of the organization, which continued to prosper. Located at the corner of Yonge and Gerrard Streets, the club's quarters consisted of a large reception room and studio, a committee room, lockers and work rooms, two darkrooms, enlarging and printing rooms. By every standard of measurement — facilities, variety and depth of activities, international stature, and a membership of 181 people by 1899 — the club stood head and shoulders above all its Canadian contemporaries.[11]

 Organized amateur activity in Hamilton began in a similar manner when 20 people under the leadership of a man named William White sought affiliation with the Hamilton Scientific Association. Formed on 18 April 1892, the

INITIATION NIGHT AT THE UP-TO-DATE CAMERA CLUB by JOHN J. WOOLNOUGH, TORONTO, ONTARIO

(The following excerpts from Anthony's Photographic Bulletin, Vol. 8 (1896), 67-72, convey the flavour of Woolnough's lengthy mock-epic, which resembles an opera by those other Victorians, Gilbert and Sullivan.)

PRESIDENT:
*A summer landscape's passing fair,
But every amateur's been there.
If you would gain an entrance here,
You'll have to seek a wider sphere.*

*Grasp Dame Nature's every mood,
Humbly mild, and grandly rude.*

*Swear you only will appease
Your picture-thirst with scenes like these!*

NOVICE:
I swear.

PRESIDENT:
*Swear you'll never take delight
In prowling round—a sorry sight—
With box of tricks (the focus fixed)
Inanely snapping left and right.*

*If there's a weakness we deplore,
It's using stop f.64.*

*That mass of sharpness everywhere
Is really more than we can bear.*

*If you do, then bear in mind
You'll reprimanded be—and fined.*

NOVICE:
*I swear; and mean to strain each nerve
Your approbation to deserve.*

association's Photographic Section pursued the goal of the "general research and advancement of photography among its members by holding monthly meetings . . . when all work done during the month will be on the table for examination and criticism," and had a membership of 66 at the end of 1899.[12] The third major Ontario club was in Ottawa, where an estimated 100 amateurs provided ample membership potential. In December 1894, a report facetiously headlined "Now Look Your Prettiest/For the Amateur Photographers Are After You" greeted the creation of the Ottawa Camera Club.[13]

The amateur movement reached Western Canada in September 1892 with the formation of the Winnipeg Camera Club, whose 45 members quickly fitted up a "cozy general room and a well appointed dark room in the McArthur Block, corner Lombard and Main Streets . . . supplied with appropriate literature and magazines."[14] In the Maritime provinces, the advent of the Saint John Camera Club on 9 June 1893 prompted the report that, since there were over 50 amateurs in the city, the club's future seemed certain. From May 1895 to January 1896, the short-lived Crescent Camera Club challenged this monopoly, but went into eclipse because "only a few took an interest in its welfare."[15] By contrast, there was good news from Halifax in March 1896: "No other city in Canada the size of ours is without a camera club, and it is a good thing that Halifax is now in line."[16] Within a few weeks, it was possible to add that the Halifax Camera Club had "already 60 members including a few ladies, barrels of enthusiasm . . . [and] is in a thoroughly healthy and flourishing condition."[17] Three thousand miles away, "great enthusiasm prevailed" at the formation in January 1897 of the Vancouver Camera Club, whose doors were open to "all lovers of the art and their friends, including the ladies."[18]

Because of the attractions they offered, camera clubs enlisted members from a variety of social backgrounds and occupations. Certainly fees were not prohibitive: a dollar a year in Hamilton and Ottawa, three dollars in Winnipeg — "very moderate and places the usefulness of the club within the reach of all interested in photography."[19] The highest fee was five dollars a year in Montreal and Toronto. *The Canadian Photographic Standard* advised that every amateur in Montreal ought to belong to the Montreal Camera Club, because "apart from the immense advantages in a photographic point, its social standing is of the very highest character."[20]

Research has revealed the disparate occupations of club members: from accountants to architects, from artists to bank clerks and businessmen, civil servants, clergymen, engineers, journalists, lawyers, military officers, and a host of others. Although most were men, there were a number of active and successful women.[21] The only club to make an issue of female membership was the Toronto Camera Club, whose executive committee held a special meeting on 18 November 1895 to debate and pass a motion admitting women as members. Although the motion was approved at a special general meeting one week later, it was noted at the annual general meeting of 1895-1896 that only three women, Miss Helen Beardmore, Miss E. Lee and Miss McGaw, had become members. Except for those like artists and scientists, who perhaps had a general familiarity because of their professions, very

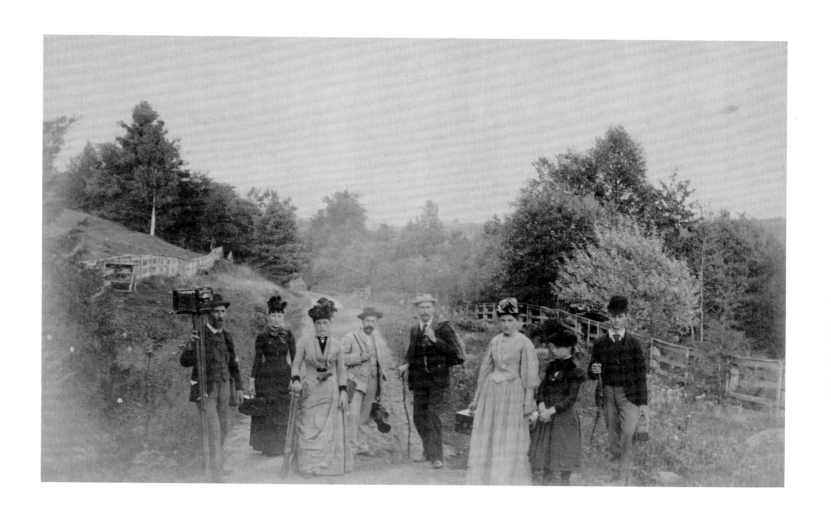

Anonymous

[James Ballantyne, far left, with members of the Ottawa Camera Club? Que. *c.* 1895-1899] Albumen 12 x 19 cm
PAC, PA-126331

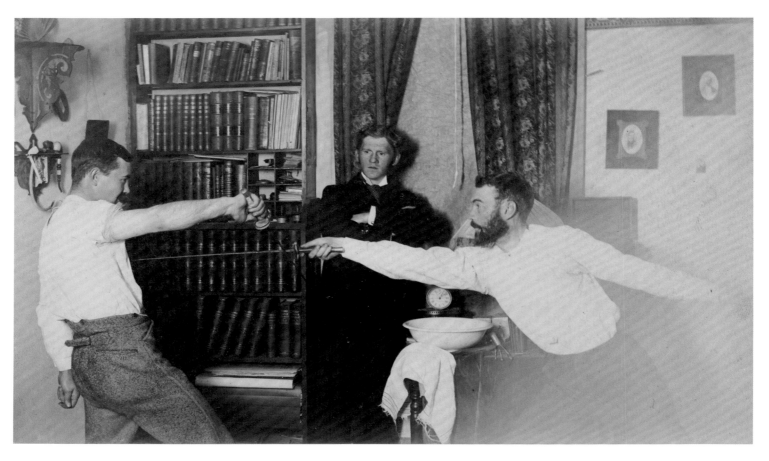

George Henry Field

First Blood, [Toronto General Hospital] Oct. 1895 Gelatin chloride 11.4 x 18.8 cm *PAC, PA-123081*

few of these people had previous experience of photography. Perhaps this explains the attitude of overconfidence expressed by statements like "the perfection of instruments and materials enables a person of ordinary intelligence to learn to work a kodak [sic] in a few weeks . . . and latent artistic talent will do the rest."[22]

All amateurs shared in varying degrees what can be described as uncomplicated enthusiasm, a desire simply to get on with photography, enjoying themselves in the company of like-minded people. Their spirit found expression in the regular field trips sponsored by all clubs, such as the Toronto Amateur Photographic Association's camping trip to Lake Simcoe in May 1889 and the Ottawa Camera Club's excursions to Chelsea and Kingsmere in the Gatineau Hills. Extolling these occasions in flowery prose, one amateur wrote, "In their search for the beautiful, the graceful and the unique in nature, these modern knights and ladies of the kodak meet with adventures innumerable that cast a glamour and romance over their everyday life, compensating for its hard realities and smoothing off its rough corners by a subtle method unknown to their compeers who know not the kodak and its mysteries."[23]

This casual approach aside, clubs must have challenged those who planned lectures and demonstrations to appeal to a wide range of compre-

Anonymous

The Camp Photographer [Dr. W.H. Ellis] after changing plates 1897 Silver 9.9 x 11.8 cm *PAC, PA-121315*

hension and varied interests. The titles suggest that, throughout the 1880s and 1890s, there was an audience for everything from the highly theoretical to the severely practical. Montreal speakers and demonstrators presented topics like "Cameras: Their Adaptation to Different Classes of Work," "Experiences of Bromide Enlarging," "Overexposures and their Treatment," and "Masters and Masterpieces in Art." The amateurs of Toronto learned about "Flash Light Photography and Apparatus," "Experiments with the Telephotographic Lens," "Enlarging and How to Do It," "Carbon Printing," and "The Development of Photographic Art." In Ottawa, subjects for discussion included "Summer Photography," "Retouching the Negative," "Platinotype Printing," and "Composition." Club members in Saint John and Halifax wanted to hear about "Photography Past and Present," "Microscopic Photography" and, as early as 1896, "Colour Photography."[24] Indeed, the relentless procession of subjects conveys a certain Victorian desire for perpetual self-improvement.

Members spent considerable time learning how to make lantern slides, whose universal popularity made them a sort of common currency. Amateurs viewed them, criticized them, and circulated them among other clubs by means of the American Lantern Slide Interchange, founded in 1885. Its offshoot, the Canadian Lantern Slide Exchange, began as a Toronto-

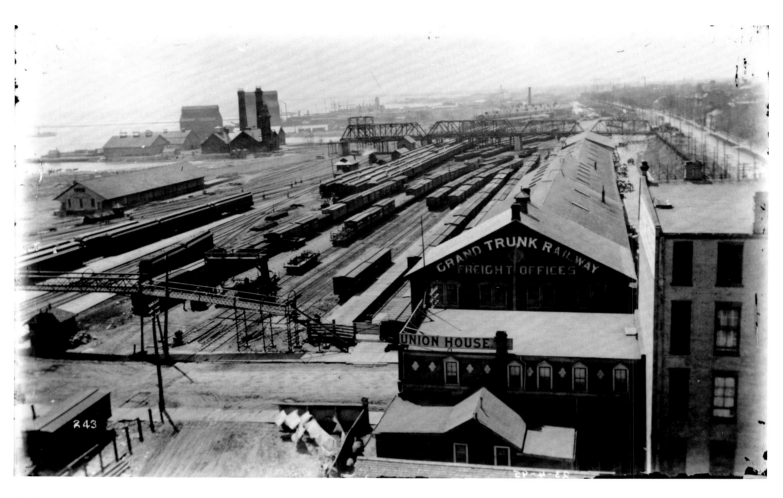

John Boyd

G[rand] T[runk] R[ailway] Yard from top of Union Station, Toronto 23 April 1895 From original glass negative 12.6 x 20.2 cm *PAC, RD-28 Courtesy of Miller Services Ltd., Toronto*

Hamilton-Montreal network in March 1893.[25] Lantern slides were a powerful force in bridging the great distances separating Canadian amateurs and in familiarizing them with each other's work.

Serious amateurs showed a readiness to try the new papers and printing processes. An 1892 report from the Toronto Camera Club mentioned that ''Mr. A.W. Croil's work was principally bromides, while Mr. F.D. Manchee had a preference for the warmer tones of silver prints. . . . Dr. W.H. Ellis also showed a number of exceedingly fine platinotypes.''[26] One year later, ''Platinotype paper has the 'call' at present. . . . 'Aristo' was there in all its glossy glory, but [there was] a marked tendency towards the neat surface and nature's grey tints of the platinotype, while the *glacé* finish was *de trop*.''[27] The statement in 1898 that ''the glossy-surface papers are giving way almost entirely to matt-surface and dull finish in Canada'' portended twentieth-century developments.[28]

Armed with versatile equipment and at least a general knowledge of photographic principles, the New Amateur theoretically enjoyed the freedom to photograph just about anything. In practice, most photographed what was

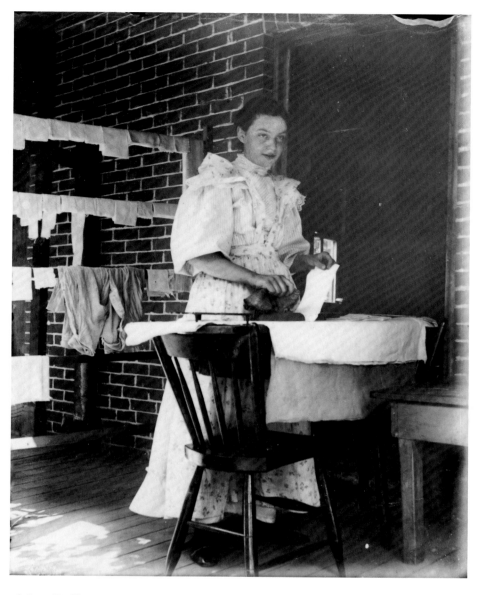

May Ballantyne

[Maggie Hyde ? ironing clothes, Ottawa] 1892 From original glass negative 12.8 x 10.1 cm *PAC, PA-131939*

familiar and accessible to them. Family members were the most available subjects. Friends of the photographer were equally fair game.

May Ballantyne's seemingly casual landscape of Hartwell's Lock on the Rideau Canal (page 155) contrasts markedly with W. Braybrooke Bayley's studious exhibition platinotype entitled *'Neath Lordly Oaks* (page 167). The conscientious John Boyd found documentary inspiration in familiar subjects like Toronto's Parkdale fire station (page 164), whereas Richard Cassels ventured into Northern Ontario for his photograph of a moose hunt (page 177). Frequently, the amateur's approach is distinguished by spontaneity or humour, as evident in James Peters' trio of snowshoers in full stride at the Quebec Citadel (page 171) and George Field's photograph of himself and his fellow interns partying at Toronto General Hospital in 1895 (page 182).

Magazines of the era provided a modest outlet for the subjects favoured by amateurs. In September 1888, the editors of *Dominion Illustrated* believed that "when Kodaks and other cameras are in everybody's hands . . . we should have views of every occurrence of any note . . . pouring in on us . . . so that the amateur would have the satisfaction of having his work repro-

Mrs. Beales near Toronto Junction [Ont.] n.d From original glass negative 16.3 x 21.5 cm *PAC, PA-800205*

duced,"[29] and over the next three years the magazine published halftone reproductions of landscapes by several Canadian amateurs. During the summer of 1894 *Toronto Saturday Night* sponsored a contest in which the themes of prize-winning prints were landscape and genre.[30] An 1897 series in the short-lived *Massey's Magazine* featured "Some Recent Pictures in Amateur Photography," which included both genre and landscape from Toronto and Ottawa.[31]

Far more important than the magazines were the club-sponsored exhibitions. These provided open forums where amateurs could compete with their peers for public recognition. These annual affairs were keenly anticipated by competitors, who spent entire club seasons memorizing the extensive regulations and perfecting their entries. Usually the judges were artists like C.M. Manly and J.C. Forbes, and professional photographers like J. Fraser Bryce and Eldridge Stanton. Prizes were medals provided by the clubs, or equipment donated by photo supply dealers. The available reviews seldom venture beyond complimentary generalities. One wishes that revealing comments like "some dark tones [were] a dismal mock of nature while the lighter ones were full of atmosphere and transparency in the shadows" were not so infrequent.[32] What the prize lists do reveal is that landscape and genre were the two most popular subjects in a host of exhibition classes. These included landscapes — large, small, beginners', marine, and waterfalls. One wonders where the distinctions were drawn between portraits, portraits of children, groups, and figure studies. A further division existed among techniques like hand camera work, enlargements, lantern slide work, flash light subjects, and objects in motion.[33] Pity the poor individual who had to struggle with such arbitrary over-categorization!

Despite their role in raising the quality of amateur photography, exhibitions were not without their critics. Writing in 1893, Braybrooke Bayley pointed out "the sad dearth of practical information or direction for the rank and file of our amateur corps." He urged greater care in the selection of judges, with "fixed rules adopted for their guidance in judging, and that of the competitors in preparing work, and some method devised to convey whereby success was achieved and wherein lay defeat."[34] More disturbing was the fact that, by separating winners from losers, exhibitions exacerbated the differences between what George Eastman astutely identified as two classes of amateur. The first were "the true amateurs, who devote time enough to acquire skill in developing, printing, toning, and their number is limited to those who have time to devote to it, inclination for experimenting, and such facilities as the darkroom." The second class were "those who, lacking some, or all of the requisites of the 'true amateur' desire personal pictures or memoranda of their everyday life. . . . They bear a relation to the limited numbers of the true amateur of one thousand to one hundred."[35] We see a growing divergence with implications for the future: on the one hand quality, on the other, quantity.

Judging the amateur photography of the era at an international level, Helmut Gernsheim has written that, apart from a handful of esthetically-oriented workers, "most of the new generation of photographers were entirely devoid of artistic training."[36] The generalization is not totally fair to

PLATINUM PRINT

Platinum paper, manufactured by the Platinotype Company from 1879 to 1937, was sensitized with a solution of potassium chloro-platinate and ferric oxalate which, as a result of the development process, produced an image formed by platinum precipitate. Characterized by its extremely full range of delicate gray tones and by its matte surface, the platinum print or platinotype possessed great permanence because of the stability of platinum.

30 [Gertrude H. Ross bathing Ian and Eugenia Ross, Que. *c.* 1898] Silver 14.1 x 10 cm *PAC, PA-113084*

Canadians; Arthur Beales, for example, was a pupil of the artist T. Mower Martin, while Braybrooke Bayley and John Boyd were, respectively, close friends of the artists A.H. Howard and Frederick S. Challener. One turns to the attitudes expressed in American and British periodicals for additional perspective. Americans generally addressed Canadians on equal terms, noting the activities of clubs and welcoming Canadian participation in the American Lantern Slide Interchange. Because prominent American amateurs like Alfred Stieglitz and Rudolf Eickemeyer were beginning to compete in Toronto Camera Club exhibitions during the 1890s, there was reason to devote attention to Canadian affairs. However, the criticism could at times be extremely frank: "We sincerely trust that the Society [Toronto Camera Club] will by the time it holds its next exhibition be in a position to refuse entries which are so bad as to disgrace photography either as an art or as anything else."[37] Although Canadians respected British amateurs, most British photographic periodicals simply ignored Canada. One prominent exception was the influential publication *Photograms of the Year*, whose editors were H. Snowden Ward and his American-born wife Catharine Weed Ward. The editorial staff significantly included W. Ethelbert Henry, formerly of *The Canadian Photographic Journal*. The editors made a point of including an annual review of photography in Canada, and offered both praise and positive criticism of individual photographs.[38]

What was the twentieth century expected to hold for the New Amateur? The mood was one of optimism, according to an 1898 report from Winnipeg that "from Cape Breton to the Pacific the kodak [sic] is abroad in the land."[39] On 30 March 1899, Snowden Ward spent an evening at the Toronto Camera Club during a lecture tour of North America. He later offered a thoughtful, if slightly condescending, assessment of the Canadian scene:

The Canadian amateurs . . . feel their somewhat isolated position . . . but by means of careful study and discussion of the articles and reproductions in the journals, as well as by very frank, breezy criticism at their own lantern-slide evenings, they are doing all that lies in their power to remedy these deficiencies It is to be hoped that they will not make the mistake of attempting to follow too slavishly the methods and opinions of European workers, but will evolve their own school, expressing their own thoughts, feelings, and even prejudices, and giving us something of the real spirit of the breezy, frank, progressive life of their great colony.[40]

BROMIDE PRINT

Manufactured in quantity by the Eastman Dry Plate and Film Company beginning in 1886, bromide paper was a developing-out paper coated with a gelatin emulsion containing light-sensitive silver bromide. Sold ready for use, bromide paper possessed a development speed faster than that of albumen paper, a characteristic which considerably simplified the process of making enlargements. Silver bromide prints have a cold gray cast to their blacks, and can be toned to various shades, as well as being produced with matte, semi-matte or glossy surfaces.

Art Ascendant/1900-1914

Lilly Koltun

U ndoubtedly the most significant movement in Canadian photography after 1900 was pictorialism. Slowly at first, this new orientation began to affect not only who took pictures but also how those photographs looked. The novelty of Kodak quantity and the familiar standards of realism established in the nineteenth century were about to be displaced by a new esthetic ideal.

Pictorialism sought to emulate traditional art media by using broad compositional design, suppression of detail, atmospheric effect, selective highlighting, and diffused or "soft" focus to create photographs that could be judged as works of art. Although any "straight" photograph was welcomed if it evidenced artistic feeling, manipulated negatives and printing processes that were amenable to manual intervention, such as gum bichromate or oil printing, emerged as favoured means to these ends. The images often looked little like photographs, and much like charcoal sketches, or distant cousins of paintings and prints. Deliberately anonymous subjects predominated: unidentified portraits, landscapes, still-life, even mythological scenes, all paralleled the concerns of artists in other media, and echoed their stylistic influences. Pictorialism's struggle to validate photography as an art often entailed denying the most recognizable of photography's features: specificity of content, accuracy of form and a smooth, invisible surface texture.

Pictorialism first arose in Europe, particularly in England, where a group of prominent photographers formed the Linked Ring in 1892. In deliberate contrast with the Royal Photographic Society, which exhibited both artistic and scientific or technically interesting photographs, the new salon sponsored by the Linked Ring focused entirely on the esthetic.[1] Its members were joined, intellectually speaking, by the Photo-Secession, a group created in New York in 1902 at the instigation of the famous Alfred Stieglitz, which pursued pictorial photography as a "distinctive medium of individual expression" and attempted "to draw together those Americans practicing or otherwise interested in art."[2] Through participation in numerous exhibitions[3] and Stieglitz's renowned quarterly publication *Camera Work*, the Photo-Secession played an influential role in the spread of the pictorialist viewpoint.

In Canada, a presentiment of the move toward photography as expressive art appears in the work of William Ide in Ottawa. If correctly dated to 1895 or 1896, the little carbon print *The Watering Place* (page 166)[4] represents a transitional point between the older "picturesque" approach of genre and landscape photographers, and the newer "artistic" approach. Its

Sidney Carter

[Maude Carter?] n.d. Platinum 21.5 x 16.4 cm *PAC, PA-138572*

William Ide

34 [Braddish Billings house, Billings Bridge, Ont.] 1900 Platinum 16.2 x 5 cm *PAC, PA-125119*

William Ide

[Photographer and children] n.d. From original lantern slide 8.2 x 8.2 cm *PAC, PA-133647*

roots are clearly in the exacting, exhibition-style printing of straight photographs, as in *'Neath Lordly Oaks* (page 167) by William Braybrooke Bayley. Equally clearly, it attempts to emulate Constable's paintings such as *The White Horse* of 1819 or *The Hay Wain* of 1824, sharing a similar posed bucolic subject, compositional pattern, and massing of light and dark. Despite the clear quotation, *The Watering Place* and other of Ide's works, such as *Dr. Frank Shutt and Friend* (page 204), are still delicately detailed and avoid stiffness. Later photographs exhibit the typically pictorialist features of broad chiaroscuro effect and "impressionist" fall of light (page 220).

Ide worked within the context of the Ottawa Camera Club, of which he was president from late 1898 to 1900 and at whose photo exhibitions he won four medals. The club was reformed as the Photographic Art Club of Ottawa in 1904, its new name revealing its interest in photography as an art form. However, despite the presence of aspiring pictorialists such as G.E. Valleau, Frank Thomas Shutt, and Charles Macnamara of Arnprior, the club's work was on the whole acidly condemned by Harold Mortimer-Lamb in *Photograms of the Year 1905* as merely "pretty-pretty." It was not Ottawa, but Toronto, which represented the most active centre of early pictorialism in Canada.

As early as 1900 the Toronto Camera Club's exhibition revealed the permeation of pictorialist imagery. A reviewer remarked that, in contrast to the

GUM BICHROMATE

Familiarly known as 'bi-gum', this process depends on principles first laid down by [A.L.] Poitevin in 1855. Briefly, it consists in coating paper with a mixture of gum and pigment sensitised with potassium bichromate solution. This paper is printed under a negative, the bichromated colloid becoming more or less insoluble in proportion to the light action. In this way a print may be obtained with a single coating, but it is usual to re-coat the print thus made and again print and develop. This may be repeated almost indefinitely, either for the purpose of reinforcing certain parts of the image, or for producing prints in more than one colour The use of various papers, the number of pigments available, the different effects resulting from modifications in coating and development, the power of multiple printings in one or more colours — all these afford opportunity for considerable exercise of control over the final result. (Bernard E. Jones, ed., Cassell's Cyclopaedia of Photography. *London, New York, Toronto and Melbourne: Cassell and Co., Ltd., 1911; 283. Reprinted by Arno Press Inc., New York, 1973.)*

show of 1899, "there is a noticeable absence of . . . glossy prints."[5] Instead, carbons and toned bromides seemed to predominate. *In the Welcome Shade*, a soft-focus treatment of cows by H.B. Lefroy, won the bronze medal for enlargements. The print was later exhibited in England and was reproduced in *Photograms of the Year 1907*, an annual begun in 1895 and devoted to international pictorialism.

Lefroy was among the first members of the Toronto Camera Club to master the revived platinum printing process, demonstrating it in February 1902. The same night, J. Percy Hodgins demonstrated gum bichromate techniques. Both demonstrations were repeated in 1903. Gum was desirable for its adaptability to hand manipulation and colouring, platinum for the permanence and subtle tonal gradations it lent to a work. These men must have been partly responsible for the increase in gums, carbons and platinums noticed at the next Toronto Camera Club exhibition during 1-5 April , 1902.[6]

The nucleus of the pictorialist group in Toronto, like Lefroy, was already exhibiting in 1901. William Henry Moss, Roger D. Stovel, W. Ross, J. Percy Hodgins and W.J. Watson all appeared in the prize list. Moss was a veteran photographer; he had been on the club's executive in 1892 and as early as January 1893 he had demonstrated Platinotype paper to the members. He remained active until his death in 1911, sitting on committees and winning the praise of his peers.

The 1902 exhibition confirmed this group as leading Toronto photographers. Both Lefroy and Hodgins had also exhibited at the San Francisco Salon, and Moss at the Philadelphia Salon.

Special notice was given as well to a newcomer, Sidney Carter, who showed a print called *Sunset on Black Creek*, which he had exhibited in Philadelphia in 1901. If this entry is typical, he was well in control of pictorial technique, and used a compositional framework derived from landscape painting. Also at the 1902 Toronto exhibition, Carter received the Members' Gold Medal, "which leads one to expect much in the future."[7] Examples of that future are reproduced on pages 185 and 188. The nude certainly represents one of Canada's rare early attempts in that direction. The ambivalent image in *The Sisters* conceals and reveals on just that level of suggestiveness that seems the epitome of pictorialism.

Arthur S. Goss and Mrs. Mary Elizabeth (J.H.) McKeggie also showed promise as pictorialists. In the 1902 show, McKeggie produced *Ayeshah*, a study of a girl in Egyptian costume, an exotic subject typically appealing to Victorians. She maintained a steady membership in the camera club, becoming proficient in portraiture, and achieved the distinction of a reproduction in *Photograms of the Year 1908*.

Arthur Goss was official photographer for the City of Toronto from 1911 till 1940, the year of his death. The results of his professional work, all highly exact and explanatory images documenting the municipality's transportation, construction, health care and other services, are now in the City of Toronto's archives. But his private photography could not have formed a greater contrast to his daily work. He showed seven prints in 1902, including the novelty of *Hazy Night*, a technical lighting problem, indicating his mastery of photography well before he joined the Toronto Camera Club in April, 1904. About

J.K. Hodgins

The Duet in *Photograms of the Year 1902* (London: Dawbarn & Ward), [1903?], 132.

1906, Goss produced the successful *Child and Nurse* (also known as *Portrait of a Child*), page 203, revealing an interest in narrow tonal ranges and unusual cut-off composition. He was clearly influenced by the work of the Photo-Secession and by the ubiquitous admiration for Japanese prints, so asymmetrical and simplified.[8]

Everyone in this group (except Mary McKeggie) ultimately served, sometimes for years, on the executive of the Toronto Camera Club before 1914. How successfully did they promote pictorialism? H.B. Lefroy was president at the crucial time in late 1902-1903 when a motion by Hodgins and Ross to conduct the club's annual exhibition along the lines of an artistic "Salon" was finally carried. The selection jury was composed of two artists (rather than one as before) and one professional photographer. For 1903 these were Charles M. Manly, A.R.C.A., president of the Ontario Society of Artists, who had judged previously for the club, George A. Reid, also A.R.C.A. and O.S.A., and John Kennedy, a leading professional in Toronto. Medals and awards were not given, as that was considered part of the "old style" of

exhibition; it was enough merely to be selected for the Salon. Interestingly, no mention was made of lantern slides or hand camera work, which had before also been judged, although in separate categories.[9]

Alfred Stieglitz had a strong if indirect influence on the Salon of 1903 in that he sent thirty items from the Loan Collection of the Photo-Secession on the request of the club. Torontonians were therefore able to see works by Stieglitz himself, Edward J. Steichen (who seems much to have influenced Carter), Alvin Langdon Coburn and a number of other eminent pictorialists. Canadians included the old Toronto dependables, Lefroy, Hodgins, Carter, Stovel and Moss, as well as other established men, such as John Stanley Plaskett of Ottawa and William Holbrook. The newer members showing included J.H. Ames, soon to become a well-known Toronto pictorialist, and Beatrice Lukes, whose *Study of a Boy* was pronounced by a reviewer as "in every way . . . about perfect."[10] As usual also, works from around the world were solicited through magazines, and many of those who responded, like Alice Boughton of New York, were confirmed pictorialists.

The next year, 1904, the Toronto Camera Club maintained a Salon style of exhibition, welcoming a new and important worker, Harold Mortimer-Lamb of Victoria, B.C., who received that year the distinction of an Honorary Membership in the Linked Ring's London Salon of Photography. In the same year Carter became an Associate of the Photo-Secession in New York; he and J.P. Hodgins are the only Canadians known to have achieved this status. Pictorialism and the ideals of the art world were thus easily accessible to Canadians, and in particular Torontonians, through their exhibitions, through other international salons, and through amateur photographic magazines, many of which catered heavily to the style and were sent on subscription to camera clubs.[11]

In addition the Club was involved with the Federation of American Photographic Societies, founded in New York in 1904. The main purpose of this conclave of clubs was the encouragement and exhibition of pictorialist work on a more popular scale. F.C. Beach, an influential author and editor in photography, was listed as coming from Toronto. With him on the Board of Governors, also as representatives of the Toronto Camera Club, were J.P. Hodgins and W.H. Moss. It was this organization which sponsored the immense First American Salon in 1904, exhibited in New York, Washington and Pittsburgh.[12]

Yet was the progress of pictorialism so entirely smooth as these advances would suggest? After all, the Toronto Camera Club had acquired almost its limit of 175 "ordinary" members by 1903, of which only a small number, largely the pictorialists, were mentioned in reviews. What of the other members?

A case in point is provided by the revamping of the club's decorations after a move to new quarters. Goss and Carter had covered the walls with burlap and selections from Stieglitz's *Camera Work*. Hardly one-tenth of the old club stand-bys were returned to the walls, and naturally this raised "an awful howl."[13]

Pictorialism's uphill battle is clear from Carter's judgement of the 1906 show — a "decided retrogression," due, he believed, to dispensing with a

Sidney Carter

Evening [or] Sunset on Black Creek [c. 1900-1901] Gum bichromate 15.2 x 9.4 cm PAC, PA-112002

Beresford B. Pinkerton

[Street scene with fire engine, Montreal] n.d. Silver 4.3 x 6.1 cm *PAC, PA-134931*

jury of selection (though each contributor was limited to four prints) and to the reinstatement of medals, which attracted many more bad prints than good.[14] Rex Stovel's pitiless assessment was similar: ". . . crowded by prints which might possibly be interesting to geologists, botanists, or other scientists . . . but to those in search of camera art — never."[15]

Although most interested in factualism, many "scientists" and straight photographers who exhibited did not necessarily ignore compositional balance, lighting, sentiment or other considerations commonly associated with art. These photographers, however, had a different, more traditional idea of what actually constituted art, involving the "picturesque" and "sublime" in landscape, and the anecdotal in figure studies. The technical execution of such prints was quite realistic, using sharp focus, clear detail and careful gradation of tones. If these photographers had a single artistic hero, it must have been Ruskin. Children were the photographic equivalent of Kate Greenaway's tots and scenery was arranged according to the patterns of Birket Foster.[16]

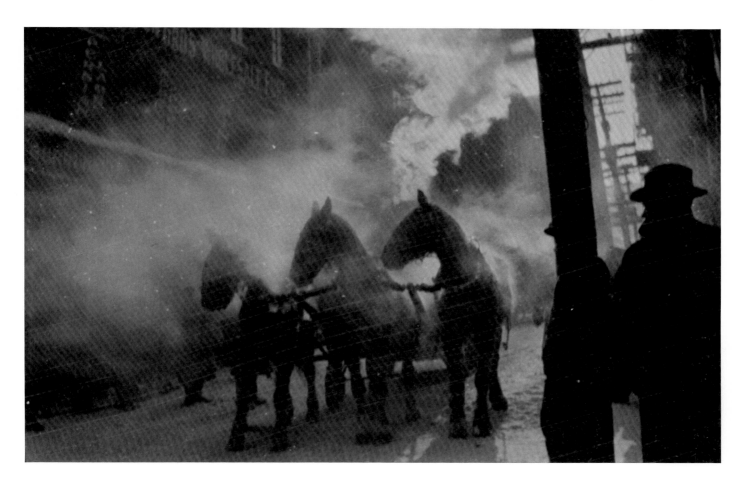

Beresford B. Pinkerton

[Street scene with horses, Montreal] n.d. Silver 4.5 x 6.9 cm *PAC, PA-134930*

The style caused a Boston critic of 1906 to state ''. . . we have a poor opinion of the anecdotic photograph, the machinery of it is always too visible . . . [and] for some reason . . . photographic landscapes suffer from the plague of prettiness, almost to pettiness.''[17] Pictorialism therefore was battling not only the straight photographer's subject matter but also his entrenched definition of art, which was still adhered to by many contemporary artists who exerted their influence in the Toronto Camera Club as judges, lecturers, critics and even members.[18]

The pictorialist also despised the professional photographer for his slavish attention to the desires of his clientele and his hide-bound attitude toward change. Pictorialists experimented with subjects, formats and printing processes, while the professionals continued to print overdressed ladies in studios, using albumen or bromide paper.[19] A review of the Montreal Camera Club's submission to the American Lantern Slide Interchange for 1901 stated ''They are good slides of the commercial type, but such as an amateur should not think worth mounting.''[20]

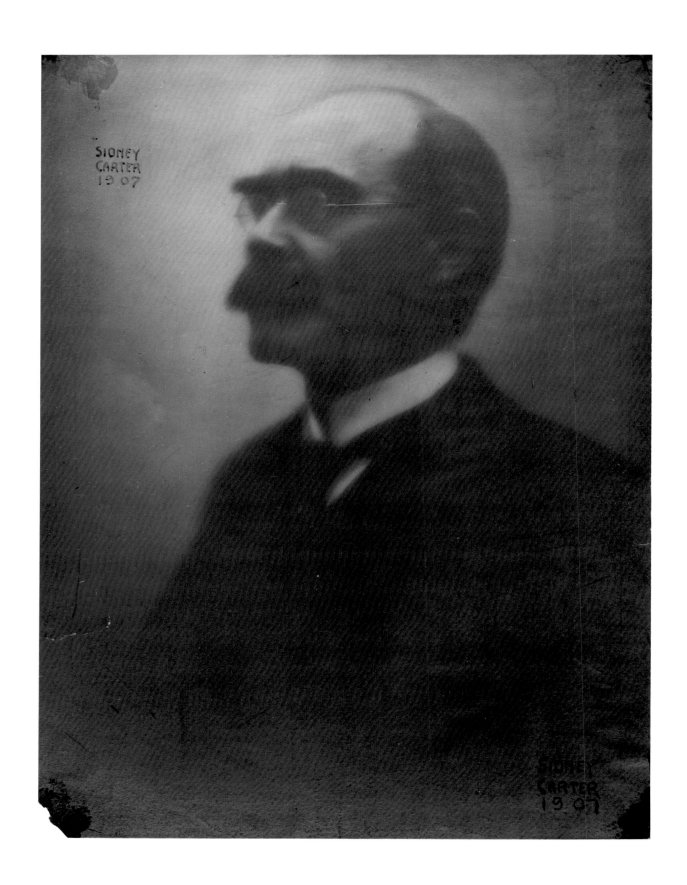

Sidney Carter

Rudyard Kipling 1907 Silver 24.9 x 18.7 cm *PAC, PA-135434*

In the fall of 1905 a new group, the Studio Club, was formed in Toronto. It was inspired by Carter, who wanted to establish a more congenial and distinctly more exclusive group, rather like the Linked Ring. Conceived as a national club that would eventually have members and exhibitions across Canada, it included Hodgins, the two Stovel brothers and Mortimer-Lamb, who had moved to Montreal early in 1905. The new club exhibited 22 frames with the Canadian Society of Applied Art in the galleries of the Ontario Society of Artists, 9-23 December 1905. It further exhibited in July 1906 at the Hove Camera Club (England) where some works, particularly two portraits by Carter, Goss's *Child and Nurse* and Hodgins' *Cypresses*, received very favourable notice. The group also seems to have been represented at an "Arts and Crafts Exhibition" in Toronto the same year. After this promising start, however, the club virtually disappeared. It suffered a double blow: late in 1906 or early in 1907, Carter moved to Montreal, where he hoped to establish himself as a portrait photographer in partnership with Mortimer-Lamb; then, in 1907 Roger Stovel unexpectedly died in Jamaica after being injured in an earthquake. Deprived of two such important members, the Studio Club seemingly dispersed.[21]

Two major trends marked the history of amateur activity in Toronto in the remaining years before 1914: the steady spread of interest in photography, and the growing dominance of the pictorialist style.

The rise in popular interest was symbolized by the commencement, in 1908, of an annual loan exhibit sponsored by the Toronto Camera Club at the Toronto Industrial Exhibition. This increasing interest was also mirrored in the establishment of four new camera clubs in Toronto around 1907-1908, the Eatonia club in particular having a number of exhibiting pictorialists, Albert Kelly among them.[22] As further evidence, *Art and Photography*, the only Canadian photographic periodical of this time, appeared during 1912-1913. It was put out first by the Ideal Trade Press, then by the W.J. Dyas Publishing Co. of Toronto. Judging by the single extant issue (for June, 1913), its quality was dubious and its demise deservedly quick.

Of great local import during these years was the affiliation of the Toronto Camera Club with the Royal Photographic Society of Great Britain in 1913. The policy of awarding medals remained undecided, but when they were awarded, they were usually won by pictorialists who steadily made converts. Among the newer photographers attracted to pictorialism were J.H. Ames, Alfred Robinson (president of the club in 1909-1910), Albert Kelly, M.O. Hammond, and Horace Boultbee who became a Life Member in January, 1911. Consequently the 1914 Salon was described as "the most successful exhibition of pictorial photography ever held in Canada."[23] It had 111 exhibitors from around the world submitting 764 prints, of which 444 were shown, four times the number of the Salon of 1903. Perhaps as a result, the club minutes of October 22, 1914 record that Edward R. Grieg, secretary and curator of the Art Museum of Toronto, offered The Grange for future shows or Salons. Photography as art had arrived.

Despite this increasing activity, Toronto could no longer be considered the leading city of the *avant-garde* after 1907. That distinction had migrated to Montreal where both Sidney Carter and Harold Mortimer-Lamb were to

OIL PRINTING

By 1907 oil printing, also a pigment process, had acquired a vogue among pictorialists which "Walrus" of American Photography delighted in satirizing: "Let no one think that an oil print is made in a hurry. After exposing the paper under a negative (if you find it necessary to use a negative) you wash the print for some hours. Or some days if you like. Then you dry it. Or keep it wet. Then stand by while it soaks for about several days. At this stage you may begin to put in a few hours dabbing on paint with a brush. . . . It is emphatically a process for the young. I say this because only a person in the first blush of youth has any chance of living long enough to get a print finished." (November, 1907; 252-254.)

be found. Carter considered Lamb's pictures "the highest achievement in pictorial photography in Canada,"[24] and in January 1907 the two men jointly ventured into the world of professional portraiture. This was an ill-starred attempt from the beginning; it limped along for a year, and finally dissolved in January 1908.

Yet only a few months previously Carter had organized and single-handedly hung a show of pictorial photography in the Art Association of Montreal, which had been open from 23 November to 7 December. Although the catalogue claimed the show was "arranged by the Photo-Club of Canada," in fact, as Carter confided with unconcealed sarcasm to Stieglitz, "this is a myth and inserted as a scape-goat on the suggestion of the chicken-livered Secretary of the Art Association"[25] who wanted no repercussions on his organization should the show flop.[26] This same man had caused the pages of the Maurice Maeterlinck essay, reproduced in the catalogue, to be gummed together because of its insistence on photography as an art form. Carter had his revenge when, by his count, about five hundred visitors attended the opening afternoon, and he considered the press comment "entirely favourable and on the whole intelligent." The Montreal *Star* for example said "taken as a whole the exhibition is interesting by reason of its quality as well as its novelty. In art it marks a distinct departure in Montreal. . . ."[27]

Carter alone chose the entries to this landmark exhibition. The Canadians listed in the catalogue were largely those already met — Carter himself (with a staggering 33 prints), Mortimer-Lamb (with an equal number, including the *Beatrice*[?], page 210), Ames, Gleason, Goss, Hodgins and Ide, together with a number of others.[28] The foreign contributors were of the highest pictorial calibre, reminiscent of the first Toronto Salon of 1903.

One of the Montrealers was Beresford B. Pinkerton, a "beginner of promise" who became president of the Montreal Amateur Athletic Association Camera Club by 1914. This club was the successor to the Montreal Camera Club, which had found its "enthusiasm extinct" by 1904 and officially ceased to exist on 1 May 1905. Reorganized and resurrected as the M.A.A.A. Camera Club on 17 April 1906, it prospered thereafter. Pinkerton's work allows a glimpse of the manipulative variety of a pictorialist's repertoire within the context of a limited range of subjects (pages 194, 195). He was expert in both needle-sharp realism, and the soft-focus treatment of a subject. In addition, a small group of contact prints show him skirting a theme reminiscent of Alfred Stieglitz.

Carter and Mortimer-Lamb remained active in pictorialist circles. Both exhibited in the London Photographic Salon of 1907. They also regularly wrote articles; it is partly through their descriptions in *Photograms of the Year* that the earlier efforts of Canadian pictorialism outside the major centres are known. For example, in 1904, Mortimer-Lamb had written that pictorialism had arrived in Western Canada only two or three years previously. He was thinking of the Victoria Brush and Camera Club, whose president was the architect Samuel Maclure. However there also existed a Vancouver Photographic Society between at least 1903 and 1905, which belonged to the American Lantern Slide Interchange. Certainly amateur photographers of

Toronto Camera Club exhibition

in *American Amateur Photographer* Vol. XVIII, No. 6, June 1906, 294.

some merit, if not in a purely pictorial style, existed on the coast as elsewhere. George M. Dow of Victoria and Russell Wilson of Vancouver, to whom references appear in 1900, produced work which could repay interested research.[29] In 1905 Mortimer-Lamb praised Mrs. Archibald Dunbar Taylor of Vancouver (later Victoria; she was the sister of the secretary of the London Photographic Salon) as the West's "only pictorial worker of any force or originality."[30] In this he reflects an earlier assessment, which judged Isabel C. Taylor's[31] ten large platinum prints submitted to the 1902 Toronto exhibition as "coming from an unhesitating hand."[32]

It is through Mortimer-Lamb and Carter that we can chart some of the growing pictorial talents in the Photographic Art Club of Ottawa where J.S. Plaskett, Frank Thomas Shutt and Charles Edward Saunders (pages 197, 218)[33] assumed prominence, and Charles Macnamara of neighbouring Arnprior became an international exhibitor. Like a number of Canadians, Macnamara submitted to the Little Gallery in London where, beginning in 1909, the magazine *Amateur Photographer and Photographic News* annually sponsored a Colonial Competition. In 1913, his print *The Intruder* was reproduced in *Photograms of the Year* along with a mention that it had hung that year at the London Salon, the highest honour to which a pictorial print could aspire.

Through Mortimer-Lamb we also learn something of the meteoric rise and fall of pictorialism in the Winnipeg Camera Club. References to this club have appeared from 1892. Another source states the club was organized on 21 May 1898; then, apparently, organized again on 29 February 1902.[34] Its first member known to attempt pictorial work was W. Rowe Lewis, who

eventually became president. About 1912, Egon Ratibor, described as a "southern German Princeling" living in Winnipeg, interested himself in the art and progressed swiftly, perhaps helping the club to win the Championship plaque at the Festival of Empire Competition in England in 1912. The club's third annual exhibition, in 1913, had F.S. Challener, R.C.A., for one of the judges,[35] and superior artistic merit was the basis of selection from the hundreds of prints submitted from around the world. The success of this show was equalled only by the subsequent exhibition of 1914, where Prince Ratibor took the gold and bronze medals as well as a special prize. Even Toronto awarded him a silver that year. The only known original print by him hardly seems to reflect the lustre of his reputation.

The coming of war in 1914 disrupted the club; Ratibor returned to Germany and about the same time Rowe Lewis left for the United States, where he died about 1917. As well, a half dozen members departed for "the trenches of Belgium." Although the club remained in existence till about 1921, it never recovered its former vigour.

References to early east coast photographers are rare in popular pictorial publications or exhibitions. Lewis E. Smith of Halifax possessed no mean pictorial skill, judging by a single discovered reproduction of one of his photographs, *Measuring the Tire*. Few clubs seem to have existed between 1900 and 1914 in the Maritimes, with the exception of the Saint John Camera Club in New Brunswick, which was active throughout the period. This is unlike Ontario, where at least thirteen clubs are recorded over the same time span. Apart from the ones in Toronto, the most prominent were the Peterborough Camera Club and the Photographic Section of the Hamilton Scientific Association, where James Gadsby and Jessie B. Dixon among several others experimented with pictorial techniques. Equally rarely is there any reference to clubs in Quebec outside of Montreal; only the Sherbrooke Camera Club surfaces peripherally in 1907. Sir John George Garneau, the popular mayor of Quebec City (1906-1910), and a man active in engineering, banking and chemistry, alone represents his city in *Photograms of the Year 1914*. Clearly the histories of amateur photography in the Atlantic region and francophone Quebec await future research.

The later careers of Harold Mortimer-Lamb and Sidney Carter reflect both success in the pictorialist idiom and a gradual accommodation to relative obscurity. In 1911, two of Carter's prints, along with one by J.P. Hodgins, were selected by Stieglitz for his prestigious International Exhibition at the Albright Gallery in Buffalo, N.Y. There they hung with the most prominent figures of world pictorialism. Closer to home, Carter exhibited with the firm of Walter Mackenzie and Fenwick Cutten at the Art Association of Montreal late in 1913. Mackenzie and Cutten were successful professional portrait photographers in the pictorialist style.

By this time many professionals were realizing the possibilities of the new style, and adopting it, albeit sometimes in modified forms. Advanced amateurs were also becoming professionals, among them A.A. Gleason (about 1908), Mrs. Minna Keene (who emigrated from South Africa to Canada in 1913), and Ashley and Crippen of Toronto, who began their business around 1918. Small wonder that Carter re-entered the professional fray,

Charles Macnamara

The Intruder in *Photograms of the Year 1913* (London: Hazell, Watson & Viney), [1914?], LXXXIV.

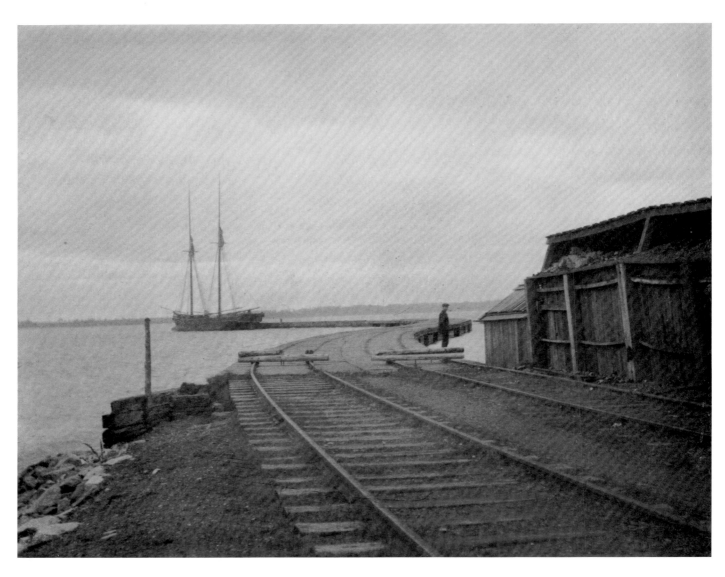

Horace Boultbee

The Loading Place n.d. Platinum 9.1 x 11.4 cm *PAC, PA-138568*

at least on a part-time basis, about 1917. He had been building a reputation as an art and antique dealer "whose rooms always had fine things." He now took on portrait commissions using what Mortimer-Lamb called his "keen psychological sense" to capture his sitters, among whom were John Singer Sargent, Percy Grainger and Serge Prokofieff.

Slowly, however, Carter's style changed from one of heavy shadows to a more even balance of light and shade and a new precision of technique. Gradually well-formed, even stylish, photographs began to leave his studio; some of the disturbing, haunting quality dissolved. By 1928, about his professional work, he wrote: "I . . . am doing less each year and with few regrets. . . ."[36] He kept up his amateur photography somewhat longer, but it

Lewis E. Smith

Measuring the Tire in *American Photography*, January 1910, 43.

probably petered out in the late 1930s or early 1940s.

Mortimer-Lamb on the other hand maintained virtually two careers throughout most of his life — one as a driving force in Canadian mining circles, and one as an equally energetic art critic, collector, photographer, and painter. In fact, in 1913, after using his paintings as backgrounds for his photographs for perhaps three years, he confessed that "painting holds greater attractions . . . than photography." He also continued to amass honours: election as a member of the Royal Photographic Society in 1910, two plaques for his 1910 and 1911 entries in the *Amateur Photographer & Photographic News* Colonial Competition in England and lay membership in the Canadian Art Club in 1911, reflecting his prominence in Canadian art

circles, where he was banner carrier for many causes.[37] He seems to have belonged to, if he did not found, every mining or art organization within a travelling radius of himself.

Together Carter and Mortimer-Lamb were among the earliest and most effective champions of the pictorial concept in Canada. Their photographs achieved the loftiest quality inspired by the movement here. They were convincing prophets, cajoling, criticizing and organizing exhibitions. By 1914 pictorialism had taken firm root in this country, ready to launch out with renewed zeal after the Great War, when the style invaded the professional field with a thoroughness equalling its concurrent spread among amateurs.[38] For a brief period before the war, pictorialism contributed an attitude to Canadian photographers — a freedom to experiment, to take a creator's pride in expressive prints, to alter or even remove the old boundaries of photography.

Yet, there is irony that the "art" which the pictorialists emulated was by this date so entirely established and conventional. Their sources were Constable and Corot, Frederick Lord Leighton, Millet and the Pre-Raphaelites, mixed with Whistler, Degas, Japanese prints, some superficial aspects of French Impressionism, even a little mild Munch. But there was nothing in pictorialism to match the explorations of Cézanne or early Cubism, of Fauvism or Expressionism. This may have been the flaw which ultimately condemned pictorialism to anachronism. It is with a certain sadness that one notes Mortimer-Lamb's pride in the reproduction of his print *Portrait Group* in Stieglitz's *Camera Work* in 1912, the magazine which reproduced Matisse's drawings.

Despite their prominence, pictorialists never dominated the bulk of amateur photography. Strength of numbers lay with the advanced amateurs or the informal snapshooters. These picture-takers perpetuated an older idea of what constituted a good photograph. They strove for images that were well-composed and exposed, well-developed and printed, clear and exact. They were interested not so much in self-expression as in recording people, places and events factually, preferably as a kind of narrative. Their highest ambition might have been membership in the Royal Photographic Society of Great Britain, rather than other associations more specifically linked to pictorialism.[39]

Despite such unanimity of purpose, however, there was dissension on the basis of technique. R. Hamilton's lament of 1902 is typical of one school of thought:

. . . the starting point in the degradation of photography was the departure of the tripod made possible by the introduction of the hand camera, and the immense popularity resulting therefrom.[40]

By 1901, the variety of hand cameras available was truly vast, from the simplest Brownie to the most complicated deluxe Graphic. The latest technical advances and many of the large camera features, such as reflex action and long focus, had been incorporated into them and they were now "skilfully handled . . . the most facile and perfect tool ever employed in the graphic art."[41] Hamilton's complaint notwithstanding, a hand camera of

Vaux family

Ice forefoot of the Illecillewaet Glacier, [B.C.] 17 August 1899 Platinum 16.4 x 21.5 cm *ACR, NG4-596*

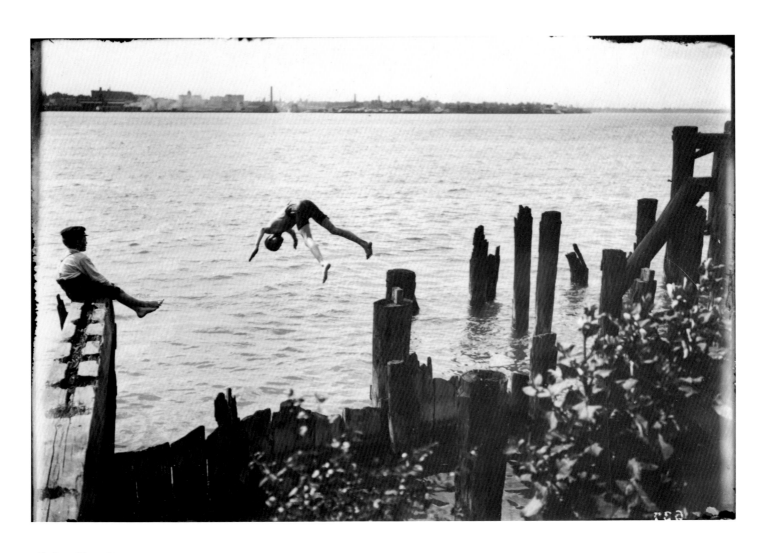

John Boyd

The Diver 1902 From original glass negative 12.6 x 17.6 cm *PAC, PA-60612*

some type, apart from being the most common instrument among snap-shooters, would also have formed part of the equipment of many tripod or "serious" amateur photographers.[42] The existence of the category of "Hand Camera Work" in photo competitions bears witness to the attempt to use this instrument with skill. The most famous manufacturer of hand cameras, George Eastman of Kodak, held annual competitions and travelling exhibitions from around 1904 to at least 1911, offering $1000 in prize money for the best pictures using Kodak equipment. Among the Canadians in the 1904 list of winners were Harold Mortimer-Lamb and Sidney Carter.[43]

In 1906 Henrietta Constantine, wife of a peripatetic Mountie, admitted to being a "Kodak-fiend — tho I only began last June."[44] Photographs on page 196, taken in 1906 or 1907, reveal how quickly she found a talent for correct exposure and satisfyingly direct composition. Her "postcard" size prints were likely produced by a No. 3A Folding Pocket Kodak introduced in the

Mattie Gunterman

[Mattie on stove, with Rose and Ann Williams, Nettie-L Mine, B.C.] 1902
From original glass negative 17.5 x 12.5 cm *VPL, 2276*

very early years of the century. George Reid Munro, level man for a survey-
ing party examining a route for the proposed Hudson Bay Railway, took the
views on page 199, probably with a No. 4 Panoram Kodak. His photographs
take advantage of that camera's 112° field of view.

Exotic locales and inhabitants made favourite amateur photos, and the
Canadian backwoods were inherently exciting. In July 1901, Ashleigh Snow
reported to the *American Amateur Photographer* that "in addition to his
ordinary camera outfit he had a hatchet in his belt for making foregrounds,
and a revolver in his hip pocket for varmints, human and animal." Mrs.
Geraldine Moodie photographed the Inuit in the Hudson Bay district where
her husband, John Douglas Moodie, was stationed, although she probably
used a large camera with a tripod to produce her touching studio portraits
(pages 200, 201). She was sufficiently market-oriented to sign and copyright
selected photographs.

Some tourists in less remote locations still preferred to process their own material *en route*; between 1899 and 1903 the Stanley House on Lake Joseph in Muskoka and the Algonquin at St. Andrews, N.B. offered darkrooms for "the convenience of Tourist Photographers." Visiting Americans were responsible for many Canadian views. Charles Lyman Smith, a Bostonian who toured the Maritimes in 1903, produced a bound typescript volume with 24 tipped-in photographs recording his vacation, including the isolation of Newfoundland. Similarly, members of the Vaux family of Philadelphia achieved a reputation for their scientifically accurate and compelling views of glacier formations in the mountains of British Columbia. Their Canadian friend, Mary Schaeffer Warren, left a record of the mountains now proudly retained by the Whyte Foundation in Banff. Equally intrepid was Ella Hartt from Illinois, whose work was recently revived and exhibited by the Glenbow Alberta Foundation. F. Dundas Todd, a "professional amateur" who acted as editor, lecturer and author in various amateur photo magazines, moved from Oregon to Victoria in 1908 and produced what may be the earliest extant telephoto shots of the Rockies.

When not documenting their tours and travels, many amateurs reverted to family scenes and favourite topics, often executing them with painstaking exactness. Not surprisingly, this was the most common subject matter for women in this period. The work of Mary Vaux, Schaeffer, Hartt, or Moodie would verge on the exceptional, as would the pictorial inclinations of McKeggie, or Mrs. C. Lambert of Montreal, who was the only Canadian woman in Carter's Photo-Club of Canada show in 1907. Of the approximately 825 amateur photographers discovered for this period, only about sixty, around seven per cent, were women. This would seem suspiciously low since women appeared consistently in photographic advertising, in many contemporary snapshots, as well as in posed genre scenes. The low percentage probably reflects the sources searched — periodicals, camera club documents and other "public" records. Women may well have approached photography privately. A rare description of what might have been a typical pattern is provided by Miss Birdie Marshall's letter from Victoria, B.C. to the *Photographic Times* in August 1913:

I always took a keen interest in portrait work and especially in that of Miss Florence Maynard [a professional active in British Columbia], and it inspired me to make an attempt. So, I asked one or two of my friends to let me go to their houses and try if I could make a picture of them. I enclose three: the bride was the first. They were all taken with a No. 3A Folding Pocket Kodak. . . .

Interestingly, she adds "We have been trying to get up a camera club in Victoria for some time, but find it impossible. . . ."

The enthusiasm and talent that women could bring to the topic of family life and travel is revealed in the negatives of Mattie Gunterman, a pioneer woman who settled with her family in Thompson's Landing (later Beaton), B.C. in 1898. Produced for a limited audience of family and friends, her work is now valued for the social insight it provides of a vanished style of life applicable to a whole community.

For most amateurs, photography was clearly a sideline, practised for per-

Madge Macbeth

[At Connaught Park, Ottawa *c.* 1913] From original celluloid negative 8.5 x 12.2 cm
PAC, PA-137941

sonal enjoyment. For some, largely scientists, photography was an indispensable tool in their work. Among such men were A.P. Low, geologist and explorer of Canada's north, who recorded native visages with an unflinching clarity that is almost painful today, or J.S. Plaskett, whose photography (outside of camera club circles, where he produced pictorially-inspired work) was put to use for astronomical "note-taking."[45] These men call in doubt the distinction between amateur and professional. That distinction is further blurred when scenes of local life, anecdotes or news events taken by amateurs were occasionally accepted for publication in the weekend supplements of newspapers or in magazines.[46] On the whole, such photographs tended to be staid genre, such as F.W. Lunan's sweetly sentimental *The Secret*, which highlights a little fellow kissing a young girl on the cheek.[47] Alternatively, the *Canadian Pictorial* (November, 1907) invited subscribers "to send photographs of current events in their locality . . . an accident, a distinguished person doing something, a big fire, a riot. . . . We will pay good prices. . . ." One of those who became proficient in such work, appearing regularly in the *Canadian Courier*, was Madge Macbeth. Among her negatives in the National Photography Collection is a series taken at the Connaught Races which exploits the amateur's strength — informal revelation arising from the swirl of everyday events. Interestingly, women appeared often as contributors to pictorial magazines of general news and social intent.

Madge Macbeth

[Harbour Scene] n.d. From original celluloid negative 8.7 x 11 cm *PAC, PA-137940*

Photographers of such work fall, like the scientists, into a gray area between love and money. Undoubtedly they followed photography for the love of it and did not live on their proceeds. Equally, they often solicited paid publication. Judging by the articles on "photo-employment" or "business methods" in amateur magazines, and the common complaint that the amateur took business away from the professional, the line separating the two in the realm of postcard views and photo-journalism could be thin to the point of invisibility.

Any further distinction between the average tourist or family photographer and the journalistic one must be arbitrary, as often these interests were united in one individual. Was Thomas Cannon's view of aviator Willard at Donlands (page 207) possibly aimed at the newspaper market? The amateur newshound also used the hand camera often chosen by the tourist, and for the same reasons of ease, portability and that essential of newspaper work — stop-action photography.[48] John Boyd, the prominent amateur whose photographs were often reproduced, wrote about both the tripod instrument and the hand camera, "as more than [three quarters] of the fast work done nowadays is with cameras held in the hand."[49] Will Sharpe was a Montreal amateur who made a specialty of stop-action sports scenes which were published in magazines.

Professional newspapermen were welcome members of camera clubs.

E.S. Dean, who worked for the *Telegram* in Toronto, belonged to the club there for at least nine years before moving to Edmonton in 1911, where he apparently attempted to found another amateur club. G.H. Jost of Halifax submitted the dramatic *Sunken at the Dock* to *Photo-Era*'s 1909 news events competition;[50] by 1914, he was a non-resident member of the Toronto Camera Club and employed in the *Chronicle* office in Halifax. A.M. Cyr described the fluid nature of press photography as a profession at this time: "No one has ever said in his heart: 'Go to. I will learn photography and make pictures for the paper.' A striking picture cleverly written up has struck the fancy of an editor; picture and story have appeared; the latent longing to appear in print has been aroused and another press photographer is the result."[51]

Realism therefore not only dominated the style of amateur photography in Canada around the turn of the century, it also provided a small means of financial gain and public notice for a private skill.

The merits of lantern slides made them a persistently popular medium and they were frequently exploited at camera club meetings. Canadian clubs which belonged to the popular American Lantern Slide Interchange at some time between 1900-1914 were those in Toronto, Montreal and Hamilton as well as the Vancouver Photographic Society. W.H. Moss won a reputation for his lantern slides, and served as chairman of the Lantern Slide Committee of the American Federation of Photographic Societies in 1905. From the few images known to be his, Moss seems to have leaned toward an exacting realism in pictorial compositions. William Ide's slides displayed an almost self-conscious pictorialism. His concerns are indicated in the surviving hand-ful of diagrammatic slides which he used to illustrate a lecture on the "Impor-tance of Curves in Composition," likely given to the Ottawa camera club. Thomas Cannon was more comfortable with the stylistic mannerisms of pictorialism, yet still indulged his love of the newsworthy or unusual (page 207). Agnes Deans Cameron, however, used lantern slides largely to record her travels, and to illustrate her lectures and books. The stereoscope exper-ienced "revivals" in 1902 and again in 1909; transparencies were a format which could take most advantage of this. Even science found a use for stereos in recording or demonstrating surgical procedures.[52] But, most important, lantern slides, singly or in stereo format, were the first vehicle of that most revolutionary of twentieth century innovations — practical colour photography.

Although the tinting or colouring of black-and-white photographs had been prevalent virtually from the birth of photography, an uncomplicated method of registering the genuine colours of nature directly on a photo-graphic plate had remained elusive. Amateurs were Canada's most experi-mental photographers, possibly because so many scientists could be counted among their ranks.[53] It seems natural that the earliest known attempts at colour photography in this country should have been made by John Stanley Plaskett, teacher of physics at the University of Toronto until 1903, and later director of the Dominion Astrophysical Observatory on Little Saanich Moun-tain in B.C., from 1918 to 1935. He was already an accomplished photo-grapher in black-and-white when he read a technical paper on "Photography

Horace Boultbee

The Lane Gate n.d. Platinum 9.3 x 11.5 cm *PAC, PA-138569*

in Natural Colours" to both the Toronto Camera Club and the Canadian Institute early in 1902.[54] The 20 lantern slides exhibited during that talk were ones he had prepared himself by the Sanger Shepherd process, described as "new" in March 1901.[55] These were probably also the same "Natural Color Slides and Transparencies" listed with his name in the Toronto Camera Club exhibition of 1902.

The only known remnants of Plaskett's experiments are two fragments in the National Photography Collection: a glass black-and-white negative showing the construction of the Dominion Observatory in 1903, and an identical blue glass positive (broken) which would have formed the base onto which red- and yellow-dyed celluloid images of the same object would have been placed in register and bound together, thus creating a full-colour lantern slide. The figure reproducing an illustration from Plaskett's lecture shows the visual effects he obtained, as well as the major drawback to the process — the need to make three identical black-and-white negatives through three different filters — which limited the method to stationary objects.[56]

On 7 April 1902, a few weeks after Plaskett's demonstration, Carl Lehmann, a member of the Toronto Camera Club from about 1899 to 1909, showed natural colour slides by the older McDonough and Joly processes, which used a tri-colour ruled screen in contact with a panchromatic plate to

Newton MacTavish

[Cowboy, *c.* 1909] Gum bichromate 10.8 x 8.9 cm *PAC, PA-138566*

Madge Macbeth

[Haida Indian Artifacts] n.d. From original celluloid negative 8.1 x 10.5 cm *PAC, PA-137942*

take a photograph in one exposure. An important disadvantage here, however, was the parallax and registration problems sometimes experienced when the positive image, developed from the panchromatic plate, had to be bound again in contact with a new tri-colour screen in order to show the colours.

The drawbacks of the processes demonstrated by Plaskett and Lehmann, as well as numerous other technical hitches, were typical of almost all colour processes known to that date. Consequently, the arrival of the Autochrome process, patented by the Lumière brothers of France in 1904 and 1906 and first marketed in 1907, caused a furore particularly among eager amateurs.

Agnes Deans Cameron

[Indian Children, *c.* 1914?] From glass lantern slide *c.* 8.2 x 8.2 cm *NMM, 222*

The Autochrome glass plate required only one exposure to produce a full-colour transparent positive.

The earliest Canadian experimenters with the Autochrome remain unknown.[57] However, the technique was undoubtedly taken up quickly, probably in the year of its release. A 1908 note on the Montreal A.A.A. Camera Club mentions almost reproachfully that "The club is at present much interested in ozobrome, with satisfactory results, but has not yet attempted color photography."[58] In viewing examples of work in this process, it is easy to see its appeal for a botanist like G.R.G. Conway (pages 280-282). Indeed, bright flowers and sunsets, as in the work of Beales or

AUTOCHROMES

*A sticky plate is coated with a
single layer of starch globules, all
of exactly the same size, and so
small that it takes no less than
20,000 to cover a single inch.
These are composed of equal
numbers of orange, green and
violet particles, and must be
placed so that they do not overlap
in the slightest degree. The minute
spaces between them are then
filled with a black substance, so
that all the light which comes
through must pass through the
coloured particles. At this stage the
film is varnished . . . [and] coated
with an extremely thin
panchromatic emulsion Now
when an exposure is made, the
light after passing through the glass
has to pass through the dyed
starch grains before it reaches the
sensitive film, and these colored
grains act as a color screen. If the
object being photographed is
green, the light from it passes
unchanged through the green
grains of starch, but is cut off by
all the orange and violet particles
. . . a positive picture of the green
object [is] formed by the light
through the green starch particles.
(Frank R. Fraprie, "Simple Color
Photography Achieved," American
Photography, Aug. 1907; 59-64.)*

Allen (pages 274, 275, 278, 279), were the earliest choice of colour photographers, to the point of boredom, if one credits the remarks of some contemporary writers!

Camera clubs kept themselves informed of the progress of colour photography, and the Hamilton camera club had a few members trying out the new colour plates in 1909-1910. These may not have been Autochromes, but possibly the Thames Screen Plate, a method based on the idea of Joly and McDonough which was patented in 1906 by C.L. Finlay in London, England, and available by 1908. A Thames One-Plate, which combined screen and emulsion on one glass to avoid registration problems, was available in 1909 but the Thames plates were quickly superseded by the Paget plate, first shown in 1912 in London and marketed in 1913. The Paget Plate was used by A.J. Ames of Toronto when photographing his son about 1915 or 1916 (page 283). The Paget, featuring a checkered screen, survived till the early 1920s. It was revived as the Duplex process by Charles Baker in 1926, and its checkers reappeared as the popular Finlay process in 1929.

Another geometrical tricolour plate which tried to improve on the Autochrome's random starch grains (whose interstices had to be filled with black, thus reducing brilliancy) was the Omnicolore. An invention of the aging Ducos du Hauron and R. de Bercegol, it was first introduced in 1907 in France. Thomas Cannon, a Toronto Camera Club member, produced some creditable results with it in 1911 (pages 276 and 277), although he was unable to resist sunsets and flowers.

Despite the sketchy nature of our knowledge concerning the earliest colour photography in Canada, one thing is established: its introduction is attributable to the avid interest and energy of amateur photographers.

Indeed, the role of amateurs in Canadian photography around the turn of the century was pivotal. Growing vastly in numbers, trying a burgeoning variety of techniques, exploring new themes, demanding higher standards, they must have seemed a confusing and contradictory group to many professionals or to the uninitiated. Could such diversity continue to flourish as the century progressed?

a)

b)

c)

d)

e)

f)

Microphotographs, representing 58x enlargements of the following Plates: a) page 280, Autochrome; b) page 277, Omnicolore; c) page 283, Paget plate; d) page 291, Dufaycolor; e) page 289, Agfacolor; f) page 295, Kodachrome.

Negative taken through Red Filter.

Negative taken through Green Filter.

Negative taken through Blue-Violet Filter.

Positive from above Negative, Blue-Green Complementary to Red.

Positive from above Negative, Magenta-Pink Complementary to Green.

Positive from above Negative, Yellow Complementary to Blue-Violet.

The Three Positives Superposed.

Illustration of the Sanger Shepherd method of colour photography. Reproduced in: Plaskett, J.S. "Photography in Natural Colours," Transactions of the Canadian Institute, Vol. VII, Toronto, 1904.

OMNICOLORE

By means of a printing machine two lines in greasy ink are printed on gelatinised glass at right angles to one another, thus leaving little rectangles between the lines of gelatine, which is alone permeable to aqueous dye solutions. A compensating yellow screen or filter is used with the plates (Bernard E. Jones, ed., Cassell's Cyclopaedia of Photography. London, New York, Toronto and Melbourne: Cassell and Company, Ltd., 1911; 380. Reprinted by Arno Press Inc., New York, 1973.)

PAGET PLATE

[In] the Paget process. . . the colour screen is separate from the sensitive plate, and consists of small square elements of red, green and blue violet arranged in a sort of plaid or chequer pattern. This screen is placed in the dark slide in front of a panchromatic plate, and the exposure made through it, a yellow filter (to retard the excessive action of the blue and blue-violet rays) being used in conjunction with the lens. Development is as usual, . . . a positive is made by a contact exposure, and this positive is mounted in contact with what is termed a viewing screen, which is similarly patterned to the taking screen, but is differently coloured. The positive then shows the colours of the object. One advantage of this process is that it is easily possible to make duplicate colour transparencies from the original negative. (William Gamble, Photography and its Applications. London: Sir Isaac Pitman & Sons, Ltd., n.d. 80-81.)

CAMERAS

a) Wet-plate camera, 1860s. Manufactured by J.F. Shew & Co., London, England. CCP /Michael Gilbert Collection, 981.1.58.

b) *No. 4 Bull's Eye Special, 1898-1904.* Manufactured by the Eastman Kodak Co., Rochester, N.Y. NMST /Rev. H.W. Reid Collection, 75341. This may be the type of camera used by Henry J. Woodside in the Klondike.

c) *New Model View Camera, 1884-1899.* Manufactured by the Rochester Optical Co., Rochester, N.Y. NMST /Wilfrid Laurier University Collection, 12598. This is the type of camera James Ballantyne may have used.

d) *Pony-Premo No. 6, c. 1900.* Manufactured by the Rochester Optical Co., Rochester, N.Y. Courtesy of Arthur W. Beales. This is the original camera used by Arthur Beales.

e) *3-A Folding Pocket Kodak, Model B-4, 1905-1914.* Manufactured by the Eastman Kodak Co., Rochester, N.Y. NMST /Archibald Riddell Estate Collection, 80322. Henrietta Constantine may have used a camera like this.

(Cameras not reproduced to scale.)

a)

b)

c)

d)

e)

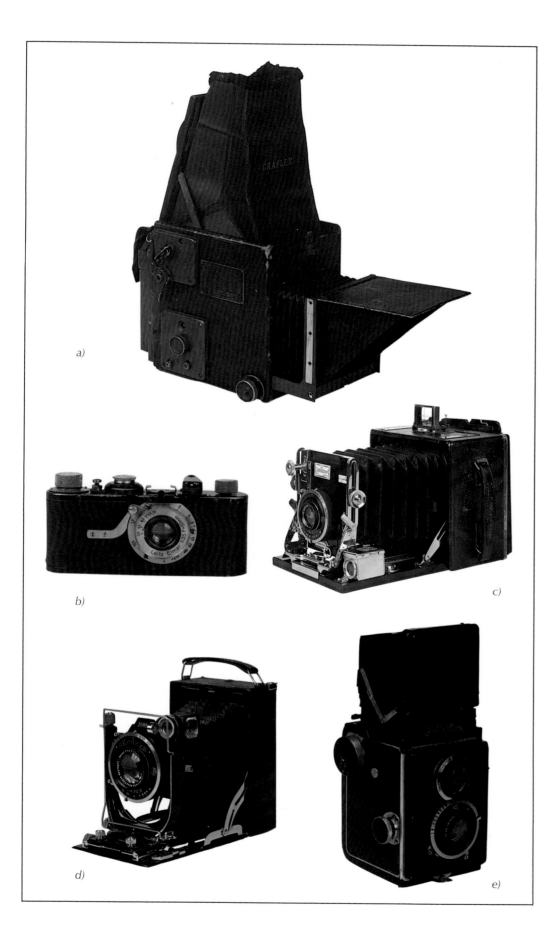

CAMERAS

a) *RB Graflex Series-D, c. 1929-1941. Manufactured by the Folmer Graflex Corp., Rochester, N.Y. Courtesy of Philip Croft. This is Croft's original Graflex. The earlier Series-B Graflex was used by other pictorialists such as Johan Helders, Edith Hallett Bethune, and Arthur Lomax.*

b) *Leica-A, 1926-1930. Manufactured by Ernst Leitz, Germany. NMST/Wilfrid Laurier University Collection, 12510. The precision of the new 35mm format attracted enthusiasts such as Leonard Davis, Arthur Tweedle, and Grant Gates.*

c) *Sanderson, Regular Model, c. 1930. Manufactured by the Houghton-Butcher Manufacturing Co., London, England. Courtesy of Arthur Lomax.*

d) *Kodak Recomar No. 33, 1932-1940. Manufactured by the Nagel Works in Stuttgart, Germany, for the Eastman Kodak Co. NMST/Alfred Upton Collection, S-69. This was the instrument used by Alfred Upton who considered it his "first real camera."*

e) *Rolleiflex (Standard Model), c. 1932-1937. Manufactured by the Franke and Heidecke Co., Germany. NMST/Wilfrid Laurier University Collection 12472. This was the type of camera favoured by Clifford Johnston and A.M. Barrach. Other users included Gordon McLeod and George Marchell.*

(Cameras not reproduced to scale.)

Salon stickers on reverse of Bruce Metcalfe's Collars *(page 241).*

Salon stickers on reverse of Bruce Metcalfe's Parade of the Wooden Soldiers *(page 242).*

AWARDS

a) Silver medal won by George Blyth from the Central Canada Exhibition Association, Ottawa in 1892. PAC, National Medal Collection 9354.

b) Bronze medal won by George K. McDougall from the Montreal Camera Club in 1898. PAC, National Medal Collection 10634.

c) Silver medal awarded to William Ide by the Ottawa Camera Club in 1898. PAC, National Medal Collection 10591.

d) Silver medal awarded by the Ottawa Camera Club to C.E. Saunders for excellence in marine photography in 1902. PAC, National Medal Collection 4005. Presented by W.J. Topley, a prominent professional photographer in Ottawa. The cherubic lad is holding a camera, and the inscription reads "Le Coeur au métier."

e) Bronze medal won by Horace Boultbee from the Toronto Camera Club about 1906. PAC, National Medal Collection, 8091.

f) Gold-plated spoon, a first prize for enlargements awarded by the Montreal Amateur Athletic Association to B.B. Pinkerton in 1908. PAC, National Medal Collection 8088.

g) Plaque awarded by Amateur Photographer and Photographic News of England to Harold Mortimer-Lamb at the annual Colonial Competition in the A.P. Little Galleries, London, England, 1910. Art Gallery of Greater Victoria, 97.

(Awards not reproduced to scale.)

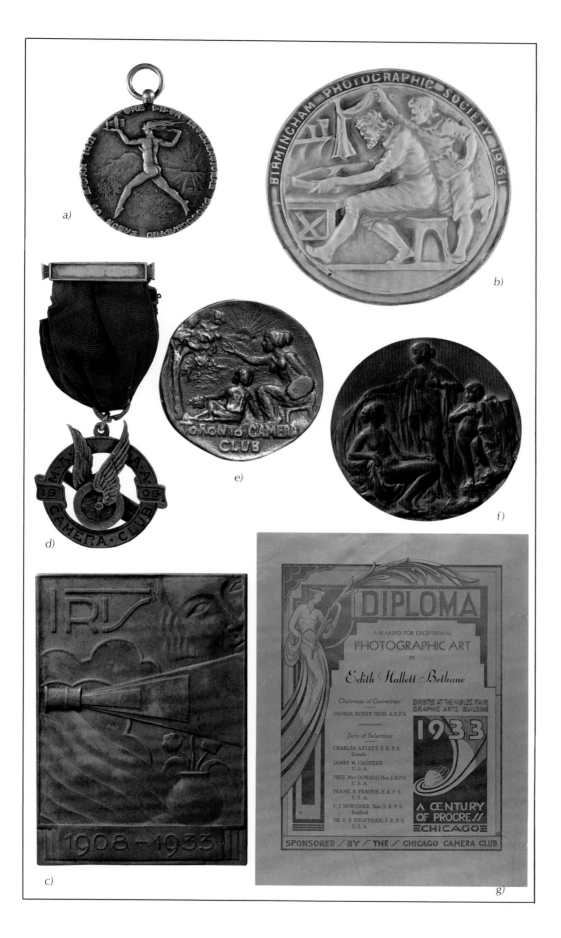

AWARDS

Clifford Johnston won many awards during the course of his prolific photographic activity. Shown here are three: a) a silver medal awarded by the Fifth International Photographic Salon of Japan, in 1931. PAC, National Medal Collection 3985; b) a silver medal from the Birmingham Photographic Society, England, in 1931. PAC, National Medal Collection 3980. The two figures are making a photographic print; c) a bronze medal awarded by the VII Internationaal Kerstsalon "Iris," Antwerp, Belgium, in 1933-1934. PAC, National Medal Collection 3981. Alfred Brigden's awards included: d) a bronze medal given by the Montreal Amateur Athletic Association Camera Club in 1909. PAC, National Medal Collection 9792; and e) a bronze medal from the Toronto Camera Club in 1922. PAC, National Medal Collection 9793. Leonard Davis was also the recipient of prizes: f) a medal from the Leicester and Leicestershire Photographic Society, England, in 1936. PAC, National Medal Collection 11068. g) Edith Hallett Bethune was awarded the Diploma for Exceptional Photographic Art, for her print Evangeline before Blomidon, at the Century of Progress exhibition sponsored by the Chicago Camera Club, Chicago World's Fair, 1933. PAC, Courtesy of Jack and Margaret Bethune.

(Awards not reproduced to scale.)

So Few Earnest Workers/1914-1930

Andrew C. Rodger

The coming of war in 1914 had a strong impact on amateur photographers, as it did on all elements of society. Photographers, like thousands of other Canadians, joined the armed forces. Many were killed, and of those who survived, many did not resume their former activities after the conflict was over. Camera clubs, as we have already seen in the case of the Winnipeg Camera Club, were disrupted and weakened. Numerous members of the Toronto Camera Club left for military service in 1914 and 1915; few returned. As Harold Mortimer-Lamb noted, "Many who have not been enlisted for active service, have found opportunity of devoting such leisure as they may enjoy to useful patriotic account. There has been little time left for photography, even if there was the inclination."[1]

Some Canadians, like Horace Brown, took their cameras with them to the Front. Though Brown went through his training at Valcartier with a fairly large camera taking negatives 5-1/2 × 3-1/4 inches in size, in England he obtained another, which took much smaller negatives. As it was a military offence for an ordinary soldier to have a camera in the lines, he needed something which could be concealed. This requirement was met by the Vest Pocket Kodak, which was advertised in England as The Soldier's Kodak camera, ". . . the owner being encouraged to 'Make your own picture records of the War'."[2]

With the outbreak of war the supply of German equipment to Canada was immediately cut off; American equipment moved to take its place. The results of increased wartime British and American photo-chemical research percolated down to the consumer during the twenties in the form of an improved and vastly expanded range of supplies. For example, improved panchromatic negative emulsions allowed a more realistic rendering of tonal values.[3] The speed of lenses increased dramatically, with improvements in other areas of lens design as well.[4] By the twenties most "serious" workers used anastigmatic lenses rather than rapid rectilinear or other earlier types. Evidently even pictorialists wanted to obtain as sharp and accurate a negative as possible, no matter how they might treat it afterwards. Cameras became smaller and lighter, though this was partly due to an increasing shift from glass plates to film. The variety and types of cameras were remarkable: from view cameras to folding cameras, reflexes to box cameras. They, along with lenses, were practically all of German or American origin, for few Canadian amateurs seemed to use British equipment. The range of printing materials

C.S. Bastla

Cliff Bastla [*c.* 1913-14] Silver 23.4 x 19 cm *PAC, PA-122698*

A.W. Griffiths

Wyn on Train Leaving Saskatoon for Sewel [*sic*] Camp, Brandon, Man. 1 April 1915 Silver 7.6 x 12.6 cm *PAC, PA-135742*

was just as great. Papers were available in a multiplicity of surfaces, colours, textures, and tones. Bearing names like Velour Black Rough, Vitava Etching Brown, Wellington Cream Rough, or the more common Azo and Velox, they seem to have existed for every possible need. They came as bromides, chlorides, chloro-bromides, carbons, and a number of other processes. To judge from the salon catalogues, Canadian amateurs favoured bromide paper; the slower chloride material was used almost exclusively by professionals.

In some ways, however, this was a period of remarkably little change. Despite improvements in equipment and materials, many photographers continued to make photographs in the same style as before the War. A derivative pictorialism became entrenched among the few who exhibited in the clubs and salons; change came only slowly. Although this was not entirely a static period, Canadian amateurs appeared uninterested in questioning their work, its ends, or its meaning. European photographic movements, such as the New Photography school in Germany, seem to

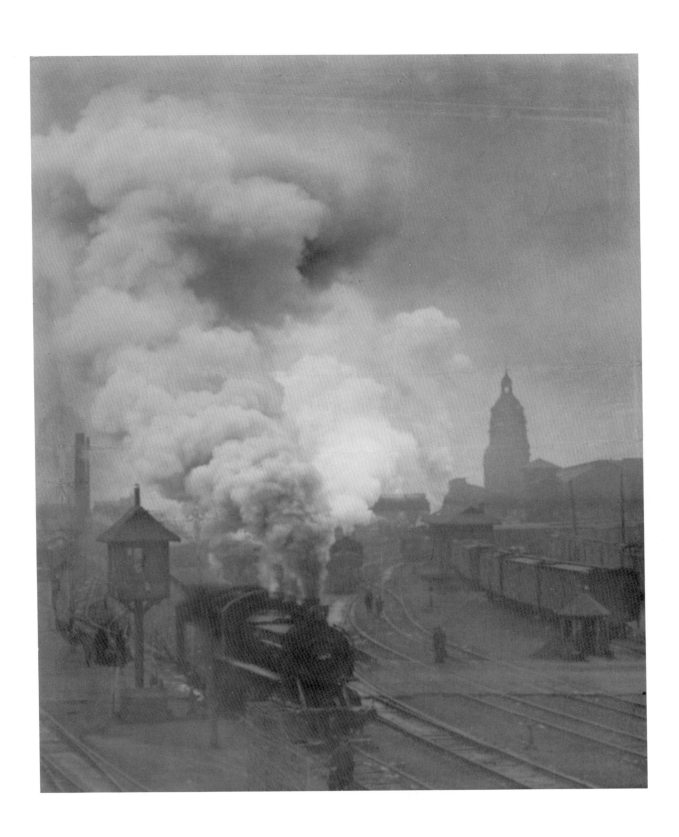

A. Van

[Railway Yard] n.d. Silver 25.4 x 20.2 cm *PAC, PA-138564*

A. Brodie Whitelaw

76 [Woman with Pekinese] n.d. Bromide 17 x 12.5 cm *PAC, PA-138567*

have passed unnoticed and without effect on Canadians. In this they were like many of their contemporaries in Britain and the United States, whose subjects and styles they continued to emulate. How then is the amateur photographer of this time to be defined?

Camera magazines and clubs of the period usually divided amateurs into two distinct groups: on one side was the large mass of "snapshooters," who might have only a vague idea of how photographs were produced, and who were interested only in keeping a graphic record of their lives. On the other side was a small elite of "serious" amateurs, who attempted to create an esthetically appealing piece of art according to a canon known as pictorial photography, and who possessed extensive technical knowledge of photographic materials and processes. The reality was more complex than this, for between these two extremes was another broad group. Unlike most snapshooters, these photographers had a good grasp of at least the fundamentals of photography; unlike the pictorialists they were interested in photographs as an end in themselves rather than as the starting point for subsequent manipulation. Photographers who had begun their activities earlier on, like John Boyd or Henry Woodside, engineers like George R.G. Conway, or naturalists like Francis Harper or Alfred Brooker Klugh simply attempted to record faithfully what they saw, rather than to express what they felt. It is this group who had the greatest interest in using technical advances such as colour. Ultimately they said much more about the Canada of their time than did the majority of "serious" amateurs.

There was a club for every type of amateur. Although information about virtually all except the Toronto Camera Club is very limited, they seem to fall into either of two general categories. One type catered to dedicated workers devoted to art, and was sometimes, as with the Photographic Art Club of Ottawa, very restricted in membership.[5] Such clubs often included professional photographers,[6] were not interested in teaching neophytes, and regarded photography as an art, always in the pictorial mode. Their members were in the forefront of salon exhibitors. The other less exclusive clubs were interested in more than pictorial photography and were open to the beginner. Indeed, a talented neophyte might soon pass the limitations of his club.[7] Differences aside, all clubs provided a place where amateurs could meet to discuss and criticize each other's work. Some went considerably beyond this, giving extensive courses in photography, organizing outings, holding competitions, and even providing equipment, studio space, and darkrooms.[8]

Camera clubs were often evanescent organizations, leaving little or no trace of their existence. Even those which lasted for some time often left little record of their passage. Because Canada lacked an amateur photography magazine, amateurs came together primarily by word of mouth, or through a common organization. Although camera clubs probably existed in many schools and universities only a few, such as those at Queen's University,[9] Upper Canada College, and the Toronto School of Science appear in the records.[10] Likewise, many large business firms may have had camera clubs but only two have been discovered, both in Toronto. Yet where a common background existed — be it place of employment, education, or residence —

ENLARGERS

During the 19th century, photographers generally made their negatives on large glass plates, from which positives could be quickly and consistently contact-printed. But with the introduction of relatively small cameras, photographers often wanted to print images larger than the size of the negatives. Early enlargers, using sunlight focused through condensing lenses, had made their appearance by the 1850s, but they could be used only during sunny days. The development of faster, more sensitive printing papers decreased the amount of light needed for enlarging, and it became possible for photographers to do their work with artificial light.

The enlarger itself could be a lantern projector, a specially built unit, or a converted camera. Wall's Dictionary of Photography (1926) gave the necessary details for building an ingenious inexpensive enlarger at home using a window and the photographer's own camera. The ultimate in a "home-brewed" mechanism must have been achieved by Donald B. Marsh during his missionary sojourn at Eskimo Point, N.W.T., where he moved in 1926. The entire outfit cost him 15 cents in new parts.

"I simply soldered an inverted funnel to an empty quart Crisco tin. A smaller tin, punctured with holes for ventilation, is soldered to the funnel to provide the lamp housing. I first used a 50-watt bulb, which was later reduced to 25 watts and then 15 to measure time more accurately. The condenser lens from the magic lantern furnished extra light, and my only problem was to hold the reflex camera in position." (Donald B. Marsh, "Arctic Darkroom," Sports Afield, September 1943; 44-45.)

J.H. Mackay

Beside the Still Waters in *Photograms of the Year 1925* (London: Iliffe & Sons), 1926, XLVI.

camera clubs sprang up, often within the confines of another group, like the YMCA in Toronto and in Winnipeg, or the Montreal Amateur Athletic Association in Montreal.

Amateur photography clubs were almost entirely an affair for English Canadians. The only known clubs in Montreal and Quebec City attracted an almost exclusively English-speaking membership. As late as 1944 Raymond Caron, a former president of the Montreal Camera Club, noted that there was no French-language club in Montreal, and that the third Montreal International Salon, taking place that year, listed but rare "noms français [qui nous] rappelent l'existence du fait français à Montréal et dans le Québec."[11] Differences in social class, educational background, and disposable income — as well as a greater tendency by English Canadians to form clubs in general — may account for part of the difference.[12] Certainly there were individual French-speaking photographers in Quebec, as the prize lists of the 1929 and 1931 Kodak International Competitions show, and considering the general quality of the prize-winning photographs, these French-Canadian photographers were not just snapshooters.

"Serious" amateurs, practically all of them pictorialists, sought recognition by exhibiting in photography salons. These also offered a way of communicating new ideas, opinions, and styles across the country, though the salons limited innovative thinking through an old system of classification which, though not listed in the catalogues, was still informally used. Thus the salons generally pigeon-holed work into the traditional categories of

E. Hoch

landscapes, architecture, portraits, marine, and genre. This last was a catch-all for any photograph showing everyday life.

Early pictorialists had drawn on a solid knowledge of the painting which influenced their photographic style: by the beginning of the First World War, however, photographic salons had begun to spread pictorialism to an audience which may not have known the original painting at first hand. The striking similarities, even repetitions, of subjects and approaches among pictorial photographs at this time suggest that the style degenerated as it influenced photographers not so directly interested in painting. The pictorialist approach to portraits, marine, or genre was often contrived and forced. Posed scenes or tableaux of mythic damoiselles served, so it seemed, to give the photographer an excuse to photograph nude women. Landscapes had to be small and cozy. Portraits were brooding, or filled with forced gaiety and entitled "Joy."

Thus pictorialism also carried in it the seeds of an intellectual aridity. Proving that photography was fine art was a serious undertaking; it meant adopting the conventions of certain schools of painting, and resulted in photographs that were neither spontaneous nor witty. They were full of deadly uplift. J. Addison Reid remarked, in a review of the 1921 Toronto Salon, "Mr. Seelig furnished perhaps the only touch of humour in the exhibition with his charming and funny table top studies."[13]

However, the pictorialists, by virtue of their interest in the physical quality of the image, encouraged the development of the finely finished print. They were concerned both with correct technique and with the appropriate choice of printing process for the subject. The importance of this attention to printing detail was underlined by J. Harold MacKay in an article on the Toronto Canadian Salon of 1930: ". . . the prints show a lack of knowledge on the part of the workers in the selection of suitable papers to carry their message over. . . . There is nothing to redeem such work. . ." [14]

Reviews of exhibitions invariably referred to 'standards' which were being improved or let fall, and to greater or lesser 'progress' being made. "Serious thought, both in selection of subject and treatment, was the pre-dominating note" at the 1924 Toronto Salon, said J. Harold Mackay.[15] But the next year he lamented that ". . . a great country so replete with natural beauty produces so few earnest workers."[16]

Canadian pictorial work "might have been done anywhere," Harold Mortimer-Lamb complained in 1913. He looked for a recognition by photographers of what was intrinsic in their land, "for 'bigness' is the characteristic of Canada."[17] However, the subject matter of pictorial photography and the manner of dealing with it was more culturally and geographically determined than many realized. As A. Brooker Klugh wrote in 1925, in an article for British consumption:

. . . scenery here [Canada] is by the mile, whereas in England it is by the foot. This very fact makes all the difference, because in England there is a great wealth of what one might term 'pretty bits'; just, in fact, the circumscribed and complete bits of landscape which make most satisfactory pictorial compositions. In Canada, on the other hand, there is a great lack of the 'pretty bits'; there are grandeur, vastness, and expansive views which are entrancing to the eye, but which do not make effective compositions when reduced to the confines of a print of any reasonable size.[18]

Those who wrote about Canadian photography continued to insist that an indigenous style be developed. Arthur Goss, one of the earliest Canadian pictorialists, wrote in 1920 that "I believe it will be along the lines adopted by a group of Canadian painters to paint our scenery in a Canadian way,[19] that photographers must progress . . . [to produce] something worthwhile and characteristic of our climate and our country."[20] But gaining acceptance was very difficult for photographers who publicly attempted to reflect the country in their work. A one-man show of the Vancouver professional John Vanderpant's photography in 1928 elicited a scathing critique from the British critic F.C. Tilney for Vanderpant's rejection of tradition and his striving after pattern. "Canada," Vanderpant replied, "is not beautiful in detail but by the immensities of its proportions, [and] for the forms, contrasts, proportions and designs which belong to Canada and to no other country."[21]

Photographic salons of wide international representation, in which such debates could take place, had had some vogue in Europe and the United States before they became common in Canada. Not until 1919 did the Toronto Salon formally become an "International Exhibition of Photography." From only six participating countries that year, the salon increased its representation to 35 countries by 1929. The Toronto International became widely recognized as one of the major exhibitions, at least in terms of exposure. "The Toronto Show," wrote an anonymous reviewer in the American magazine *The Camera* in 1922, "is a great educator, in that it demonstrates to countless thousands who drift (the term is used advisedly) through the exhibition rooms, the possibilities which lie in the camera as a medium of artistic expression."[22] Regularly listed in the "Forthcoming Exhibitions" sections of the magazines, it annually solicited prints from their readers. Yet the Toronto International Salon, though attracting a very broad cross-section of foreign contributors, did not do the same for Canadian amateurs. Arthur S. Goss remarked obliquely in 1921 that "There is a great opportunity offered to Canadians, who, unfortunately, do not all avail themselves of it, to make the Exhibition at Toronto a completely representative Canadian show. . . . Our Canadian photographers, through a little more cooperation, could make this a really notable event in Canadian photography."[23] What a "little more cooperation" meant is moot. In 1918, the Toronto Salon hung 246 photographs, the work of 54 photographers. Of these, 20 were Canadian, 16 being members of the Toronto Camera Club. In 1926, 25 members of the Toronto Camera Club were represented in the Salon; the work of only eight other Canadians was hung. The Toronto International Salon was thus far from being a show-case for Canadian photography. Instead, it represented a very small group of workers; and of these there were some like Albert T. Roberts (pages 230, 231), John Morris (page 236), or M.O. Hammond, who, once accepted in the Salon, thereafter had at least one print hung almost every year. J.H. Mackay, director of the Toronto International Salon for much of the twenties, and correspondent to *Photograms of the Year* from 1924 to 1930, revealed stunning Toronto-centred insularity in what he considered worthwhile Canadian photography.[24]

The Toronto International, though the largest, was only one of three

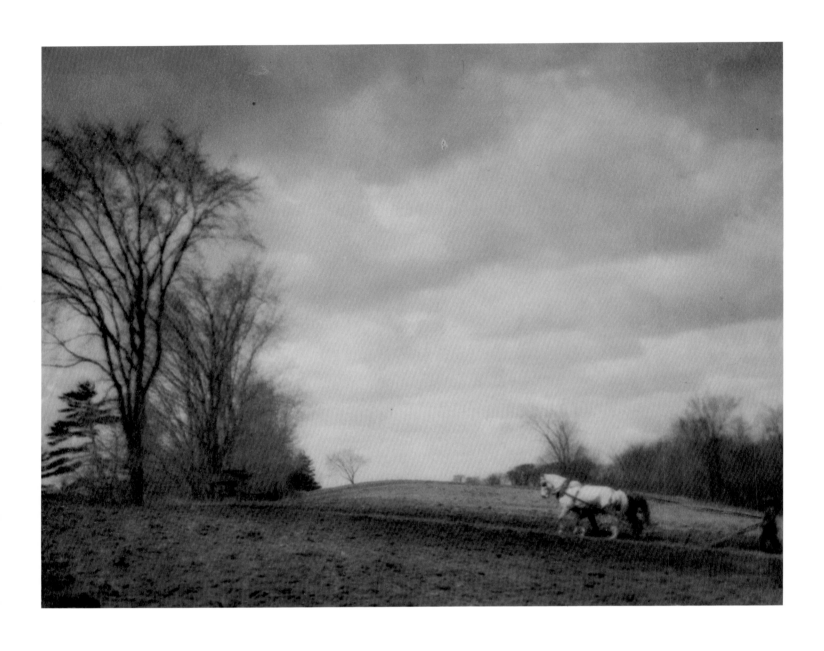

Bruce Metcalfe

[Farm scene] n.d. Bromide 18.8 x 23.9 cm *PAC, PA-124034*

Canadian international exhibitions which existed between 1914 and 1930. Ottawa arranged a similar show for several years during the early 1920s, though by 1928 the organizers had decided to cancel it because the quality of submissions was not high enough.[25] On the West Coast the New Westminster Salon was organized in 1921 and continued until the end of the decade. The larger pool of photographers in the Vancouver and Victoria areas may have contributed to its relative longevity. Workers like Cyril Rosher and Rosella Weller of Victoria and John Vanderpant and Johan Helders of Vancouver were very active internationally. Indeed, at one point, both Rosher and the professional Vanderpant were each accepted in more than 40 exhibitions during a single year!

The Toronto, Ottawa, and New Westminster salons were all connected with more general agricultural and industrial exhibitions. For many years such exhibitions had given prizes for various domestic and fine arts. Without the prize lists or exhibition programmes, it is impossible to trace the progress of prize-giving in photography. All we know is that slowly photography became an accepted category for such awards.

Other small photographic exhibitions were held from time to time, generally as individual club shows or in connection with fairs. Before the war the Montreal Amateur Athletic Association Camera Club show was international in character (as was Toronto's) and Ottawa had a biennial salon where its members displayed their work to the public. But admission to most club exhibitions was restricted to club members and their influence in developing Canadian photography outside the clubs went unrecorded.

Apart from the salons, amateurs were often not aware of what was happening in other parts of the country. There was no national body around which amateurs could coalesce, nor even a national photography magazine for the amateur. Everything was imported: magazines, ideas, opinions, equipment. Lines of communication were north-south in character: Toronto is closer to Buffalo (where the Photo-Pictorialists of Buffalo had been a considerable force during the first decade of the century) than to Ottawa or Montreal, not to mention Edmonton, or Halifax. Much more about the Vancouver scene was reported in *Camera Craft*, published in San Francisco, than in any other magazine.

The popular national press like *Maclean's*[26] or *Saturday Night* gave little space to amateur photography until the late twenties. One exception was the *Canadian Magazine* whose editor, Newton MacTavish, had been a member of the Toronto Camera Club since 1906. Most issues featured one or two pictorial photographs, and used some to illustrate articles; occasionally they included prints (not always by Canadians) from the Toronto International Salon. Some newspapers, such as the Montreal *Standard* or the Toronto *World*, carried the work of individual photographers, but they were for local, not national, circulation. The camera clubs may have had internal newsletters, though the Toronto Camera Club *Focus* didn't appear until 1930; similar publications from other clubs all seemed to have started in the thirties.

A photographic press would have had to depend mainly on support from the photographic industry; and the major Canadian manufacturer,

JOHN VANDERPANT

On 8 May 1931 the great American photographer Edward Weston wrote to a friend in Canada, John Vanderpant: "Strange coincidence, we both showed red cabbages, — halved! [at the 14th Annual International Salon of Pictorial Photography in Los Angeles] but mine was cut the other way."

Although John Vanderpant was a professional, his influence on amateur and pictorial photography during the twenties and thirties was so important that it must be acknowledged even in a book devoted to amateur photography, and his photo Heart of the Cabbage *is reproduced above (courtesy of Anna Vanderpant Ackroyd and Catharina Vanderpant Shelly, Vancouver, B.C.).*

Vanderpant organized and judged exhibitions, lectured widely, and published in Camera Craft. *He organized the first New Westminster Photographic Salon in 1920 and, three years later, the first New Westminster International Salon of Photography, which continued until the end of the decade. In 1927, he held an international salon at The Vanderpant Galleries which he had opened on Robson Street in Vancouver with Harold Mortimer-Lamb the previous year. In addition to bringing the work of Imogen Cunningham, Edward Weston and some of the world's leading pictorialists to Vancouver, he also had his own solo exhibitions in town in 1925, 1932 and 1937; a memorial exhibition of his work was held at the Vancouver Art Gallery in 1940.*

importer, and distributor was Kodak Canada Limited. Kodak, in fact, produced the only "Canadian" publication directed toward amateurs. *Canadian Kodakery,* a virtual copy of the Rochester-based *Kodakery,* was first published in the spring of 1914. It promoted the Kodak line of equipment and products and the old Kodak slogan "You push the button; we do the rest." It generally avoided technical considerations. Although at the beginning of the period it assumed that many readers would be interested in doing their own darkroom work — it gave considerable advertising space to Brownie enlargers, Velox enlarging paper, and other similar equipment — by the time the magazine was closed as an economy measure in 1932, the advertising was exclusively concerned with cameras and accessories. Articles like "Making the Most of Your Kodak," "Holiday Remembrances," "Photographic Greeting Cards," and "You Can Take Pictures Like These" emphasized the record-making function of the camera. Only one article by a known Canadian photographer, the professional Harry Pollard of Calgary, was published; and only a handful of Canadian photographs — mainly of the Rockies — were published before the contests of 1929 and 1931, which allowed greater exposure of Canadian work.

The absence of Canadian photography magazines meant that amateurs in Canada had to obtain their information from foreign sources, primarily British and American. While many would not at this time have considered Great Britain a "foreign" source of information, British magazines were naturally most interested in their own local activities. In compensation, *The Amateur Photographer & Photography* (previously *Amateur Photographer and Photographic News*), based in London, annually sponsored a Colonial Competition, and published the winning prints. Few Canadian prints appeared — whether because few Canadians entered or because their work was unacceptable is not clear.[27] Likewise, there were rarely articles or photographs from Canadian sources in the regular issues of British magazines. In comparison, American magazines printed a considerable amount of work by Canadians. Although this was partly because more photography magazines were published in the United States than in Britain, it was rare for one of the major magazines — *Camera Craft, American Photography, Photo-Era,* among others — to have an issue in which no mention of a Canadian photographer appeared. But because much of this was in print criticism or exchange club columns, Canadian photography could never be appreciated in terms of movements or groups but only as the work of isolated individuals.

Only one Canadian amateur seems to have been a regular contributor to any of the photography magazines, British or American. He was Alfred Brooker Klugh, a professor of biology at Queen's University in Kingston. Long interested in nature photography, he began a prolific monthly column on the subject in *American Photography* in 1923, continuing it until his untimely death in 1932. Each month he presented the work of several other nature photographers — none, unfortunately, identified by area of origin — and often permitted his readers to carry on a sort of correspondence in the column. The longevity of his column indicates that it served a loyal clientele: obviously not all "serious" amateurs were exclusively interested in the pictorialism promoted elsewhere in the magazine.

John Morris

[John and Jane Drope] before 1929 Silver 17.4 x 21.5 cm PAC, PA-131490

Apart from Klugh's sort of nature work, what interested the average exchange club amateur? As a general rule, it was what interested every normal young man (practically all correspondents in the clubs were men). While some had a monomania for railways or airplanes, a typical entry was like that of Clifford S. Bastla of London, Ontario, in 1914: "3-1/4 × 4-1/4, 4 × 5 and enlargements, all papers. Views of all the principal cities of United States and Canada, also some Mexican marines, ships, street scenes, nudes, draped figures, bathing girls, décolleté girls, bathing scenes, good work only. Will answer all exchanges sent."[28]

Nudes, bathing girls, and the like were mentioned very often. Considering that these were virtually never dealt with by Canadian pictorialists[29] — at least in their public work — the general amateur's interest is noteworthy. There was apparently no fear of linking one's name with such a request, or the possibility of interference with one's mail by the Post Office.[30]

Before the war a system of exchanges of lantern slides had existed among a number of American and Canadian clubs, but after the war this network does not seem to have continued. While this may have been because of a decreasing interest in such lantern slide work, the contacts that had previously been carried on with some regularity were now broken.

Clifford M. Johnston

Design 1934 Bromide 34.1 x 27 cm PAC, C-34427

Colour photography does not appear to have been of great interest to Canadian amateurs during the twenties. While the period after 1900 saw the creation and marketing of several transparency systems, the war interfered with further immediate development. Researchers continued to seek a simple method by which colour prints could be made on paper but without great success. No Canadian salon catalogue seen for this period lists a Canadian photographer, either professional or amateur, as exhibiting colour print work. Nonetheless, some colour work was being done. A small group in Toronto associated with the Eaton camera club was reportedly experimenting with three-colour methods prior to the war.[31] It is safe to suppose that apart from G.R.G. Conway and Frances Harper there were many individuals using Autochrome and other similar plates. Yet the use of colour went against the grain for many pictorialists. Writing in *Photograms of the Year 1923* the editor gave the opinion that "we doubt whether any entirely 'straight' photographic representation of nature in colours will ever have the aesthetic quality or give the same pleasure that a more individual rendering in colour . . . in the shape of multi-colour bromoils and transfers . . . is likely to do, no matter how perfect the mechanical record may be."[32]

It was a contradictory decade and a half. While at the beginning of the period pictorialists could claim but few adherents in Canada, by the Depression pictorialism was the accepted style. Yet by 1930 pictorialism had been long since abandoned internationally by those who had first taken it up, resolved as they were that photography's justification lay in its own qualities and not in aping the painterly arts. But it was not yet abandoned in Canada. Although some amateurs, such as Brodie Whitelaw (pages 237-239), were working towards a geometrical approach — using graphic design, and variations of light and shade — this movement was slow and was anything but a radical break with the past. Canadian salon amateurs had not developed any particular school or style of photography as the Group of Seven had done in painting.

While photographic thinking remained becalmed, the possibilities for technical virtuosity increased. New equipment and supplies made it easier for the photographer to take previously difficult photographs. But the wit to use the hardware for creative ends was too often lacking.

The way was open for new developments in Canadian amateur photography. The war had decimated one young generation; now, more than a decade later, many new faces were appearing. Would they also see with new eyes?

Salon Crescendo/1930-1940

Joan M. Schwartz

T he thirties marked a watershed in the history of amateur photography in this country. It was a decade of endings and beginnings, of progress and diversification. To an unprecedented degree, new technology offered the amateur greater opportunity, control and variety in the pursuit of the medium. Reflecting this, the number, size and activity of camera clubs grew, and the salon scene thrived. On the whole, the development of Canadian pictorial photography deviated little from the pattern elsewhere, though perhaps the conservatives were less tenacious and the radicals less daring. Gradually, salon work became less painterly as photographers finally recognized, accepted and began to explore the full defining powers of improved lenses and the recording speed of new films. But the beginning of the new era of "modern" photography also heralded the passing of traditional pictorialism which, despite its inertia, is difficult not to cherish for its romanticism.

During the thirties, technical change occurred faster than ever before. Films of high speed, fine grain and panchromatic sensitivity were perfected; new papers, colour films and flash bulbs were introduced. Cameras of all kinds — point-and-shoot box cameras, adjustable folding models, large-format, miniature, single- and twin-lens reflex — flooded the market.[1] Perhaps most significant, the 35mm film cassette helped to simplify and standardize photography, reduce manufacturing costs and pave the way for a new range of medium- and low-priced cameras.[2]

As hand cameras became simpler and less expensive, the number of snapshooters increased to the point where *Photograms of the Year 1932* declared that the camera "had become a regular part of the impedimenta of many thousands of holiday-makers . . . [who], beyond being responsible for loading the camera with a spool of film and making the exposures, have no further knowledge of the subject."[3] Although somewhat contemptuous of the "D. and P." (developing and printing) industry, *Photograms* reluctantly admitted that the growth in amateur photography would certainly contribute to progress in pictorial photography. Nevertheless, it was the non-pictorialist who led the way in adopting the 35mm camera and the new colour transparency films.

While photography was still essentially a black-and-white medium in the early thirties, experimentation with colour films and processes continued apace. Colour photography on paper made comparatively little progress

Leonard Davis

Glass Patterns 1935 "Bromide print from Leica negative" 37 x 28 cm *PAC, PA-126640*

DUFAYCOLOR

First introduced as ciné film in 1932, Ilford's Dufaycolor was sold for the still photography market in roll, sheet and pack form in 1935. The British Journal Photographic Almanac, 1936 (London), 270, explained: "The Dufaycolor process . . . [utilizes] a ruled screen incorporated in the film itself, between the emulsion and the base, through which the exposure is made. The film is subjected after exposure to the usual colour plate reversal process and emerges as a positive transparency. The film differs from former processes in, among other things, the extreme fineness of the screen. Another characteristic is its speed, which is about one-third that of standard [black and white film, equivalent to about ASA 10 . . . It] is loaded and used in exactly the same way as ordinary film, [and] is moreover used in daylight without any filter — an important feature." As late as 1938, Dufaycolor was still considered to be the ultimate screen process; had the integral tri-pack Kodachrome not been introduced at this time, Dufaycolor would have enjoyed even greater popularity. Even so, its fine screen, sensitive emulsion and simple processing made it popular with amateurs and professionals into the 1950s.

throughout the period. One-shot and repeating-back cameras, used to make separation negatives, were improved, but the fact remained that, apart from hand-tinting, one or other of the complicated three-colour processes continued to be the only common means for producing colour prints on paper. In 1939, *Photograms of the Year* acknowledged that "while a number of excellent results have been produced and shown at the exhibitions, they are still somewhat too complicated for regular amateur use."[4]

Real advances came in the mid-thirties when colour films originally developed for the motion picture industry were adapted to still photography. The most popular was Dufaycolor, launched in 1935 in both roll and sheet form. However, improvements in the Autochrome, Agfacolor and other screen base and starch granule colour films were totally eclipsed by the announcement of a revolutionary new film which laid the foundation of modern colour photography. Kodachrome, the first commercial integral tri-colour pack film, was released as movie film in April 1935 and was made available to the still photography market in 35mm and 828 format in September of the following year.

The snapshooter and the miniature camera user benefited most from the advances in colour photography. At first, many of the transparency films were available only for miniature camera use. Kodachrome, for example, was not introduced in a larger format until November 1938, when problems with processing and stability had been solved. Kodak's ready-mounting service, which returned processed transparency film in card-mounted form, further freed the snapshooter just to "point and shoot." The amateur photographer now turned to colour slides for a record of holiday travels or family gatherings. Even ardent pictorialists such as Philip Croft (pages 289-291) and Leonard Davis (page 294) experimented with colour slides as reminders of personal activities. The colour transparency was also quickly adopted as a documentary medium. Bill Norfolk, working for the Ontario government, returned from a summer in the bush with Dufaycolor slides of Lake Aguasabon (page 293). During his tenure as Missionary-in-Charge at Eskimo Point, N.W.T., Donald Ben Marsh used the recently released Kodachrome to produce a series of views of Inuit life at many northern locations (pages 296, 297). However, apart from encouraging a revival in lantern slide photography, these colour films did not significantly influence Canadian pictorial photography in the 1930s.

One phenomenon which contributed to the growth of amateur photography during this period was the photo competition. Vying for the miniature camera market, both Leica's Leitz and Zeiss sponsored competitions, and General Electric encouraged use of its newly introduced Photoflash and Photoflood lamps through contests for indoor or artificial light photographs. Newspapers and magazines also organized photo-contests, offering prizes from cash to encyclopedias to bicycles as incentives. Canadians were regularly invited to enter contests in American magazines and in Canada, readers of *Maclean's* submitted snapshots "of Canadian scenery, particularly of those beauty spots less generally known" for the annual Canadian travel number. Even more enthusiastic support came from *Saturday Night*, the Toronto "national weekly, whose sustained weekly

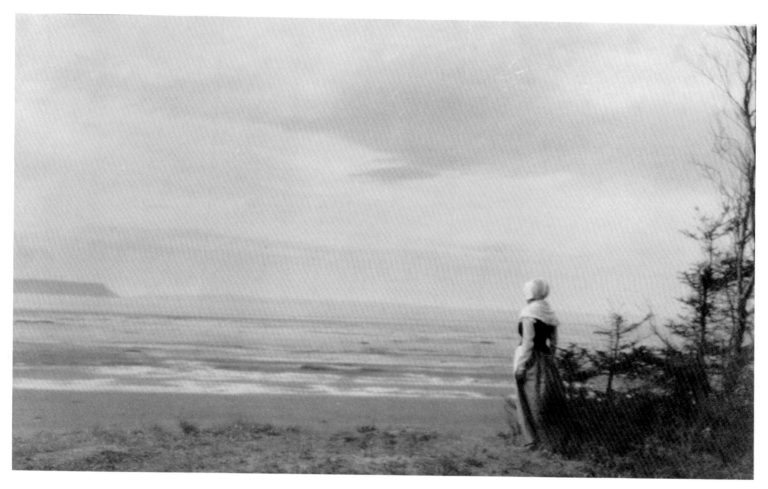

Edith Hallett Bethune

Evangeline before Blomidon 1933 Bromide 21.1 x 33.1 cm *PAC, PA-126056 Courtesy of Jack and Margaret Bethune*

competitions for several years. . . stressed the Pictorial viewpoint."[5]

In 1931, Kodak announced its "$100,000 competition for amateur picture-takers" with 286 prizes in the Canadian district alone. The contest, "to find the world's most interesting snapshots," emphasized that no special experience was required and that "the owner of a Brownie, Hawk-Eye or the simplest Kodak [had] the same chance to capture a prize as users of costly cameras."[6] Contestants were not required to own their own cameras, nor to do their own photo-finishing. These contests not only supported the growth of amateur photography, but also turned many snapshooters into budding pictorialists. Encouraged by her success with a commercially finished snapshot in the 1929 Kodak competition, Edith Hallett Bethune of Berwick, Nova Scotia, purchased a new camera with her winnings and began producing salon prints for which she was to achieve international prominence. Bethune captured the $100 second prize for "scenes" in the 1931 competition for an early version of her most famous print *Evangeline before Blomidon*. Among the winners there were also many established Canadian pictorialists, among them John Morris, Bruce Metcalfe, Brodie Whitelaw and Johan Helders.

With the tremendous growth of popular photography came a golden age in pictorial photography, largely encouraged and made visible through the activities of camera clubs. Many clubs had not survived the onset of the Depression and in the earliest years of the decade amateur activity was at a low ebb. But as the economy recovered, camera clubs began to spring up across the country. In fact, they increased ten-fold during the thirties. Early in the decade, Ottawa, Hamilton and London joined Toronto as the country's major amateur centres, but clubs sprang up in all the larger cities — Halifax, Fredericton, Montreal, Winnipeg, Regina, Saskatoon, Calgary, Vancouver and Victoria, as well as in many smaller communities of the Prairies, south-western Ontario and Nova Scotia. By the end of the decade, several public, private, company and student clubs had been formed in Toronto, in addition to the well-established Toronto Camera Club and Hart House (University of Toronto) Camera Club.

With the growth of camera clubs came a spate of bulletins and newsletters, published more or less regularly, and sent, not only to club members, but also to other camera clubs.[7] *Focus* (Toronto), *The Bellows* (Hamilton), *Cameragrams* (Montreal), *Photo-Flash* (London) and *Photo-Tab* (Sarnia) were a few of these. Although there was still no photographic magazine published expressly for the Canadian pictorialist, news of happenings in Canada frequently appeared in the many American and British journals, and a separate review of Canadian photography was a regular feature of the British annual, *Photograms of the Year*, and in the late thirties, *The Gallery*. At the same time, *Saturday Night* popularized photography among the general public. A regular column by staff photographer "Jay" (Thomas George Jaycocks) included such topics as "Making Salon Prints." It also devoted considerable space to publicity, reviews and reproductions of the National Gallery's Canadian International Salon of Photographic Art and the Hamilton Camera Club's Canadian Salon of Photography. Photo essays by "Jay" or by press and amateur photographers filled the first page of the "People • Travel • Fashion • Homes • Letters" section, in addition to reproductions of winning prints from *Saturday Night*'s many photo competitions.

Club activities diversified. In the larger clubs, splinter groups pursued specific interests — lantern slide, natural history and scientific, cine, miniature, and colour photography. Lectures and demonstrations continued to form the backbone of the clubs' activities, though they were sometimes criticized by advanced workers as repetitive and geared to the needs of the beginner. Topics reflected advances in equipment, processes, films and styles, but old favourites such as pictorial composition, Christmas cards, or paper negatives cropped up time and again.

For the pictorialist, the focal point of the camera club's activities continued to be the monthly print criticism. This was both a didactic tool and a source of personal satisfaction. Sometimes there were material rewards. At the Toronto Camera Club, a trophy cup, first donated in 1931, was awarded annually to the member with the highest number of points in the monthly competitions. Prints could be submitted in the traditional categories such as Architecture, Landscape & Marine, Portraiture, Genre, and Still-Life, as well as in newer classes such as Design & Table-Tops, Natural History & Scientific.

KODACHROME

Kodachrome revolutionized colour transparency films by dispensing with the screen process and employing the integral tri-pack, a method of coating three separate emulsions on the same film base. For the first time, the colours formed in different layers, rather than side by side. The sharper, more brilliant image required less light for projection. The sensitive coating of Kodachrome film consisted of five exceedingly thin layers — three layers of emulsion and two intervening filtering layers of dyed gelatin. No thicker than ordinary film and sensitive enough to permit exposures of 1/30th of a second in good light, Kodachrome was loaded in the camera and exposed in the usual way. However, the processing of Kodachrome was both intricate and exacting, and the exposed film was returned to Eastman Kodak Company to do the work.

Albert T. Roberts

Soap, Two Eggs, Cauliflower [*c.* 1930s] Silver 6.8 x 8.7 cm *PAC, PA-138558*

There was a separate class for lantern slides, divided into pictorial and scientific, and in February 1934, a category for enlargements from miniature negatives was added. Each month there was also one special assignment — perhaps Children at Play, or Toronto at Night. At smaller clubs a single topic was assigned for the month. Leonard Davis produced a series of prints on Hamilton's high level bridge (page 265) for a camera club exercise on architectural detail; a bowl of eggs and a milk bottle were the basis of a FotoForum assignment on "high key." Prints that survived the monthly criticism often found their way to major salons. However, rejection of a print was sometimes taken as a challenge to submit the image to numerous competitions in the hope of accumulating enough acceptances to prove the merit of one's work and the folly of one's peers.

The camera club was also the moving force behind the main vehicle of pictorial photography, the salon. But, with the exception of the annual Toronto Salon of Photography and a core of serious pictorialists, there was no continuity between the flourishing salon activity of the mid-twenties and the mid-thirties in Canada. This was another effect of the Depression. Foreign salons and magazine competitions bridged the gap. Canadian pictorialists such as Johan Helders, C.M. johnston and Bruce Metcalfe became familiar contributors to the leading American salons. English and Scottish camera

Johan Helders

Pool No. 1 [negative *c.* 1925] Bromide 42.9 x 33.5 cm VPL, not copied

J.K. Hodges

Fire Fighters, [c. 1927] Bromide 23.7 x 33.3 cm *PAC, PA-125729*

clubs offered opportunities to those who could afford overseas postage,[8] and the names of Canada's more industrious exhibitors occasionally appeared in salon catalogues in France, Spain and various South American countries.

In 1930, the Toronto Salon of Photography was already in its 39th year. Held annually at the Canadian National Exhibition under the auspices of the Toronto Camera Club,[9] it was a popular international show of some 300 prints, purportedly "third in importance in Photographic Exhibitions throughout the world."[10] The Toronto Salon's experiment of exhibiting technical and scientific work was so well received in 1930 that a separate Scientific Section was added. Approximately 60 to 75 prints, selected by a separate jury, were hung each year until 1936, when the Scientific Section was discontinued in favour of a strictly pictorial show.

In 1934, pictorial photography in Canada received an immeasurable

boost with the establishment of the Canadian International Salon of Photographic Art by the National Gallery of Canada in Ottawa. Most of the work of assembling and arranging the first show was undertaken by officials of The Camera Club of Ottawa, most notably Clifford Johnston and Harold Kells. Acting as Salon Secretary, Kells took it upon himself "to write a personal letter to every outstanding pictorial photographer throughout the world."[11] Prints were submitted by the world's great pictorialists including Edward Alenius, Margaret Bourke-White, Frank Fraprie and Max Thorek of the United States, Leonard Misonne of Belgium, Alexander Keighley of England, Julian Smith of Australia and Will Till of South Africa. In the foreword to the catalogue, the National Gallery director Eric Brown expressed the hope that the Gallery's recognition of the artistic aspects of modern photography would result in the formation of a "national Canadian Photographic Society" and suggested that, as a result, "the exhibition might well become an annual one and a valuable addition to the art of the Dominion."[12] The public and press responded enthusiastically; large crowds and favourable reviews followed the show on its coast-to-coast tour.

This success prompted the National Gallery to create the proposed annual show, and for the remainder of the decade, the Canadian International Salon of Photographic Art was Canada's premier pictorial salon. Following a two-week sojourn on the walls of the National Gallery in Ottawa, the 200-odd prints were sent on tour, to be exhibited "as an educational feature"[13] at art associations, camera clubs, galleries, libraries and hotels in some twenty centres across the country. There was no charge for admission, and an illustrated catalogue, available at 10¢ a copy, was praised by the press as a work of art in itself.[14]

As the Salon grew in popularity, requests to host it increased, making it difficult for the National Gallery to maintain a one-year schedule without refusing venues. In 1937, the suggestion that the exhibition might become a biennial event because of its popularity and the consequent length of its tour[15] met with vocal opposition, especially from the West.[16] Then, in 1940, "owing to war conditions and the difficulty of securing entries from all parts of the world," the Seventh Canadian International Salon of Photographic Art was postponed "until further notice."[17] However, when the president of The Camera Club of Ottawa suggested in 1946 that it be resumed, the new director of the National Gallery, H.O. McCurry, claimed that the time was not ripe.[18] Eric Brown's enthusiasm and the momentum of the pre-war years had been lost; the Canadian International Salon of Photographic Art was never revived.

The post-Depression photographic awakening also gave rise to other new salons, by 1937 a veritable "epidemic," according to Clifford Johnston.[19] A host of fledgling clubs were eager to hold an annual salon, usually of local or regional work, often bolstered by an invitational showing from one of the larger, well-known clubs. The most ambitious was the newly reconstituted Hamilton Camera Club, which held its first Canadian Salon of Photography in the spring of 1934, with over two hundred prints representing clubs and cities from Nova Scotia to British Columbia, including an "invitation" entry of 25 prints from the Toronto Camera Club.[20] The Hamilton show quickly

View of the display area and style of hanging of the Second Canadian International Salon of Photographic Art installed at the National Gallery in Ottawa in 1935, as recorded by Clifford M. Johnston (PAC, PA-56891).

Anonymous

Judging of the Third Canadian International Salon of Photographic Art, National Gallery of Canada, Ottawa, (near left: Johan Helders; middle left: Bruce Metcalfe) 1936 Bromide 5.8 x 8.5 cm PAC, PA-127027

became an important annual event which, despite the occasional protest that it become international, continued to be an all-Canadian exhibition.

The Canadian Interchange Print Circuit Eastern Division, begun in 1937, included work by members of the Queen's (Kingston), Hart House (Toronto), Toronto, Chatham, Sarnia, Montreal and Ottawa camera clubs. Far from the vigorous salon activity of southern Ontario, Vancouver was not only a venue for the National Gallery show, but also a stop for a travelling print show that made the rounds of western centres in Canada, from Winnipeg to the Coast. In 1934, the Vancouver Camera Club in conjunction with the Pictorial Photographers of Victoria brought the 200 prints of the first Canadian Salon of Photography to the West Coast after the exhibition closed in Hamilton. The city also hosted major international salons at the beginning and at the end of the decade; in the interim, it enjoyed showings of pictorial photography at the gallery of John Vanderpant on Robson Street and, beginning in 1938, at the annual Canada Pacific Exhibition. On the Prairies, the Western Canadian Salon of Pictorial Photography was organized in

Yousuf Karsh

Johan Helders, negative 1938, print 1983 Silver 50.4 x 40.4 cm *PAC, PA-138574*

Photographs accepted for exhibit at a salon were given a sticker, which was pasted on the back of the print to show where the picture had been displayed. Samples of these acceptance stickers (from the reverse of Bruce Metcalfe's Parade of the Wooden Soldiers *and* Collars) *are reproduced on pages 68 and 69. They give an indication of how the same image — though not necessarily the same print of it — moved through the international photographic salon circuit during the twenties and thirties. Dates of salons on the stickers indicate an overlap in time, implying that more than one print of* Parade *was being circulated. All the exhibition stickers received by an image would afterwards often be attached to one print. Some photographers, J.K. Hodges among them, even kept special master prints, never exhibited but used only for mounting their awards.*

Winnipeg by the Manitoba Camera Club, and there were as well the annual salons of the Regina "Y" and Medicine Hat camera clubs. Early in the forties, Lethbridge began its all-Canadian salon, a co-operative venture by Brandon, Saskatoon, Regina, Calgary and Edmonton produced the 5-Club Salon of Pictorial Photography, and Calgary initiated its own salon of photography shown annually during Stampede week; Edmonton did not follow suit with its "Gateway to the North Exhibition of Photography" until after the war. In the Maritimes, the National Gallery show was supplemented by the Nova Scotia Salon of Photography in the late thirties, and later by the salons of the very active Sydney Photo Forum. And for those living without the stimulus of a nearby salon, there were a number of correspondence camera clubs circulating portfolios of prints, as well as the profusely-illustrated monthly and annual photographic publications.

If the proliferation of international exhibitions was a boon to the pictorial photographer, it was the bane of the salon organizer. The decision of the Western Ontario Salon to "go international" was greeted with consternation by The Camera Club of Ottawa. Clifford Johnston wrote to the secretary of the London Camera Club, pointing out that the output of the world's front-rank workers was limited, making it difficult to get any number of them to patronize more than a few of the better established salons. Johnston proposed that the Canadian International was the solution to all camera clubs who aspired to "having a first-class annual show in their city:"

In this day of Salons bidding for contributions from the world's best workers we feel that the Gallery, with its prestige and no entry fee, can attract a much wider band of workers and give us a better Salon at a trifling cost to ourselves. We get the same benefit, the same public sees it, and there are no headaches.[21]

Though London did request that it be added to the venues of the Canadian International, the Western Ontario Salon continued as an international competition. It attracted entries from the prolific American notables, but its 1938 catalogue included the names of only four, lesser-known exhibitors from India, China and Japan. And even before the last Canadian International had completed its tour, the Vancouver Photographic Society announced its First Annual International Salon of Pictorial Photography; Windsor, Montreal and Victoria were soon to follow suit. However these shows could never again give Canadians across the country the same opportunity to view the work of so many of the world's great pictorialists at one time.

In 1930, the Fine Arts Department of the Canadian National Exhibition (C.N.E.) decided that "a purely national show, both in the Fine and Graphic Arts would act as an incentive to Canadian artists to produce more and better work."[22] Accordingly, the Toronto Salon was open only to Canadian entrants. Although the number of contributors increased nearly 200 per cent, and some 400 prints were accepted, the exhibition was "reported not to have been very successful because of the limited number of pictorialists whose work could be drawn upon."[23] Despite the tremendous subsequent growth of pictorial photography in Canada, the announcement of another "All-Canada Year" at the C.N.E. of 1939 elicited regret from one Toronto Salon organizer who claimed that the decision placed the Toronto Camera

Club "in a difficult position, it being no easy matter to get together some 300 prints from Canada that shall be of even fairly high salon quality."[24] The Hamilton Camera Club's annual Canadian Salon of Photography inevitably invited similar comment. Nevertheless, it was an important event in the calendar of the Canadian pictorialist aspiring to compete successfully in the larger international arena.

In response to the staggering number of salons that had come into existence around the world, a Toronto photographer and critic mused:

One wonders who sends to all these Salons, and if the net result is not rather to produce pictorial factories instead of artists . . . 'Salonitis' is certainly a disease to which pictorialists seem strangely susceptible.[25]

With more and more pictorialists producing larger volumes of prints for ever-multiplying salons, there developed a need for some standard by which to measure national progress or individual success. Statistics were often quoted to corroborate boastful claims. For example, in 1936, an editorial note in *Focus* announced that "at the recent 3rd Canadian International Salon of Photographic Art, photographers from the Dominion were successful in competition with the world's best workers." Citing figures that 15 per cent of successful exhibitors and 16 per cent of accepted prints were Canadian, *Focus* concluded "Canada marches on photographically."[26]

During the thirties, *The American Annual of Photography* began to publish lists of "outstanding" exhibitors based on statistics derived from its "Who's Who in Pictorial Photography," a regular feature which gave the names and addresses of pictorialists who had had more than forty prints accepted in open salons over the previous year and more than 200 acceptances over the preceding five years. These lists transformed what was originally intended as "a reasonably accurate mailing list" into "an intense, if not formally recognized competition" which resulted in "much jealousy and heartburning."[27] Confusing "outstanding" with "prolific," *The American Annual* drew sharp criticism for its approach. In a stinging letter to the editor, H.G. Cox of New Westminster asked whether "volume production [had] invaded the hitherto inviolate realm of Art," imploring that quality, not quantity, be the goal in pictorial art.[28] Another writer suggested that photography was simply not a fit subject for competition and that photographers were debasing their hobby by making it so.[29]

In 1938, *The American Annual* acknowledged that the mere counting of prints accepted by the salons of the world was not a sufficient rating of pictorial merit, and changed "outstanding" to "most prolific" in the titles of its rank lists. However, it also introduced a weighting factor (calculated according to the difficulty of having a print accepted at a given salon) that was supposed to permit "a simple and accurate measure of the pictorial achievement of salon exhibitors." To succeed at this new game, exhibitors were warned not to send out poor prints or pick "easy" salons:

Make four first-class prints, and send them only to the salons which limit entries to four prints, and your name will be near the top of the list next year.[30]

GORDON TRANTER

One of western Canada's leading pictorialist photographers was Gordon Tranter, Secretary of the Calgary Photographic Society and an earnest advocate of camera clubs. His enthusiasm had been stimulated by his association with the Calgary Photographic Society, and he heartily recommended that any amateur "get in touch with a photographic club, as the aid and the friendly criticism of their efforts are a most valuable stimulus to improving future work." (The Amateur Photographer and Cinematographer, 17 August 1938; 192)

Unfortunately, no original print of Tranter's has been located, and his work is preserved only in secondary form; in 1937 his photograph Coming to Rest *was used as the background for the acceptance sticker of the 4th Annual Canadian Salon of Photography (Hamilton Camera Club, Hamilton, Ontario), which is reproduced above (PAC, PA-126520).*

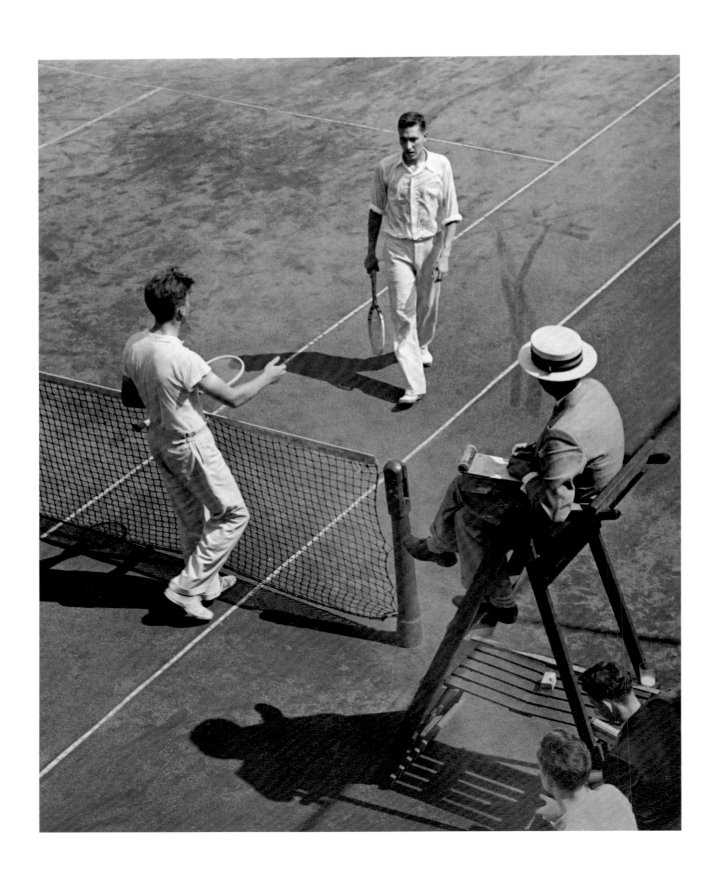

John Morris

Finale, [c. 1934] Bromide 31 x 24.8 cm *PAC, PA-138560*

Canadian photographers were drawn into this statistical arena. Few, however, were prolific enough to compete with the pictorialists, especially from the United States, who were showing over 100 prints at more than 30 salons in a single year. Even in *The American Annual*'s rank list for 1937-1938, when a record 77 Canadians were listed, only fourteen had had 10 or more print acceptances and only five had had their work hung in 10 or more salons. In fact, during the thirties, Harold Kells, Johan Helders, Clifford Johnston and Frank Halliday were the only ones with more than 40 acceptances in a single year, and only the last three had 200 or more acceptances over a five-year period. If not particularly significant to the majority of Canadian pictorialists, *The American Annual*'s "numerical evaluation of pictorial achievement" did contribute to the international prestige and popularity of some of the Canadian salons. In 1938, the Canadian International ranked a very respectable fourth out of 87 salons according to "print value factor." Deemed to be only a fraction behind that of the prestigious "Royal" exhibition of the Royal Photographic Society, the Ottawa salon quickly attracted prints from the leading pictorialists eager to accumulate points in *The American Annual*'s statistical competition.

Salon photography in the thirties witnessed an inexorable evolution of artistic taste. The trend in subject toward abstraction and away from generalized landscape, which had begun in the mid-1920s, continued. Increasingly, misty scenes gave way to compositions with an emphasis on clarity and design. Echoing the sentiments of those who advocated "the necessity of sharp and distinct photography as opposed to the vague and blurred effects which imitate painting,"[31] *Photograms of the Year* declared at the close of 1934: "the straighter the photograph the better the art."[32] However, photographic literature continued to carry articles on soft-focus screens, double printing, printing through tissue or from the wrong side of the paper, etching, toning and retouching. Writers continued to expound the pictorial attributes of water, clouds and trees. Even though straight bromide and chloro-bromide prints dominated the salon scene by the latter half of the decade, the occasional article advocated one or another of the neglected control processes.[33]

The experimentation that nurtured pictorial progress also produced "an overdose of hocus-pocus."[34] Bizarre subjects or unusual angles were dismissed as the freak work of the commercialist swayed by recent trends in advertising and the graphic arts. "Why should we tie knots in string, enlarge the result and consider that a Salon print?"[35] A few years later, the pictorial pendulum swung back again, settling between the extremes of fuzzy romanticism and stark realism: "Subjects previously associated with the out-of-focus school are again in fashion, but are now shown with all the wonderful detail, vigour and perfection of tonal quality that only fine technical photography can give."[36]

In 1932 Bruce Metcalfe noted an almost total neglect of the control processes among Canadian photographers, in spite of the excellent samples of oils and transfers coming from Europe.[37] In fact, few Canadians had consistently practised the refractory processes that had captured the imagination of the earlier pictorialists. Clifford Johnston, one of Canada's internationally known salon exhibitors, expressed a prevalent sentiment:

Arthur H. Tweedle

Lillies (*sic*) n.d. Bromide 20.2 x 25.4 cm *PAC, PA-138561*

I admire bromoil work, but as I believe it to be too complicated for the limited time at my disposal, I consider it better to seek improvement with a simple process rather than be a third-rate muddler in a more difficult one.[38]

Metcalfe and his Toronto Camera Club colleague Alfred Brigden were two of the die-hards who practised the bromoil process. Although not an active salon exhibitor, F.G. Ashton of Ottawa produced a large collection of gum bichromate, bromoil transfer, oil and carbon prints around 1930 (pages 248, 249). Leslie G. Saunders of Saskatoon began exhibiting bromoils in the late twenties and continued with success into the mid-thirties. His print *The Road from the Beach* was the only bromoil by a Canadian and one of only 19 hung among more than 700 prints at the Century of Progress Salon at the 1933 Chicago World's Fair.

Unlike gums and oils, the paper negative was one of the pictorial devices that not only survived the demise of the soft-focus aesthetic, but actually enjoyed sustained interest throughout this period. As late as 1937 the president of the Toronto Camera Club, Norman P. Smith, praised and recommended it, noting the accomplished work of club members A.T. Roberts and Alfred Brigden.[39] Brigden, who was called upon to give a demonstration of paper negatives to the Toronto Camera Club in 1931, was still exhibiting in this medium in 1939. Bill Lehman, too, exhibited paper negative prints in the

John Morris

An Apple [*c.* 1931] Bromide 20 x 17.5 cm *PAC, PA-138562* 105

James Crookall

[Woman at Drinking Fountain c. 1937] From original 35mm celluloid negative CVA, CVA 260-670

late thirties, and Leonard Davis experimented with the technique in the mid-forties. Philip Croft's *Lancashire* (page 256) shows how the paper negative technique "permitted the pictorialist to remove unwanted detail or accentuate a light or dark mass to achieve a harmonious composition with the most distinctive results while retaining characteristic photographic quality."[40]

Canadians worked comfortably within the mainstream of salon interests during the 1930s, and, as in the twenties, did not contribute significantly to the more controversial aspects of the international exhibition scene: the nude study and the colour print. For example, in the Pictorial Section of the 1934 Toronto Salon of Photography, there were only 14 nudes among 302 prints hung, and these, wrote Stanley Harrod, were "far from satisfactory:"

Many of them are . . . depressed beyond belief. Others are very strained in attitude. . . . Others are printed in such a way that all beauty of skin texture is lost, and all but two or three are simply 'posey'.[41]

The only Canadian pictorialist of the thirties to exhibit nude studies with regularity and success was the artist-turned-photographer Harold F. Kells of Ottawa. Shunning gimmicks like the grotesque pose and the truncated torso, Kells produced such award-winning compositions as *Freedom* and *Soul of the Dance* (page 254). Working during a period when "contrived" did not necessarily carry a pejorative connotation, Kells produced a series of elaborate historical/mythological images on classical themes, including *Death of*

Cleopatra, Maid of Athens, The Sacrifice of Andromeda and *Grecian Nocturne* (page 255). Leslie G. Saunders also achieved some recognition in this field. *South Wind* (page 253) was shown at more than a dozen centres in the United States after winning an honourable mention in the Eighteenth Annual Competition of *American Photography* in 1938.[42] *South Wind* also appeared in *Saturday Night* after it was accepted at the Fifth Canadian International Salon. Reaction was not always favourable.[43] The Canadian public, postal regulations and customs officials looked askance at photographs of nudes, invariably women, regardless of artistic purpose. At the 1936 Canadian International Salon of Photographic Art, Kells' print, *Salome (Remorse)* — more allegorical than erotic — was among several nude studies which prompted one shocked Ottawa citizen to write to the local newspaper:

Could they not at least be all grouped together and placed as much as possible apart from the general collection? But better still . . . would be their exclusion altogether from an exhibition which is open to the public.[44]

The colour print also received a mixed welcome. In 1934, "three-colour prints . . . drew much attention and favourable comment both at the judging and at the Exhibition" of the Toronto Camera Club's annual salon.[45] Members of camera clubs in Toronto, London and Montreal heard lectures on colour composition, saw demonstrations of printing and read articles on the latest developments in materials. But none of Canada's leading pictorialists produced salon work in colour and few others achieved more than limited recognition. There was even some question whether colour prints should be exhibited. By 1938, the Toronto Salon of Photography had been accepting colour prints for several years; there were four colour prints in the Hamilton club's Fifth Canadian Salon and at least one in the first Western Ontario Salon. On the other hand, the National Gallery refused to add a colour section to its Fifth Canadian International on the grounds that colour work was not yet "important from a pictorial stand point."[46]

Colour work on paper progressed little during the decade. Like the control processes, colour printing did not appeal to the average Canadian pictorialist because of the investment of time and skill it required. Those who had the patience to produce oils and transfers were often the first to turn to colour. Toronto photographer Ernest Letten, for example, exhibited bromoils in the Toronto Salon of Photography up to 1934, three-colour work in 1935, and wash-off relief prints for the remainder of the decade. Harold Kells (page 298) "designed and built a one-shot colour camera which was capable of taking three colour separation negatives in one instantaneous exposure. It proved to be highly successful technically but was too cumbersome for use other than in the studio."[47] Philip Croft (page 299) also dabbled in colour photography and, unlike Kells, submitted some of this work to salons.

During the thirties, the new, smaller-format, hand-held cameras gained many adherents among Canadian pictorialists. By the time Zeiss Ikon marketed its Contax in 1932, the Leica had already attracted a devoted following based on its reputation as a precision instrument with high quality lenses. The appearance of the Contax began a rivalry which saw a succession of new models incorporating technical improvements in hopes of

WASH-OFF RELIEF

In 1935, Kodak introduced the Eastman Wash-Off Relief Process, a refinement of existing dye-transfer processes: at an important stage in the process softened gelatin was washed off a film support to leave a relief image or matrix. For each of three colour separation negatives, Wash-Off Relief film was exposed and a matrix produced in which the various tones were represented by varying thicknesses of hardened gelatin. Highlights were transposed as a thin layer, shadows as a thick layer. Each matrix was then soaked in a different dye solution, and the amount of dye taken up by the matrix was proportional to the height of the relief image. The dyed matrices were then placed, consecutively and in register, in contact with specially coated paper. The dye transferred to the gelatin of the paper, and the three dyed images together on the paper combined to form the final colour print. The process, also known as imbibition, required an hour or more to produce a single print.

capturing the precision 35mm market. In 1934, the first Kodak camera to use 35mm film — the Retina — was produced. The Argus, the first inexpensive camera in the same format, was sold in 1935 and then improved in 1939. The Exakta, the first single-lens reflex version of the miniature camera, appeared in 1937. Improved enlarging equipment, finer-grained emulsions and graduated printing papers, all developed in response to the miniature camera user, allowed the salon worker to take advantage of the miniature camera's precision and portability without sacrificing the quality of the final print.

The growing popularity of the 35mm camera coupled with the introduction of improved transparency films encouraged lantern slide photography. But while slides were an integral part of the monthly competitions of camera clubs, they were never part of the salon scene, despite being an accepted format for the salons of the Royal Photographic Society and most English camera clubs.

Though slow to respond, the Toronto Camera Club was forced to take up the challenge of the miniature camera. In February 1934, a new category for enlargements from negatives 2-1/4"-square and smaller was added to the monthly print competition. A contact print of the negative had to be pasted onto the mount of salon print enlargements. In January 1935, a collection of Leica studies by Toronto press photographer and club member Albert Van was on exhibit in the club rooms. Throughout the year, articles appeared in *Focus* on various aspects of miniature photography, and members clamoured for an enlarger for 2-1/4"-square and 35mm negatives. Finally, in December of 1936, the club purchased one to "settle once and for all the rumors that the Toronto Camera Club is unfavorable to the miniaturists."[48]

Not all camera clubs were so conservative. Leonard Davis, first president and an active member of the Hamilton group, was one of Canada's earliest and most loyal Leica pictorialists. Intrigued by reports of the accuracy of the new German 35mm camera, he ordered his first Leica — the model A with a fixed lens — in 1929. Undaunted by his early attempts, which were overexposed and overdeveloped, Davis developed an infectious enthusiasm for the Leica. His salon prints (pages 265, 266) proudly bore the neatly printed label: "Bromide enlargement from Leica negative." He also was one of the first Canadians to put the Leica to commercial use, photographing everything from flower pots to foundry operations for the blotting pads and calendars of his printing business clientele.[49]

The miniature camera liberated amateur photography by simplifying the work, thereby attracting thousands unwilling to face larger and more complicated apparatus.[50] Because of the independence of the miniature camera worker, the camera club began to lose its position as the bastion of pictorial photography. In 1938, the Toronto Camera Club's annual Spring Salon was widened from a showing by members only to a Toronto and District Exhibition:

With the almost universal use of the miniature camera, many workers have their own equipment, and many do not find the necessity for joining clubs, so that if a local Salon is to show the best in that district, it cannot well be confined to the work of a Camera Club alone.[51]

Leonard Davis

The Enthusiast 1934 Bromide 19.8 x 27 cm *PAC, PA-126652*

But this ease of operation also contributed to a snapshooting tendency among pictorialists who, in turn, were criticized for giving insufficient thought to composition before making an exposure. At a meeting of the Toronto Camera Club, J.W. Beatty, R.C.A., O.S.A., stressed that only a fraction of a second was required to make an exposure — but that to compose the subject might well take hours.[52] Though styles and technology had evolved, the advice remained unchanged: successful pictorial composition was achieved through careful planning. Whether striving for atmospheric effects or sharp detail, the photographer should have a clear idea of the desired result and a thorough knowledge of the equipment, films, processes and papers that would produce it.

In various articles Harold Kells, too, contended that a photographic work of art was a preconceived idea and had to have a purpose. He emphasized that every compositional element must contribute to the unity of the underlying structural pattern.[53] Kells claimed that technical data such as type of camera, focal length of lens, length of exposure, type of developer, etc., were of little value unless "supported by the more important information comprising a description of the conception and an analysis of the composition."[54] Referring to his famous *Soul of the Dance* (page 254), Kells described

John Morris

110 Ferry Fares [c. 1935] Bromide 24.3 x 18.9 cm *PAC, PA-138563*

in detail the evolution of the print from an idea, through its transformation into a sketch, to the execution of the final product, including both artistic and technical problems. It was left to the reader to decide whether he had achieved his artistic intentions.

Kells' articles were one element of the debate over photography-as-art that had been raging with varying intensity for almost a century. During the thirties, the issue was argued on the pages of the British and American photography journals, and spilled over to the meetings and newsletters of camera clubs in Canada. Local artists fuelled the fire with lectures on composition, and photographers were occasionally compelled to defend their artistic endeavours. But if some pictorialists actively engaged in the debate, others dismissed the issue entirely. W.H. Hammond, a leading member and past president of the Toronto Camera Club, summed up the feeling of many Canadian photographers when he wrote: " 'Who gives a d- - -' whether photography is an art or a craft, and whether we be artists or craftsmen; does it really matter?"[55]

Debate aside, pictorialism continued to be a meeting ground for the photographer and the artist. Internationally known painter, etcher and woodblock printer Leonard Hutchinson was an honorary member of the Hamilton Camera Club and an active participant in the activities of the Toronto Camera Club. Introduced to photography by Leonard Davis, he regularly attended the meetings of the Hamilton group, acting as art critic and teacher, explaining the theory of composition, encouraging pictorial work and suggesting technical improvements. Hutchinson pursued his own photography, often using it as a means for studying human motion for his wood-cuts, and even exhibiting his own prints in the photographic salons. He was one among many accomplished artists active in sufficient numbers in the photographic community to imply a certain level of artistic ambition among Canadian pictorialists.[56]

The serious amateur benefited also from contact with the professional. Some professionals gave lectures; others organized, juried or reviewed salons; many belonged to camera clubs. After locking their studios, they turned to hand-held cameras as a welcome change from portrait or commercial work. Their salon prints were lovingly composed, exposed and printed to satisfy their own creative urges, not the demands of a paying clientele. Few Canadian amateurs did not know the names of Charles Aylett (Toronto), Yousuf Karsh (Ottawa), Wallace Macaskill (Halifax) and John Vanderpant (Vancouver). Harold Kells' salon photography differed substantially, in content as well as in style, from his commercial work. Similarly, Alfred Brigden's job in the photographic department of Engravers and Electrotypers Ltd., Toronto, was not representative of his salon submissions like The Alchemist. Their careers in professional photography developed out of their initial involvement with camera clubs or artistic photography as amateurs. Conversely, some ardent amateurs found uses for their hobby in their work-a-day lives and, in turn, found new subjects for their pictorial efforts. Grant Gates took photographs in and around the steel-making operations at Stelco for his work in the engineering department, but Light on Industry (page 268) and other shots were taken for pictorial, not documentary, purposes.

HELDERS ON ART

Subject matter has little or nothing to do with art. It is the essence that counts — the reflection of the artist's soul. There can be more art in the 'shooting' of a dust-pail than in the setting of a sun. It all depends on what the man himself makes of it. Sentimentality is not art; it is the misunderstanding of it. ("How I make my Exhibition Pictures. No. XCV. Mr. Johan Helders," The Amateur Photographer and Cinematographer, 21 October 1931; 385.)

In 1939 photographer-critic Stanley
Harrod claimed, "As a country we
have produced very few really
good snowscapes." A review of
the work of Canada's leading
pictorialists, most notably Alfred
Brigden, Johan Helders, Bruce
Metcalfe and Alfred Upton,
contradicts Harrod's assertion.
However, one cannot suppress a
wry smile upon reading the excuse
Harrod offers: ". . . in nine cases
out of ten [our snow] is powdery
and very dry, and usually when it
snows there is a high wind, which,
of course blows it off the trees as
quickly as it falls;When we
do get wet snow which sticks to
the trees we nearly always have
dull, gloomy skies so that the snow
lacks sparkle and is equally unfit
for picture purposes, so it will be
seen that we are not altogether to
blame for the small number of
snowscapes that we produce."
(Stanley Harrod, F.R.P.S.,
"Canadian Letter," The Gallery,
7,3, March 1939; 47.)

Many fruitful associations developed between amateur and professional. Johan Helders, Canada's leading pictorialist of the late twenties and early thirties, readily admitted that, under John Vanderpant's influence and friendship, his photography "improved very much."[57] Later, in Ottawa, Helders enjoyed a close association with the emerging photographic giant, Yousuf Karsh, who exhibited a study of Helders at the 1938 Toronto Salon.

Amateur photography in Canada continued to be affected by "our neighbourly contact with the United States, its photographic press, salons and camera club activities."[58] Despite occasional criticism of this influence, no one could deny its strong, often beneficial effects. If the critics were sometimes divided over the trends in pictorial photography, they were universally agreed upon the impediments to its progress in Canada. Simply, there were too few workers, too few camera clubs and too few salons — all too far apart. But, as the thirties progressed, and paucity gave way to plenty, "vastness" remained the lament. The embryonic photographic community suffered from the typically Canadian problem of poor communication in a large and sparsely populated country — one critic pointed out that Macaskill and Vanderpant lived 3000 miles apart.[59]

The problem of "vastness" also raised questions of aesthetics about the portrayal of the Canadian landscape, and elicited obvious comparisons with the Group of Seven. Everyone seemed to agree that there was no Canadian school of photography and that there should be one. In an effort to explain why Canadians had failed to develop a style of their own, Stanley Harrod cast his net wide, variously blaming the photographers themselves, the juries of selection, the land itself, and even the quality of snow.[60] One critic claimed that Canada's vastness was "difficult to depict or to confine within the small borders of a photographic print."[61] The next declared that "our rugged landscapes, brilliant atmosphere and the sharp divisions of our seasons"[62] offered Canadian pictorialists unparalleled opportunities. Echoing Harold Mortimer-Lamb,[63] Harrod concluded that there would be no Canadian photographic vision to compare with the success of the Group of Seven "until some genius among us shall arise to whom the land is his very being."[64]

In 1931, Clifford Johnston confessed his desire to produce such a nationalistic vision, but admitted that there were practical draw-backs:

If I have an ambition it is to be able to interpret in monochrome, as our artists are doing in colour, the spirit of this country of ours. But the most symbolic themes — the great forests, the hills, the vast silent places — are inaccessible to me.[65]

Johnston's love of landscape, architecture and marine subjects (pages 221, 244,245), combined with his command of composition and process, brought him close to achieving his ambition. Yet, on the whole, Canadians were accused of being "content to portray household pets, still-life and genre subjects."[66] Bruce Metcalfe wrote in Photograms of the Year 1933 that, with the exception of the occasional brilliant individual, Canadian workers were "rather colourless, and possess neither the brilliance and virility of the best Americans, nor the mature thoroughness of the British."[67] Four years later, Johnston suggested that, rather, Canadian pictorialism was a fusion of view-

D.G. McLeod

Wintry Farmlands [c. 1939] Bromide 24.7 x 29.8 cm *PAC, PA-125744*

points which incorporated an inherent British tradition and a neighbourly American influence.[68] If their interpretations differed, their argument was the same: Canadian pictorialists had not yet developed a distinctive style in photography.

The onset of the Second World War brought retrenchment. Salons and competitions, especially in Great Britain and Europe, but including the Seventh Canadian International sponsored by the National Gallery, were cancelled or postponed. Camera sales declined and the flow of German precision equipment was halted. Shortages of paper, and problems of block-making and transport, caused many periodicals to cease or suspend publication.[69] Camera clubs survived, but the number of salon exhibitors declined sharply.[70]

The international conflict that ushered in the forties drew to a close this decade of growth and change. For the Canadian pictorialist, it marked the end of an era, but for the snapshooting amateur, a new beginning.

References

CHAPTER ONE

1. Public Archives Canada (PAC), MG 24, I117 (Microfilm Reel M-788) Pierre-Gustave-Gaspard Joly de Lotbinière, ''13,'' 14-15. See also Hazen Sise ''The Seigneur of Lotbinière — His 'Excursions daguerriennes','' *Canadian Art*, vol. IX (October, 1951), 6-9.

2. PAC, *ibid*., 12-13.

3. Hazen Sise quotes from a catalogue by André Jammes of Paris, '' 'The architect Horeau attempted to reconstruct in one vast panorama the ancient Egyptian monuments To this end he used daguerreotypes brought by Joly de Lotbinière.' '' Hazen Sise to Edmond Joly de Lotbinière, 14 May 1971.

4. University of Toronto Archives, Sir Daniel Wilson Diaries (edited by H.H. Langton), 25 November 1853.

5. Reference was made to Irving's lecture in *The Globe* (Toronto), 5 April 1853, 2, col. 5.

6. H.J. Cundall letterbooks, 9 July 1859, in the Public Archives of Prince Edward Island. I am grateful to Theresa Rowat for access to her unpublished manuscript *Photography on Prince Edward Island, 1839-1873* for the information on Cundall.

7. See Stanley G. Triggs, ''Alexander Henderson: Nineteenth Century Landscape Photographer,'' *Archivaria*, No. 5 (Winter 1977-78), 45-49. Triggs has expanded on this article in a forthcoming book on Henderson to be published by Coach House Press, Toronto. Dennis Reid, ''*Our Own Country Canada*''. *Being an Account of the National Aspirations of the Principal Landscape Artists in Montreal and Toronto 1860-1890*, (Ottawa: National Gallery of Canada, 1979), 56-62, 159-164, places Henderson in the context of the Montreal artistic community.

8. In a letter to *The Photographic News*, 21 October 1859, 82-83, Henderson commented: ''. . . about two years ago a circumstance occurred to me, which astonished me at the time (I was then a beginner)'' It is unlikely, therefore, that he began photographing before 1855 and more likely in 1856 or 1857.

9. *Ibid*., 9 September 1859.

10. *Ibid*., 21 October 1859, 82-83.

11. *British Journal of Photography*. 21 August 1874, 1.

12. Henderson was an acquaintance of William Notman whose studio was a gathering place for Montreal artists. In 1865 the Art Union of Montreal offered two Henderson prints to each new subscriber, indicating that he had an established position in the artistic community. Reid, *Our Own Country Canada*, 108.

13. *Ibid*., 57.

14. Provincial Archives of British Columbia (PABC), Francis G. Claudet Papers, AE C57 C57, Claudet to Mary Claudet, 20 June 1860.

15. *Ibid*., 4 August 1860.

16. *Ibid*., 27 January 1861.

17. W. Driscoll Gosset and J. Vernon Seddall, *Industrial Exhibition. Circular Respectfully Addressed to the Inhabitants of British Columbia*. (New Westminster, 1861), 18-19.

18. Sophia Cracroft, the niece of Lady Jane Franklin, wrote that on 13 March 1861, Claudet called on them in New Westminster bringing a set of views of the town. Some of these doubtless formed part of his contribution to the London Exhibition. Dorothy Blakey Smith (ed.), *Lady Franklin Visits the Pacific Northwest: Being Extracts from the Letters of Miss Sophia Cracroft, Sir John Franklin's Niece, February to April 1861 and April to July 1870*, Provincial Archives of British Columbia Memoir No. XI, (Victoria: Provincial Archives of British Columbia, 1974), 68.

19. H.G. Deignan, ''HBC and the Smithsonian,'' *The Beaver*, June 1947, 5-6.

20. Sandford Fleming, *Letter to the Secretary of State, Canada, in Reference to the Report of the Canadian Pacific Railway Royal Commission*, (Ottawa: MacLean, Roger & Co., 1882), 23.

21. For a discussion of Horetzky's career with the Railway Survey see Andrew Birrell, ''Fortunes of a Misfit; Charles Horetzky,'' *Alberta Historical Review*, Winter 1971, 9-25.

22. James L. Cotter, ''The Eskimos of Eastmain,'' *The Beaver*, December 1929, 301-306; March 1930, 362-365. For a reminiscence of Cotter by his son, see H.M.S. Cotter, ''Chief Factor and Photographer,'' *The Beaver*, December 1933, 23-26, 66.

23. H.M.S. Cotter, *ibid*., 24-25.

24. Malloch's letters were published in several newspapers, apparently appearing first in the *Ottawa Times*. See the *Times*, 24 October 1870, 2; 29 December 1870, 2; 4 January 1871, 2; 18 January 1871, 1.

25. Provincial Archives of Manitoba, Hudson's Bay Company Archives, B 135/6/55, 48, Charles Horetzky to W.G. Smith, 12 February, 1868. In this letter, Horetzky not only orders photographic equipment and chemicals for McTavish, he mentions that Mr. Anderson also orders material from the same supplier.

26. *The Philadelphia Photographer*, October 1885, 337-338. The next issue added, ''When the mania for photography takes possession of a man it is said to exceed the passion for French cookery. The camera is as constant a companion as tobacco to a smoker.'' November 1885, 366. The *New York Times* article appeared 20 August 1884, and is cited in William Welling, *Photography in America. The formative years 1839-1900*, (New York: Thomas Y. Crowell Company, 1978), 291.

27. Anon., ''Life in the Old West: Boorne and May 1886-1889,'' *Farm and Ranch Review*, October 1960, 18-19; December 1960, 16-17.

CHAPTER TWO

1. ''Photographs Taken Under Fire,'' *The Canadian Militia Gazette*, Vol. 1, No. 32 (15 December 1885), 252.

2. Woodside's 3,042 negatives and 5,004 prints are part of the National Photography Collection, Public Archives Canada.

3. See ''The History of Kodak Canada Ltd.,'' *Photographic Canadiana*, Vol. 6, No. 2 (July/August 1980), 4-7.

4. *Quebec Morning Chronicle*, 1 December 1892, 2; 2 December 1892, 2; 7 December 1892, 4.

5. See *Cherrier's Quebec City Directory 1885-1886* (Quebec, 1885), 43, for a list of the Association's officers. The president, Charles Hethrington, may be the same person who later moved to the United States and became active in the affairs of the Professional Photographers of America.

6. *Quebec Morning Chronicle*, 10 February 1887, 1.

7. *The Gazette* (Montreal), 8 December 1887, 3.

8. *Canadian Photographic Standard*, Vol. 7, No. 5 (May 1899), 639.

9. *Annual Report of the Canadian Institute, Session 1888-1889* (Toronto, 1889), viii.

10. *The Photographic Times and American Photographer*, Vol. 18 (6 April 1888), 167.

11. The Public Archives Canada holds the papers of the Toronto Camera Club. Because of their voluminous nature, it is possible to describe the history of the Club in detail, an undertaking beyond the scope of the present work.
 The minor clubs in Ontario who looked to the T.C.C. for inspiration and advice included the St. Catharines Camera Club, the Upper Canada College Camera Club, the Owen Sound Camera Club, the Collingwood Camera Club, and the Lindsay Camera Club. The activities of both the London Camera Club and the Galt Camera Club remain obscure.

12. *Journal and Proceedings of the Hamilton Association for Session of 1891-92* (Hamilton, 1892), 195.

13. *Ottawa Evening Journal*, 11 December 1894, 1.

14. *Manitoba Daily Free Press*, 5 December 1892, 8.

15. *Saint John Globe*, 11 January 1896, 2.

16. *Halifax Herald*, 20 March 1896, 8.

17. *Photographic Times: An Illustrated Monthly Magazine Devoted to the Interests of Artistic and Scientific Photography*, Vol. 28 (August 1896), 397.

18. *Vancouver Daily World*, 8 January 1897, 8. The Club claimed incorrectly to be ''the first Camera Club started in British Columbia;'' the first club in the province had in fact been established in Vancouver during March 1895 (q.v. *Vancouver News-Advertiser*, 14 March 1895, 8; 21 March 1895, 8). I would like to thank Mr. David Mattison of Victoria, B.C. for drawing the Club's activities to my attention.

19. *The Photographic Times and American Photographer*, Vol. 23 (27 January 1893), 45.

20. *Canadian Photographic Standard*, Vol. 7, No. 10 (October 1899), 766. Perhaps the social attractions outweighed the other reasons for joining a camera club. Based on an examination of club membership records and on contacts with the descendants of the amateurs of the era, the author has the impression that there was a fairly constant turnover rate and that many amateurs, in later life, completely gave up photography.

21. They included Miss M.E. Baylis, Miss Carrie M. Derick, Miss E. Laing, Miss Redpath, Miss. Anson McKim and Mrs. A. Dunbar Taylor of the Montreal Camera Club; Miss Heneker of Sherbrooke, Que.; Miss Louise Murray and Miss A. Woodburn of the Saint John Camera Club; Miss May Ballantyne, Miss Marion Whyte, Miss L. Millen, Miss Jennie Mather, and Miss Rothwell of the Ottawa Camera Club; Mrs. Eliza K. Macfie of London, Ont.; Mrs. R.E. Carr, Mrs. J.H.D. Munson and Mrs. Allan Sutherland of the Winnipeg Camera Club; and Mrs. Mattie Gunterman of Thompson's Landing, B.C.

22. *Ottawa Evening Journal*, 28 February 1896, 1.

23. ''The Winnipeg Camera Club,'' *The Great West Magazine*, Vol. XIII (New Series), No. 1 (September 1898), 4.

24. The *Saint John Globe*, 19 May 1896, 1, reported that Count Robert Visart de Bury et de Bocarme, Belgian Consul at Saint John and a member of the Saint John Camera Club, had

presented an "interesting paper on Colour Photography" at the Club's meeting on the previous evening. This is one of the earliest references to indicate an interest in the subject by Canadian amateurs.

25. *The Canadian Photographic Journal*, Vol. II, No. 3 (March 1893), 30.

26. *American Amateur Photographer*, Vol. 4 (1892), 316.

27. *The Canadian Photographic Journal*, Vol. II, No. 1 (January 1893), 286.

28. *Anthony's Photographic Bulletin*, Vol. XXIX (1898), 30.

29. *Dominion Illustrated*, Vol. 1, No. 11 (15 September 1888), 162. The magazine published photographs by amateurs Leonard Allison of Sussex, N.B.; James Peters and William Imlah of Quebec City; Frederick Minden Cole, J. Rawson Gardiner, Albert Holden, E.F. Kerr and George Lighthall of Montreal; William W. Fox, Roderick Matheson, Hugh Neilson and E. Havelock Walsh of Toronto; and John Scougall of Kincardine, Ont. The subjects included Allison's *View of Bishop's Rock, Grand Manan, N.B.*, Imlah's *The Natural Steps, Montmorenci River, near Quebec*, and Walsh's *On Dufferin Lake, near Orangeville, Ont.*

30. *The Toronto Saturday Night*, Vol. VII (22 September 1894), 6.

31. Examples of genre included George Valleau's *Five O'Clock Tea* (*Massey's Magazine*, June 1897, 427), James Wilson's *Evangeline*, and John J. Woolnough's series *The Course of True Love Never Did Run Smooth* (*ibid.*, March 1897, 176-177). Both Walter Massey and Walter Selden, a Massey family employee, were keen amateur photographers who belonged to the Toronto Camera Club at this time. Walter Massey presented a lecture on "The Development of Photographic Art" at a meeting of the club on 6 February 1893.

32. *Ottawa Evening Journal*, 28 February 1896, 1.

33. The prize awarded by *The Canadian Photographic Journal*, Vol. III, No. 5 (May 1894), 194 for photographs of "Pretty Children, Gracefully Posed" represents the ultimate form of over-categorization.

34. *The Canadian Photographic Journal*, Vol. II, No. 12 (December 1893), 412.

35. Letter from George Eastman to Myron G. Peck, 19 January 1892, cited in Beaumont Newhall, *The History of Photography* (New York, 1964), 94.

36. Helmut Gernsheim, *Creative Photography: Aesthetic Trends 1839-1960* (New York, 1974), 116.

37. *The Photographic Times and American Photographer*, Vol. 24 (9 March 1894), 148. The text of the article makes clear that the source of the criticism was likely Alfred Steiglitz, who was disgruntled because his genre photograph *Weary* received only a third prize from the T.C.C.

38. See for example the review of George Valleau's *At Eventide* in H.

Snowden Ward and Catharine Weed Ward, eds., *Photograms of the Year 1899* (London, 1899), 75.

39. "The Winnipeg Camera Club," *The Great West Magazine*, Vol. XIII (New Series), No. 1 (September 1898), 6.

40. H. Snowden Ward and Catharine Weed Ward, eds., *Photograms of the Year 1899* (London, 1899), 73-74.

CHAPTER THREE

1. It should perhaps be noted that the debate over photography as art had been born virtually at the moment of photography's public beginnings in 1839 and had recurred in various manifestations throughout the 19th century. The most recent debate before pictorialism, and leading to it, had centred around Henry Peach Robinson, ultimately a founder member of the Linked Ring, and Peter Henry Emerson, who had himself once espoused the artistry of photography.

2. Oliver, Maude S.G. "The Photo-Secession in America," *American Photography*, October 1907, 180-185 and Newhall, B., *The History of Photography*, 106.

3. *American Amateur Photographer*, May 1903, 213, reports that Loan Collections of prints from the Photo-Secession had been sent "within the past few weeks" to be exhibited in Germany, Russia, France, several places in the United States, and Toronto, Canada.

4. The date seems to have been added to the reverse of the photograph subsequent to the actual printing of the image, possibly as recently as 1971 at the time of the retrospective exhibition of the works of the Ottawa Camera Club members at the Public Archives Canada.

5. Unidentified newsclipping: "Camera Club Exhibition," Toronto Camera Club papers, Public Archives Canada, MG 28, I 181, vol. 5.

6. Greene, J.E. "The Toronto Camera Club's Eleventh Annual Exhibition," *Professional and Amateur Photographer*, 1902, 176-82.

7. *Ibid.*, 180.

8. H. Mortimer-Lamb compared it, in *Photograms of the Year 1906*, to Mrs. Gertrude Käsebier's productions, which Goss would indeed have seen at the Toronto Camera Club's 1903 exhibition. But Lamb arrived at the surprisingly unlikely assessment that the cut-off of the adult figure was largely a technical expedient to allow concentration on the child.

9. Another separate category in exhibitions of the early 1900s had been enlargements. Of the Toronto Camera Club's 496 exhibits in 1901, 72 were enlargements and 43 were "hand camera work," (*American Amateur Photographer*, January 1901, 39-40). However as camera clubs improved their enlarging equipment and the technique became more common, this separation from contact printing was less often used.

10. *American Amateur Photographer*, June 1903, 272.

11. Among the most prominent were *Photograms of the Year*, *Amateur Photographer and Photographic News* and *American Amateur Photographer*. The Toronto Camera Club subscribed to these, as well as to at least twenty-four others intermittently throughout this period.

12. Despite the prestige of this involvement, the Toronto Camera Club reduced its membership in the Federation from "salon" to "ordinary" in August 1904, due to straitened finances resulting from the club's move to "more commodious and fitting" new quarters, from the Forum Building on Yonge Street to the Bank of Hamilton building, corner of Yonge and Gould Streets. On 13 September 1906, on a motion by Sidney Carter, seconded by A.S. Goss, the club decided to resign from the Federation altogether.

13. Letter to Alfred Stieglitz from Sidney Carter, January 22, 1906. Collection of American Literature, the Beinecke Rare Book and Manuscript Library, Yale University, U.S.A. There is a noteworthy parallel here with the experience of James Abbott McNeill Whistler in England. In 1886 he became President of the Society of British Artists. He encountered the fury of the members in renovating the exhibition which was promptly criticized for leaving the walls "more than half-uncovered." The retort was that "empty space [was] preferable to poor pictures." An influence from Whistler, fin-de-siècle aestheticism, and symbolism is visible in the style of the pictorialists as well as in their method of exhibition.

14. H. Mortimer-Lamb (who quotes S. Carter) "Pictorial Photography in Canada," *Photograms of the Year 1906*, 10-12.

15. Rex Stovel, "The Toronto Camera Club Exhibition," *American Amateur Photographer*, June 1906, 196-97.

16. Kate Greenaway (1846-1901) was an English artist who enjoyed massive commercial success for her charming illustrations of numerous children's books, as well as for her Christmas card and Valentine designs. She worked for the *Graphic* and the *Illustrated London News*, honing a talent for anecdotal scenes. Ultimately, her work was copied on glass, crockery, fabrics, stationery and many other products, making her style one of the most widely recognizable in the 19th and early 20th centuries. It permeated society to such a degree as to become idiomatic on almost a folk level.

Myles Birket Foster (1825-1899) enjoyed an immense success by exploiting a formula of picturesque composition. His early education was in engraving, from which he progressed to drawing for *Punch* and the *Illustrated London News*. He too was a book illustrator, but by 1859 he moved into painting and made rustic English cottage scenery his special domain. Sweetness,

daintiness, and attention to detail were the hallmarks of his popular style, along with a heavy reliance on traditional and repetitive compositional forms.

17. Frank R. Fraprie, who is quoting the art critic of the Boston *Transcript*, "The Kodak Exhibition," *American Amateur Photographer*, November 1906, 529-32.

18. A. Dickson Patterson, a well-known Toronto illustrator of books who used his own photos of western Canada in his work *The Quiver* of 1889, criticized Toronto Camera Club members' slides "from an artist's point of view." Undoubtedly his own picturesque style would have coloured his judgements. Artist members of the Toronto Camera Club included Noah H. Ramer and the self-taught E.B. Shuttleworth of the Ontario School of Art, as well as the architect Frank Darling, who exhibited six photographs in 1902. John Home Cameron, an artist who lectured to the TCC in 1902 on the Pre-Raphaelites was voted an Honorary Member in 1903. The Club also listened to two lectures on "composition" in 1903 and 1904 given by John D. Kelly, O.S.A., and made C.M. Manly, A.R.C.A. and President of the Ontario Society of Artists, a judge for their salons and an Honorary Member of the Club.

19. Interestingly, professional photographers occasionally joined amateur clubs. Louis Mendel for example joined the Peterborough Camera Club and Eldridge Stanton was an honorary member of the Toronto Camera Club whose print competitions he often judged. A number of photo suppliers also joined the clubs, combining business with pleasure.

20. "American Lantern Slide Interchange," *American Amateur Photographer*, June 1901, 283.

21. Yet the later Photo-Club of Canada may have been another of its manifestations. This is suggested by Carter's own rather confusing remarks in *Photograms of the Year 1908* (99-80): "A few years ago Mr. Mortimer Lamb, . . . hinted at the possibility of forming a society of the more advanced camera workers in CanadaThe idea was quickly taken up in Toronto . . . and the Photo-Club of Canada came into existence. It was only in this last year that anything of a concrete nature was accomplished under its auspices, when it gave an Exhibition in December at the Galleries of the Art Association of Montreal on the invitation of that body." Carter also offers a kind of apologia in stressing the difficulty of keeping up a national club over Canada's vast distances, a plaint which is repeated often by Canadian photographers.

22. They were the Toronto Canoe Club Camera Club, the Toronto School of Science Camera Club, the Toronto Y.M.C.A. (Central) Camera Club and the Eatonia Camera Club, all first mentioned in the *British Journal of Photography Almanac* of 1909. Of minor interest is the Upper Canada

College Camera Club which existed throughout this period 1900-1914.

23. *Amateur Photographer and Photographic News*, 1914, 479.

24. Sidney Carter, "Pictorial Work in Canada," *Photograms of the Year 1907*, 80.

25. Letter to Alfred Stieglitz from Sidney Carter, November 26, 1907, in Collection of American Literature, the Beinecke Rare Book and Manuscript Library, Yale University, U.S.A.

26. Compare this version of events with Carter's published remarks in previous footnote, #21.

27. "Pictorial Photography Exhibition," Montreal *Star*, Nov. 23, 1907, 5, col. 2-3.

28. However it should be noted that Carter wrote "about thirty of those in the catalogue [went] unhung — they were mostly Canadians (my own among others)," letter to Alfred Stieglitz, November 26, 1907. The Carter article in *Photograms of the Year 1908*, 80, says 277 prints were shown; but that is the number in the catalogue. Hence it seems most likely that only about 247 were exhibited.

29. A seaside photo by Dow appears in the *Professional and Amateur Photographer*, 1900, 238, and Russell exhibited a "collection of amateur photographs" at the Vancouver Arts and Crafts Association exhibition in 1900.

30. "Pictorial Photography in Canada," *Photograms of the Year 1905*, 86.

31. It is assumed by this author that Mrs. Dunbar Taylor, first noticed in Montreal, and Mrs. Isabel C. Taylor of Vancouver, B.C., who showed again in the Third Salon of the Toronto Camera Club in 1905, are likely the same person.

32. J.E. Greene, *op. cit.*, 177. There is also a remark that she had shown at the Philadelphia Salon.

33. Interestingly, all three of these men were scientists. The careers of Plaskett and Saunders are mentioned elsewhere. Shutt was Dominion Chemist at the Experimental Farm in Ottawa.

34. The 1898 date comes from the *American Annual of Photography and Photographic Times Almanac for 1902*, (New York, 1901), 341. The 1902 date is given by the same source for 1913, published 1912, 328. The annual persists with this founding date until at least 1914.

35. The others were D. Macquarrie, curator of the Winnipeg Civic Art Gallery where the shows were held, and C.F. Ford, late secretary of the Plymouth (England) Photographic Society.

36. Letter from Sidney Carter to Alfred Stieglitz, September 8, 1928, Collection of America Literature, Beinecke Rare Book and Manuscript Library, Yale University, U.S.A.

37. He was one of the first to support the Group of Seven and, after his "retirement" to the West Coast about 1920, also the very first to recognize Emily Carr's talent and to attempt to draw it to national attention. (See: Maria Tippett, "Who discovered Emily Carr," *Journal of Canadian Art History*, Vol. 1, No. 2, Fall 1974, 30-35).

38. Mortimer-Lamb is himself proof of this. In 1926 he participated in an exhibition with the aspiring professional J. Vanderpant, to mark the opening of their partnership and studio in Vancouver. As had been the alliance with Carter, this partnership lasted only about one year.

39. Of the twelve Canadians known to have been RPS members between 1900-1914 only Mortimer-Lamb and Nichol Elliott have been connected with the pictorial movement. The twelve, with their dates of election, are: R.J. Buchanan, Hamilton (1907); Lieut.-Col. J.H. Burland, Montreal (1905); Ernest K. Gripps, Sault Ste Marie (1912); Nichol Elliott, Toronto (1915); R. Laidlaw, Hamilton (a Fellow, 1907); A. Moos, Toronto (before 1913?); Charles Morris-White, Wetaskiwin, Alta. (1910); Harold Mortimer-Lamb, Montreal (1910, Hon. Fellow 1938); F.J. Spielmann, Montreal (1902); Egbert Louis Tom Taylor, Victoria, B.C. (1914?); L. Avory White, New Westminster, B.C. (1905); R. Norris Wolfenden, M.D., Grimsby, Ont. (1897, a Fellow 1899).

The Royal Photographic Society did indeed have an interest in pictorial work but as one style among many; it gave much pride of place to technical work as well.

40. Hamilton, R. *American Amateur Photographer*, August 1902, 342.

41. Chalmers, J.P. "Success with the Hand Camera," *American Amateur Photographer*, May 1901, 195.

42. Harry Gordon Wilson, who photographed landscape and instantaneous views in Quebec, admitted using a 3/A Kodak with roll film on a small metal tripod in: "Plates or Films," *American Annual of Photography 1913*, (New York, 1912), 202. Wilson even believed in the moral virtue that a Kodak could instill in children "teaching the child the love of the beautiful, educating the eye . . . to be able to see things that the ordinary person would pass by" ("The child and the Kodak," *American Annual of Photography 1914*, (New York, 1913), 252-54).

43. Mortimer-Lamb won 22nd prize in the "N.C. Film — Class A" category and 10th prize in the "Kodoid Plate — Class A" category, while Carter won 16th prize in the "Kodoid Plate — Class A" category. Kodak's plans in Canada after their entry in 1899 included the announcement of an upcoming new factory in Toronto in 1909 and the purchase of land near Toronto for a "possible factory" in 1914.

44. Letter from Henrietta Constantine to E. Deville, from Great Slave Lake, Alberta, 27 March 1907, Public Archives Canada, Federal Archives Division, RG 15, C 2, file 1667.

45. A party he accompanied to Labrador in 1905, led by Dr. E.E. King, Chief Astronomer, which intended to record an eclipse of the sun, took five large and specialized cameras among other equipment to accomplish that purpose. Could these scientists be said to be "professional" photographers? They had not after all chosen photography as their careers.

46. Among the most prominent dailies using photos were the *Star, News, Globe, Mail-Empire,* and *World* in Toronto and the *Star Herald, La Presse,* and *Gazette* in Montreal. The weekly *Standard* of Montreal, *Sunday World* of Toronto, the *Canadian Pictorial* and *Canadian Courier* were also heavily illustrated. All these papers and magazines were usually supplied by staff photographers or free-lance professionals such as the prolific R.R. Sallows of Goderich, Ontario, Pringle and Booth of Toronto, or an organization called the Canada Newspaper Syndicate Ltd., which seems to have provided photos of international interest.

47. *Canadian Pictorial*, October, 1906, 12. That magazine seems to have encouraged such children and dog pictures.

48. The *American Amateur Photographer*, May 1906, 149-50, recommends the 3-B Quick Focus Kodak for amateur newspaper work requiring speedy action photography.

49. "Success in Instantaneous Exposures," *American Amateur Photographer*, November 1906, 524. Another article, "Press Photography in Canada" by David J. Howell, (*British Journal of Photography*, April 2, 1909, 265) characterizes A.A. Gleason of Toronto as a "specialist in this line" who had obtained remarkable horse-race and footrace finishes. By this date Gleason may have made the transition from amateur to professional.

50. The photo represented a steamer named *Parisian* which had been rammed by another ship and raced back to Halifax to sink at the dock with nine hundred people on board.

51. "Press Photography for the Amateur," *American Photography*, Mar. 1909, 166-168.

52. Dr. Newton Albert Powell lectured on this use to the Toronto Camera Club in 1909.

53. Eminent hobbyists were found among medical doctors, chemists, engineers, naturalists and scientists of every kind, including for example Robert E: Young, Chief Geographer of Canada in 1910, Joseph Burr Tyrrell, geologist and member of Canadian Geological Surveys, Ernest Thompson Seton, naturalist, author and painter, and J.E. Keppy, President of the Toronto School of Science.

54. On February 17, 1902, he lectured at the Toronto Camera Club and on March 15, 1902 at the Canadian Institute. The latter body published his talk in *Transactions of the Canadian Institute*, Vol. VII, (Toronto, 1904), 371-190. However his interest in the physics of light must have dated from at least 1901 when he had presented a paper to the Institute called "Colour Values in Monochrome" on the problems of rendering the relative values of the spectrum on orthochromatic black and white plates.

55. *Photographic Times*, March 1901,104-107. Sanger Shepherd had been awarded the medal of the Royal Photographic Society in London for three-colour filters in 1899.

56. Three of Plaskett's three-colour slides formed part of the Toronto Camera Club's submission to the American Lantern Slide Interchange in 1902-03.

57. In the United States, a noted horticultural author and photographer, J. Horace McFarland, mistakenly supposed that it was he who made "the first exposure on this continent . . . on the wonderful Lumière Autochrome colorplate, November 15, 1907." ("My Photo Beginnings" by J. Horace McFarland, part of: "Extracts from the Postal Photographic Club's Experience Notebook," *American Photography*, October 1913, 574-576). Frank Fraprie reports ("Simple Colour Photography Achieved," *American Photography*, August 1907, 59-64) that the plates were still not commercially available in the United States by August, 1907. However a test sample had arrived by June, as C.H. Claudy of Washington stated (*Photographic Times*, 1908, 58) that his first efforts with the plates took place then.

58. *American Photography*, April 1908, 229.

CHAPTER FOUR

1. "Pictorial Photography in Canada," *Photograms of the Year 1915*, 21.

2. Brian Coe and Paul Gates, *The Snapshot Photograph: The Rise of Popular Photography 1888-1939*. (London, Ash and Grant, 1977), 34.

3. L.P. Clerc, *Photography Theory and Practice*, (D.A. Spencer, ed.), London and New York, Focal Press, 1970, Chapter XX, passim.

4. These improvements are noted from year to year in *Photograms of the Year*, "The Year's Work;" and in articles by Carroll Neblette in *The American Annual of Photography*, commencing in 1922.

5. The background of the current Camera Club of Ottawa is covered in the exhibition catalogue *75 Years of Photography*, Ottawa, 1971. It notes that the Photographic Art Club became much more open to new members by about 1922. The Toronto Camera Club, and doubtless other clubs, required nomination of new members, passage through a probationary period, and then final acceptance by the Board of Directors. This limited the size of the membership somewhat.

6. For example, the Ottawa Photographic Art Club, which limited its membership to twelve, included the

professional William James Topley. C.J. Duncan, member of several west coast clubs over the years, was a photographer with the RCAF. The Toronto Camera Club counted many professionals among its members, including such portrait photographers as Charles Aylett and Randolph MacDonald, who bought out Aylett's studio. Several amateurs, such as John Morris and Brodie Whitelaw, subsequently became professionals; but Otto Eaton, also of Toronto, first supplemented his income during the Depression by taking weddings and other similar work, and subsequently joined the Toronto Camera Club. Other professionals, like John Vanderpant of Vancouver, were instrumental in keeping the Salons — in his case, the New Westminster International — alive and in good health.

7. The Canada Life Camera Club was merged into the Toronto Camera Club in 1922 when it was discovered that most of its members belonged to both clubs.

8. The members of even a major club — again the TCC — might not have all the equipment one would have expected. In a report on the club carried in *Photo-Era*, March 1923, 127, M.O. Hammond wrote that ''There is a tendency to use small plates or films, and then enlarge these to the required size. Several members have an enlarging camera in their own homes . . .'' which would indicate that the majority did not. Several articles in *American Photography*, from about 1913-1922, had shown how to convert a camera into an enlarger.

9. It appears to have ceased existence during World War I.

10. The *British Journal of Photography Almanac* and the *American Annual of Photography* each had lists of clubs in Canada for part of this period. The *British Journal* list was not kept very up-to-date; for example, many lists of officers continue with the same names for several years after they are known from other sources to have changed. Thus this information is only of indicative and not factual value. The *American Annual* was more up-to-date but of course primarily interested in American clubs. On occasion it failed to mention any Canadian clubs.

11. 'A nos compatriotes de la langue française' in the catalogue of the third Montreal International Salon of Photographic Art, 13 May — 4 June 1944, Montreal.

12. This has changed radically. In 1981 there were 43 clubs, with over 3,000 members grouped in the Association québécoise des photographes amateurs. The organization's objectives were primarily the promotion of photography as a hobby or leisure-time activity. It published an information bulletin, and an annual review in which appeared works taken from the annual competition. *Perspectives*, vol. 23, no. 22, (30 mai 1981), 15.

13. J. Addison Reid, ''The Toronto Exhibition,'' *The Photographic Journal of America*, vol. 58, 1921, 418.

14. J.H. Mackay, ''Photography in Canada,'' *Photograms of the Year 1930*, 16.

15. J.H. Mackay, ''Photography in Canada,'' *Photograms of the Year 1924*, 15.

16. J.H. Mackay, ''Photography in Canada,'' *Photograms of the Year 1925*, 17.

17. H. Mortimer-Lamb, ''Pictorial Photography in Canada,'' *Photograms of the Year 1913*, 34.

18. A. Brooker Klugh, ''Landscape Photography in Canada,'' *Amateur Photographer & Photography*, 29 April 1925, 435.

19. He is here referring to the Group of Seven, the members of which he knew well through their common membership in the Toronto Arts and Letters Club.

20. Arthur S. Goss, ''Pictorial Photography in Canada,'' in *Photograms of the Year 1920*, 16.

21. Quoted in Charles C. Hill, *John Vanderpant, Photographer*. (Ottawa: National Museums of Canada, 1976), 19.

22. 'Onlooker,' ''The Pittsburgh Salon,'' *The Camera*, vol. 26, 1922, 257.

23. Arthur S. Goss, ''Pictorial Photography in Canada,'' in *Photograms of the Year 1921*, 24-25.

24. In seven articles he wrote a total of 40 published paragraphs; of these 37 were concerned with the Toronto Salon. In seven years he mentioned only four Canadian photographers by name, three of whom (Vanderpant of Vancouver, Keene of Oakville, and Aylett of Toronto) were professionals. Johan Helders, of Vancouver and Ottawa, was the only amateur named. H. Mortimer-Lamb, on the other hand, had given extensive coverage to the Canadian scene; and it was evident from his comments that he knew many of the photographers personally.

25. Dr. Tadeusz Cyprian, ''Suggested by Ottawa,'' *American Photography*, vol. 22, 1928, 666-668.

26. Beginning in the mid-1920s *Maclean's Magazine* carried the occasional snapshot — always a landscape or scenic — in its pages; by 1931 this had developed into a ''Canadian Snapshot Album'' which was published in an early summer issue devoted to travel and tourism in Canada, and which included the work of 29 different amateurs, including Edith Hallett Bethune.

27. Probably few Canadians entered these competitions, Bruce Metcalfe (pages 240-242) and Travers Sweatman being among the handful of names. Current Canadian library holdings of British amateur photography publications for the period 1914-1930 are meagre and imcomplete, especially when compared with holdings of American publications from the same period. As most existing library periodical runs of amateur photography magazines were the result of contemporary subscriptions rather than of retrospective collecting, it seems likely that American magazines played a greater role in Canada than did British. The British influence on Americans — especially in matters of pictorial photography — cannot however be discounted.

28. ''Round World Exchange Club,'' *American Photography*, 1914, 55.

29. Of all 48 prints from Canadian sources found in the London-based publication *Photograms of the Year* during 1914 to 1930, only two were of nudes. No nude by a Canadian was found in any other published sources — annual, magazine, exhibition catalogue or other printed source — for this same period. One member of the Toronto Camera Club, George Washington, was blackballed for having used the club rooms to make ''nude figures,'' as the Club minutes put it (PAC, MG 28 1181, vol. 1, minutes 20 September 1920, 135). This Canadian abhorrence of nudes is in stark contrast with the situation in Britain, the United States, and other countries. Forman Hanna, Arthur Kales, J. Pondelicek, J. Dritkol, and others seem to have specialized in nudes — and their cloying, artificial work was regularly published in the magazines and shown in the salons.

30. In the summer of 1931 the American photographer Edward Weston wrote John Vanderpant that ''I would have sent [the Vanderpant Galleries in Vancouver] a few nudes but feared postal regulations.'' Hill, *op. cit.*, 23.

31. Letter by Otto J. Eaton, Toronto Camera Club *Focus*, February 1980.

32. ''The Year's Work,'' *Photograms of the Year 1923*, 6.

CHAPTER FIVE

1. In the spring of 1936, more than 70 cameras, none taking pictures larger than 2¼'' square and not including all models of each one, were reviewed in the special miniature camera issue of *The Amateur Photographer*. Three years later, over two hundred miniature cameras, most of German origin, were classified and described (June 1939). The amateur was so seduced by this explosion of equipment that the President of the Toronto Camera Club was prompted to editorialize, ''Amongst photographers and would-be photographers of to-day [1938], there seems to be an ultra-modern craze to possess, at all costs, the very latest camera or gadget appearing on the market, or to own at least half a dozen assorted instruments.'' He encouraged camera enthusiasts to direct their energy toward producing pictures rather than acquiring equipment. (Norman P. Smith, ''The President's Corner,'' *Focus*, 8,6, (March 1938), 1.)

2. Brian Coe, *Cameras: From Daguerreotypes to Instant Pictures* (New York: Crown Publishers, Inc., 1978), 115-116. The reloadable cassettes pioneered by Leica were soon superseded by an expendable version developed by Kodak for the Retina.

3. F.J. Mortimer, ''The Year's Work,'' *Photograms of the Year 1932*, 4.

4. F.J. Mortimer, ''The Year's Work,'' *Photograms of the Year 1939*, 4.

5. C.M. Johnston, ''[Photography in] Canada,'' *Photograms of the Year 1938*, 19.

6. A two-page advertisement announcing the ''Kodak $100,000 Competition'' appeared in *Maclean's Magazine*, 1 May 1931, 44-45.

7. For example, in 1937, *Focus* boasted that an impressive array of publications was available in the Reading Room of the Toronto Camera Club, and that the Club's own newsletter was sent to nineteen clubs in Canada and another fifty in the United States. *Focus*, 7,4, (February 1937), 2.

8. To save postage, members of FotoForum, London, bundled their prints and forwarded them as a group, asking that salon organizers in Britain send the lot to the next salon, with the result that in at least one catalogue all FotoForum members were listed at the address of George Pearce.

9. The Toronto Camera Club also presented a Spring Salon open only to its members until 1938 when it began to accept work by all Toronto and district photographers.

10. According to the *Catalogue of the Arts* (Toronto: Canadian National Exhibition, 1934, 122), the Exhibition of the Royal Photographic Society was first and The Pittsburgh Salon was second. This was likely a bit of bragging, and did not correspond with the ranking of salons later prepared by *The American Annual of Photography*.

11. Letter, Harold F. Kells to the author, dated Ottawa, 27 February 1982.

12. *Catalogue*, Canadian International Salon of Photographic Art (Ottawa: The National Gallery of Canada, 1934), 3.

13. Paragraph 1, ''Conditions,'' *Entry Form*, Fifth Canadian International Salon of Photographic Art (NGC Correspondence file 5.5P: 5th Canadian International Salon of Photographic Art, 1938 - April 1939).

14. ''Canada's Third International Salon of Photographic Art is Now Open,'' *The Evening Citizen* (Ottawa), 26 October 1936, 20.

15. ''Foreword,'' *Catalogue*, Fourth Canadian International Salon of Photographic Art (Ottawa: The National Gallery of Canada, 1937), 3.

16. Leading Canadian pictorialist Frank Halliday of Calgary wrote to the Director of the National Gallery to express his concern that,

Cities like Calgary & others on the prairies would suffer. The National [Gallery's Canadian International] is the only showing of the world's outstanding prints that we get. During the week it is held at the Stampede here, thousands of people see it. It is quite the most popular show at the Exhibition. Since it has

been shown in Calgary, camera clubs have really got started on a firm foundation and personally I should hate to see the prime incentive to pictorial effort lessened by only having a viewing every two years.

(Letter, Frank A. Halliday to the Director, National Gallery of Canada, dated Calgary, 15 November 1937. NGC Correspondence file 5.5P: 4th Canadian International Salon of Photographic Art.)

Another Calgary photographer, Gordon M. Tranter, concurred that holding the Canadian International every two years would be "a most regrettable thing," and echoed Halliday's point that, for Calgary, it was the only opportunity of viewing an international show. (Letter, G.M. Tranter to Director, National Gallery, dated Calgary, 4 January 1937 [1938]. NGC Correspondence file 5.5P: 5th Canadian International Salon of Photographic Art, 1938- April 1939.)

17. A printed postcard with the announcement was sent by the Gallery (NGC Correspondence file 5.5P: 7th Canadian International Salon of Photographic Art).

18. Letter, H.O. McCurry, Director, National Gallery of Canada, to C.H. Weaver, President, The Camera Club of Ottawa, 14 November 1946 (NGC Correspondence file 5.5P: 7th Canadian International Salon of Photographic Art).

19. Clifford Johnston, "Photography in Canada," Photograms of the Year 1938, 19.

20. Focus, 4,8, (June 1934), 4.

21. Letter, The Camera Club of Ottawa to The Secretary, Camera Club of London, 2 October 1937 (NGC Correspondence file 5.5P: 4th Canadian International Salon of Photographic Art).

22. J.H. Mackay, "Photography in Canada," Photograms of the Year 1930, 16.

23. Frank R. Fraprie (Boston), "Photography in America," Photograms of the Year 1930, 14.

24. Letter, Stanley Harrod to D.H. Baker, Secretary, National Gallery of Canada, Ottawa, dated Toronto, 8 January 1939 (NGC Correspondence file 5.5P: 5th Canadian International Salon of Photographic Art, 1938- April 1939).

25. Stanley Harrod, "Canadian Letter," The Gallery, 7,3, (March 1939), 47.

26. Focus, 7,2, (December 1936), 3.

27. The American Annual of Photography, 1938, 294.

28. Letter to the Editor, H.G. Cox, "Among the Exhibitions," American Photography, XXXI, 2, (February 1937), 151.

29. Letter to the Editor, Franklin I. Jordan, "Competition in Pictorial Photography," American Photography, XXXI, 4, (April 1937), 302-303.

30. The American Annual of Photography, 1938, 294.

31. Modern Photography (London), 1934-35, 7.

32. C.J. Symes, "Some Comments on the Pictures Reproduced in this Volume," Photograms of the Year 1934-35, 6.

33. One writer went so far as to explain a modification of the gum bichromate process which used red corpuscles of human blood to take the place of carbon pigment. Better Photography, April 1939, 9.

34. Modern Photography (London), 1933-34, 14.

35. Stanley Harrod, "Canadian Letter," The Gallery, 6,10, (October 1938), 159.

36. F.J. Mortimer, "The Year's Work," Photograms of the Year 1937, 3.

37. Bruce Metcalfe, "Photography in Canada," Photograms of the Year 1932, 20.

38. "How I make my Exhibition Pictures. Methods and Ideals of well-known Pictorial Workers. C.M. Johnston (of Canada)," The Amateur Photographer and Cinematographer, 25 March 1931, 254.

39. "The President's Corner," Focus, 7,6, April 1937, 1.

40. Ibid.

41. "43rd Toronto Salon Reviewed by Stanley Harrod, F.R.P.S.," Focus, 4, 9-10, August - September 1934, 2.

42. South Wind was reproduced in American Photography, XXXIII, 7, (July 1939), 491 with commentary on 550. Another nude by Saunders, Figure Study, was hung at salons in Winnipeg and Medicine Hat in 1938, and at several camera clubs in the United States.

43. Leonard Davis recalls that he was chosen first President of the Hamilton Camera Club over one other candidate who intended to include nude modelling sessions in the Club's programme, an activity Davis and his supporters felt Hamilton citizens were not prepared to accept. Personal communication with the author, interview, Dwight, Ontario, 8 August 1982.

44. "At the Photographic Salon," Letter to the Editor, Citizen, Ottawa, dated 3 November 1936, published 4 November 1936.

45. "43rd Toronto Salon Reviewed by Stanley Harrod, F.R.P.S.," Focus, 4, 9-10, (August - September 1934), 4.

46. Draft reply (unsigned) to D. Ritchie, Kodak Heights Camera Club, dated Ottawa, 13 May 1938 (NGC Correspondence file 5.5P: Fifth Canadian International Salon of Photographic Art).

47. Personal communication with the author, letter, dated Ottawa, 27 February 1982, 4.

48. Focus, 7,2, (December 1936), 3.

49. Personal communication with the author, interview, Dwight, Ontario, 8 August 1982.

50. F.J. Mortimer, "The Year's Work," Photograms of the Year 1933, 3.

51. Stanley Harrod, "Canadian Letter," The Gallery, 6,4, (April 1938), 63.

52. Focus, 7,6, (April 1937), 4.

53. H.F. Kells, "The Science of Pictorial Composition," American Photography, XXVII, 10, (October 1933), 577-90.

54. H.F. Kells, "How It Was Done," Camera Craft, December 1934, 565.

55. Focus, 7,6, (April 1937), 1.

56. For example, J.W. Beatty, R.C.A., O.S.A., had been an honorary member of the Toronto club since the teens. As well, Owen Staples, G.A. Reid, Frederick S. Challener, F.S. Haines and C. Goldhamer were some of the artists who regularly delivered lectures on pictorial composition to the Toronto Camera Club and juried the annual Toronto salon. Leonard Hutchinson, A.R.C.A., helped select the winning prints for the Sixth Canadian International Salon in 1939 and in London, the artist Clare Bice was an active associate of the members of FotoForum.

57. "How I make my Exhibition Pictures. Methods and Ideals of well-known Pictorial Workers. Mr. Johan Helders," The Amateur Photographer and Cinematographer, 21 October 1931, 385.

58. C.M. Johnston, "Photography in Canada," Photograms of the Year 1937, 19.

59. Bruce Metcalfe, "Photography in Canada," Photograms of the Year 1933, 22.

60. Stanley Harrod, "Canadian Letter," The Gallery, 15 January 1938, 15-16; 15 September 1938, 121-122; March 1939, 46-47, passim.

61. Stanley Harrod, "Canadian Letter," The Gallery, 15 September 1938, 121.

62. From unidentified typescript page, in NGC Correspondence file 5.5P: 5th Canadian International Salon of Photographic Art, 1938 - April 1939. The one-paragraph critique, under the heading Fifth Salon, appears to be an excerpt from a review of the exhibition. Concern with a Canadian school of photography, often espoused by Stanley Harrod, became a popular issue with the success of the Group of Seven; however, nationalism of quite another sort was transposed from the political consciousness to the realm of international photography. Photograms of the Year 1938 noted, "the international crisis in the autumn . . . inevitably had an effect on every phase of photography." ("The Year's Work," [F.J. Mortimer], 6).

63. Harold Mortimer-Lamb, Photograms of the Year 1913, 34: "Yet to some man some day inspiration will come, and he will give expression to the spirit of our northern solitudes; but that is work for genius."

64. Stanley Harrod, "Canadian Letter," The Gallery, 15 September 1938, 122.

65. "How I make my Exhibition Pictures. Methods and Ideals of well-known Pictorial Workers. Mr. C.M. Johnston (of Canada)," The Amateur Photographer and Cinematographer, 25 March 1931, 254.

66. See footnote/reference #62.

67. Bruce Metcalfe, "Photography in Canada," Photograms of the Year 1933, 22.

68. Clifford Johnston, "Photography in Canada," Photograms of the Year 1937, 19.

69. The Gallery ceased publication in April 1939; Better Photography followed suit in December of that year. In July 1940, The Camera (Dublin) suspended publication "by reason of the paper shortages also of transport and other difficulties." Photograms of the Year 1940 (2) also cited problems involving "paper, block-making and printing," but managed to overcome these obstacles and present its annual edition in its usual form.

70. The number of Canadian salon exhibitors listed in The American Annual's "Who's Who" increased seven-fold from 11 to 77 between 1930 and 1937, only to decline to 23 by 1940.

71. F.J. Mortimer, "The Year's Work," Photograms of the Year 1941, 3.

The Plates

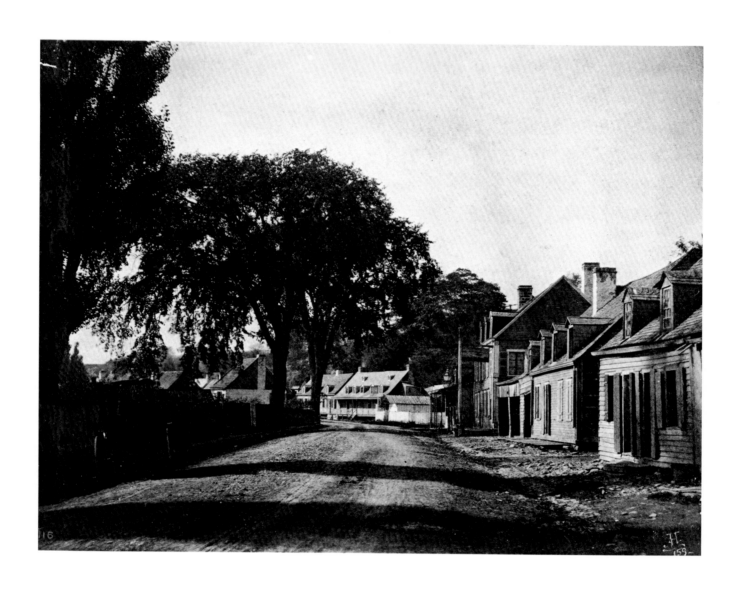

Alexander Henderson

Tanneries Village [*c. 1858*] Albumen print from a paper negative 19 x 23.8 cm *PAC, PA-123822*

Alexander Henderson

Hoarfrost [1860-1865] Albumen 15.7 x 21.4 cm *PAC, PA-28613*

Alexander Henderson

At Hochelaga [1860-1865] Albumen 16.4 x 21.1 cm *PAC, PA-126623*

Alexander Henderson

124 Valley Near Beauport Lake Taken During a Fall of Snow [1860-1865] Albumen 16.4 x 21.5 cm *PAC,*
PA-126620

Alexander Henderson

Great Ice Shove Montreal, 1863 Albumen 15.9 x 21.6 cm *PAC, PA-126622*

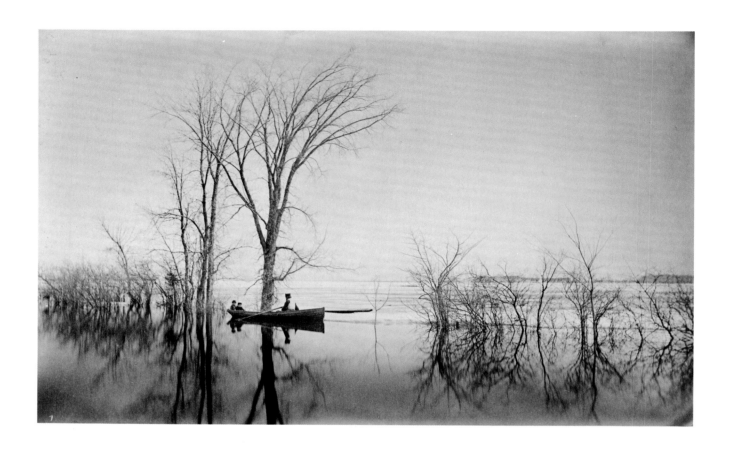

Alexander Henderson

126 Spring Inundation. Bank of St. Lawrence River 1865 Albumen 11.2 x 18.3 cm *PAC, PA-126621*

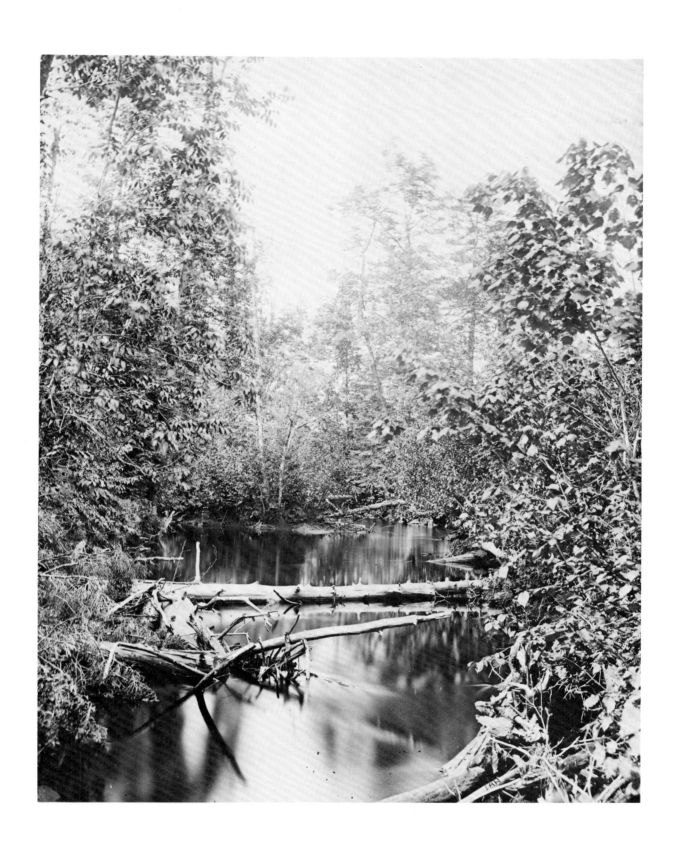

Alexander Henderson

The Trout Brook [1860-1865] Albumen 21.6 x 16.9 cm *PAC, PA-28608*

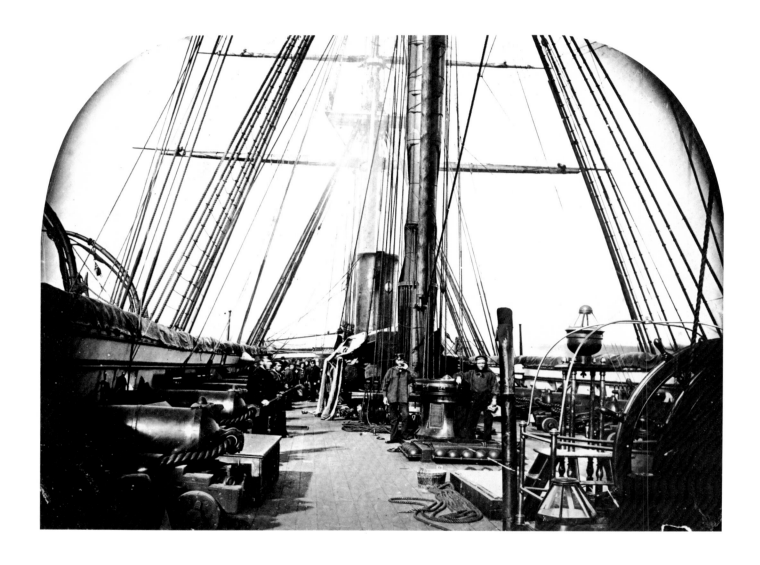

Richard Roche

HMS *Satellite* [1858-1860] Albumen 16.4 x 21.8 cm *PABC, 569*

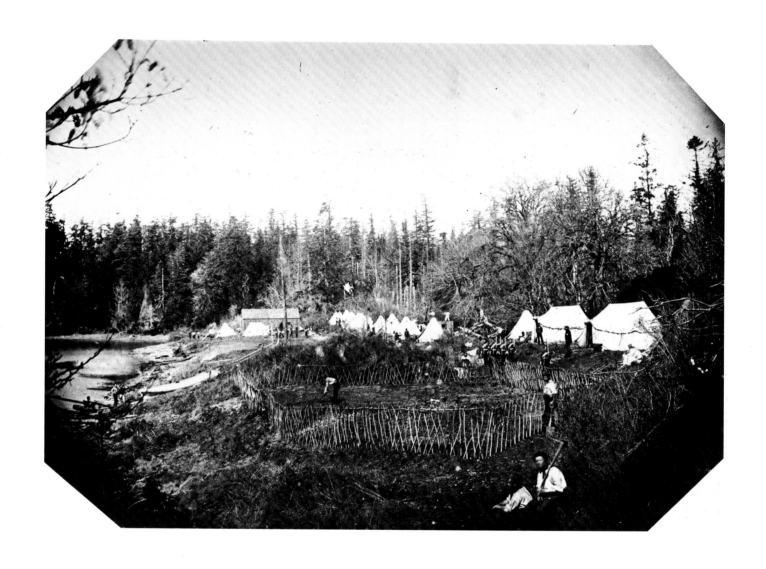

[Richard Roche, attr.]

English Camp. San Juan, Vancouver, British Columbia [1860] Albumen 15.1 x 20.2 cm *PABC, 12720*

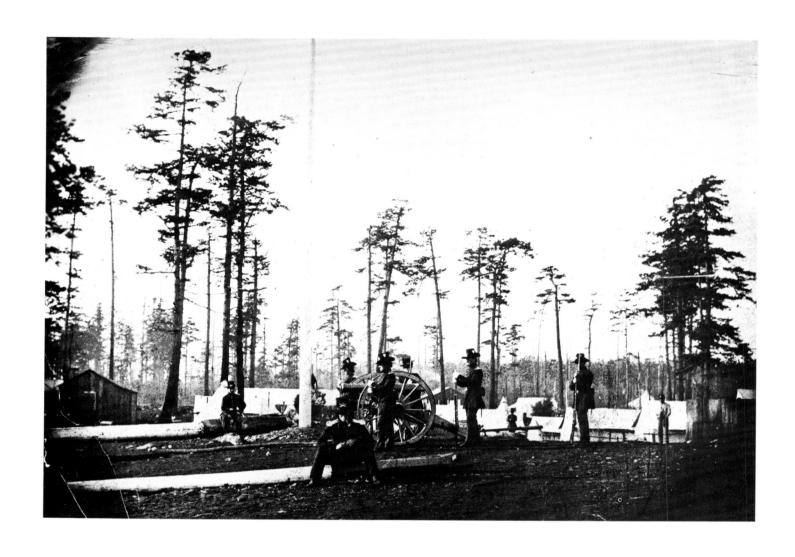

[Richard Roche, attr.]

130 American Artillerymen. San Juan, Vancouver's Island, B.C. [1859] Albumen 14.5 x 20.5 cm *PABC, 81387*

Francis George Claudet

Government House & Camp. New Westminster — British Columbia [1860-1865] Albumen 17.7 x 26.5 cm
PABC, *15084*

131

Francis George Claudet

[Church, New Westminster, B.C. c. 1860] Albumen 20.4 x 27.1 cm *PABC, 3898*

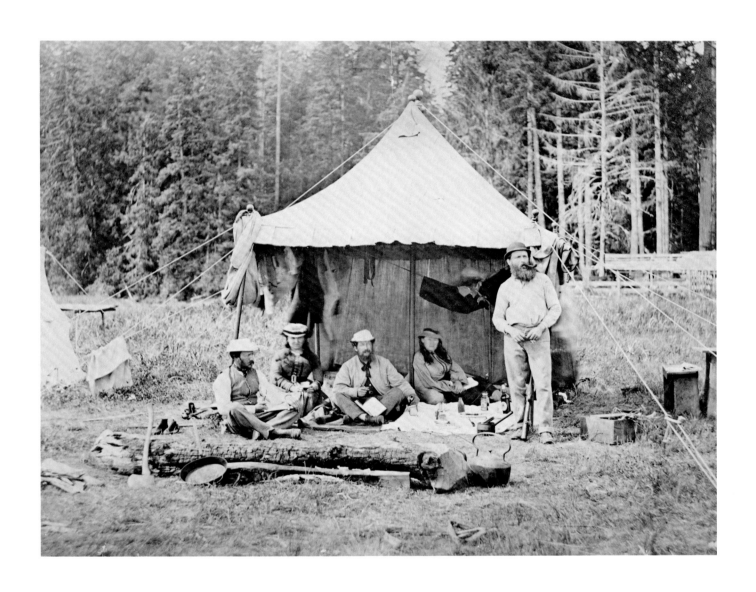

Francis George Claudet

[Picnic at Burrard Inlet, B.C. 1860-1865] Albumen 21.7 x 26.5 cm *PABC, not copied*

Francis George Claudet

Interior of Holy Trinity Church, New Westminster, B.C. [*c.* 1870] Albumen 24.1 x 28.1 cm *PABC, 95387*

George Simpson McTavish

[Avenue in "The Poplars," Rupert's House 1860-1870] Albumen 9.5 x 15.7 cm *AO, S2004*

[Abitibi River 1865-1870] Albumen 9.8 x 12.2 cm *NPA, MP391 (16)*

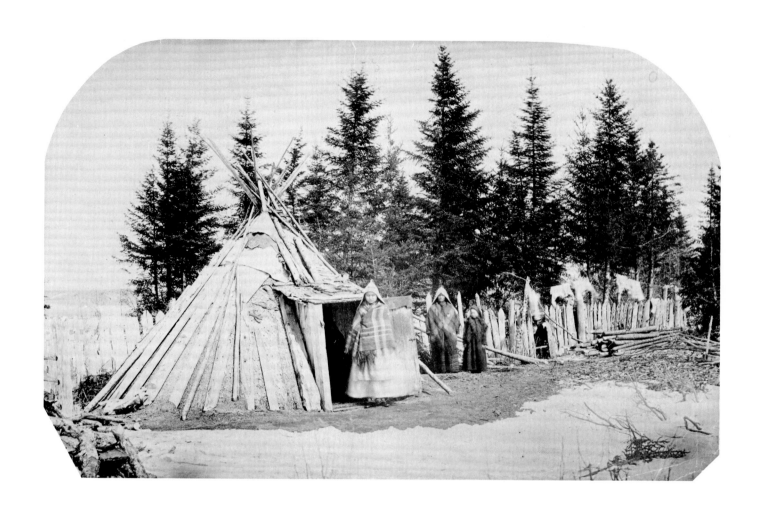

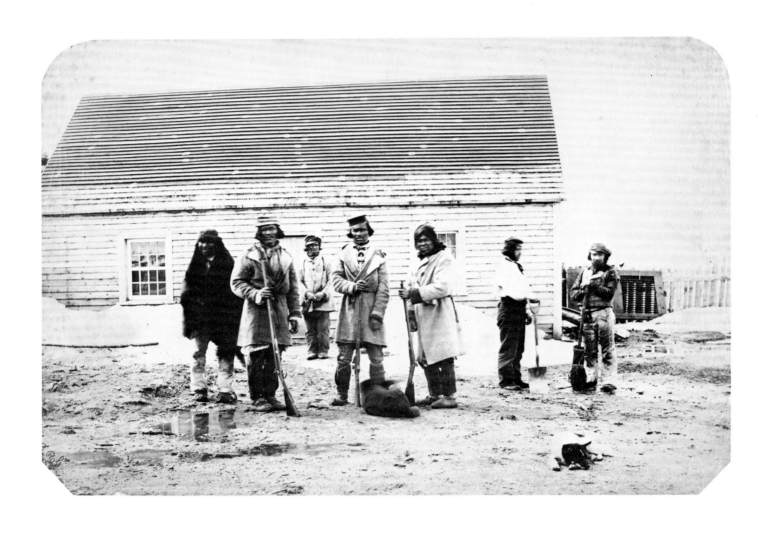

Bernard Rogan Ross

[Hunters. Rupert House 1868] Albumen 14.5 x 21.1 cm *AO, S2011*

Red Stocking's Wife Cree, Madeline

Sally & Emma. Jemmy Guns [?] Daughters.
Chamakunis [?]

Red Stockings and Son. Cree. Chemallawaish

Short Neck's Wife and Daughter. Cree.
Betsy & Harriet

[Bernard Rogan Ross, attr.]

Cartes-de-visite, c. 9 x 6 cm, [1865-1870] Albumen *clockwise*, AO: *S1956, S1949, S1944, S1955*

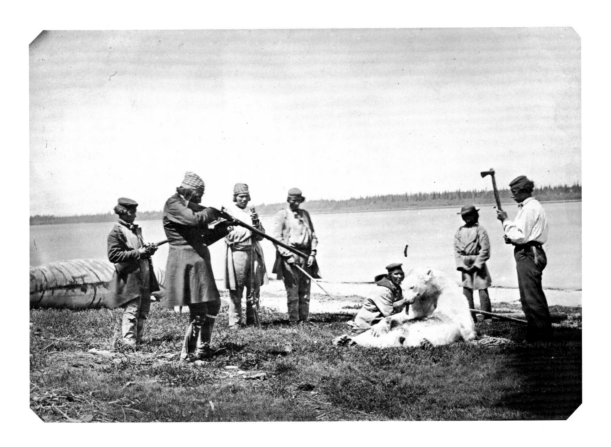

Bernard Rogan Ross

140 Rupert's House. Salt Store and Forge [1865-1868] Albumen 10.8 x 14.2 cm *PAC, C-15041*
Rupert's River. Shooting a White Bear [1865-1868] Albumen 10.7 x 14.6 cm *PAC, C-8158*

Bernard Rogan Ross

Schooner *Fox* August, 1868 Albumen 12.9 x 18.6 cm *PAC, C-8159*

Charles George Horetzky

142 Moose Factory: From the Flats [*c.* 1865] Albumen 11.1 x 17.2 cm *AO, S1981*

Charles George Horetzky

Indian Village, Moose Factory [*c.* 1865] Albumen 11.9 x 17.7 cm *AO, S1984*

Charles George Horetzky

144 Moose Factory. S.W. Front [1865] Albumen 11.1 x 17 cm *PAC, C-6412*

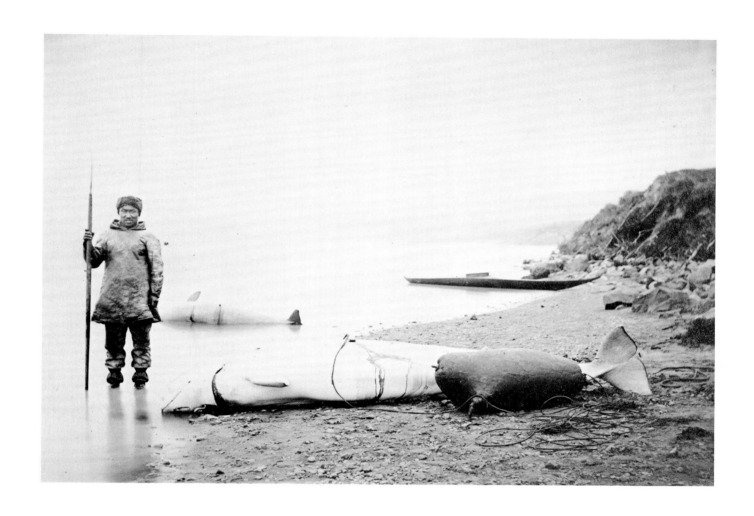

George Simpson McTavish

[Inuit at Little Whale River 1865-1875] Albumen 11.4 x 16.6 cm *PAC, C-8160*

James L. Cotter

146 Indian Camp n^r Moose Factory, Hudson Bay [1867-1872] Albumen 9.9 x 15.4 cm *PAC, PA-118272*

James L. Cotter

Camp. Shores of Hudson Bay [1867-1872] Albumen 11.2 x 15.3 cm *PAC, PA-118275*

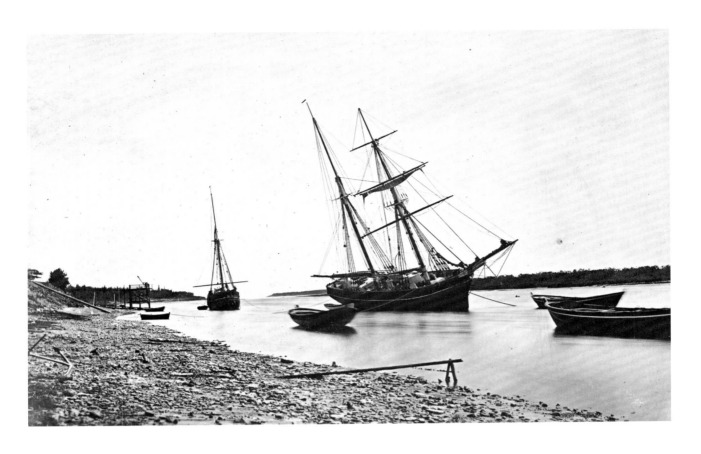

[James L. Cotter, attr.]

[Schooner *Otter* at Moose Factory 1867-1872] Albumen 10.9 x 17.1 cm *NPA, MP391 (26)*

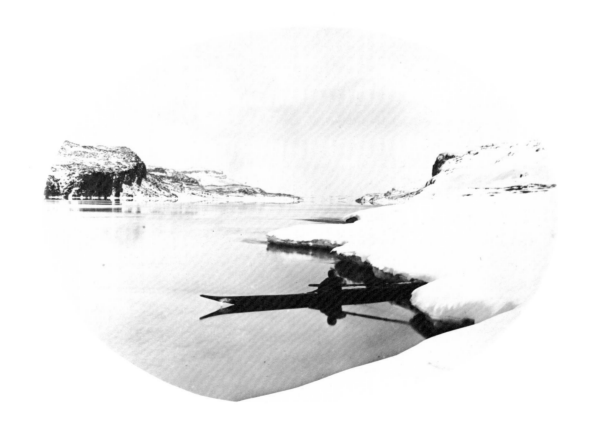

[Moose Factory Group, attr.]

148 Entrance to Richmond Gulf — Winter View [1865-1870] Albumen 11.9 x 16.8 cm *NPA, MP391 (3)*

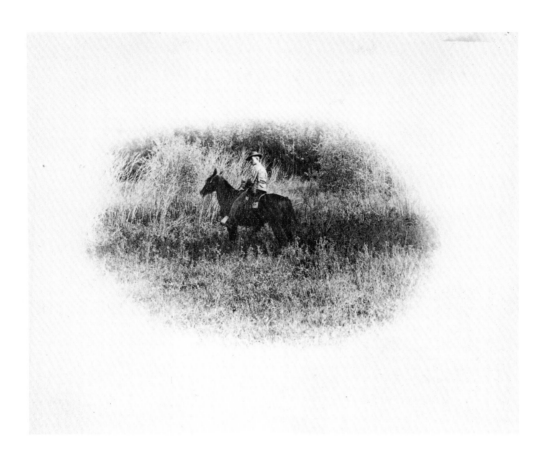

William Hanson Boorne

A Nor'West Rancher 1883 Albumen 8.3 x 10.6 cm *NPA, MP062/82 (7)*
School Treat. St. Paul's Manitoba 1883 Albumen 8.3 x 9.5 cm *NPA, MP062/82 (7)*

William Hanson Boorne

150 French Canadians Thrashing with Old Tread Power Mill 1882 Albumen 8.3 x 10.8 cm *NPA, MP062/82 (5)*
 Shooting Camp 1884 Albumen 8.3 x 10.5 cm *NPA, MP062/82 (5)*

William Hanson Boorne

Red River Ox Cart 1882 Albumen 8.3 x 10.5 cm *NPA, MP062/82 (2)*
Cattle Standing Around Mosquito Smudge 1882 Albumen 8.3 x 10.3 cm *NPA, MP062/82 (2)*

William Hanson Boorne

152 Log Farm House — Alberta N.W.T. 1886 Albumen 8.6 x 10.8 cm *NPA, MP062/82 (13)*
 Horse Ranche. Alberta N.W.T. 1886 Albumen 8.4 x 10.6 cm *NPA, MP062/82 (13)*

I. May Ballantyne

Dude Group Taken While Raining [Charles, Adam, Norman, Arthur and Harry Ballantyne, Ottawa East, Ont.] Christmas Day, 1891 From original dry-plate negative 12.1 x 17.7 cm *PAC, PA-130016*

I. May Ballantyne

154 Lillie and Jo [Lillie Ballantyne and Joe O'Gara, Ottawa East, Ont.] 1891 From original dry-plate negative
10 x 12.5 cm *PAC, PA-130011*

I. May Ballantyne

Well-Sweep, First Locks [Hartwell's Locks, Rideau Canal, Ont.] July 18, 1892 From original dry-plate
negative 17.5 x 12.5 cm *PAC, PA-130017*

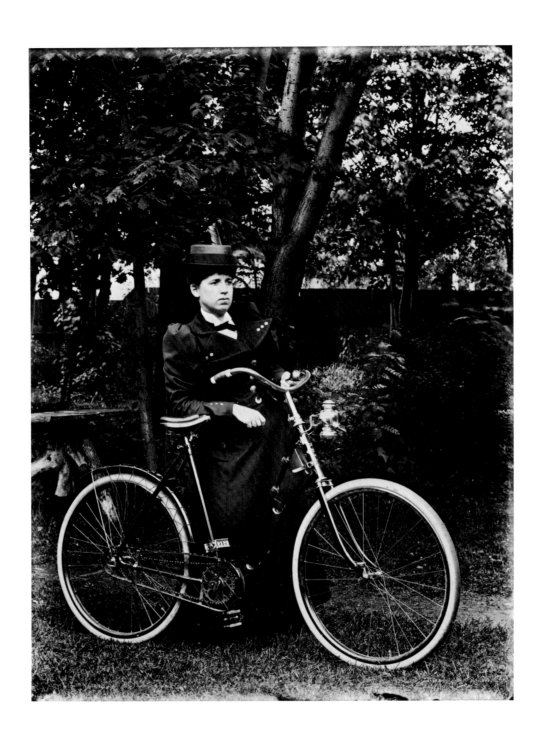

James Ballantyne

156 Mrs. Campbell on Wheel [Mrs. Albert H. Campbell, Ottawa East, Ont.] June, 1897 From original dry-plate negative 16.5 x 11.7 cm *PAC, PA-130015*

James Ballantyne

Charlie in Chair [Charles Ballantyne, Ottawa East, Ont.] September, 1896 From original dry-plate negative
10.2 x 12.5 cm PAC, *PA-130010*

James Ballantyne

158 Stone Cutters at Work [Victoria Memorial Museum, Ottawa, Ont.] April 20, 1899 From original dry-plate
negative 16.4 x 12 cm *PAC, PA-130013*

James Ballantyne

Lizzie Graham [in the conservatory of the Ballantyne home, Ottawa East, Ont.] March, 1898 From original dry-plate negative 12 x 16.4 cm *PAC, PA-130014*

James Ballantyne

160 Mrs. Foster [Mrs. Adam Foster, Ottawa East, Ont.] June 5, 1899 From original dry-plate negative 16.5 x 12 cm
PAC, PA-130012

John Wardrop Ross

[Ian A. Ross (left) and E. Marjorie Ross, Que. c. 1898] Bromide [?] 15.4 x 19.8 cm *PAC, PA·113089*

William Hodgson Ellis

162 Around the Camp Fire, [Nipissing or Timiskaming District, Ont.] 1897 Silver gelatin 9.5 x 11.7 cm
PAC, PA-121269

John Boyd

Fish Stories, Sparrow Lake, [Ont.] 1896 From original dry-plate negative 12.5 x 20.2 cm *PAC, PA-130008* 163

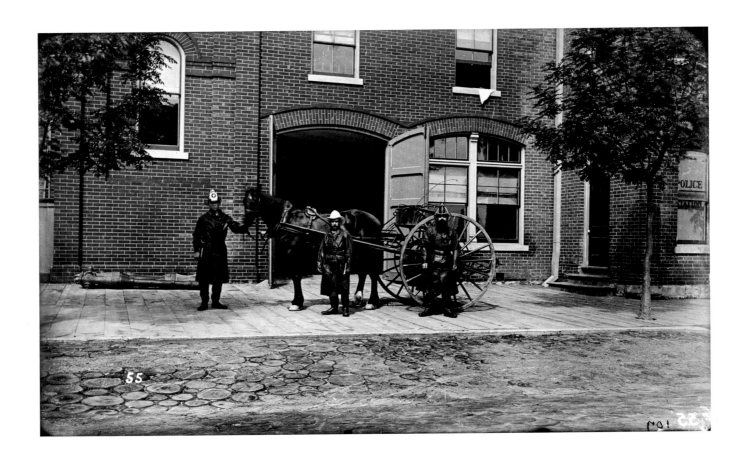

John Boyd

164 Parkdale Fire Brigade at Hall with Reel. [Toronto, Ont.] 1888 From original dry-plate negative 20 x 12.5 cm
PAC, PA-130009

Nevil Norton Evans

[Lecturer (possibly Nevil Norton Evans) Writing on Blackboard in the W.C. Macdonald Physics Building, McGill University, Montreal, Que. 1895-1900] Silver gelatin 7.3 x 10 cm *PAC, PA-122876*

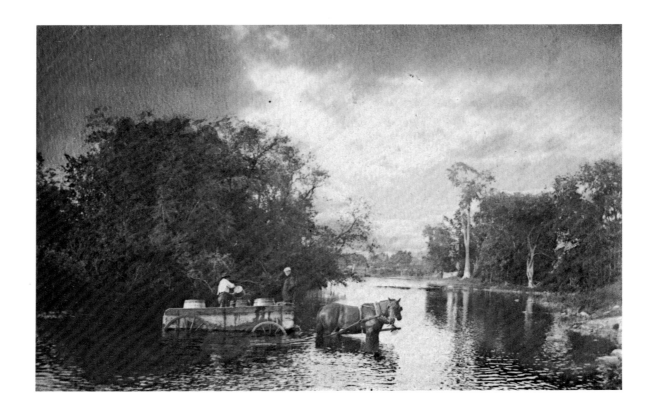

William Ide

166 The Watering Place 1895 or 1896 [?] Carbon 7.5 x 11.5 cm *PAC, PA-125108*

William Braybrooke Bayley

'Neath Lordly Oaks [taken near Long Branch, Ont. *c.* 1893] Platinum 15.4 x 19.7 cm *PAC, PA-126653*

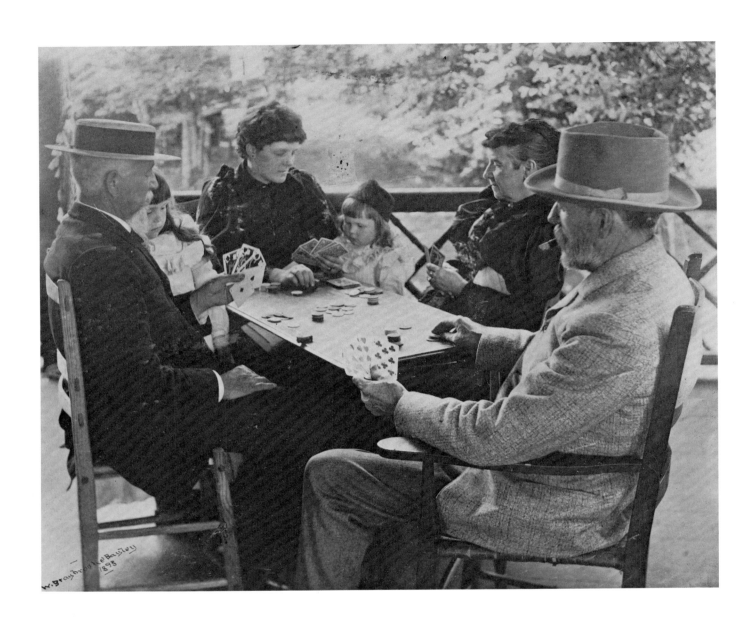

William Braybrooke Bayley

168 A Quiet Game [taken on the porch of the Bayley cottage near Long Branch, Ont.] 1893 Silver gelatin
18.6 x 15.5 cm *PAC, PA-126655*

William Braybrooke Bayley

[Woman with churn near Long Branch, Ont.] 1893 Gelatin chloride 14.7 x 20.4 cm *PAC, PA-126654*

James Peters

170 Riel [Louis Riel] a Prisoner, [Batoche, N.W.T. May 19, 1885] Albumen 9.6 x 12.6 cm *PAC, C-3450*

James Peters

They Go For a Tramp: Seaton, Bailie & Machin. [Citadel, Quebec, Que. *c.* 1885] Albumen 10.2 x 12.8 cm
PAC, *C-16916*

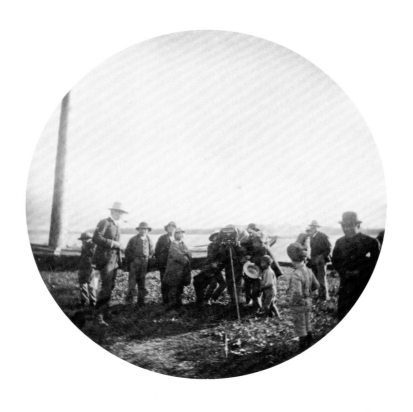

Robert Wilson Reford

Town Council Taking It In, [Masset, B.C. 1890] Albumen 6 cm diameter, *PAC, C-60834*
Chinese Seamstress, [probably Victoria, B.C. 1889] Albumen 6 cm diameter *PAC, PA-118195*

Arthur Beales

[City Hall, Toronto, Ont. *c.* 1895-1905] From original dry-plate negative 20.1 x 25.4 cm *PAC, PA-800242*

Arthur Beales

174 [John Chubb family, Toronto, Ont. *c.* 1895-1905] From original dry-plate negative 16.4 x 21.5 cm
PAC, PA-800199

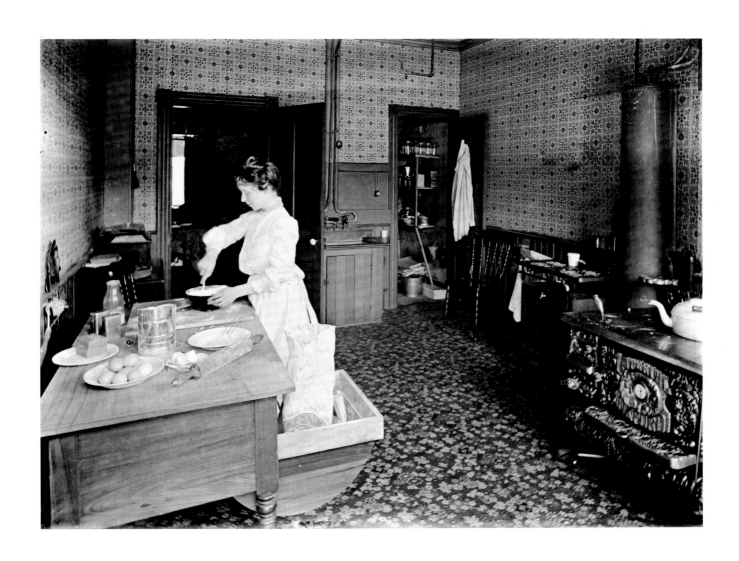

Arthur Beales

[Mrs. Arthur Beales in her kitchen, Toronto, Ont. *c.* 1903-1913] From original dry-plate
negative 21.4 x 16.4 cm *PAC, PA-800211*

Richard Scougall Cassells

176 Hudson Bay [Company] Agent at Bay Lake [Ont.], (S. L'Africain), wife and daughter [August 21, 1896]
Gelatin chloride 9 x 10.5 cm *PAC, PA-123351*

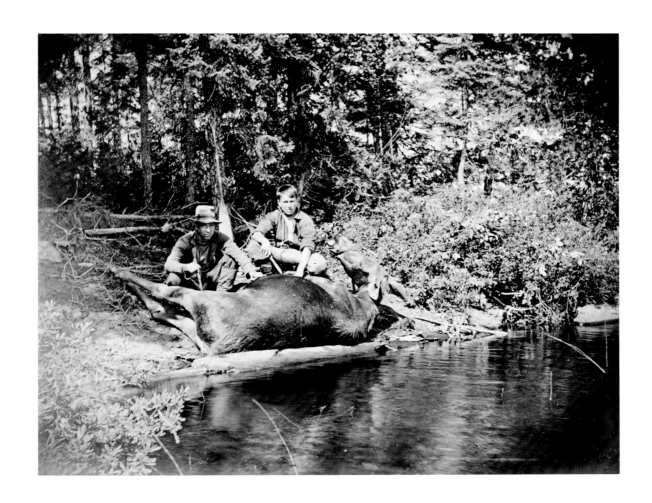

Richard Scougall Cassells

"The place for feasting on moose", Nemagabinagashesing [River, Ont. Left to right are W. Rein
Wadsworth and W. Ridout Wadsworth August 12-18, 1896] Gelatin chloride 9 x 11.4 cm *PAC, PA-123347*

At Stewart City, Yukon April, 1899 From original celluloid negative 10 x 12.5 cm *PAC, PA-16247*

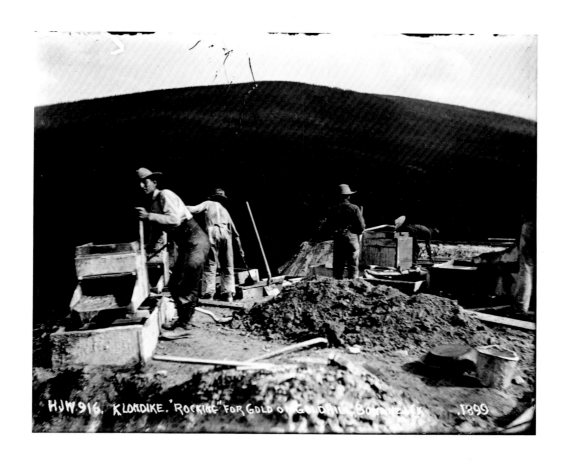

Henry Joseph Woodside

Klondike. "Rocking" for gold on Gold Hill, Bonanza C[ree]k, [Y.T.] 1899 From original dry-plate negative
10 x 12.5 cm *PAC, PA-16223*

Henry Joseph Woodside

180 Eldorado C[ree]k, looking up from No. 14 claim, Klondike, Yukon May, 1901 From original dry-plate negative 10 x 12.5 cm *PAC, PA-16281*

George Henry Field

Taken from Top of City Hall, Winnipeg, [Man.] August, 1888 Albumen 19.5 x 11.5 cm *PAC, PA-123111*

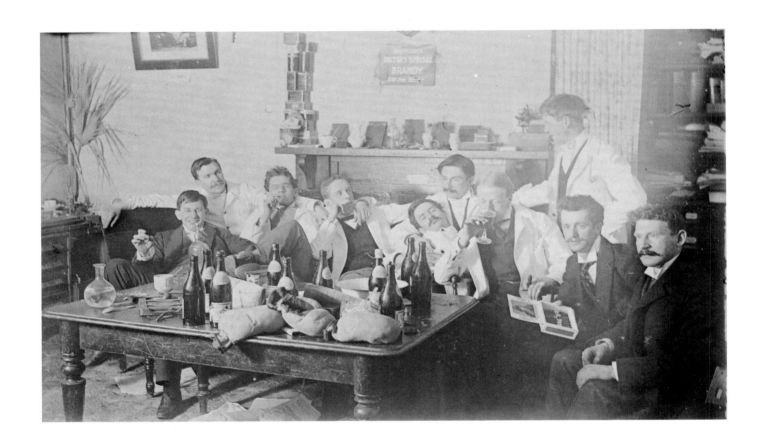

George Henry Field

[Resident staff, Toronto General Hospital] February, 1895 Albumen 11.5 x 19.5 cm *PAC, PA-123087*

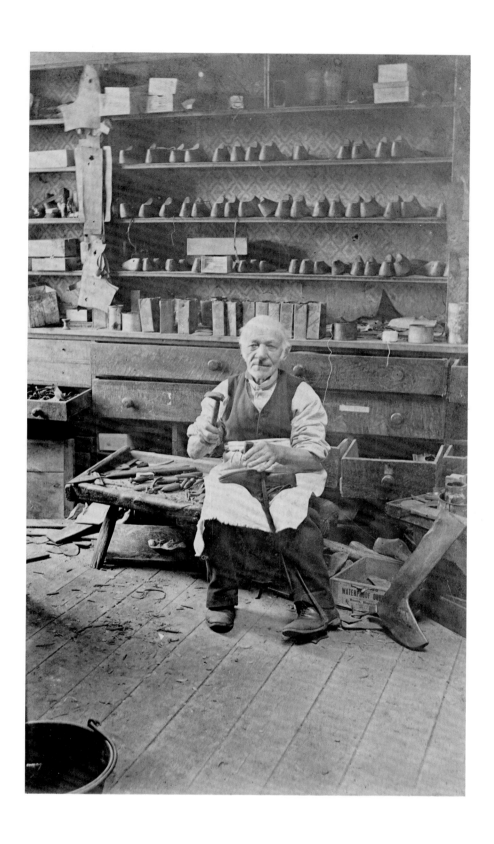

[George Henry Field, attr.]

[David Hill, King Street West, Cobourg, Ont. 1887-1897] Albumen 18.4 x 10.6 cm *PAC, PA-123090*

Sidney Carter

The Sisters [*c.* 1906] Platinum 21.5 x 16.2 cm *PAC, PA-126979*

Sidney Carter

[Landscape with Birch Trees 1907] Platinum 20.8 x 15.9 cm *PAC, PA-112243*

Sidney Carter

[The Kiss, small version] 1910 Platinum 17.3 x 12.2 cm *PAC, PA-126981*

Sidney Carter

188 [Nude Bending] n.d. Platinum 25.3 x 19.1 cm *PAC, PA-112022*

Sidney Carter

Portrait — Joliffe Walker, Esq. [*c.* 1908] Platinum 22 x 15.8 cm *PAC, PA-126983*

Horace Boultbee

[The Commons, Parliament Buildings, Ottawa] 1905 Gum bichromate 19.4 × 9.5 cm *PAC, PA-126988*

These photographs come from an album;
a very similar album, with some identical
images, exists in the Archives of Ontario,
attributed to M.O. Hammond.

[Horace Boultbee, attr.]

Evening Reflections n.d. Platinum 5.3 x 11.4 cm *PAC, PA-126985*
Belleville, Marsh n.d. Platinum 9.2 x 11.1 cm *PAC, PA-126975*

Robert Scott

[In a Formal Garden, Saratoga Springs, N.Y. ?] n.d. Silver gelatin 12.5 x 17.7 cm *PAC, PA-126991*

Beresford Pinkerton

194 [Landscape with Rail Fence] n.d. Platinum 6.6 x 16.6 cm *PAC, PA-121500*

Beresford Pinkerton

[Tiger Lilies] n.d. Sepia-toned silver gelatin 15.4 × 8 cm *PAC, PA-121499*

[Irises] n.d. Sepia-toned silver gelatin 15.4 × 8.1 cm *PAC, PA-126989*

Henrietta Constantine

196 R.C. Mission, Lesser Slave Lake 1906-07 Silver gelatin 8.1 x 13.7 cm *PAC, C-30269*
Pine [?] Hill from Fish Cr. 1906-07 Silver gelatin 8 x 13.8 cm *PAC, C-30270*

Charles Edward Saunders

Sheep on the Western Prairies *c.* 1910 Silver gelatin 36.5 x 48.2 cm *PAC, PA-126801*

George Munro

Geraldine Moodie

200 Eskimo Woman Wearing Beaded Deerskin Dress Made for Lady Grey 1906 Silver gelatin 15.4 x 10.3 cm
RCMP, 34-6-62

Geraldine Moodie

[Eskimo Orphan *c.* 1905] Silver gelatin 16.9 x 11.9 cm *PAC, PA-61519*

Arthur S. Goss

202 Prof. James Mavor n.d. Silver gelatin 24.2 x 19.1 cm *PAC, PA-126982*

Arthur S. Goss

Child and Nurse [also called Portrait of a Child 1906] Silver gelatin 20.9 x 16 cm *PAC, PA-126977*

William Ide

204 Dr. Frank Shutt and Friend *c.* 1912 Silver gelatin 16.3 x 11 cm *PAC, PA-126976*

William Ide

Mrs. Wm. Ide n.d. Platinum 18.6 x 8.5 cm *PAC, PA-125120*

William Ide

206 A Fair Wind on the Lower Thames [*c.* 1902] Silver gelatin lantern slide 8.3 x 8.3 cm *PAC, PA-131093*

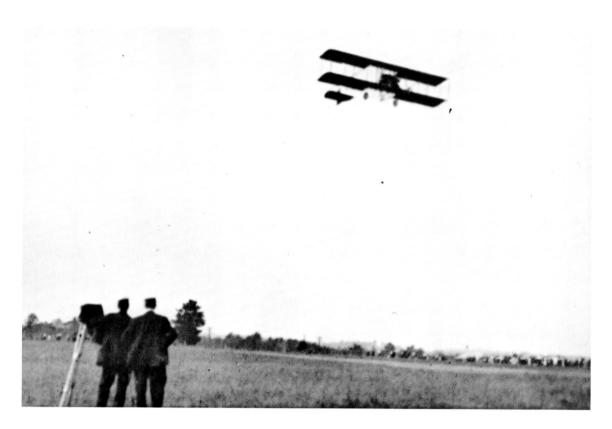

[Charles F.] Willard [Flying] at [the] Donlands [Aviation Meet, Toronto, Ontario] [August 5,] 1911

The Girls Race n.d.

Thomas Cannon

Silver gelatin lantern slides c. 8.3 x 8.3 cm, cropped *top: PAC, PA-131094 bottom: PAC, PA-131095*

John Boyd

208 "Ward" Aeroplane, trying out engine October 5, 1911 From original silver gelatin negative 12.6 x 17.7 cm
PAC, PA-60831

John Boyd

Diver at Work, on ladder going down 1905 From original silver gelatin negative 17.6 x 12.5 cm
PAC, PA-60680

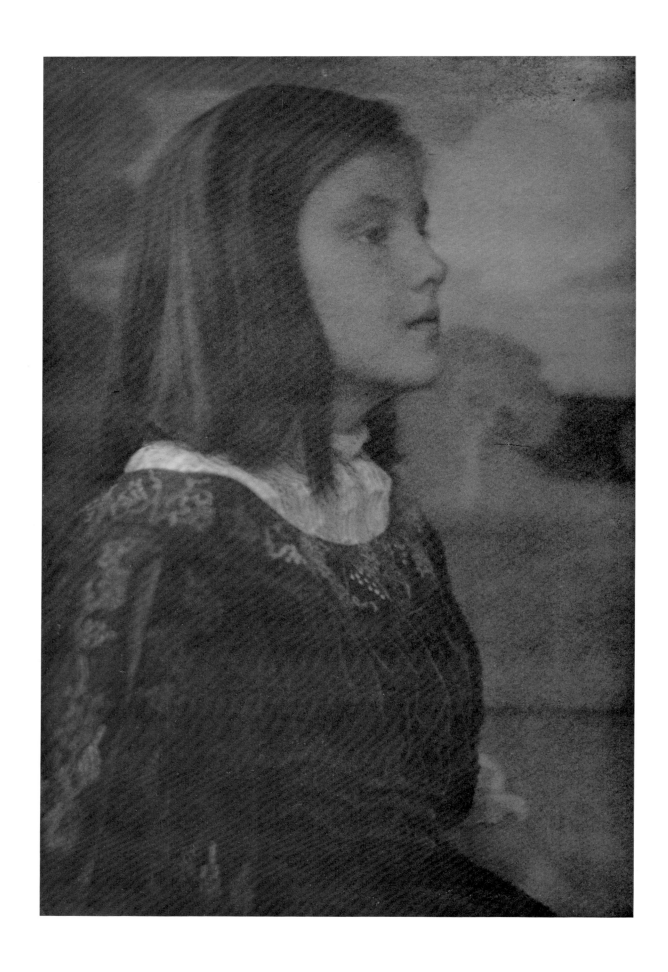

Harold Mortimer-Lamb

210 Beatrice [?] [1907 or earlier] Platinum 24.9 x 16.7 cm *PAC, PA-111984*

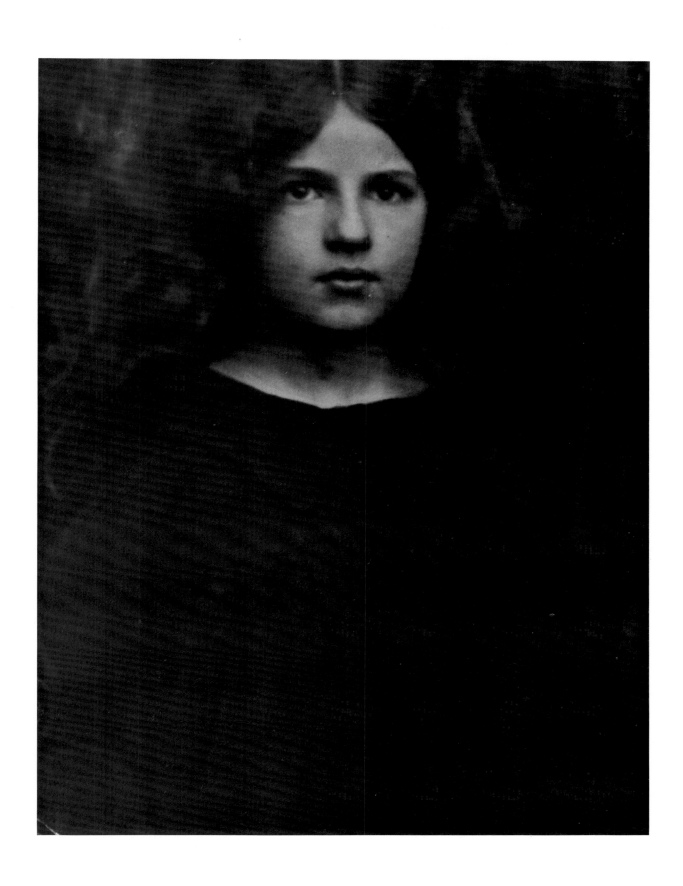

Harold Mortimer-Lamb

Portrait [1905] Platinum 20.3 x 15.5 cm *PAC, PA-126984*

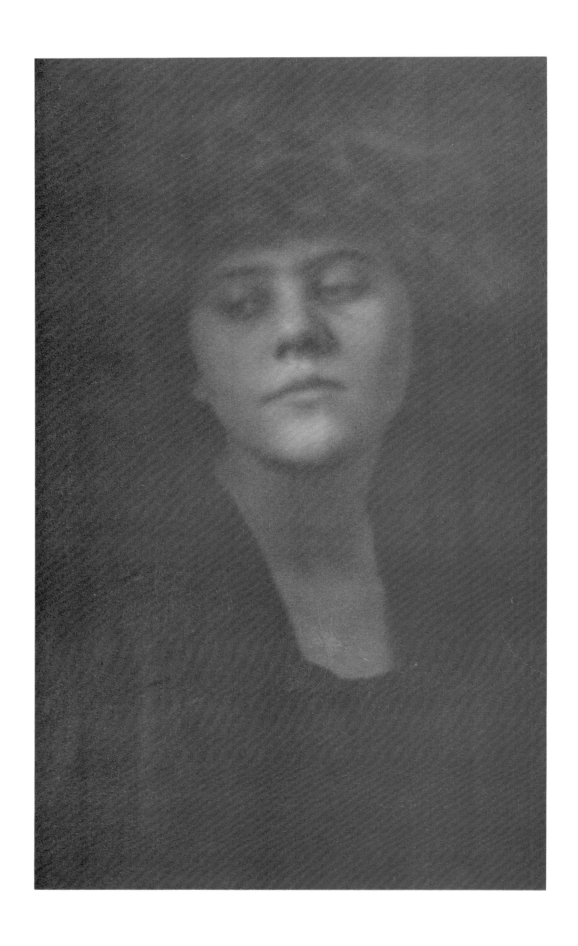

Harold Mortimer-Lamb

212 Portrait — Miss D. [c. 1908] Platinum 24.1 x 14.4 cm *PAC, PA-126990*

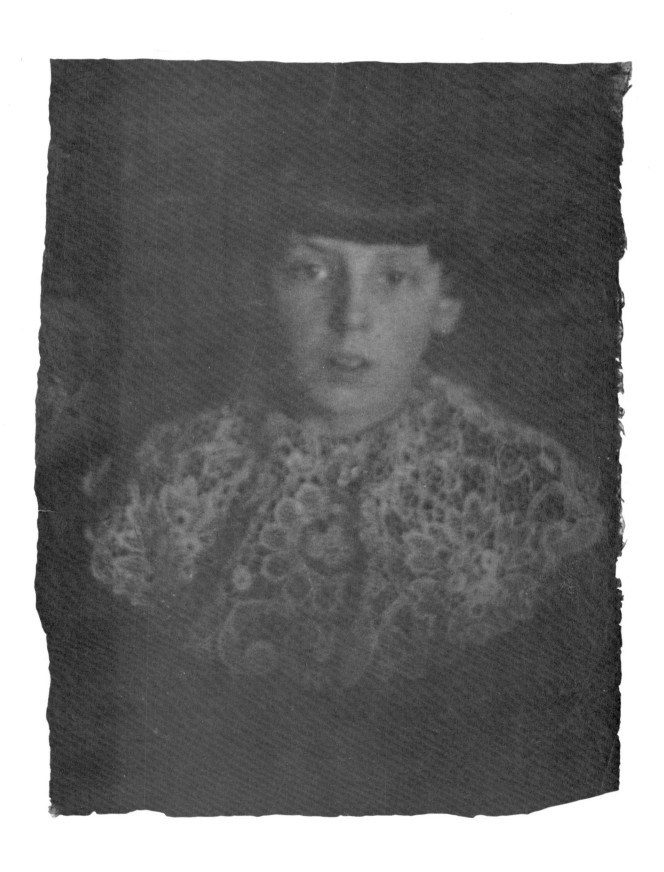

Harold Mortimer-Lamb

[Child in a Lace Collar] n.d. Platinum on tissue 21.1 x 15.5 cm *AGGV, PH983.1.145*

Harold Mortimer-Lamb

Portrait of Lady Drummond [*c. 1907*] Platinum 25.5 x 19.7 cm *NGC, P75:026 Lamb*

Johan Helders

The Only Two 1925 Silver gelatin 32.5 x 42.3 cm *VPL, not copied*

Johan Helders

Johan Helders

Umbrella Weather 1925 Silver gelatin 21.4 x 27 cm *VPL, not copied*

Charles Edward Saunders

Romance — Aunt Mary n.d. Sepia-toned silver gelatin [?] 17.7 x 23.8 cm *PAC, PA-126740*

William Ide

[Backstreet in Old Montreal *c.* 1915] Silver gelatin 24.3 x 14.5 cm *PAC, PA-126734*

William Ide

[Scene in Europe] n.d. Silver gelatin 16.8 x 21.4 cm *PAC, PA-126699*

Clifford M. Johnston

November Fog, London [negative *c.* 1918; print *c.* 1926] Toned silver gelatin 23.8 x 31.3 cm *PAC, PA-126738* 221

Albert Van

222 Worn Out [*c.* 1920] Silver gelatin 20.2 x 27.2 cm *PAC, PA-126698*

Albert Van

[The Knife Sharpener *c.* 1920] Silver gelatin 25.2 x 20.3 cm *PAC, PA-126700*

Albert Van

224 Mustafa Bay 1918 Bromoil on laid paper 30.2 x 23.3 cm *PAC, PA-126695*

Albert Van

Summer Morn [*c. 1920*] Bromoil on laid paper 31 x 19.3 cm *PAC, PA-126685*

Albert Van

226 Mountain Sheep 1927 Sepia-toned silver gelatin 25.7 x 33.5 cm *PAC, PA-126684*

Albert Van

The Blue Heron [*c.* 1925] Toned silver gelatin 25 x 33.3 cm *PAC, PA-126696*

John Kirkland Hodges

Clearing the Land 1921 Bromide 25.8 x 32.6 cm *PAC, PA-37448*

John Kirkland Hodges

Idle Moments 1926 Bromide 21.4 x 29.2 cm *PAC, PA-125728*

Albert T. Roberts

230 [Portrait of A.T. Roberts' daughter, Gladys ? *c.* 1925] Gum bichromate 23.1 x 18.9 cm *PAC, PA-123217*

Roberts' ability to blend the sky scene (made with a separate negative) with the objects, and to light the whole so that it appeared natural, although this is a "table-top" study, indicates his capacity as a technician.

Albert T. Roberts

Poplars, Evening [c. 1931] Toned chlorobromide 25.3 x 29.1 cm *PAC, PA-123218*

William J. Grant

232 The Shore Road. Nr Beaconsfield, Que. 1920 Bromide 15 x 25.3 cm *PAC, PA-126666*
The Winter Trail 1921 Bromide 15 x 25.3 cm *PAC, PA-126667*

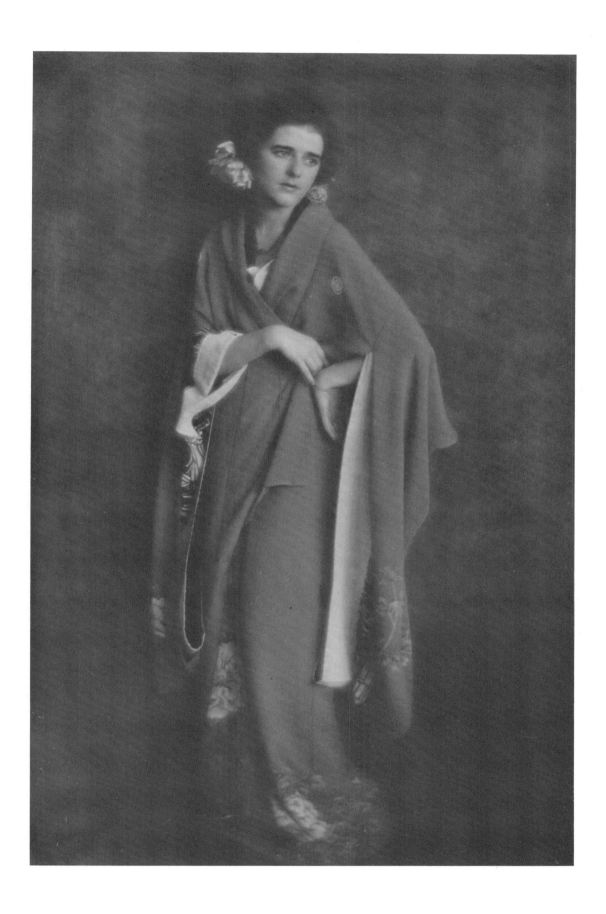

Sidney Carter

[Woman in Oriental Costume] 1917 Silver gelatin 21.2 x 13.8 cm *PAC, PA-111991*

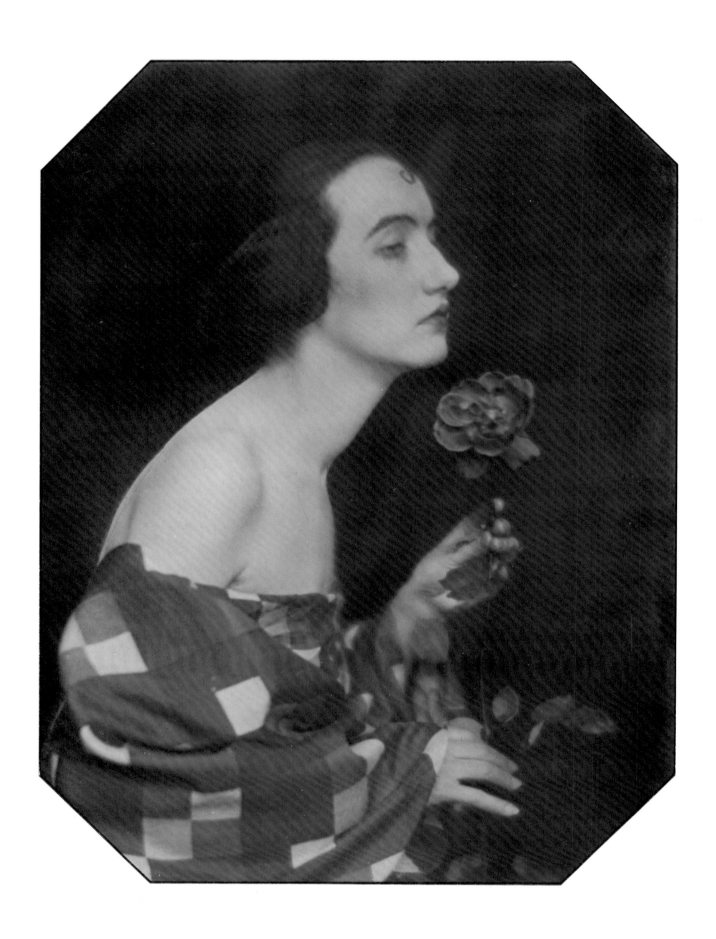

Sidney Carter

234 The Rose [*c.* 1920] Silver gelatin 20.8 x 15.5 cm *PAC, PA-112203*

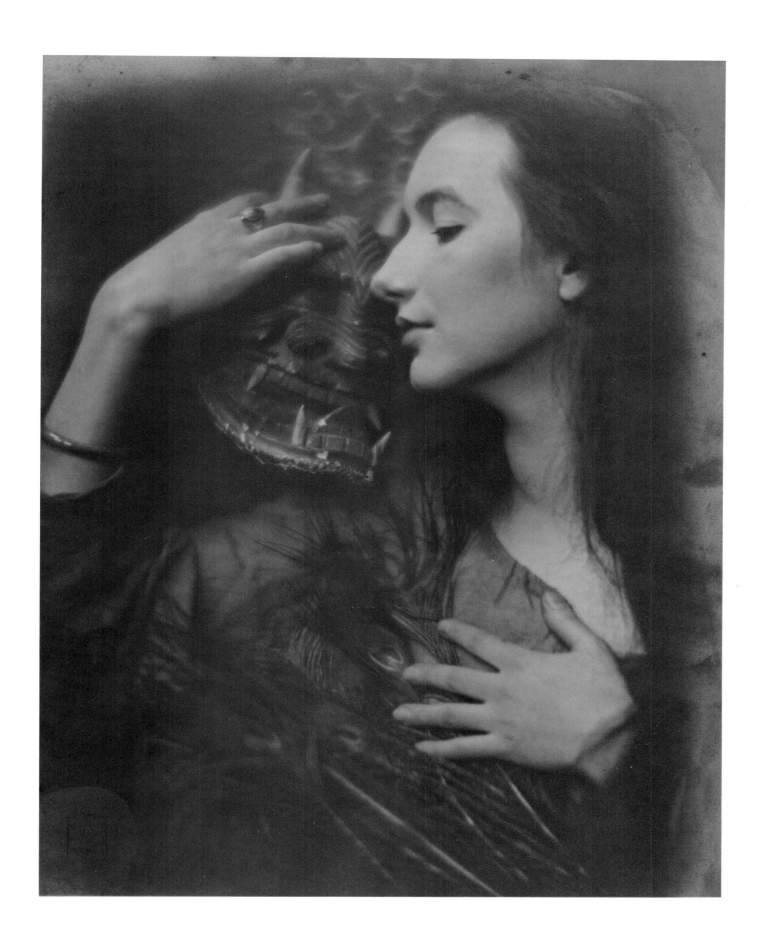

Sidney Carter

Fantasy [*c.* 1921] Silver gelatin 24.3 x 19.2 cm *PAC, PA-112013*

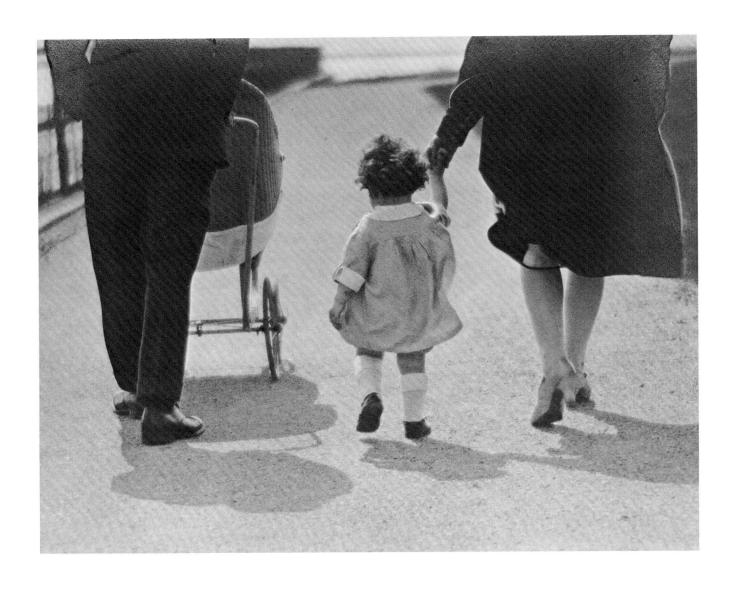

John Morris

236 The Family 1927 Silver gelatin 24.2 x 29.8 cm *PAC, PA-126728*

A. Brodie Whitelaw

Canton Alley [*c.* 1928] Silver gelatin 12.3 x 16.9 cm *PAC, PA-126739*

A. Brodie Whitelaw

Gas Tanks [*c.* 1928] Bromide 16.8 x 12.5 cm *PAC, PA-126683*

A. Brodie Whitelaw

Architectural Fantasy [c. 1929] Silver gelatin 22.9 x 17.9 cm *PAC, PA-126737* 239

Bruce Metcalfe

240 An Ontario Farm 1926 Silver gelatin 28.5 x 24 cm *PAC, PA-124035*

Bruce Metcalfe

Collars 1927 Bromide 17.8 x 22.7 cm *PAC, PA-126505*

Joseph Harold Mackay

Sentinels 1934 Toned silver gelatin 37.3 × 29.8 cm *PAC, PA-126637*

Clifford M. Johnston

244 Traffic Plays the Tune 1930 Chlorobromide 25.9 x 31.0 cm *PAC, PA-126513*

Clifford M. Johnston

Reflections 1931 Chlorobromide 24.1 x 34.6 cm *PAC, PA-126635*

A.M. Barrach

Arthur H. Lomax

Skylight 1934 Bromide 30.4 x 23.5 cm *PAC, PA-126643*

Frederick G. Ashton

248 Painting Ship [*c.* 1930] Bromoil transfer 16.3 x 11.2 cm *PAC, PA-126646*

Frederick G. Ashton

Untitled — [Two nuns *c.* 1930] Bromoil transfer 16.2 x 11.0 cm *PAC, PA-126748*

John Fleetwood-Morrow

250 A.M. Union Station 1938 Silver gelatin, from 35 mm negative 28.9 x 22.8 cm *PAC, PA-126644*

Walter B. Piers

Bull Pines [*c.* 1938] Toned bromide 25.3 x 34.1 cm *PAC, PA-124587*

Leslie G. Saunders

252 West Coast Sawmill [*c.* 1931] Bromoil 29.2 × 25.4 cm NGC *(on loan)*
Courtesy of Jessie Saunders

Leslie G. Saunders

South Wind [*c.* 1937] Silver gelatin print from paper internegative 22.7 × 28.2 cm NGC (*on loan*).

Courtesy of Jessie Saunders

Harold F. Kells

254 Soul of the Dance 1934 Modern toned silver gelatin print from original negative 40.9 x 45.0 cm *NGC, P72:432*

Harold F. Kells

Grecian Nocturne 1935 Modern toned silver gelatin print from original negative 36.1 x 48.7 cm *NGC, P72:437* 255

Philip J. Croft

256 Lancashire [*c.* 1940] Silver gelatin, from paper negative 19.6 x 23.3 cm *PAC, PA-126235*

Arthur Tweedle

Authority Speaks! [*c.* 1938] Silver gelatin 27.7 x 27.5 cm *PAC, PA-126516*

Alfred Brigden

258 Mickey on the Spot 1932 Chloride 24.3 x 29.4 cm *PAC, PA-123492*

D. Gordon McLeod

Leicawocky [c. 1938] Silver gelatin 23.4 x 19.6 cm PAC, PA-125746

John Morris

Montreal Boat 1939 Silver gelatin 26.2 x 32.7 cm *PAC, PA-126638*

John Morris

Sundaes 1934 Silver gelatin 24.4 x 17.6 cm *PAC, PA-126642*

George Marchell

Excursionaires 1937 Bromide 23.5 x 29.6 cm *PAC, PA-125721*

W. Edwin Lehman

The White Wall 1934 "Sulphide Toned ChloroBromide" 25.4 x 27.1 cm *PAC, PA-126226*

George A. Pearce

264 Murk 1937 Silver gelatin 24.2 x 18.9 cm *PAC, PA-126641* Courtesy of Jane Pearce

Leonard Davis

Grant Gates

Untitled — [Cole Bros. Circus] 1940 Silver gelatin 22.2 x 30.0 cm *PAC, PA-126222* 267

Grant Gates

Light on Industry 1939 Bromide 29.6 x 24.4 cm *PAC, PA-126504*

Otto J. Eaton

Mystic Wood 1940 Chlorobromide 37.2 x 29.5 cm *PAC, PA-126636*

Alfred S. Upton

270 Black Iris 1939 Gevaluxe 21.4 x 17.5 cm *PAC, PA-126633*

Alfred S. Upton

St. Jacobs Country 1931 Bromide 23.8 x 31.2 cm *PAC, PA-126828*

Alfred S. Upton

272 Magnolia 1937 Bromide 29.7 x 22.9 cm PAC, PA-126632

Alfred S. Upton

Prelude 1935 Bromide 22.8 x 27.9 cm *PAC, PA-126631*

Arthur Beales

[Fruit Trees in Flower] n.d. Autochrome 16.5 x 21 cm *PAC, PA-126860 (b/w)*

Thomas Cannon

High Park, Toronto 1911 Omnicolore 8.3 x 8.3 cm, cropped *PAC, PA-126864 (b/w)*

Crocuses at Seymour Lake, B.C. [?] [*c.* 1913] Autochrome 8.3 x 8.2 cm PAC, PA-126865 *(b/w)*

George P. Allen

Skunk Cabbage in Flower, Seymour C[ree]k, [B.C. *c.* 1913] Autochrome 8.3 x 8.3 cm *PAC, PA-126866 (b/w)*

George R.G. Conway

280 Road to Capilano [Near Vancouver, B.C.] Evening April 1914 Autochrome 12.5 x 10 cm *PAC, PA-122971*
 (b/w)

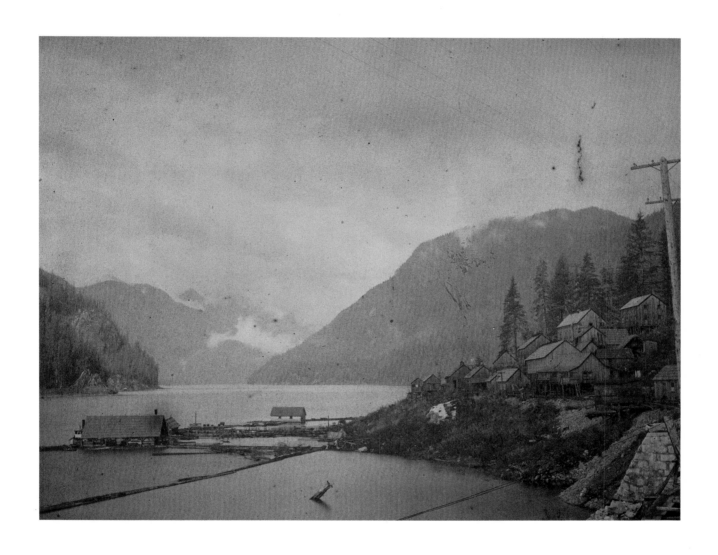

George R.G. Conway

Lake Coquitlam Aug. 1913 Autochrome 10.1 x 12.7 cm *PAC, PA-122960 (b/w)*

George R.G. Conway

282 Bunty Nov. 1913 Autochrome 12.7 x 10.2 cm PAC, PA-122967 (b/w)

Arthur J. Ames

[Ronald A. Ames, son of A.J. Ames *c.* 1915 or 1916] Paget plate 8.4 x 8.4 cm *PAC, PA-126867 (b/w)*

A. Brooker Klugh

[Flowers *c.* 1920] Hand-tinted silver gelatin on printing-out paper 7.5 x 9.7 cm *PAC, PA-126693 (b/w)*

A. Brooker Klugh

286 [Goldenrod *c. 1920*] Hand-tinted silver gelatin on printing-out paper 9.6 x 7.2 cm *PAC, PA-126690 (b/w)*

A. Brooker Klugh

[Trilliums on Forest Floor *c. 1920*] Hand-tinted silver gelatin on printing-out paper 9.4 x 7.4 cm
PAC, PA-126692 *(b/w)*

A. Brooker Klugh

288 [Sunset at Maginan Lake *c.* 1915] Hand-tinted silver gelatin on printing-out paper 7.1 x 9.8 cm
PAC, PA-126691 *(b/w)*

Philip J. Croft

[Grove of Trees, Mount Royal Park, Montreal, Que. *c.* 1936] Agfacolor 7.0 x 7.5 cm PAC, PA-126869 *(b/w)* 289

Philip J. Croft

[Upper Deck, Ferry, Digby, N.S. — Saint John, N.B.] 1937 Dufaycolor 7.5 x 6.7 cm *PAC, PA-126871 (b/w)*

Ralph Speiran

[Cottage Country *c.* 1938] Dufaycolor 5.6 x 5.7 cm *PAC, PA-126862 (b/w)*

William A. Norfolk

[Campfire Self-Portrait, Lake Aguasabon, Ont.] 1939 Dufaycolor 35 mm *PAC, PA-126872 (b/w)*

Edith Hallett Bethune

[John E. Bethune and Terrier *c.* 1937] Hand-tinted silver gelatin 25.4 × 15.5 cm PAC, PA-126006 *(b/w)* 295
Courtesy of Jack and Margaret Bethune

Donald B. Marsh

Aheamuit, Tribe of Arloo, Eskimo Point, [N.W.T. *c.* 1937-40] Kodachrome 35 mm *PAC, PA-126875* *(b/w)*

Donald B. Marsh

Eating Raw Cariboo, Eskimo Point, [N.W.T.] 1937 Kodachrome 35 mm *PAC, PA-126874 (b/w)*

Made from three-color separation negatives, produced in one-shot, beam-splitting camera, designed and built by the author.

Harold F. Kells

298 Hallowe'en Still-Life 1935 Experimental dye transfer print 25.1 x 30.7 cm *PAC, PA-126536 (b/w)*
Courtesy of Harold and Margaret Kells

Never actually used for advertising purposes, Advertising Plate *was successful in salon competition.*

Philip J. Croft

Advertising Plate 1939 "Wash-Off Relief From 3 Separate Shots" 16.6 x 23. cm PAC, PA-126232 *(b/w)*

John Fleetwood-Morrow

300 Study of a Rose [1940] "Direct transfer Carbro from 35 mm Kodachrome" 14.8 x 20.7 cm *PAC, PA-127332*
 (b/w)

John Fleetwood-Morrow

Untitled — [Sunglasses] 1940 "Direct transfer carbro from 35 mm transparencies" 14.7 x 17.2 cm
PAC, PA-127333 *(b/w)*

Key to Captions

Illustrations are courtesy of:

ACR	Archives of the Canadian Rockies, Whyte Foundation, Banff
AGGV	Art Gallery of Greater Victoria, Victoria
AO	Archives of Ontario, Toronto
CCA	Collection centre canadien d'architecture/Canadian Centre for Architecture, Montreal
CCP	Canadian Centre of Photography and Film, Toronto (defunct)
CTA	City of Toronto Archives, Toronto
CVA	City of Vancouver Archives, Vancouver
Glenbow	Glenbow Archives, Glenbow Museum, Glenbow-Alberta Foundation, Calgary
NGC	National Gallery of Canada, Ottawa
NMM	National Museum of Man, History Division, Ottawa
NMST	National Museum of Science and Technology, Ottawa
NPA	Notman Photographic Archives, McCord Museum, Montreal
PABC	Provincial Archives of British Columbia, Victoria
PAC	Public Archives Canada, Ottawa
PEI	Prince Edward Island Heritage Foundation, Public Archives of P.E.I., Charlottetown
RCMP	Royal Canadian Mounted Police Museum, Regina
VPL	Vancouver Public Library, Vancouver

[] Information within square brackets was added by the authors
All dimensions are height × width.

[**A. Van, attr.**]

[Man with a camera *c.* 1916] Silver 15.7 x 10.6 cm *PAC, PA-138571*

Biographies of Photographers

ALLEN, George Pethybridge
(21 August 1876, England — 8 September 1960, Victoria, B.C.)

After a boyhood in Cornwall, England, and a science degree from the University of London about 1901, George Allen taught for perhaps ten years in Wales. In 1913 he came to Canada and accompanied a survey party to Seymour Creek, B.C., north of Vancouver. Several accomplished images taken in Great Britain verify that he had already been practising colour photography. During the First World War Allen worked for the Victoria Chemical Company and, subsequently, as Chief Chemist for Canadian Explosives Ltd., later Canadian Industries Ltd. *LK*

COLLECTIONS

PUBLIC ARCHIVES CANADA
J.T. Biller Collection (Acc. No. 1981-29) contains seven Autochromes.
J.T. Biller Collection (Acc. No. 1982-101) contains 18 Autochromes, one Thames Plate (probably taken while in Great Britain), and some additional b/w prints and notes.
PRIVATE COLLECTION

I am grateful to J.T. Biller, a descendant of George Allen, for the information in these notes. LK

PAC. PA-804287

AMES, Arthur John
(1880, London, England — 1973, Canada ?)

A.J. Ames was employed by the London firm of E.R. Watts and Son, manufacturers of scientific instruments, from 1902. The company opened branch offices in Winnipeg (1907) and Ottawa (1909), and in 1913, Ames was transferred to Ottawa as the managing director of Canadian operations. He retired in 1951, although he maintained an interest in the company (which in 1921 had become Instruments Limited) and its products. He had a scientific background, with a strong inclination toward the arts, and his personal interests included travelling, painting and poetry. *LK*

COLLECTIONS

PUBLIC ARCHIVES CANADA
A.J. Ames Collection (Acc. No. 1974-132) contains about 900 prints and lantern slides, only a small number of which were probably taken by Ames.

Ashton

ASHTON, Frederick George
(1888, England — 5 February 1967, Ottawa, Ontario)

Frederick Ashton has been described as a recluse, living alone in a rented room near downtown Ottawa. One colleague recalls he used to go out every day to shoot a roll of film, which he developed, printed, and then threw out. Ashton went to work for the federal government in 1913; he spent five years in military service during the First World War, and joined the then Civil Service Commission in 1919. During the 1930s he was a member of The Camera Club of Ottawa, and in 1946, he was one of eleven members to secede and form the f11 Camera Group.

Ashton preferred the more manipulative methods of producing prints, particularly the gum bichromate and bromoil transfer processes. He produced hundreds of prints, but exhibited little. Upon Ashton's death, his camera club colleague and close friend, Ted Walsh, salvaged hundreds of Ashton's prints, several of which were exhibited in 1971 in the 75th anniversary exhibition of The Camera Club of Ottawa. Ironically, it is these and the large collection of gums and transfers that were never exhibited for which Ashton deserves recognition. *JMS*

COLLECTIONS

NATIONAL GALLERY OF CANADA
F.G. Ashton Collection (P75:022:1-70) contains 70 prints, mostly bromoil transfers and gum bichromates dating from the thirties.
PUBLIC ARCHIVES CANADA
Ottawa Camera Club Collection (Acc. No. 1971-161), a collection of 256 prints from The Camera Club of Ottawa exhibit "Seventy-Five Years of Photography" contains 16 prints by F.G. Ashton.
Edward C. Walsh Collection (Acc. No. 1982-259) contains 32 prints, mostly bromoil transfer, gum bichromate and carbon, by F.G. Ashton.

J. Ballantyne

BALLANTYNE, James
(9 March 1835, Newcastleton, Scotland — 6 April 1925, Ottawa, Ontario);
BALLANTYNE, Isa May
(1864-1929)

James Ballantyne emigrated to Canada with his parents about 1840. He grew up on the family farm near Smiths Falls, and moved to Ottawa in 1863. In partnership with his brother Thomas, he established a cooperage factory, J. and T. Ballantyne, which came to specialize in selling fuel and was active until the 1960s.

James Ballantyne was one of the original members of the Ottawa Camera Club, established in 1894. Ballantyne's daughter May was Vice-President of the club in 1898-1899, and his son Adam was Secretary in 1899-1900. *PR*

COLLECTIONS

PUBLIC ARCHIVES CANADA
James Ballantyne Collection (Acc. No. 1980-232) consists of 592 negatives and 145 lantern slides, illustrating the daily life of the Ballantyne family and their relatives and friends, as well as street scenes, landscapes and events in and around Ottawa, 1889-1916.

BARRACH, Aaron Meyer
(7 April 1900, Glasgow, Scotland — 12 June 1983, Hamilton, Ontario)

Meyer Barrach traced his interest in photography to his schooldays in Glasgow. At that time, negatives of English and Scottish soccer teams were sold in stores, and it was a popular school-yard activity to produce photographs of favourite teams using printing-out paper. Barrach moved to Canada in 1912 and became involved in the Hamilton Camera Club when it was first re-organized in 1932, at a meeting in Walter Hill's camera store with Leonard Davis, Art Lomax and a handful of others. He served as Secretary of the club in 1937, Vice-President in 1938, and President in 1939, and continued to be an active member thereafter. From box camera beginnings, Barrach turned to the 2 1/4"-square format of a twin-lens Rolleiflex.

During the 1930s, his prints were shown at the major annual salons in Toronto, Hamilton, London and Vancouver. *JMS*

COLLECTIONS

PUBLIC ARCHIVES CANADA
A.M. Barrach Collection (Acc. No. 1982-112) consists of 8 mounted salon prints, *c. 1933-43*.
A.M. Barrach Collection (Acc. No. 1983-108) contains one copy negative made from a portrait of Barrach, *c. 1933*.
PRIVATE COLLECTIONS

BAYLEY, William Braybrooke
(22 July 1857, Manchester, England — 8 February 1939, Toronto, Ontario)

W. Braybrooke Bayley emigrated to Canada with his parents in 1858. The family settled first at Montreal, then moved to Toronto in 1868. Bayley studied at the Ontario College in Picton before embarking on a career as an importer and exporter in Toronto. An accomplished musician, he was at one time the organist and choirmaster of All Saints Church in Toronto.

Joining the Toronto Camera Club on 7 December 1891, Bayley became one of the foremost amateur photographers in Canada, winning medals and prizes in many photographic salons and exhibitions in both Canada and the United States, particularly between 1893 and 1895. An extensive personal journal/scrapbook of photographic processes is part of the National Photography Collection at the Public Archives of Canada. *PR*

COLLECTIONS

PUBLIC ARCHIVES CANADA
W. Braybrooke Bayley Collection (Acc. No. 1979-318) consists of 173 original prints, illustrating the activities of the Bayley family at their cottage near Long Branch, Ont., as well as landscapes and genre subjects near Long Branch, *c. 1883-1896*.

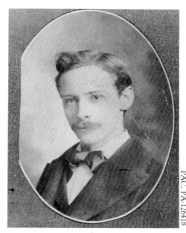

BEALES, Arthur
(10 October 1871, Brentwood, Ontario — 6 October 1955, Toronto, Ontario)

From 1898 to 1914, Arthur Beales worked for the Canadian Photo-Engraving Bureau, later known as the Alexander Engraving Company, in Toronto. He devoted much of his leisure time to amateur photography, recording landscapes in and around Toronto as well as the activities of his family and friends, and attempting his first colour photography in 1910. Moreover, he painted in both watercolours and oils, taking lessons from the artist T. Mower Martin.

In July 1914, Beales joined the Blueprint and Photographic Department of the Toronto Harbour Commission, making photography not only his avocation but also his profession. For the next 35 years he photographed the development of port facilities, and industrial and recreational areas on the city's waterfront.

Despite the loss of his left eye in an accident in March 1920, Beales continued to perform his duties. Hampered by losing his depth of vision, he at first used a piece of string knotted at regular intervals to measure distances when photographing, and later bought a Kodak 35mm single lens reflex camera fitted with an Anastar 50mm lens and a range-finder. Matters of medical treatment, insurance, compensation, and pension were a source of constant worry to Beales up to the time of his retirement from the Harbour Commission in 1951. *PR*

COLLECTIONS

PUBLIC ARCHIVES CANADA
Arthur Beales Collection (Acc. No. 1979-153) consists of 205 negatives, *c. 1890-1914*, illustrating the daily life of the Beales family and relatives, as well as buildings and landscapes in and around Toronto, and interior views of the studio of the artist T. Mower Martin.
Toronto Harbour Commissioners Collection (Acc. No. 1975-323) Consists of five colour transparencies of landscapes in southern Ontario taken by Beales in 1910.
Toronto Harbour Commissioners Collection (Acc. No. 1975-158) consists of 1211 negatives duplicated from originals held by the Toronto Harbour Commissioners, and illustrating all aspects of the developments of the Port of Toronto from 1910 to 1948. The majority of photos are by Beales.
TORONTO HARBOUR COMMISSION
Toronto Harbour Commissioners Collection consists of 13,000 original negatives, the majority by Beales, illustrating the development of the Port of Toronto from 1910 to 1950.

BETHUNE, Edith Hallett
(3 November 1890, D'Escousse, N.S. — 28 February 1970, Berwick, N.S.)

Edith Hallett Bethune was the wife of Dr. R.O. Bethune, "a poor country practitioner" in Berwick, N.S., an Annapolis Valley town with a population of about 650. Independent in spirit, and far ahead of her time, she often photographed the family's pets and her three children, as well as the Micmac children she found in her husband's waiting-room. She also enlisted a neighbour to dress in Acadian costume and pose for such award-winning prints as *Evangeline before Blomidon* and *The Lantern*.

From a box camera, Bethune progressed to a folding Kodak 116 and, by the late thirties, a 3 1/4" x 4 1/4" Graflex. Her earliest exhibition prints were essentially snapshots, developed and printed commercially, and her photo-essays won first prize for both "Portraits" and "Landscapes or Marine" at the provincial exhibition in Halifax.

Throughout the thirties and forties, Bethune's work was seen at the Hamilton Camera Club's Canadian Salon of Photography, the National Gallery's Fourth and Fifth Canadian International Salons, the 1939 "All Canadian" Toronto Salon of Photography, and the exhibitions of the Sydney Photo Forum and the Nova Scotia Salon of Photography in Halifax. Her work was published in *American Photography, The American Annual of Photography*, and *Photo-Era Magazine*.

Working in isolation at first, Bethune later became associated with the Annapolis Valley pictorialists based in Kentville. She enjoyed hand-colouring her black and white prints, sometimes producing coloured versions of her better known salon work, other times producing small coloured landscapes for framing. Many of her negatives were inadvertently destroyed after her death in 1970; however, a collection of her prints was preserved by her son, Dr. John E. Bethune. *JMS*

COLLECTIONS

PUBLIC ARCHIVES CANADA
Edith Hallett Bethune Collection
(Acc. No. 1979-276) consists of
one hand-tinted print entitled
Orchard. St. Berwick, N.S., found
in an antique store in London,
Ontario.
Edith Hallett Bethune Collection
(Acc. No. 1982-113). On loan to
the National Photography
Collection is a collection of 104
prints by Edith Hallett Bethune,
including 8 hand-coloured prints,
some 40 salon prints, an album of
30 prints entitled "A Family
Gathering — New Year — 1934"
and two award-winning photo-
essays as well as a "Diploma
awarded for Exceptional
Photographic Art" from the 1933
Century of Progress International
Photographic Salon at the Chicago
World's Fair.
Edith Hallett Bethune Collection
(Acc. No. 1983-78) contains copy
negatives of two original
photographs of Bethune, c. 1935,
1950.
PRIVATE COLLECTIONS

BOORNE, William Hanson
(3 December 1859, Bristol,
England — 1945, England)

W. Hanson Boorne was
educated as a chemist and took
up photography as a hobby
while still a young man. In 1882
he emigrated to Manitoba,
homesteading for several years at
Bird's Hill, until in 1885 or 1886
he went to Calgary. He
persuaded his cousin, Ernest G.
May, to join him there and the
professional photography studio
of Boorne and May flourished
until 1893 with a branch studio
in Edmonton. Boorne was
probably best known for his
photographs of the Sun Dance
ceremony of the Blood Indians,
for which he won a gold medal
at the Chicago World's Fair in
1893. *AJB*

COLLECTIONS

NOTMAN PHOTOGRAPHIC
ARCHIVES, McCORD MUSEUM
W. Hanson Boorne Collection
consists of approximately 40
original prints dated 1882 to 1886,
all from Boorne's amateur days.

GLENBOW-ALBERTA ARCHIVES
(Acc. No. PD-5). An album
containing approximately 380
views by the studio of Boorne and
May taken along the CPR.
ALBERTA PROVINCIAL ARCHIVES
Ernest Brown Collection contains
photographs by Boorne and May.

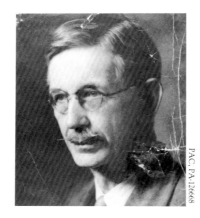

PAC, PA-126668

BOULTBEE, Horace (1875,
Bangalore, India — 1965,
Toronto, Ontario)

A journalist with the Toronto
Globe in 1898, Horace Boultbee
was later posted to Ottawa as
parliamentary correspondant.
There he remained (having
moved to the *Mail and Empire* in
1904), until in 1907 ill-health
forced his premature retirement.
There too he photographed with
his fellow journalist M.O.
Hammond, and created some of
his most impressive extant work.
On his return to Toronto he
joined the Hugh C. Maclean
Publishing Co. as managing
editor. In 1919, he became
associated with the
Lumberman's Credit Bureau Inc.,
with which he remained until
1958.

Most of Horace Boultbee's few
remaining prints, made between
about 1900 and 1906 while he
was still a young man, show a
level of technical and artistic
competence indicating either
years of experience or natural
aptitude. Boultbee's favoured
printing method seems to have
been the gum bichromate print,
rarely used by other Canadians.

Boultbee's darkroom included
an enlarger, a piece of

equipment not then usually
owned by amateurs. He used a
number of different cameras
over the years: a 4'' x 5'' view
camera which took glass plates,
an Ansco roll-film camera, and a
Voigtländer of unknown size. He
also had access to the
equipment of the Toronto
Camera Club, which listed him
as a "lifetime member" in 1923.
He exhibited very little,
apparently being content to turn
out excellent work for his own
enjoyment and that of his
friends. *ACR*

COLLECTIONS

PUBLIC ARCHIVES CANADA
Horace Boultbee Collection (Acc.
No. 1980-240) includes c. 50
prints, many gum, and some,
including beautifully finished
platinums, in a small album taken
mainly in Ottawa and area at the
turn of the century.
ARCHIVES OF ONTARIO
M.O. Hammond Collection (Acc.
No. 6355) A mixed collection of
albums containing over 2500
prints, made primarily by
Hammond in the period
1900-1930. One of the albums,
with work by Horace Boultbee
and possibly others, is incorrectly
attributed to Hammond.

AO

Jno Boyd (signature)

BOYD, John
(22 December 1865, Emyvale,
Ireland — 14 April 1941,
Toronto, Ontario)

During the 1870s John Boyd
accompanied his parents from
Ireland to Canada and the
Parkdale district of Toronto.
Boyd left school in 1881 at the
age of fifteen to work as a
messenger in the Toronto freight
office of the Grand Trunk
Railway. In subsequent years he
achieved increasingly responsible
positions: appointed Super-
intendent of the Weighing
Department of Canadian
National Railways in 1918, he
held that position until his
retirement in 1931.

Boyd was a naturalist and
taxidermist who collected and
studied birds and small animals.
In 1888 he took up photography,
specializing at first in nature
photography but also recording
family activity and subjects of a
more general nature. Moreover,
on business trips with the G.T.R.
throughout eastern Canada and
the United States he always
carried a camera. On a visit to
Rochester, N.Y., he met George
Eastman of Kodak fame, and the
two men frequently corre-
sponded about matters of
photographic technology.

Like Eastman, Boyd was an
innovator, constructing his first
camera from a box fitted with a
pinhole and covered with black
oilcloth. In later years, he
designed and built such items of
equipment as an exposure
timing chart, a lens shade, and a
fixing tank, communicating the
results to others by articles in
publications like *The American
Annual of Photography*. During
the 1930s, he was one of the
first in Canada to master and use
the Dufaycolor process.

Boyd applied to his
photography the same patience
with which he observed wildlife.
Moreover, he had a strong sense
of composition, undoubtedly
strengthened by his long
friendship with the artist
Frederick Challener. He died at
seventy-six, leaving behind him
more than thirty thousand
negatives and prints
documenting over fifty years of
life in Canada. *PR*

COLLECTIONS

PUBLIC ARCHIVES CANADA
John Boyd Collection (Acc. No. 1971-120) consists of 28,964 negatives, illustrating the daily life of the Boyd family, as well as views of cities and towns in Ontario, Quebec and the United States, and documentation of a variety of subjects, notably rail and marine transportation. Inclusive dates are 1888-1920.

ARCHIVES OF ONTARIO
John Boyd Collection (Acc. No. 9912) consists of 1,087 original prints of urban and rural views in Ontario, as well as fishing and camping activity, *c.* 1880-1930.

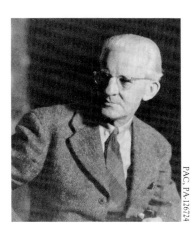

PAC. PA-126724

BRIGDEN, Alfred (4 September 1880, Meadowvale, Ontario — 15 January 1952, Toronto, Ontario)

Alfred Brigden, educated in Streetsville, Ontario, moved in his twenties to Montreal to take a job as a commercial artist with a newspaper. There he joined the Montreal Amateur Athletic Association Camera Club and began a long and distinguished involvement with photography. In 1909, he served as Treasurer of the club and won two medals for his prints. He married the following year, and in 1911 moved to Toronto where he immediately joined the Eatonia Camera Club. By the end of the decade he had begun active membership in the Toronto Camera Club; over the next twenty years, he held many executive positions, including Vice-President and President

during the 1920s and Director in the early 1930s. He served on the Salon Committee of the Toronto Salon, judged monthly print competitions and gave demonstrations, lectures and one-man shows. His hobby led him to a career in the new field of commercial photography, and for 38 years he worked for the firm of Photo Engravers and Electrotypers Ltd., Toronto.

Chairman of the Ontario Society of Photographers, and around 1939 becoming an Associate in The Royal Photographic Society, in 1945 he was one of the first two Canadians to be awarded the degree of Master of Photography by the Photographers Association of America.

Although not a prolific exhibitor, by 1930 he had clearly established a reputation as one of Canada's leading pictorialists, and one of the few achieving success with both bromoil and paper negative processes. *JMS*

COLLECTIONS

PUBLIC ARCHIVES CANADA
Alfred Brigden Collection (Acc. No. 1979-286) contains 11 salon prints from the twenties and thirties, 13 photographic Christmas cards or card enclosures and four photographs of Alfred Brigden, as well as his M.Photog. diploma, four medals and a 1933 newspaper clipping from the Toronto *Telegram* which featured two of Brigden's prints, including *Mickey on the Spot.*

CANNON, Thomas

Which of two generations of Thomas Cannons was the photographer is not yet known. He was either Thomas Edward Cannon, Junior (1866, England — 19 March 1956, Toronto, Ontario) or his son Thomas Hamilton Cannon (d. 6 February 1946, Toronto, Ontario). Perhaps both men were amateur photograpers.

In 1871, Thomas E. Cannon, Junior, came to Toronto, to the Seaton Village district. He joined his father's construction

company, T. Cannon & Son, about 1887, and five years later became a member of the city's Builders Exchange. From 1914 to 1925, he served as president of the family firm, which became a cartage company for the last five years of its existence. He came briefly out of retirement to serve as vice-president of his son's garage and cartage business, Thomas H. Cannon Limited, from 1931 to 1933. Cannon was a member of the Toronto Camera Club from 1908 to 1913, probably resigning his membership at that time because of the pressures of business. He specialized in lantern slides, four of which appeared in the New York Lantern Slide Interchange of 1913. Cannon's other memberships were notable for their longevity: Sons of England, Surrey Lodge, 71 years; Church of the Epiphany, Parkdale, 67 years; Alpha Lodge, A.F. & A.M., 55 years; High Park Club, 38 years.

During 1914 and 1915, Thomas H. Cannon was a commercial traveller with Contractors Supply Company of Toronto. Both he and his brother Fred served with No. 599 Company of the British Army Service Corps, a motor transport unit, in the East African campaign during 1916 and 1917. He was probably the person responsible for the many photographs of the campaign which form part of the National Photography Collection's Thomas Cannon Collection. From 1923 to 1930 Cannon was a cartage agent in Toronto. He operated his own short-lived garage and cartage business, from 1931 to 1933 as president and secretary-treasurer. There followed a series of jobs: cartage agent 1936-1939; truck driver 1939-1940; manager of Lakeshore Taxi Company 1941-1946. *PR*

COLLECTIONS

PUBLIC ARCHIVES CANADA
Thomas Cannon Collection (Acc. No. 1972-287) consists of 730

lantern slides (1909-1917): views of Toronto and vicinity, photographs of a wide variety of sports, views of New York City and Washington, photographs of the activities of the Grenfell Mission in Labrador, and photographs of the operations and personnel of No. 599 Company, British Army Service Corps, in East Africa during World War I. There are also 14 colour slides.

PAC. PA-112016

CARTER, Sidney Robert (18 February 1880, Toronto — 27 March 1956, Montreal)

In 1897, the *Toronto Business Directory* lists Sidney Carter as a "clerk." But he had discovered his talent for photography early; in 1901, he exhibited at the Royal Photographic Society in London and in Philadelphia. By 1902, Carter was exhibiting with the Toronto Camera Club and in the Philadelphia Salon; he was represented the next year in the "first Salon" of the Toronto Camera Club, as well as in Chicago. His activity and talent in the direction of pictorial photography were so well received by 1904 that he was elected an Associate of the Photo-Secession in New York.

From 1904 to 1906, Carter exhibited with the Canadian Society of Applied Art, with the Toronto Camera Club (where he also served on the Executive Committee), and in Philadelphia, London, Vienna, and, with the Photo-Secession in New York. Imbued with dedicated pictorialist ambitions, he was an originating force behind the establishment of "The Studio Club" in Toronto, which was intended as a Canadian version of the Linked Ring in England. During at least part of this time, he earned his living at the Ontario Bank in Toronto. In November of 1906, however, the bank failed and he found himself unemployed. He immediately moved to Montreal to begin a partnership in professional portraiture with Harold Mortimer-Lamb.

The venture was unlucky from the beginning, whether because their style was too advanced for their market or because Mortimer-Lamb had other concerns. Their partnership stayed alive if not vital for about a year. Yet within that time Carter had engineered the successful opening of Canada's first pictorialist exhibition. This had taken place between 23 November and 7 December 1907, in the galleries of the Art Association of Montreal. Carter's activities in 1907 also included writing the Canadian chapter for *Photograms of the Year* and organizing the Canadian section of the Royal Photographic Society show in London. Despite these herculean efforts, and Carter's coup of a Rudyard Kipling portrait taken during the poet's visit to Montreal in 1907, the city's buying public preferred other photographers.

In 1908, Carter was employed in an office of the Canadian Pacific Railway, and early in January 1909, he began working for W. Scott & Sons, fine art dealers with offices in Montreal, Toronto and Ottawa. Hopes of a professional photography career were put away until about 1917.

Possibly visits to Toronto in 1909 (one extended by a bout of smallpox) caused him to be listed as an "artist" in that city in the *Toronto Business Directory*. However, Montreal was still his home. By 1917, he was an "artist" at "344 Dorchester, W." and in 1918 an "art and antique dealer" at "340 Dorchester W.." This period marked his re-entry into professional portrait photography in Montreal. Pictorialism had acquired some vogue among professionals, and over the next twelve years or more Carter was able to produce a long series of society portraits and images of prominent personalities such as Serge Prokofieff, Bliss Carman, Percy Grainger and John Singer Sargent. By this time some of the disturbing haunting quality of Carter's style had been replaced by a firmer outline and an interest in graphic effect. He kept up his amateur photography for some time, submitting prints to the Toronto Camera Club's 1930 all-Canadian exhibition.

As an art dealer, however, Carter achieved a reputation for having fine objects, particularly from the Orient. He managed to maintain his business through some monetary reverses and through the Depression, despite an unbusinesslike attitude which was apt to lead him to give works away or to sell low to those who appreciated art. He liquidated the stock of his studio/gallery, just two years before his death in 1956. *LK*

COLLECTIONS

PUBLIC ARCHIVES CANADA
Sidney Carter Collection (Acc. Nos. 1979-56, 1979-57, 1979-87, 1979-111, 1979-128, 1981-74) Taken together, the collections contain *c.* 420 prints, mostly by Carter.
METROPOLITAN MUSEUM OF ART, NEW YORK, U.S.A.
One print in the Stieglitz Collection
PRIVATE COLLECTIONS

PAC. PA-123284

R. S. Cassels.

CASSELS, Richard Scougall
(5 October 1859, Holland House, Quebec — 17 July 1935, Toronto, Ontario)

Richard Cassels was born at Holland House near Quebec City. A graduate of the University of Toronto and of Osgoode Hall, he was called to the Ontario Bar in 1883, and subsequently for fifty-two years practised law with the firm of Cassels, Brock and Kelley in Toronto. Cassels served as a lieutenant with the Queen's Own Rifles during the Northwest Rebellion of 1885. He was one of the founders of the 48th Highlanders of Canada, attaining the rank of captain with that regiment. He was a life member of the Royal Canadian Military Institute.

Cassels was elected a member of the Toronto Camera Club on 10 April 1897. He was a noted photographer of wildflowers, and illustrated J.E. Jones' handbook *Some Familiar Wild Flowers*, published in 1930. He bequeathed an extensive collection of botanical slides to the Department of Botany of the University of Toronto. *PR*

COLLECTIONS

PUBLIC ARCHIVES CANADA
Richard S. Cassels Collection (Acc. No. 1979-316) consists of 332

original prints, illustrating the daily life and residences of the Cassels family in Toronto, portraits of family and friends, as well as a fishing trip by Richard Cassels and friends to the Temagami district of Ontario. Inclusive dates are 1893-1906.

PARC

CLAUDET, Francis George
(1837, England — 1906, England)

Francis Claudet was born in England, the son of Antoine François Jean Claudet, one of the foremost portrait photographers of the time. He trained as a mining engineer and metallurgist and in October, 1859, he was appointed Assayer in the Government Refinery and Assay Office to be established at New Westminster, British Columbia. His initial appointment was for two and a half years, but he stayed until 1873, taking on as well a number of other positions: Justice of the Peace, Coroner, and Assistant Commissioner of Lands and Works. In 1873 he returned to England and remained there until his death in 1906.

Claudet obviously learned photography from his father and on arriving in British Columbia soon sent for his equipment. He made numerous photographs of New Westminster and other localities in the colony and surrounding area. During his stay there he was called on to take photographs for the 1862 Industrial Exhibition in London,

where his work received an honourable mention. *AJB*

COLLECTIONS

PROVINCIAL ARCHIVES OF BRITISH COLUMBIA
The two Francis G. Claudet Albums (Acc. No. 98201-79) contain numerous original prints as well as some copy prints. There is also an album (Acc. No. 98201-91) containing six original prints by Claudet.
UNIVERSITY OF BRITISH COLUMBIA, SPECIAL COLLECTIONS
The Special Collections has approximately 10 original prints by Claudet.

CONSTANTINE, Henrietta
(fl. 1906-07)

Henrietta Constantine was the wife of Charles Constantine (1894-1912), who served with various Canadian policing forces in the west, eventually joining the North West Mounted Police as an inspector. He later became Superintendent of various divisions in the Yukon and the Northwest Territories, commanding detachments at Fort Saskatchewan (1901-05), Lesser Slave Lake (1905-07) and along the Peace River-Yukon Trail (1904-07). Mrs. Constantine seems to have regularly accompanied her husband, as implied in her letter to Edward Deville, dated March 27, 1907 (PAC, RG15, C2, file 1667):

> As I am again in one of the outside posts — and a Kodak fiend — tho I only began last June — I enclose a couple of my snapshots. . . . There is so much to learn in Photog'y — but I shall keep on trying — it is my only pleasure here.

Nothing else is known at the moment of Henrietta Constantine's life, although an examination of her husband's papers in the Public Archives of Canada (MG 30, E55) might be more revealing. *LK*

COLLECTIONS

PUBLIC ARCHIVES CANADA
Henrietta Constantine Collection (Acc. No. 1969-133) contains six postcard-size views.

CONWAY, George Robert Graham (28 April 1873, Southampton, England — 20 May 1951, Mexico City)

George Conway was trained in civil engineering. After work as municipal engineer in several English and Scottish cities, he went to Mexico in 1907 as chief engineer of the Monterey Railway Light and Power Company. In 1909 he came to Vancouver, where he worked as chief engineer and assistant manager of the British Columbia Electric Railway Co. Limited. He moved to Toronto in 1916 where he established a consultancy, but returned to Mexico in 1917 as managing director and, later, president of the Mexican Light and Power Company.

Conway was active in many fields and had a wide variety of interests. A major avocation was researching Mexican history, particularly the relationships between Britain and Mexico. The numerous transcript and original documents he amassed have been deposited at the Library of Congress, Washington, D.C., and at university libraries and institutes in London, Cambridge, Aberdeen, Tulsa, Oklahoma, and Monterey, Mexico. Whether Conway's own personal papers have been collected is unknown. Thus while a great deal can be inferred about the man's public and professional life, his activities as an amateur photographer can be deduced only from the photographs themselves.

As far as is known, the Public Archives Canada has the only extant collection of Conway's photographs; his work from 1913 and 1914 provides the earliest dated Autochromes available there. From the technical control evident it seems that he had considerable earlier experience as an amateur photographer. The photographs in the collection appear to be of his family and home; two of them

may be self-portraits. Some evidence that he was interested in using the camera for his professional work can be seen in views of the Coquitlam electric development in British Columbia, as well as in some black-and-white lantern slides of Mexican installations.

In 1915 Conway wrote two books: *Water Powers of Canada; Province of British Columbia*, and a *Report on Coquitlam-Buntzen Hydro-Electric Development, B.C.*, prepared for the federal government as Water Resources Paper No. 13. The former contains numerous photographs of the Coquitlam-Buntzen project but, as none of them is credited, attribution to Conway is uncertain. *ACR*

COLLECTIONS

PUBLIC ARCHIVES CANADA
G.R.G. Conway Collection (Acc. No. 1980-22) includes c. 15 Autochromes made in Vancouver, B.C., and area, as well as several lantern slides, some humorous, some of Mexico.

COTTER, James L.
(? India — 6 August 1889)

James Cotter was born in India, the son of a Scot employed by the East India Company. He came to Canada in 1857 and with the aid of his uncle, the Honourable John Stewart, he secured a position as apprentice clerk with the Hudson's Bay Company. He served in a wide number of posts until October, 1867, when he was appointed to Moose Factory. In 1872 he went to the Eastmain District, serving at Fort George and Rupert's House until 1879 when he returned for a further ten years to Moose Factory. He rose through the Company ranks, becoming a Chief Factor in 1883.

Cotter appears to have taken up photography after arriving at Moose Factory. From that point on he was an avid photographer, recording life in and around the various posts where he served. He seems to have had a

particular interest in photographing the Inuit. Cotter continued his hobby until his death, leaving behind a valuable, if scattered, record of the northern posts. His work was published in the form of engravings in the *Illustrated London News* and in several annual reports of the Geological Survey of Canada. *AJB*

COLLECTIONS

PUBLIC ARCHIVES CANADA
Montreal Book Auctions Collection (Acc. No. 1977-216) contains 6 views by Cotter.
NOTMAN PHOTOGRAPHIC ARCHIVES, McCORD MUSEUM
William Bell Malloch Collection. contains 35 original prints by a number of Hudson's Bay Company employees including Cotter.

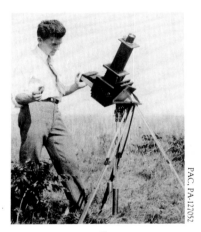

PAC, PA-127052

CROFT, Philip James
(b. 24 November 1901, Weybridge, Surrey, England)

Philip Croft's sister gave him "a little box camera" when he was 10 years old, and his aunt taught him the fundamentals of taking pictures and developing plates. In 1920, when he moved to Canada to begin an engineering apprenticeship at Westinghouse in Hamilton, Croft brought with him his mother's folding Kodak #1A. Though interested in photography, he did not become active in camera clubs or

pictorial work until the 1930s. He moved to Montreal in 1927 to take up a position with the city's power commission, and in 1932 was one of a small group responsible for reviving the Montreal Camera Club. He served as Secretary of the club from 1933 to 1935, and then as President from 1937 to 1939; in 1942, he was named an Honorary Life Member.

In 1945 Croft moved to Toronto, where he promptly joined the Toronto Camera Club. Apart from his own pictorial photography and his partici- pation in the monthly print critiques of the Montreal and Toronto clubs, Croft drew upon his interests in physics, optics and chemistry to give classes in photographic technique. These lectures were later collected and published; few copies have survived. Croft combined his interests in colour photography and natural history, but increasingly wildflowers, butter- flies and insects became his absorbing interest. Finally, when he moved to the west coast in 1957, Croft joined, not the local camera club, but the natural history society.

Croft used a number of different cameras, but discovered early that he could do good work with simple equipment. He preferred to produce pictorial work in quarter-plate format using a series D Graflex. Croft made his own photographic solutions from pure chemicals, and dabbled with bromoil, carbro and paper negatives. Much earlier than most of his Canadian contemporaries, he became interested in colour photography, exploring the gamut of materials and processes — from hand-tinted lantern slides to wash-off relief prints, Dufaycolor, and Agfacolor.

During the "Dirty Thirties" when work was slow, Croft put his photographic talents to good use on some advertising and fashion photography. Enamoured of the work of such greats as Steichen, Fassbender and

Mortensen, Croft sheepishly admits he was "a little bit apt to imitate some of their work." Regarding pictorial photography, he believed that out-of-focus was not soft or diffused, merely out- of-focus, and that needle-sharp negatives were required before pictorial effects were added in the printing. *JMS*

COLLECTIONS

PUBLIC ARCHIVES CANADA
Philip J. Croft Collection (Acc. No. 1981-84) comprises 28 b/w and 4 colour salon prints, and 1 Agfacolor and 28 Dufaycolor transparencies.
Philip J. Croft Collection (Acc. No. 1981-264) contains two colour snapshots of Philip Croft taken 27 January 1981 in his home in West Vancouver.
Philip J. Croft Collection (Acc. No. 1983-77) consists of copy negatives of five photographs of Croft, 1932-1967.
PRIVATE COLLECTIONS

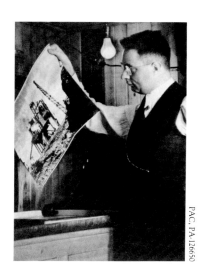

PAC. PA-126650

DAVIS, Leonard (b. 9 December 1906, Hamilton, Ontario)

By the age of 12, Len Davis and a school chum had already begun a photo-finishing service for neighbours, teachers and friends. In "shop" class, he built his own contact-printer and the wooden parts for an enlarger. After using a succession of cameras, including a Baby Box Brownie, a folding Kodak, the popular Graflex and a vest pocket Kodak, Davis purchased

his first Leica in 1929. A zealous convert to the 35mm format, Davis introduced the Leica to many of his Hamilton colleagues. In 1932, Davis was a founding member and first President of the reconstituted Hamilton Camera Club, and quickly became a moving force behind the club's annual Canadian Salon of Photography.

In the thirties, Davis exhibited bromide enlargements and in the mid-forties he experimented with paper negatives. His work was shown across Canada and the United States as well as in France, Spain and Monaco. He became an Associate of the Royal Photographic Society in 1937 and was made an Honorary Life Member in 1980. In 1960, Davis moved to Dwight, Ontario, where he joined the Huntsville Camera Club; more recently he became active in the Muskoka Photographers' Guild and a member of the National Association for Photographic Art. Davis contends "a photographer must have a darkroom" and, apart from his early brush with Dufaycolor, he never became interested in slide photography. Particularly interested in the technical aspects of photo- graphy, Davis continues to experiment in and lecture on sensitometry and densitometry. *JMS*

COLLECTIONS

PUBLIC ARCHIVES CANADA
Leonard Davis Collection (Acc. No. 1983-26) comprises 39 mounted salon prints, including 7 prints exhibited at the Hamilton Camera Club's first salon in 1933. Also included is an uncut strip of 46 exposures of 35mm Dufaycolor slides and three bronze medals won in photographic competitions.
Leonard Davis Collection (Acc. No. 1983-55) includes half a dozen paper negative prints from the mid-forties among over one hundred salon prints from the period 1934 to 1953.
Arthur H. Tweedle Collection (Acc. No. 1983-90) contains a portrait of Tweedle taken by Leonard Davis in November 1969.

Otto J Eaton, A.R.P.S.

EATON, Otto John
(18 September 1895, Toronto, Ontario — 7 November 1982, Toronto, Ontario)

Otto Eaton was educated in the public schools of Toronto and, after graduation, was immediately employed by Eaton's department store. A conscientious objector during the First World War, he worked on a farm near Goderich, Ontario. After the war he returned briefly to Eaton's and then became office manager of a Toronto-based mattress factory. In 1930 he returned to Eaton's where he remained until his retirement in 1960 from a very senior position. From then until his death he worked for the Clarkson Co. Ltd., rescuing small firms headed for receivership.

He began amateur photography around the age of fifteen, using a box Brownie. When he had completed the first roll of film, he opened the camera, expect- ing to find the prints ready and waiting. From this inauspicious beginning, he quickly acquired sufficient expertise to process film for a neighbourhood drug- store. Before the First World War he joined the Eatonia Camera Club. By 1923 he became a member of the Toronto Camera Club, but left after two years to work on his own.

During the Depression, the T. Eaton Company cut its employees' salaries, and Eaton began working part-time as a professional photographer. Having served his apprenticeship as a professional, he rejoined the Toronto Camera Club in the late 1930s. In the early 1940s he was elected President, and from 1963 he acted as Treasurer or Honorary Treasurer. For many years, he was also a member of the Eaton's Camera Club, serving as its President. About 1939 he was elected an Associate of the Royal Photographic Society.

Although he had been successful in competitions as early as 1913, it was not until the late 1930s that Eaton began extensive salon exhibiting. His subjects were generally scenic or architectural views, or portraits. His approach, whether in monochrome prints or colour slides, was always straightforward, though the "grounding in pictorialism" of his juvenile years remained. *ACR*

COLLECTIONS

PUBLIC ARCHIVES CANADA
Otto John Eaton Collections (Acc. Nos. 1982-116, 1982-117) The two collections include *c.* 80 salon prints, selected by Eaton as his best work.

ELLIS, William Hodgson

(23 November 1845, Bakewell, England — 23 August 1920, Lake Joseph, Ontario)

William Ellis accompanied his parents to the United States in 1854. The family spent six years on a farm near Bloomington, Illinois, before moving to Canada, first to Guelph and, in 1863, to Toronto. That year, Ellis entered the University of Toronto, receiving in 1867 a B.A. degree with Gold Medal in Natural Science. Postgraduate studies resulted in an M.A. in 1868, an M.B. in 1870, and an L.R.C.P. in 1871 after studies at St. Thomas' Hospital in London, England.

Upon returning to Toronto, Dr. Ellis embarked upon a long and distinguished academic career at the University of Toronto; he was also a member of the University Senate for over thirty years. From 1876 to 1907, Dr. Ellis was Public Analyst for the Department of Inland Revenue, performing most of the chemical analyses in criminal cases prosecuted by the Attorney General of Ontario; and he was a member of many learned societies.

Dr. Ellis was also one of the early members of the organized amateur photography movement in Canada. He joined the Photographic Section of the Canadian Institute formed in 1887, and in the following year became a member of that organization's successor, the Toronto Amateur Photographic Association, serving first on the Executive Committee and then in 1890 being elected to the post of Vice-President. After the Association changed its name to the Toronto Camera Club in December 1891, Dr. Ellis remained active in its leadership, as a member of the Executive Committee in 1892-1893 and as Honorary President in 1893-1895. *PR*

COLLECTIONS

PUBLIC ARCHIVES CANADA
W.H. Ellis Collection (Acc. No. 1979-64) consists of 72 original prints, illustrating the activities of the Ellis and Mickle families at Toronto and Lake Simcoe, as well as views of the University of Toronto, and a canoe trip to Lake Temiskaming by Dr. Ellis and friends. Inclusive dates are 1889-1912.

EVANS, Nevil Norton

(28 September 1865, Montreal, Quebec — 9 September 1948, Montreal, Quebec)

Nevil Norton Evans was educated at Montreal High School and at McGill University, where he obtained a B.A.Sc. degree in 1886. He undertook further studies in chemistry at the Royal Saxon School of Mines, Freiberg, Germany, and at the University of Leipzig before returning to McGill to obtain an M.A.Sc. degree in 1892. Joining McGill's Departmen of Chemistry as a graduate assistant, Evans was appointed Lecturer in 1892, Assistant Professor in 1899, Associate Professor in 1907, and Professor in 1928. Upon completing a

record fifty years of teaching, Evans retired in 1936 with the rank of Professor Emeritus, recognized by McGill with an honorary LL.D. degree.

A member of the Montreal Camera Club, Evans served on the Executive Committee in 1895-1896 and 1898-1899. He was a pioneer scientific photographer, producing in February 1896 some of the first Röntgen (X-ray) photographs in Canada. Many of his photographs illustrate cycling excursions around Montreal and camping holidays in the Eastern Townships. *PR*

COLLECTIONS

PUBLIC ARCHIVES CANADA
Nevil Norton Evans Collection (Acc. No. 1979-304) consists of 252 original prints, illustrating Evans' life as a university student in Germany, views in and around Montreal and in the Eastern Townships of Quebec, the cycling and camping activity of the Evans family and friends, as well as some of the first X-ray photographs taken in Canada. Inclusive dates are *c.* 1890-1905.

FIELD, George Henry

(10 April 1872, Cobourg, Ontario — 16 October 1962, Toronto, Ontario)

George Henry Field was educated at Cobourg Collegiate Institute, at Victoria College in Cobourg, and at Trinity College in Toronto, graduating in 1894 with an M.D. degree with silver medal for academic achievement. During these years, one of his many hobbies was photography; he developed his own prints, entered competitions, and on 30 January 1893 was elected a member of the Toronto Camera Club.

Field completed his internship at Toronto General Hospital in 1894-1895 before spending some months as a ship's surgeon with the Furness-Withy Line on the North Atlantic. In 1896, he undertook six months of postgraduate study at Edinburgh University, obtaining the degree

of L.R.C.P. & S. Dr. Field then resumed the occupation of ship's surgeon, sailing from Tacoma, Washington, across the Pacific to Japan, Hong Kong and China.

In 1898, he returned to Cobourg and set up a medical practice which continued until 1932. During this time, he was Cobourg's Medical Officer of Health and was active in the affairs of the Cobourg General Hospital. From 1933 to 1936, Dr. Field practised at Campbellford, and in 1937 moved to Roseneath, where he remained in active practice until 1962. He retired a few months before his death at the age of ninety, having paid sixty-eight years of dues to the College of Physicians and Surgeons. *PR*

COLLECTIONS

PUBLIC ARCHIVES CANADA
George H. Field Collection (Acc. No. 1979-317) consists of 237 original prints, including activities of the Field family at Cobourg, Ont,; family portraits; views of Cobourg, Rice Lake, Winnipeg and Edinburgh; and the activities of interns at Toronto General Hospital. Inclusive dates are 1860-1895.

FLEETWOOD-MORROW, John

(b. 1909, London, England)

John Fleetwood-Morrow's interest in the graphic arts was possibly encouraged by the example of his father, an amateur painter. He acquired his first camera, a Kodak No. O, while he was a teenager, and most of his photographic technique was self-taught.

He had apprenticed in England as a photo-engraver, and after moving to Canada in 1937 he continued this work with Dominion Envelope in Toronto. In 1938 he joined the Toronto Camera Club (which elected him President in 1940-41) and began serious and extensive exhibition

work. His prints were hung in numerous Canadian, British, American, South African, and Bermudian salons during the period 1938-1942. Fleetwood-Morrow was also active in the Toronto arts community, joining the Arts and Letters Club in 1939.

In the Second World War, he joined the RCAF as a photographer, serving both in Britain and on the Continent. After his discharge, he remained in Britain until 1948, continuing his work as an engraver. However, his interest in photography gained the upper hand and by 1950, after returning to Toronto, he was employed by the T. Eaton Co. commercial studio. In 1956 he returned to the printing trade.

Interested in colour work, Fleetwood-Morrow had made tri-colour carbros in the late 1930s, and experimented with Kodachrome. During the war he used infra-red emulsions to cut through the haze of landing-beach mist and fog. He was equally interested in landscape, architectural and portrait work. Although using advanced equipment in his later professional work, he tried to convince students in his many classes and workshops that the most important factor in photography was the photographer, and not the camera. To prove his point he made numerous exhibition prints using box Brownies and other similar simple cameras. After his retirement in 1975, he moved to Perth, Ontario, where he devoted himself to painting. *ACR*

COLLECTIONS

PUBLIC ARCHIVES CANADA
John Fleetwood-Morrow Collection (Acc. No. 1980-235) includes several hundred prints, negatives and slides covering the 1930s-1960s, and concentrating on his amateur interests.

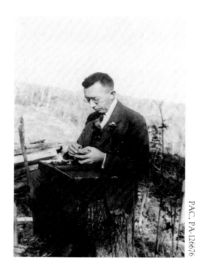

P.A.C. PA-126676

G. Gates A.R.P.S

GATES, Grant Gordon
(18 July 1895, Fairground, Ontario — 14 August 1978, Hamilton, Ontario)

Grant Gates first became interested in photography at the age of fourteen. He attended high school eight miles from Fairground, and during the school year boarded with the family of a photographer. Gates watched the man work, saved up to buy one of his old cameras, then devoted all his spare time to photography, processing his film in a piano crate that he had converted into a darkroom. After obtaining his degree in engineering from McGill University, Montreal, Gates went to work for a surveying firm in Hamilton. In the early twenties, he joined the engineering department of Stelco.

An active amateur, Gates held the positions of Treasurer, Secretary and Vice-President of the reconstituted Hamilton Camera Club during its early years, and later assumed the office of President. He participated regularly in the club's monthly print competitions, but did not exhibit widely, although his prints were hung frequently at the Toronto Salon and the Canadian Salon of Photography. At Stelco, Gates photographed steel-making in its

many aspects — foundry workers, coke ovens, blast furnaces and rolling mills — and transformed the results into a series of award-winning salon prints. Gates abandoned the company's large-format Linhof in favour of the Leica, which he found equally successful but much less cumbersome, and took with him on holidays and outings. In 1944, Gates became an Associate of the Royal Photographic Society. In later life, he turned to colour slide and nature photography. *JMS*

COLLECTIONS

PUBLIC ARCHIVES CANADA
Grant Gordon Gates Collection (Acc. No. 1979-16) contains 71 salon prints (c. 1930-1955), many of which were submitted to open exhibitions and to the monthly competitions of the Hamilton Camera Club.
Grant Gordon Gates Collection (Acc. No. 1979-287) consists of 13 glass plate negatives (c. 1908), taken by Grant Gates at Fairground, Ontario; also included in the collection are some 70 salon catalogues (c. 1934-1972) including almost a complete run for the Hamilton Camera Club's "Canadian Salon of Photography" from 1934 to 1972.
Grant Gordon Gates Collection (Acc. No. 1982-260) includes 14 miscellaneous salon prints and a half dozen snapshots by or of Gates, as well as his A.R.P.S. certificate.
PRIVATE COLLECTIONS

CTA. 92.3G No. 745

GOSS, William Arthur Scott
(4 March 1881, London, Ontario

— 1 June 1940, Toronto, Ontario)

In 1883 the Goss family moved from London to Toronto, and in 1891, after his father's death, an eleven-year-old Arthur was taken out of public school and employed by the City of Toronto as an office boy in the Engineer's Office. In one capacity or another, he continued to serve that department for the rest of his working life.

Goss' interest in photography began early, perhaps when the staff of his department began to take photographs in 1899. In 1900 and 1902 he exhibited works at the Toronto Camera Club's annual exhibitions. By April, 1904, he had become a member of the club, serving as part of the jury for the 1905 salon and as vice-president in the same year. He was also one of the founding members of the short-lived and idealistic Studio Club. He showed seven photos with the group when they exhibited with the Canadian Society of Applied Art in Toronto that year, followed by three photos with the subsequent "Photo-Club of Canada" in 1907 in Montreal. He received mention in *Photograms of the Year* for 1906 to 1908 and exhibited in England at the Photographic Salon in 1906 and at the Little Gallery in 1909. Goss exhibited with the Toronto Camera Club on a sporadic basis at least through the early 1920s. These activities certainly indicate his heavy commitment to the pictorial style, so impressively displayed in his *Child and Nurse*.

Yet Goss entirely ignored pictorialism during the course of his work as a professional photographer for the City of Toronto, a position to which he was appointed in 1911. All Goss' professional work, dating from 1911 to 1940 and totalling some 26,000 surviving items, was executed in an exactingly realistic style which contrasted starkly with his amateur pictorial work. Goss' section, the Photography and Blueprinting

Section of the City Engineer's Office, grew to include assistants and a variety of services, such as lantern slides, motion pictures and photomicrography. Unfortunately, nothing of the last two activities has survived. *LK*

COLLECTIONS

CITY OF TORONTO ARCHIVES, TORONTO
Contains the largest collection of Goss' professional negatives and lantern slides, estimated at *c.* 26,000 items.
PUBLIC ARCHIVES CANADA
Sidney Carter Collection (Acc. No. 1981-74) contains two pictorial prints by A.S. Goss.
Andrew Merrilees Collection (Acc. No. 1980-149) contains a small number of glass negatives possibly by Goss.
PRIVATE COLLECTIONS

GRANT (né Crewe), William James (1854, Somerset, England — 17 February 1936, Hamilton, Ontario)

According to his grandson, William Grant was born William Crewe but changed his name for undetermined reasons after he came to Canada in 1871. He began working on the railway almost immediately, and from the early 1880s he was the freight agent for various lines going through Hamilton. By 1890 he was an employee of the Canadian Pacific Railway, a connection broken only by his retirement in 1929. Grant was very active in his community, serving on the Hamilton School Board and becoming a founding member of the Hamilton Art Gallery. He was a noted horticulturist, and sportsman, enjoying golf tournaments until shortly before his death.

His amateur photographic career was equally vigorous. Grant was elected chairman of the executive committee of the Photographic Section of the Hamilton Association (the forerunner of the Hamilton Camera Club) in April 1892. It is apparent that his interest in photography was already well

established. His earliest surviving work dates to the turn of the century.

Grant made several trips to Europe, and some of the photographic results were shown at the Toronto and other salons. By 1914 Harold Mortimer-Lamb, reporting on Canadian pictorialism for *Photograms of the Year*, mentioned him as a coming worker. During the teens and twenties he continued to exhibit, using both recent and older negatives as the basis of his work. Unfortunately so little of this salon work still exists that it is difficult to know the range of his abilities. *ACR*

COLLECTIONS

PUBLIC ARCHIVES CANADA
William J. Grant (Acc. No. 1979-225) includes *c.* 200 prints and negatives of the family and his travels.
William J. Grant (Acc. No. 1983-27) includes six salon prints.

PAC. PA-80467

HELDERS, Johan Anton Joseph
(3 May 1888, Rhenen, Gelderland, Netherlands — 4 February 1956, Homestead, Florida)

Johan Helders began a long and distinguished career in hotel catering in his native Holland. In 1919 he took his wife and two sons to Batavia (Djakarta) in the Dutch East Indies (now Java)

where he became a hotel executive. In 1924, Helders moved his family to Vancouver, British Columbia, where he opened a restaurant. In 1926, Helders took up the post of Maître d'Hôtel at the Château Laurier in Ottawa, a position he held for thirteen years. In May 1939, Helders returned to Vancouver to become catering manager of the newly opened Hotel Vancouver until his retirement in 1953.

Helders was unquestionably Canada's outstanding amateur pictorialist during the late twenties and early thirties. His involvement with organized amateur photography began in the Dutch East Indies where he was President of the Batavia Photographic Society and originator of the Batavia Salon. He lost no time resuming his photography after the move to Canada, picking up a bronze medal in the Fourth Annual New Westminster Salon of Pictorial Photography in 1924. Helders exhibited extensively during the late twenties and early thirties. His output was prodigious; according to *The American Annual* Helders was the only Canadian to have more than 100 print acceptances in a single year. His prints were accepted at salons across the United States and Canada, throughout the British Isles and Europe, as well as in South America, Australia and Japan. During this same period, he collected awards from all the leading British and American photographic monthlies and annuals. In 1929, Helders became an Associate of the Pittsburgh Salon for the "consistent excellence" of his work. The following year, he was made an Associate and shortly thereafter a Fellow of the Royal Photographic Society. During the thirties he also held the office of Director for Canada of the Photographic Society of America. Helders was frequently asked to judge salons, and served on the jury of selection of the National Gallery's Canadian

International Salon in 1934, 1936, and 1937.

Helders was essentially a pictorialist who, refusing to leave successful shots to chance, planned his photographs beforehand. He then used a soft-focus lens on his enlarger to achieve "a pleasantly diffused image." Helders' pictorial work continued to attract attention and praise throughout the thirties, but as the decade progressed, his output declined. He adapted his style to the changing salon aesthetic, using a sharper focus and concentrating on detail, but his later efforts fell short of his earlier work. Although he continued to jury exhibitions, he exhibited little after his return to Vancouver in 1939. *JMS*

COLLECTIONS

VANCOUVER PUBLIC LIBRARY
John Helders Collection of 31 salon prints contains some of Helders' most acclaimed pictorial work.
NATIONAL GALLERY OF CANADA
Johan Helders Collection (P81:017) consists of the salon print *Evening*.
PUBLIC ARCHIVES CANADA
Ottawa Camera Club Collection (Acc. No. 1971-161) contains *Castle of Light* among the prints exhibited in the Club's 75th anniversary retrospective.
Johan Anton Joseph Helders Collection (Acc. No. 1981-44) consists of one unmounted salon print, a photograph of Helders taken at Jasper in the early fifties and a snapshot of Helders with John Vanderpant photographing on Mount Baker in the State of Washington.
Jules Alexander Castonguay Collection (Acc. No. 1965-57) contains three studio portraits of Helders taken by Ottawa portrait photographer J.A. Castonguay in 1939.
Johan Helders Collection (Acc. No. 1983-66) consists of a modern gelatin silver print from a negative made by Yousuf Karsh in 1938 of Johan Helders in Karsh's Ottawa studio.

HENDERSON, Alexander
(1831, Scotland — 4 April 1913, Montreal, Quebec)

Alexander Henderson was the son of a relatively wealthy merchant, Thomas Henderson. He trained as an accountant and emigrated to Canada in 1855. Until at least 1863 he was a commission merchant in Montreal. It is not known when he began photography, but the earliest extant photos date from 1858. The following year he was listed as a member of the Stereoscopic Exchange Club in England. From this point forward he was an active photographer and there exist a considerable number of photographs to indicate that from the beginning landscape was his passion. The climax of his amateur work was the publication of *Canadian Views and Studies* in 1865, copies of which were probably produced only on special order. This slim folio volume consisted usually of twenty prints, mounted one to a page, with a letterpress or handwritten title underneath. The photographs varied considerably from volume to volume.

In 1866 or 1876 Henderson became a professional, opening a studio in Montreal. He followed this calling until his retirement in the late 1890s, one of the few in Canada able to make a satisfactory living from outdoor photography. For several years during the 1890s he was Manager of the Canadian Pacific Railway Photography Department. *AJB*

COLLECTIONS

NOTMAN PHOTOGRAPHIC
ARCHIVES, McCORD MUSEUM
 The Alexander Henderson Collection contains approximately 800 original prints and 8 original glass negatives ranging over the whole of Henderson's career.
PUBLIC ARCHIVES CANADA
 Alexander Henderson Collections (Acc. No. 1932-468). One original print.
 (Acc. No. 1939-146). One original print.

(Acc. No. 1961-28). 30 original prints of Montreal and landscapes, c. 1865-1887.
 (Acc. No. 1968-108). *Canadian Views and Studies*.
 (Acc. No. 1975-285). 43 views of Montreal and rural landscapes, c. 1865-1885.
 (Acc. No. 1980-189). One original print of Manitoba, 1890.
 Sandford Fleming Collection (Acc. No. 1936-272) contains 179 prints, including a later copy of *Canadian Views and Studies*. The majority of the prints are commissioned views of the work along the Intercolonial Railway, 1872 and 1875.
 Thomas J. Grant Collection (1960-51). A large album containing 17 original Henderson prints, c. 1865-1870.
 Robert Bell Collection (Acc. No. 1963-51). A published set of 20 original stereo half prints in a volume entitled "Photographs of Montreal by Alex. Henderson."
 Leon Jacobson Collection (Acc. No. 1974-11). Ten original prints, c. 1870-1875.
 Hastings Gallery Collection (Acc. No. 1978-179). One original print of Montreal.
 Andrew Merrilees Collection (1980-149). This collection has an unusual version of *Canadian Views and Studies* which has no title page and contains 41 original prints. Albums from C.T. Hart contain approximately 50 original prints and other parts of the collection have additional prints.
 Ken & Jenny Jacobson Collection (Acc. No. 1981-156). An album stamped "John Shaw from Waddell, of Montreal. 1877" on the cover. It contains 71 original prints of Montreal, Ottawa and views along the Intercolonial Railway, c. 1865-1877, 9 of which are 11" x 14".
 Lawrence G. McDougall Collection (Acc. No. 1981-250). Six original prints.
 Yajima Gallery Collection (Acc. No. 1982-57). An album of 46 original prints by Henderson from the 1870s and 1880s.
 Stephen White Collection (Acc. No. 1982-71). 12 original prints.
 Literary and Historical Society of Quebec Collection (Acc. No. 1983-69) contains the early version of *Canadian Views and Studies by an Amateur* with 40 albumen prints.
 Serge Vaisman Collection (Acc. No. 1984-65) contains an album of

31 albumen prints, c. 1877-1884.
TORONTO PUBLIC LIBRARY,
BALDWIN ROOM
 The Baldwin Room has three copies of *Canadian Views and Studies* and an album containing Henderson's work. The total in all is approximately 100 prints.
UNIVERSITY OF TORONTO
LIBRARY, RARE BOOKS
 The Rare Books section has a copy of *Canadian Views and Studies* and an album of approximately 50 prints from the 1870s.
NATIONAL GALLERY OF CANADA
 The National Gallery has a copy of *Canadian Views and Studies* and two albums of original prints containing views of the QMO&O Railway and of various landscapes.
BIBLIOTHEQUE DE LA VILLE DE MONTREAL
 38 original prints, c. 1863-1869.
UNIVERSITE DE MONTREAL
 The Social Sciences Library has a copy of *Canadian Views and Studies*. The Louis Melzack Collection contains *Snow and Flood after Great Storms of 1869* consisting of 18 original prints.
ROYAL GEOGRAPHICAL SOCIETY
 Approximately 50 prints, c. 1865-1880.
VICTORIA & ALBERT MUSEUM
 The F.C. Ford album contains approximately 24 original prints of various sizes, c. 1865-1877.
ART GALLERY OF ONTARIO
 An album of 24 prints, c. 1870-1884. Inscribed "A.W. Henderson, 1884" (Acc. No. 80/90.1-.24).
ARCHIVES OF ONTARIO
 Approximately 25 original prints.

HODGES, John Kirkland
(28 March 1888, Ann Arbor, Michigan — 6 July 1969, Victoria, B.C.)

Described in *Saturday Night* as "one of the most versatile of Canadian pictorial photographers," Kirk Hodges was most active in the twenties and thirties. His prints were hung at salons in Toronto, Hamilton, Montreal, Regina and Ottawa, as well as in Rochester, Detroit, Minneapolis and Los Angeles. His work was reviewed or reproduced on the pages of *American Photography*, *The Camera* (Dublin), *Photo-Era* and *Saturday Night*.

He was born in Ann Arbor, Michigan when his mother was visiting her parents, and grew up in Westmount, Quebec.

Hodges first became fascinated with pictorial photography when he was still a schoolboy. At nineteen, he was awarded an honourable mention in a contest run by the popular monthly magazine, *Canadian Pictorial*; two of his prints were reproduced in the February 1907 issue. In 1910, Hodges joined *American Photography*'s Round World Exchange Club, organized "to enable its members to compare their work with that of others, to collect pictures of regions and objects not personally accessible to them, and to benefit by the experience of other earnest workers" (October 1910, 603).

During the First World War Hodges served with the 9th Field Ambulance, Canadian Army Medical Corps, in France, then returned to Montreal. In 1923, he moved to Winnipeg to work as a departmental chief clerk with the Canadian Pacific Railway. That same year, he was awarded a Certificate of Merit for his print *Winter Night* in a competition organized by *The Amateur Photographer* for photographs taken by artificial light. Five years later, Hodges became manager of the Empress Hotel in Victoria. Hodges was active in both the Pictorial Photographers of Victoria, where he served as Vice-President in 1934-35 and President in 1935-36, and its successor, the Victoria Photographic Society, which he headed from 1936 to 1939. During this period, he adopted the Leica as his favourite camera. Two of his prints were included in the Canadian Section of the International Exhibit sponsored by Leica in 1935-36. In the forties, Hodges continued to submit some of his older prints to the occasional salon, but produced little new pictorial work. *JMS*

COLLECTIONS

PUBLIC ARCHIVES CANADA

John Kirkland Hodges Collection (Acc. No. 1979-45) contains 32 mounted salon prints, a third of which won awards during the twenties, thirties and forties.

PAC. PA-52367

HORETZKY, Charles George

(June 1838, Edinburgh, Scotland — 30 April 1900)

Horetzky was the son of Felix Horetzky, a Polish gentleman who had lost his lands in the revolution of 1830, and of Sophia Robertson of Roxburgh-shire. He was educated in Aberdeen and Belgium. About 1858 he joined the Hudson's Bay Company and was sent to Fort William on the Ottawa River for five years. In 1864 he was sent to Moose Factory as Accountant. In 1869 he was transferred to Fort Garry, but owing to the Riel disturbance he was unable to carry out his work. In 1871, thanks to the influence of Sir Charles Tupper, he was hired to work on the Canadian Pacific Railway Survey. Repeatedly embroiled in arguments and controversies with his superiors, he was suspended in 1873, rehired the following year through his friendship with Alexander Mackenzie, and left for the last time in 1881. For the last seventeen years of his life he was an employee of the Govern-ment of Ontario, supervising the construction of sanitary sewers

for public institutions.

Horetzky probably learned photography with the group of active amateur photographers located at Moose Factory, since this is the first evidence of photography we have from him. His largest body of work comes from his period with the CPR surveys. While he was initially hired for his photographic ability, he was quickly promoted to the level of Exploratory Engineer and made long lone trips using his camera to document his findings. He was the first photographer on any Canadian survey known to use collodion dry plates, and his experience may have encouraged the Geological Survey of Canada to adopt the camera and dry plate technique for its other surveys. *AJB*

COLLECTIONS

PUBLIC ARCHIVES CANADA

W.J. Topley Collection (Acc. No. 1936-270). Approximately 75 original negatives from the CPR Surveys, 1871-1879.
Sandford Fleming Collection (Acc. No. 1936-272). Approximately 175 original prints from the CPR Surveys, 1871-1879, and one original from Moose Factory.
Hector Langevin Collection (Acc. No. 1963-9). Ten original prints from CPR Surveys, 1871-1872.
D.M. Beach Collection (Acc. No. 1973-11). Album of 40 CPR Survey prints, 1871-1873, presented to Lord Dufferin. Entitled "Saskatchewan, Peace River, Rocky Mt$_s$. and Northern B.C. Views 1872 & 1873 by C.P. Exploratory Party."

ARCHIVES OF ONTARIO

H. Lionel Smith Collection (Acc. 2210). Four original prints from Moose Factory.

PROVINCIAL ARCHIVES OF BRITISH COLUMBIA

Two albums of original prints from the CPR Surveys, 1871-1875, including one bound album entitled "Photographs, Pacific Railway Survey, British Columbia, 1875" consisting of views of the Homathco River. The contents of this album are identical to those in the Vancouver Public Library and PAC.

VANCOUVER PUBLIC LIBRARY

Two albums containing 70 original CPR Survey prints, 1871-1875. One album entitled "Homathko River" is inscribed, "Doctor Tupper with the Compliments of the Author, Ottawa, 10$_{th}$Feb'$_y$-77." The second album contains prints from the 1871 and 1872 surveys and also was Sir Charles Tupper's personal copy.

GLENBOW-ALBERTA ARCHIVES

(PB 239-1 to PB 239-18). 18 original albumen prints taken during the CPR Survey of 1871.

PAC. PA-l2938

IDE, William,

(15 April 1872, England — 16 May 1953, Ottawa, Ontario)

The catalogue for the Camera Club of Ottawa's exhibition *Seventy-five Years of Photography 1896-1970*, presented by the Club in the Public Archives Canada in 1971, gives the following biography:

Born in England, William Ide (M.B.E.) came to Canada in 1892 and after attending Queen's University, obtained his Bachelor of Arts Degree. Following employment with an Ottawa law firm and the C.P.R., he joined the Civil Service. During a distinguished public service career from 1895 to 1937, he was private secretary to eight cabinet ministers in Liberal and Conservative administrations. Subsequently, during World War II, he served voluntarily as the Secretary of the Ottawa Rental Control Board. He had widely travelled, and his

photography was highly regarded by his colleagues.

In the realm of amateur photography, William Ide maintained a close relationship with the Ottawa Camera Club from at least 1896, when he exhibited with the group and was elected Secretary-Treasurer. Subsequently he often held a position on the Executive Committee, including that of President (November 1898-1900). After the club was re-formed as the Ottawa Photographic Art Club in 1904, he was its Secretary from 1909 until at least 1914.

Ide's prominence in the early history of Canadian amateur photography is verified not only by his success in winning various medals at camera club compe-titions, but also by the fact that he had three prints in the "Photo-Club of Canada" exhibition in Montreal in 1907, the most ambitious attempt to date to present photography as an art form in this country.

Ide remained an active club member after a further reform which created the Ottawa Camera Club in 1922. Most significantly, he was also one of the eleven members who broke away to form the f/11 Camera Group in 1946. This group, still active in 1971, was dedicated to pursuing the art in photography and included Frederick George Ashton, Robert M. Cunningham (a past President of the Ottawa Camera Club), Alison Dickison and A.Y. Smith. Along with his club membership which lasted until 1952 (surely some form of record!), the large collection of prints, negatives and transparencies which William Ide left makes it clear that he retained his interest and his skill in photography virtually until his death. *JMS*

COLLECTIONS

PUBLIC ARCHIVES CANADA
William Ide Collection (Acc. No. 1981-60) contains c. 3,620 negatives, prints and slides by Wm. Ide.

William Ide Collection (Acc. No. 1981-190) contains 99 prints, most by Wm. Ide, and four medals. *Ottawa Camera Club Collection* (Acc. No. 1971-161) contains a small number of prints by Wm. Ide.
PRIVATE COLLECTIONS

JOHNSTON, Clifford Milton
(13 September 1896, Parry Sound, Ontario — 25 May 1951, Ottawa, Ontario)

Clifford M. Johnston took up photography while studying engineering at Queen's University in Kingston. He was unable to participate in more strenuous recreations because of health limitations that followed a childhood attack of rheumatic fever. Johnston joined the Queen's camera club in 1914 and, using a hand camera and commercially processed roll film, photographed scenes around campus. From 1917 to 1919, Johnston served as an ambulance driver with the Canadian Army Medical Corps in Britain and Europe. He was especially impressed by an exhibition of striking photographs of the battle of Vimy Ridge, sponsored by the Canadian War Records Office and held at the Grafton Gallery in London during July 1917. Disappointed that he could not take his camera on active service, Johnston "seized every opportunity of recording some of the beauties of the British Isles" while on leave. With a discerning eye for composition, he photographed architectural detail and park scenes around London and landscapes along the coast of Cornwall, later exhibiting work from this period.

Johnston returned to Canada in August 1919 to complete his engineering studies at Queen's and settle into the responsibilities of business and family.

One day, Johnston saw a notice of meeting of the local camera club: *"I attended, became infected with the germ of pictorialism, and have never recovered. I discovered that there was more in photography than snapshotting, and that it can be a medium of personal expression."*

In the late twenties, Johnston entered the competitive world of salon photography and quickly won international acclaim. He generally used a reflex camera and admitted that one of his chief photographic delights was composing the picture on the focusing screen.

Johnston became an Associate of the Royal Photographic Society in 1932, and a Fellow four years later. He considered salon work a "fine sportsmanlike game" and exhibited widely in Canada and the United States, as well as in Britain, Belgium, Germany, Austria, Czechoslovakia, Spain, South Africa, Argentina and Australia. An active member of The Camera Club of Ottawa, Johnston was instrumental in organizing the first Canadian International Salon of Photographic Art, and served regularly on the jury of selection for the National Gallery show throughout the thirties. He was also a corresponding member of the Toronto Camera Club and acted as a judge for the Pictorial Section of the 1934 Toronto Salon of Photography.

With the outbreak of another war, failing health and growing business demands, Johnston disappeared from the world of salon photography. He died at the early age of fifty-four. *JMS*

COLLECTIONS

PUBLIC ARCHIVES CANADA
Clifford M. Johnston Collection (Acc. No. 1968-186) consists of some 5,500 celluloid b/w negatives and approximately 4,400 prints, including mounted salon prints. Papers accompanying the collection are held in Manuscript Division (MG 30 D165) and 22 medals won by Johnston in photographic competitions are in the care of the National Medal Collection (3972-3993). *Ottawa Camera Club Collection* (Acc. No. 1971-161). Nine of Johnston's award-winning salon prints were included in the club's

75th anniversary show in 1971.
I am grateful to my colleague, Peter Robertson, for biographical information on Clifford M. Johnston contained in his unpublished manuscript "One of those Daft Birds," prepared in 1977. JMS

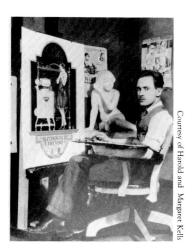

Courtesy of Harold and Margaret Kells

KELLS, Harold Frederick
(b. 2 October 1904, Ottawa, Ontario)

Ottawa artist-turned-photographer, Harold F. Kells achieved international prominence during the mid-1930s for his composite figure studies and pictorial landscapes. Kells joined the Ottawa Art Club in his early teens, and studied modelling, casting, life drawing and painting. He then worked as a commercial artist, continuing his art studies all the while. In the late twenties, Kells became mildly interested in a camera that a friend had purchased — a roll-film, postcard-size Kodak. He borrowed it and tried a self-portrait, and, he admits, "was bitten by the 'photography bug'."

His first salon submissions were not accepted, but Kells persisted, and in 1931 a bromoil entitled *Design* was hung at the Toronto Salon of Photography. In 1932 Kells began to exhibit in earnest. His salon output was never prodigious, but he quickly

achieved international acclaim. Kells' prints won prizes at salons in England, the United States, Austria, Australia, Belgium, Czechoslovakia and Spain, as well as awards from annual and monthly competitions of *American Photography* and *Camera Craft.* Kells served on the executive of The Camera Club of Ottawa during the thirties and was instrumental in organizing the first Canadian International Salon of Photographic Art. He was also a member of the jury of selection of the first Western Ontario Salon of Photography in 1936. But after 1935 his salon and print acceptances fell off dramatically. His prints continued to appear, but his pictorialist efforts declined. In 1938, Kells was awarded the Stephen H. Tyng Foundation Award of the Royal Photographic Society for his print *Grecian Nocturne,* first shown three years earlier.

Between 1933 and 1938, Kells had operated a studio, first as a portrait photographer for Photographic Stores of Ottawa, then on his own. But his work was not confined to photography; many of his oil paintings were used as designs for vignettes on bank notes, stocks and bonds by the British American and Canadian Bank Note Companies. Business slumped as war threatened, and Kells took a temporary position with the Public Relations Branch of the Post Office. With the declaration of war, Kells was asked to travel with the "March of Time" movie unit to do a series of promotional photographs of Canada's war effort. Kells then returned to the Post Office where he remained until his retirement in 1966. At the same time, he turned to colour photography which he pursued for the next decade until ill-health forced him to curtail his activities. *JMS*

COLLECTIONS

NATIONAL GALLERY OF CANADA
Harold F. Kells Collection

(P72:429-438) is a collection of ten toned silver gelatin prints which includes all of Kells' best known figure studies of the mid-thirties. *Harold F. Kells Collection* (on loan) contains one colour print by him as well as prints acquired by him from several of the leading American pictorialists of the thirties.

PUBLIC ARCHIVES CANADA
Harold F. Kells Collection (Acc. No. 1983-12), on deposit with the National Photography Collection, consists of 15 items, including three colour prints from the thirties, a self-portrait and three pictorial landscape prints.

KLUGH, Alfred Brooker

(6 May 1882, South Hampstead, London, England — 1 June 1932, Kingston, Ontario)

A. Brooker Klugh came to Canada with his parents in 1896. After a session at the Ontario Agricultural College in Guelph, Klugh studied botany and zoology at Queen's University, Kingston, graduating in 1910 with his Master of Arts degree. From then until his death he was associated with the university in one of several teaching capacities. He obtained his Ph.D. in zoology from Cornell University in 1926, and was made an associate professor in 1930. He was killed in a train-automobile collision only two years later.

As early as March, 1900, when he was only 17, Klugh helped found the Wellington Field Naturalists Club. Shortly there-after he became a charter member of the Great Lakes Ornithological Club. While at Queen's he founded or organized several other naturalist clubs. He also wrote widely about many nature subjects in both Canadian and foreign magazines.

Klugh was president of the Queen's Camera Club during the teens, and wrote articles on nature photography for the *American Annual of Photography* in 1916 and 1917. His major contribution to photography was, however, in the "Nature and Wildlife" column which he wrote monthly for the *American Photographer* from March 1923 until June 1932: several pages of editorial material on a wide variety of subjects, concerned with photographing wildlife or nature in general, and offering considerable technical guidance. Each article carried several photographs — often his own — which looked out of place beside the pictorial work found in the rest of the magazine. He tried hand-colouring prints, and by the mid-1920s he was experimenting with colour photography, probably transparencies.

Alfred Klugh was the only Canadian amateur whose work was regularly published in any photographic magazine, American or British. His column was evidence that an audience existed which sought an outlet in accurate scientific photography, rather than in pictorialism. *ACR*

COLLECTIONS

PUBLIC ARCHIVES CANADA
Alfred Brooker Klugh Collection (Acc. No. 1979-165) contains less than 12 small contact prints, most hand-coloured.

WELehman

LEHMAN, William Edwin

(6 October 1905, Green River, Ontario — 25 March 1981, Destin, Florida)

Bill Lehman became active in amateur photography with the Hart House Camera Club at the University of Toronto in the 1920s. Then, as an engineer with Bell Engineering, he belonged to the Leaside Camera Club. When his work took him from Toronto to London in 1954 and to Hamilton in 1962, he joined the London and Hamilton Camera Clubs, as well as the Colour Photographic Society. Lehman retired in 1965 and returned to London where he turned his attention to colour work almost exclusively, though he maintained his interest in pictorialism. In the early seventies, he became a member of the National Association for Photographic Art.

During the thirties, Lehman contributed regularly to the Annual Exhibition of the Hart House Camera Club, to the Canadian Salon of Photography in Hamilton and to the annual Toronto Salon of Photography. Over the years, he used a variety of cameras, including a 5'' x 7'' Pony made by Kodak around the turn of the century, a postcard-size Kodak which was "not good pictorially," a 35mm, a half-vest pocket camera and a Hasselblad. He favoured bromides and chlorobromides for his salon work, but also experimented with paper negatives, carbro and Dufaycolor. *JMS*

COLLECTIONS

PUBLIC ARCHIVES CANADA
William Edwin Lehman Collection (Acc. No. 1979-215) contains 26 mounted salon prints, c. 1930-1974.
PRIVATE COLLECTIONS

LOMAX, Arthur Henry

(b. 4 September 1911, Hamilton, Ontario)

Following his father's death in the First World War, Arthur Lomax went to live in England with his mother. There he was first exposed to photography by his next door neighbour; although curious about the process, Lomax did not pursue photography until after his return to Canada in 1924. He became friends with the sons of a Hamilton professional photographer, Wilfred Johnson, who made Lomax's first enlarge-ments. At sixteen, Lomax was employed in a Hamilton manufacturing company. A year later, he began a long career with the City of Hamilton, first in the health department and, after a stint in the RCAF during the war, in the traffic department; he retired in 1971.

Lomax was a founding member of the reconstituted Hamilton Camera Club, Secretary of the club in 1936 and 1937, and President in 1938, and served as a member of the Salon Committee of the Canadian Salon of Photography throughout the thirties. His own salon work was not extensive, but Lomax's prints were regularly exhibited at the major Canadian salons, as well as at Cannes, France, several British salons and, by invitation, at the Empire Exhibition in Johannesburg in 1936. In the mid-thirties, Lomax attended a week-long course in composition at the photography school of noted pictorialist Nicolas Haz, in Woodstock, New York. Lomax was also strongly influenced by the work of compatriots Clifford Johnston, Philip Croft, and John Morris, and by Ansel Adams' 1935 publication, *Making a Photograph*.

Lomax graduated from his first Brownie to an inexpensive folding 116 model, then to vest-pocket and larger equipment. During the Depression, he acquired a 2 1/4'' x 3 1/4'' revolving back Graflex B. A few years later, he purchased a British-made "Sanderson," using it for much of his salon work. Lomax's prints generally are marked by angularity in composition. He shied away from photographing people, preferring shipping, architectural and railway subjects, often more as record shots than as exhibition prints. Apart from some work with Dufaycolor, Lomax did not turn to colour photography until his retirement, when he began to use 35mm slides to record his travels. *JMS*

COLLECTIONS

PUBLIC ARCHIVES CANADA
Arthur H. Lomax Collection (Acc. No. 1979-270) contains 22 photographs, including several salon prints and photographs of members and excursions of the Hamilton Camera Club. A large collection of salon catalogues, periodicals and papers accompanied the photographs.

Constitution, reports and correspondence of the Hamilton Camera Club (c. 1932-1941) constitute MG 30 D268 in the Manuscript Division.
Arthur H. Lomax Collection (Acc. No. 1982-220) consists of 20 salon prints (1934-1940), including *Skylight* and a photograph of Lomax with his Sanderson camera, and two snapshots of a salon installation.

Courtesy of Bill Rattray

MACKAY, Joseph Harold
(1875 or 1876, Markham, Ontario — 18 March 1947, Toronto, Ontario)

After completing his technical education, J.H. Mackay joined the Bell Telephone Company. Five years later he moved to the Stark Telephone, Light, and Power System, and in 1912 he joined the Toronto Niagara Power Co., remaining with this company and its successor until his death in 1947. For the last two years of his career he worked as a photographer, producing many publicity stills for various publications of the Hydro-Electric Power Commission of Ontario (now Ontario Hydro).

A long-time member and officer of the Toronto Camera Club, he was either Secretary or Director of the Toronto International Salon of Photography from 1922 to 1929. In 1930 he was Director of the Toronto Salon of Canadian Photography. During the twenties and thirties, he judged numerous exhibitions and was a member or a regional vice-president of the Pictorial Photographers of America. In *Photograms of the Year* for the period 1922 to 1930 he wrote the article on Canadian photography, confining his remarks almost entirely to the Toronto International Salon.

Because few of his photographs still exist, much of Mackay's reputation is based on the opinion of his contemporaries. His extant work is that of a mature, thoughtful photographer. In his writings he emphasized "sound line composition and design" and recommended the use of "the complete range of plates, films and papers" to produce "pure photography." This emphasis on design can be seen in his published and collected photographs. Although pictorialist soft focus is used for such work as *Beside the Still Waters* (*Photograms of the Year 1925*) or *Lunar Fantasy* (*American Annual of Photography,* 1929), the strong feature of each is still the emphasis on line and geometric form.

J. Harold Mackay's articles reveal that he was most involved with an international style of photography as practised by some Canadians, mainly in Toronto, and not with the development of something distinctly Canadian. His interest in geometrical form can be seen in the work of other Canadians — for example, John Vanderpant and Brodie Whitelaw, both of Vancouver. Yet there is no evidence that he sought to put more than an engineer's sense of order into the multi-faceted and chaotic world of reality. *ACR*

COLLECTIONS

PUBLIC ARCHIVES CANADA
J. Harold Mackay Collection (Acc. No. 1982-251) contains one photograph.

MACTAVISH, Newton McFaul
(1877, Staffa, Ontario — 1941, Toronto, Ontario)

Successively a journalist, editor, and Commissioner of the Civil Service Commission of the Government of Canada, Newton MacTavish always had a great interest in the visual arts. MacTavish joined the Toronto *Globe* as a journalist in 1899. His interest in photography may have begun even earlier, for by the time he moved to Montreal in 1903 as business agent and correspondent for the *Globe*, he was photographing his lodgings there and making portraits of his wife and children. When he returned to Toronto in 1906 to become editor of *The Canadian Magazine*, journalist-photographers Horace Boultbee and M.O. Hammond sponsored him as a member of the Toronto Camera Club. In 1908 he became one of the founding members of the Arts and Letters Club, a group which also included such pictorialist photographers as Arthur Goss.

Although MacTavish did not exhibit a great deal of his photography, the quality of his work improved greatly in the next few years. "The Last Great Round-Up," an article about buffalo herding published in *The Canadian Magazine* in 1909, was in part illustrated with MacTavish's own photographs, printed in the pictorialist mode favoured at the time. His photography seems to have tapered off as his professional commitments grew, although his continuing interest in it can be seen in the number of amateur photographs printed in *The Canadian Magazine*. Among MacTavish's later publications is the first major Canadian art history, *The Fine Arts in Canada* (1925) and *Ars Longa* (1938). From 1920 to 1932 he was a Trustee of the National Gallery of Canada. *ACR*

COLLECTIONS

PUBLIC ARCHIVES CANADA
Newton MacTavish Collection

(Acc. No. 1980-239) Almost 300 prints, primarily snapshots of MacTavish's family, but including photographs used in the feature article "The Last Great Round-Up."

MARCHELL, George William
(1 September 1901, Woodstock, Ontario — 6 August 1976, London, Ontario)

George Marchell took up photography in his twenties, but did not enter the salon scene until after the Depression. Upon his arrival in London, he met avid amateurs George and Jean Pearce, and joined the London Camera Club. He served on the organizing committee of the First Western Ontario Salon of Photography in 1936. In November of that year, growing dissatisfaction led several members of the London club to form FotoForum. George Marchell was a founding member and early President of this small active group of advanced photography enthusiasts who met informally, organized outings, held competitions and staged exhibitions.

In the mid-thirties, Marchell embarked upon a period of salon activity that was to span three decades. He exhibited bromides before the War, then turned almost exclusively to chlorobromide papers. Marchell's prints — landscape, still-life, table-top and genre — were hung in salons not only in Canada and the United States, but also in England, Spain, Yugoslavia and Argentina. A cost accountant by profession, Marchell was fondly remembered by another amateur, Gordon McLeod, as "a photographer of ideas and humour." *JMS*

COLLECTIONS

PUBLIC ARCHIVES CANADA
George W. Marchell Collection (Acc. No. 1979-240) consists of over 1,500 celluloid negatives, mostly 2 1/4"-square, and more than 300 salon prints from the thirties through to the sixties.

Courtesy of Mrs. D.B. Marsh

MARSH, Donald Ben

(24 November 1903, Enfield, Middlesex, England — 5 February 1973, London, England)

Educated in his youth in England, Donald Marsh graduated from Emmanuel College, Saskatoon, in 1926, the same year he was ordained a deacon in the Anglican Church at Kenora, Ontario. From that year until 1943 he was Missionary-in-charge at Eskimo Point on the west coast of Hudson Bay, becoming a priest in 1929 and serving as Archdeacon of Baffin Land from 1939-1943. He held other northerly posts until 1950, when he was elected Bishop of The Arctic.

His enduring interest in arctic life and inhabitants was expressed in the variety of his photographs, and in the articles on northern topics which he published in *The Beaver, Sports Afield* and *Popular Photography*. Particularly fascinating are his descriptions of taking, developing, printing and enlarging negatives in sub-zero winter weather. Bishop Marsh's persistence produced not only black and white negatives, but also Kodachrome slides, dating from the late 1930s. These represent what may be the earliest colour photography in the north using the technique, only introduced to the market by Kodak in 1936. He was also

known to have taken movie film on 16mm Kodachrome. His talent has provided Canada with a precious and virtually unique record in colour of this remote part of the country and its people, at what was still a relatively early point of contact with the outside world. *LK*

COLLECTIONS

PUBLIC ARCHIVES CANADA
Donald B. Marsh Collection (Acc. No. 1978-39) contains 193 negatives and slides by D.B. Marsh.
Donald Ben Marsh Collection (Acc. No. 1981-238) contains 132 slides and *c.* 500 negatives by D.B. Marsh. NEGATIVES RESTRICTED.
PRIVATE COLLECTION

PAC. PA-125748

McLEOD, Donald Gordon

(b. 15 December 1914, London, Ontario)

Gordon McLeod's life-long interest in visual images stemmed from a fascination with the work of a neighbour who occasionally carried his large, wooden view camera into the McLeods' garden. In the mid-thirties, McLeod joined the London Camera Club; when a handful of disgruntled members, led by George Marchell and George Pearce, broke away to form FotoForum, McLeod followed.

During the War, McLeod was stationed in Montreal at the Royal Canadian Ordnance Corps Depot, as a procurement officer.

There he was often called upon to photograph equipment or events, at first developing and printing his negatives at the camera club facilities of the local ''Y'' and later in the photo unit darkroom which he helped to equip and supervise. After the war, McLeod returned to London, to the hardware business, an agricultural implements firm, and subsequently his own hardware business. In 1962, he took over the audio-visual services of the photography business of Foto-Forum colleague Ron Nelson. McLeod is a past President of the National Audio-Visual Association of Canada, and has taught courses in both photography and audio-visual techniques in London schools.

During the thirties, McLeod's work was shown in Canada at the annual Toronto and Hamilton salons and was seen across the country as part of the tours of the National Gallery's Fifth and Sixth Canadian International Salons. McLeod also exhibited widely in England, Scotland and Wales. He served as Competition Chairman for FotoForum and has since helped organize and judge amateur exhibitions, including the Western Ontario Salon of Photography. McLeod used a variety of cameras and formats, first concentrating on black and white, then, in the mid-fifties, turning to serious colour work. In 1982 his colour prints (1956-1980) were exhibited at the London Regional Art Gallery, Ontario. Much of McLeod's salon work and approximately 15,000 negatives were destroyed by a flood in the basement of his home in 1968. *JMS*

COLLECTIONS

PUBLIC ARCHIVES CANADA
D. Gordon McLeod Collection (Acc. No. 1979-209) contains more than 50 salon prints (1937-1947) by McLeod and five prints (*c.* 1915) by neighbour and amateur photographer, David Sare. Also included in the collection are nine issues of *Photo-*

Flash (1936) and 51 salon catalogues from the period 1937 to 1952.
PRIVATE COLLECTIONS

McTAVISH, George Simpson

(b. *c.* 1834-?)

McTavish remains a shadowy figure. Apparently born in Canada and reputedly a grandson of Sir George Simpson, McTavish joined the Hudson's Bay Company, probably in 1849, as an Apprentice Clerk. He was transferred to the Southern Department and in 1859 was commissioned a Chief Trader. In 1875 he was promoted to Inspecting Chief Factor.

His photographic production was probably slight, though he may have been responsible for some of the many unsigned works from the Moose Factory and Eastmain districts during the 1860s and 1870s. *AJB*

COLLECTIONS

PUBLIC ARCHIVES CANADA
Sandford Fleming Collection (Acc. No. 1936-272) contains two prints.

PAC. PA-124111

Bruce Metcalfe

METCALFE, Cecil Bruce (1890 or 1891, Bingley, Yorkshire, England — 16 November 1962, Erin, Ontario)

Bruce Metcalfe moved to Canada from England with his family at the age of 12, living in Guelph and then in Thistletown where, still in his teens, he

played the organ for the Weston Presbyterian Church. At about 18, Metcalfe studied piano in Toronto. He created the mood music accompanying silent movies on the great Wurlitzer organs in major theatres in Toronto and Cleveland and for many years played piano in a well-known Toronto trio. for a short time Metcalfe also worked as a commercial photographer. In the late thirties, he began teaching high-school music in Weston, Ontario, serving as well as supervisor of music for the area. Metcalfe retired early to continue full-time as organist at Central United Church in Weston.

Metcalfe gained recognition as an accomplished photographer, naturalist and lapidary. In 1924, he joined the Toronto Camera Club and became one of the club's most active members. He served on the executive in many capacities, including a two-year stint as President in the early thirties. In the years between 1927 and 1932 he consistently had thirty or more print acceptances in at least a dozen salons world-wide each year.

Through photography and his wife, a member of the Ontario Federation of Naturalists, Metcalfe developed an interest in natural history. In 1932, he exhibited four prints in the Scientific Section of the Toronto salon, including an eight-part photo-essay entitled *Luna Moth Emerging from Cocoon*. In 1946 he contributed 73 photographs with accompanying descriptions to a handbook on *Native Ferns*, published by *Canadian Nature Magazine*. Increasingly, Metcalfe turned from photography to his interest in natural history and, after his retirement, to geology and lapidary. *JMS*

COLLECTIONS

PUBLIC ARCHIVES CANADA
C. Bruce Metcalfe Collection (Acc. No. 1979-269) contains mounted salon prints including 6 of his better known pictorial works, an 8-part photo-essay on the "Luna" moth and two

photographs of Metcalfe.
C. Bruce Metcalfe Collection (Acc. No. 1982-233) consists of 129 celluloid b/w negatives and 4 glass plate negatives, of which two are of Metcalfe, and 6 miscellaneous snapshots.
PRIVATE COLLECTIONS

MOODIE, née Fitzgibbon, Geraldine (31 October 1854, Toronto, Ontario — 1945 or 1946, Calgary, Alberta)

Geraldine Fitzgibbon married John Douglas Moodie (21 November 1849, Edinburgh — 5 December 1947, Calgary) on June 8, 1878 at Telford, Surrey, England. They and an infant daughter came to Canada about 1879 or 1880, where J.D. Moodie pursued a distinguished career in the North West Mounted Police from 1884 till 1917, retiring as a Superintendent. By 1888, they had had five other children, all born in Canada.

Both Moodies were amateur photographers. For at least two years around 1906, Geraldine accompanied her husband on what may have been his most notable assignment — to the Hudson Bay district where he remained in command from 1904-1910, erecting posts at Cape Fullerton and Fort Churchill. She set up a darkroom in their ship, and photographed the Eskimos whom she met. It is for these photographs, produced in relatively large sizes and occasionally signed "G. Moodie," that she is known today. She carefully maintained her copyright on some images; even a drawing taken from her work credits her with the original photograph. Despite this, confusion does exist between her photographs and those attributed to her husband, to the scientist A.P. Low, to F. MacKean, or to George Comer (an American on board the whaling schooner *Era*), all of whom produced similar work at the same time in the same area. Attributions are further confused by the name of George R.

Lancefield, a professional who photographed in the same area on an expedition of the C.G.S. *Arctic* in 1906-1907.

An unidentified newspaper clipping of 1945 or 1946 claims that Geraldine Moodie contributed to a book on the northland and that she was also an amateur painter. *LK*

COLLECTIONS

BRITISH MUSEUM, LONDON, ENGLAND reportedly holds what may be the best single collection of G. Moodie's Eskimo photographs (unconfirmed).
ROYAL CANADIAN MOUNTED POLICE MUSEUM, REGINA holds c. 24 prints by the Moodies of both Eskimos and Indians, c. 1890s — 1910.
ROYAL CANADIAN MOUNTED POLICE, PUBLIC RELATIONS BRANCH, OTTAWA
Their photograph archives contain the 38 original photographs from which the two copy collections listed under Public Archives Canada (see below) were taken.
WHYTE FOUNDATION, BANFF, ALBERTA has one print by G. Moodie.
PUBLIC ARCHIVES CANADA, NATIONAL PHOTOGRAPHY COLLECTION
J. Bernier Collection (Acc. No. 1947-123) contains 69 original prints, 4 of which are signed G. Moodie.
Joseph Elzéar Bernier Collection (Acc. No. 1976-193) contains 34 copies of negatives from the Musée du Collège de Lévis (see below), some of which may be by G. Moodie.
Royal Canadian Mounted Police Collection (Acc. No. 1976-243) contains 16 copies of photographs of the Canadian expeditions to Hudson Bay 1903-1905, attributed to J.D. Moodie and G. Moodie; only two of the items are signed G. Moodie. Originals in the R.C.M.P. Public Relations Branch (see above).
MUSEE DU COLLEGE DE LEVIS, LEVIS, QUEBEC holds 34 (or more) glass negatives of the expedition to Hudson Bay in 1904-1905 on board the C.G.S. *Arctic*; some of these negatives may be by G. Moodie.

I am indebted to Ed Cavell of the Whyte Foundation, Banff, and to Ed McCann of the R.C.M.P. Museum in Regina for much of the preceding information. L K

MOOSE FACTORY GROUP (c. 1865-1875)

A number of photographs attributed to this group bear no indication of the photographer or of the exact location. However their source, their style and their content all point without question to an origin in the active amateurs working for the Hudson's Bay Company in the region around James Bay. In addition to the photographers represented in this exhibition, such as Ross, Horetzky, McTavish and Cotter, there are a few others who are known, among them Dr. William Bell Malloch. The members of the group frequently exchanged prints with one another and sent copies to friends in more civilized centres. *AJB*

COLLECTIONS

PUBLIC ARCHIVES CANADA
Sandford Fleming Collection (Acc. No. 1936-272) contains a number of prints which have no specific attribution.
NOTMAN PHOTOGRAPHIC ARCHIVES, McCORD MUSEUM
William Bell Malloch Collection contains 35 original prints by Hudson's Bay Company employees. Most prints have no photographer identified.

PAC. PA-127104

MORRIS, John Pearson, (1904, Grimsby, Ontario — 1978, Hamilton, Ontario)

John Morris began photography in his youth. What sort of

equipment he possessed is unknown, and very little of his early work still exists. Some items indicate an interest in genre that continued throughout his amateur career.

Morris first worked as a clerk for several banks and investment companies in Toronto. By 1938 he was employed with the graphic arts firm Rapid Grip & Batten, for which he had earlier briefly worked as a salesman. In May 1940, he was commissioned as a Flight Lieutenant in the Photographic Branch of the RCAF. Released from service in March 1945, he set up a professional commercial studio in Hamilton, Ontario. His commercial work included many contracts with such industrial firms as Westinghouse Limited; eventually he became corporate photographer for the company. He retired from active photography in the early 1970s.

The larger part of John Morris' amateur photographs are concerned with pastoral or marine scenes, or people and their activities treated in an informal, often sentimental manner. He won several prizes in the 1929 and 1931 Kodak photography competitions.

His first known salon acceptance was at the Toronto International in 1926. He became a member of the Toronto Camera Club in that year, and served in various official capacities until 1945. His work was accepted in some of the more prestigious American and Canadian salons, and between 1926 and 1945 he exhibited at least one print at the Toronto International each year. Morris also judged for various salons and exhibitions from the late 1930s onward. However, as his attention was increasingly given to his business and professional work, during the later 1940s he withdrew from amateur club and salon activities. *ACR*

COLLECTIONS

PUBLIC ARCHIVES CANADA

John Morris Collection (Acc. No. 1980-238) includes *c.* 200 salon prints, and *c.* 675 negatives made while he was an amateur, and several hundred additional photographs made during his professional career.

AGGV

MORTIMER-LAMB, Harold
(21 May 1872, Leatherhead, Surrey, England — 25 October 1970, Burnaby, B.C.)

Harold Mortimer-Lamb, son of an English naval officer, emigrated to Victoria, B.C., in 1889 with the intention of learning to farm. He soon discovered a talent for newspaper work. Editor of the *Chilliwack Progress* and *The Midway Advance* and an editorial contributor to *The Province*, he progressed to found the *Boundary Creek Times* in 1895. He also became a founding member of what was possibly British Columbia's earliest (but short-lived) art club or society in Victoria. In 1896 he began editing the *B.C. Mining Record*, becoming Managing Director the following year, a position he retained until 1904. With typical energy, in 1902-03 he also wrote provincial government bulletins.

Photography may first have interested him about 1898. Progressing quickly in the avant-garde and highly aesthetically-oriented pictorialist style, in 1904 he received the distinction of an Honorary Membership in the

London Salon of Photography in England, and wrote the chapter "Pictorial Photography in B.C." in *Photograms of the Year 1904*. The annual also reproduced a platinum print of his *Study of a Child's Head*.

The next year, Mortimer-Lamb was elected Secretary of the Canadian Mining Institute and editor of the *Canadian Mining Review*, causing him to move to Montreal. Until 1919, he pursued the dual interests of his life with vigour, winning the admiration of both his mining and his artistic peers.

In 1905 he exhibited two portraits with the Canadian Society of Applied Art Exhibition in Toronto, as a member of "The Studio Club," Canada's first attempt to found a national pictorially-oriented group. He became acquainted with the prominent American pictorialist Alfred Stieglitz and soon became the friend of leading artists such as Homer Watson and William Brymner, educating himself in "moderns" such as Matisse. There is some indication that he actually studied painting under Laura Muntz, Maurice Cullen, and at the Art Institute in Montreal. Meanwhile he continued to be a contributor to the Toronto Camera Club and other Canadian exhibitions, to *Photograms of the Year*, and to a variety of other internationally-oriented exhibitions and photographic periodicals.

In 1907 he participated substantially in a landmark Canadian show, the "Photo-Club of Canada" exhibition in Montreal, which was organized and promoted by Sidney Carter, another dedicated Canadian pictorialist. Each man had 33 photographs listed in the catalogue, far outstripping all other exhibitors. The two were so clearly of a mind that they essayed a professional partnership in Montreal. It was not a commercial success, possibly due to pictorialism's novelty in Canadian circles, and the partnership dissolved in

about a year. Yet for a time, the styles of the two men were so similar as to make the attribution of unsigned and unpublished prints from this period very difficult today.

Mortimer-Lamb continued to win honours — election as a member by the Royal Photographic Society in September, 1910; plaques for his 1910 and 1911 entries in the *Amateur Photographer and Photographic News* Colonial Competition in England; lay membership in the Canadian Art Club in 1911; charter membership in "The Arts Club" of Montreal.

In 1919, at 47, Mortimer-Lamb resigned from the Canadian Mining Institute due to ill health. By 1920 or 1921, he had returned to British Columbia, where he promptly began another career founding, joining, encouraging, criticizing, and creating, in both his fields of expertise. In 1921 he "originated the Arts and Letters Club in Vancouver," and the Mining Association of B.C., and took an active part in the B.C. Art League, the Vancouver Art Gallery, the Burnaby Art Society, and the B.C. Division of the Canadian Institute of Mining and Metallurgy. In 1928, he took over as editor of *The Miner*, continuing to contribute to technical journals in Canada, the United States and Great Britain. It was only in 1945 that he finally retired from his mining connection.

Not so for art. After his move to the west coast, he ventured on another photographic partnership, this time with J. Vanderpant, and exhibited photographs at the opening of the Vanderpant Galleries in Vancouver in 1926. Unfortunately, this partnership too lasted only about one year.

In the 1920s he wrote to Eric Brown, Director of the National Gallery, calling attention to Emily Carr's work (Maria Tippett: "Who discovered Emily Carr," *Journal of Canadian Art History*,

Vol. 1 No. 2, Fall 1974, 30-35), and he was one of the earliest defenders of the Group of Seven. In 1938, he was made an Honorary Fellow of the Royal Photographic Society of Great Britain, followed in 1939 by fellowship in the Royal Society of Art.

It was probably in the mid to late 1940s that he finally gave up photography altogether, plunging instead into a passion for painting. He had always wanted to make the camera lens give him a diffused and lyric simplicity, even distortion, effects which he achieved now more thoroughly in his paintings. Mortimer-Lamb had three exhibitions of his paintings before his death, at the advanced age of 98; he passed his talent to his daughter, Molly Lamb Bobak.

Harold Mortimer-Lamb's industry and energy, attested by his numerous writings, memberships and honours in two very different fields of activity, can never be doubted. But did he disperse those energies too widely? He was the constant exponent: a critic, speaker, writer, photographer, painter. Yet, despite his personal prominence, he never achieved that position of power in Canada's art world which would have allowed him to act on his proposals. Nor did he withdraw sufficiently to concentrate his talents on the production of art works, in photography or painting. *LK*

COLLECTIONS

ART GALLERY OF GREATER VICTORIA
A large uncatalogued collection of negatives, prints and manuscript material.
NATIONAL GALLERY OF CANADA
Five prints.
PUBLIC ARCHIVES OF CANADA
Sidney Carter Collection (Acc. No. 1979-87) contains one print.
Sidney Carter Collection (Acc. No. 1981-74) contains two prints.
ROYAL PHOTOGRAPHIC SOCIETY, BATH, ENGLAND
At the time of writing, the

collection was closed. However, correspondence in papers held at the Art Gallery of Greater Victoria indicates the very likely existence of prints by Mortimer-Lamb in this collection.

MUNRO, George Reid
(1887-1920)

George Reid Munro was a "level man" with one of the survey parties examining terrain from the late summer of 1908 until October 1909, prior to the construction of the Hudson Bay Railway. The route took them through The Pas and ended at Fort Churchill. On the way, Munro took a series of snapshots of local scenes of interest, natives, Hudson Bay employees and of his colleagues, all of which complement his letters and diaries held in the Public Archives Canada, Manuscript Division (MG 30, A36). *LK*

COLLECTIONS

PUBLIC ARCHIVES CANADA
George Reid Munro Collection (Acc. No. 1975-11) contains three albums with about 430 prints.

PAC. PA-127061

NORFOLK, William Allen
(12 October 1913, Georgetown, Ontario — 13 August 1980, London, Ontario)

Bill Norfolk bought his first camera, a Kodak Vollenda, in instalments at 50¢ a week; later, he progressed to a Contax. Norfolk graduated from the University of Western Ontario in 1938 after three years in Mathematics and Physics and

another three in Geology. Throughout college, he served as staff photographer for the university yearbook, working in his own darkroom. At the same time, he joined the London Camera Club, and contributed editorials to *Photo-Flash*. Frustrated that the club was geared to accepting new members and repeating basics, Norfolk joined good friends Gordon McLeod and Ron Nelson to help form FotoForum in 1937.

Norfolk exhibited little before 1940 and never aspired to the volume of exhibition work of many of his colleagues. However, he was an avid photographer of landscapes and women, and his interest in theatre and big bands led him to stage photography. When the war came, Norfolk trained in England as a radio operator, was posted to the Suez, and spent four and a half years as commanding officer of an RAF mobile radar unit in the Middle East. Upon his return Norfolk opened a portrait studio and became official photographer for the London (Ontario) Little Theatre. He also became associated with the Doon School of Fine Arts and did publicity photography for the school's brochures. In 1951, with a small inheritance from an aunt, Norfolk went to teachers' college in Toronto, first specializing in science, then switching to art. Subsequently, he taught for 21 years in Sarnia, eventually becoming head of the art department of one of the high schools. *JMS*

COLLECTIONS

PUBLIC ARCHIVES CANADA
William A. Norfolk Collection (Acc. No. 1979-211) consists of 23 miscellaneous negatives from the forties, 43 black-and-white prints of theatre personalities associated with the Dominion Drama Festival and of Canadian artists at the Doon School of Fine Arts. Also included are five Dufaycolor 35mm slides taken in 1939 at Lake Aguasabon when Norfolk worked

on a geological survey crew for the Ontario Department of Mines. *D. Gordon McLeod Collection* (Acc. No. 1979-209) contains a mounted salon print entitled *Bill*, a portrait of Bill Norfolk.

Courtesy of Jane Pearce

PEARCE, George Augustine
(18 June 1901, Machynlleth, Montgomeryshire, N. Wales — 3 March 1979, London, Ontario)

George Pearce, the son of a watchmaker and photographer, grew up in Corwen, Wales. He bought his first camera at the age of 10 and did his own processing in his father's darkroom. In 1922, George and his brother Ed came to Canada and opened a watch shop in London. When Ed died two years later, George took over the business. Returning from a visit to Wales in 1926, George Pearce came to the conclusion that he could not afford both smoking and photography; in a symbolic gesture, he threw his cigarettes overboard and from then on concentrated his efforts on his hobby. Two years later, George bought a house in London and soon added a darkroom which he shared with his wife, Jean, herself an avid amateur photographer and salon exhibitor. One of the original FotoForum founders, George was Vice-President in 1939 and President the following year. Both George and Jean served on the Salon Executive Committee of the First Western Ontario Salon in 1936. They each

became an Associate of the Royal Photographic Society in late 1938 or early 1939, and continued to exhibit in salons, particularly in Great Britain, into the fifties. George especially prized a series of prints he produced of the Chapel of the Mohawks, at Brantford, Ontario, sensitively documenting the famous Indian church in 1937 and again in 1940 after restoration. Jean Pearce died in 1960; George remarried five years later and died in 1979. Together, they left behind more than 500 salon prints attesting to two lifetimes of dedicated amateur photography. *JMS*

COLLECTIONS

PUBLIC ARCHIVES CANADA
George Pearce Collection (Acc. No. 1979-235) contains 12 prints acquired by George Pearce from his London colleagues.
George and Jean Pearce Collection (Acc. No. 1979-302) consists of a deposit of 69 salon prints by George Pearce and 65 salon prints by Jean Pearce, spanning the mid-thirties to the mid-fifties.
George Pearce Collection (Acc. No. 1983-3) contains *Murk* and *Darkroom Self-Portrait*, on loan to the National Photography Collection.
PRIVATE COLLECTION

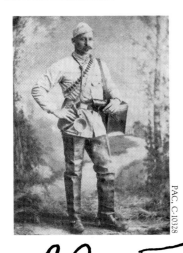

PETERS, James (1853, Saint John, N.B. — 1927, Victoria, B.C.)

Born and raised in Saint John, New Brunswick, James Peters began his military career at the age of seventeen with the 62nd Saint John Fusiliers of the active militia during the Fenian raid of 1870. Two years later, he joined the permanent force 'A' Battery of the School of Gunnery at Kingston, Ontario. Following a tour of garrison duty at Fort Garry, Manitoba, Peters returned to Kingston in 1873 where he qualified as a lieutenant in 1874 and was promoted to captain in 1878. In 1881 he went to England as adjutant of the first Canadian artillery team to take part in the Shoeburyness competition.

During the Northwest Rebellion of 1885, Captain Peters commanded 'A' Battery of the Regiment of Canadian Artillery in the actions at Fish Creek and Batoche and in the pursuit of the Cree chief Big Bear. For his conspicuous service, he was mentioned in despatches. During the campaign he also acted as correspondent for the Quebec *Morning Chronicle* and found time to pursue his hobby of photography, becoming in the process the first Canadian military photographer. He was one of the original members of the Quebec Camera Club, founded on 8 February 1887, and served as its first President.

In 1887, Major Peters assumed command of the newly-formed 'C' Battery, RCA, which crossed Canada to take up station at Esquimalt, British Columbia. Promoted to the rank of lieutenant-colonel in 1890, he served at Victoria from 1893 to 1901 as District Officer Commanding Military District No. 11. He held the same appointment in Military District No. 1 at London, Ontario from 1901 to 1909, and then returned to Victoria. After thirty-seven years of service, Colonel Peters retired in 1910 to live near Work Point Barracks in Victoria. *PR*

COLLECTIONS

PUBLIC ARCHIVES CANADA

Frederic Hatheway Peters Collection (Acc. No. 1958-179) consists of 428 original prints by James Peters and William Imlah, illustrating the operations of 'A' Battery, Regiment of Canadian Artillery, during the Northwest Rebellion, and 'C' Battery, R.C.A., on the Skeena River, B.C., as well as military activity at Quebec City and Kingston, and activities of the Peters family and friends. Inclusive dates are 1884-1888.

PIERS, Walter Barrington
(3 May 1890, London, England — 10 September 1964, Haney, B.C.)

Barry Piers came from a family of bankers, and in 1911 arrived in Canada to take up a position with the Bank of Montreal. His first branch was in Vernon, B.C. Later he moved to Salmon Arm, and in 1931 he settled in Haney where he remained manager of the local Bank of Montreal until ill health forced him to retire in 1949. Piers became an active member of the Vancouver Camera Club, serving as its Vice-President during the late thirties, and driving 90 kilometres from Haney to Vancouver to attend the monthly meeting. Though his salon activity was limited, he exhibited regularly in Toronto and Hamilton, and in the Sixth Canadian International Salon of Photographic Art. Piers preferred landscape and nature photography and had a particular affinity for cloud and tree studies in and around the Haney area of the lower Fraser Valley. He graduated from a folding Kodak to a Zeiss Ikon, and frequently hand-coloured his prints, many of which were hung in local stores and businesses. Though not interested in portraiture, Piers took photographs at weddings, christenings and other family occasions to give as gifts. Despite his attraction to the outdoors, some of his most successful prints were table-top or still-life compositions which show careful attention to lighting and arrangement. Much of Piers'

work and his collection of photographic periodicals were destroyed in a fire in 1962. *JMS*

COLLECTIONS

PUBLIC ARCHIVES CANADA
W.B. Piers Collection (Acc. No. 1981-143) contains 60 of Piers' salon prints as well as a portrait of Piers and a snapshot of his darkroom.
PRIVATE COLLECTIONS

PINKERTON, Beresford Bright
(1887, Montreal, Quebec (?) — 3 January 1975, Montreal, Quebec)

Pinkerton was among Montreal's earliest pictorialist photographers. In 1907 he exhibited two prints with the "Photo-Club of Canada," the landmark show organized by Sidney Carter, and was mentioned by Carter in *Photograms of the Year 1907* as a "beginner of promise." His name appeared again in *Photograms of the Year 1908*, and from about 1909 (when he exhibited in the Toronto Camera Club salon) he was a member of the Montreal Amateur Athletic Association Camera Club. He became their Secretary in 1912, Vice-President in 1913 and President in 1914. His growing photographic prominence was recognized by a bronze medal awarded him in the "Portrait Class" by the Eatonia Camera Club of Toronto in 1913 and by three silver spoons he won from the M.A.A.A. Camera Club. He had an entry in the Royal Photographic Society's show in London in 1914 and he was

further mentioned in *Photograms of the Year 1914*.

The Montreal city directory of 1925-26 lists Pinkerton as a "clerk;" in later years, like his father Robert, he seems to have worked for one or more insurance companies in Montreal. *LK*

COLLECTIONS

PUBLIC ARCHIVES CANADA
Beresford B. Pinkerton Collection (Acc. No. 1979-139) contains c. 775 prints, a medal, three silver spoons, and a few newspaper clippings.

REFORD, Robert Wilson

(19 August 1867, Montreal, Quebec — 15 November 1951, Montreal, Quebec)

Robert Wilson Reford was educated at Upper Canada College in Toronto and at Lincoln College in Sorel. In order to broaden his education before joining his father's shipping firm, the Robert Reford Company, he travelled to the Mediterranean in 1885, to Britain in 1887, and to France in 1888, perfecting his command of the French language.

From 1889 to 1891, young Reford lived at Victoria, British Columbia, immersing himself in the commercial life of the province. He assisted in running the affairs of the Mount Royal Rice Milling and Manufacturing Company and acted as Ship's Agent for the firm's clipper ship *Thermopylae*, which brought rice from China. During these years of apprenticeship, he used one of the new Kodak No. 1 cameras to record the activities of himself and his friends, and to document the landscape and people of British Columbia. He continued his interest in photography as a member of the Montreal Camera Club in 1894.

In 1892, Reford became the Reford Company's agent at Antwerp, Belgium, and later

returned to Montreal to become the company's Secretary-Treasurer. Upon the death of his father in 1913, he became President, remaining active in the management of the company until his resignation as Director in 1946. *PR*

COLLECTIONS

PUBLIC ARCHIVES CANADA
Robert W. Reford Collection (Acc. No. 1973-50) consists of 841 original prints, illustrating the activities of Robert Reford and friends in British Columbia, as well as views of Victoria and Port Simpson, and photos of the Indian and Chinese people of British Columbia. Inclusive dates are 1889-1891.

ROBERTS, Albert Townshend

(1874 or 1875 — 9 November 1944, Toronto, Ontario)

Albert T. Roberts' origins and early career are vague. Only in the last twenty years of his life, from 1923, was he a member of the Toronto Camera Club. When he began to exhibit his work publicly, he gained considerable reputation both as a technically accomplished photographer and as a gently humorous individual. His wit and clarity of expression could be seen in practically all his photography, which was welcomed annually at many Canadian and American salons. During this period he worked for a number of Toronto commercial photographic firms; then, during the late thirties, in partnership with John Warwick; and finally, until his death, with Milne Studios.

A.T. Roberts' amateur activity was distinguished by a willingness to experiment. In 1924 the Toronto International Salon hung 500 prints, of which 77 were by Canadians. Some 21 different printing processes were used by the exhibitors, but only five were used by Canadians, and Roberts' portrait *Private Richardson, V.C.* was one of the few Canadian bromoils shown that year. Later salons show that he was successful in using the other common printing

processes, varying his technique according to the situation or, equally likely, to what was available. He was adept at using paper negatives, and was also aware of such special effects as the use of great depth of field in photographing miniature constructions. His specialty was "table-top" work: scenes created from bits of coal, stones, fur, roots or grasses, all photographed so as to appear like natural landscapes. On at least one occasion his "table-top" was accepted and hung as a genuine landscape.

Roberts had several prints hung in the Toronto International Salon practically every year from 1923 until 1944; his work was also hung in numerous Canadian and American salons, perhaps because many of his prints were full of wit — a commodity often in short supply in the period — and expressed a joviality of spirit said to be in the man's character. Few of A.T. Roberts' prints still exist; those known represent work of high technical and graphic quality. *ACR*

COLLECTIONS

PUBLIC ARCHIVES CANADA
Albert T. Roberts Collection (Acc. No. 1980-42) contains three salon prints.
Albert T. Roberts Collection (Acc. No. 1984-123) contains 18 contact prints of "table-top" studies.
John Morris Collection (Acc. No. 1980-238) contains one print by Roberts.

ROCHE, Richard (16 June 1831,

England — 6 May 1888, Isle of Wight)

Roche was the son of George Tierney Roche, a Church of England cleric. In 1851 he began his career in the Royal Navy as a mate on the *Herald*. He was promoted to the rank of Lieutenant in 1855 and began his tour on the *Satellite* in October, 1856. The *Satellite* left that December for Vancouver Island to survey the boundary between British possessions on the coast and those of the United States. During the 1859 American occupation of San Juan Island the *Satellite* was stationed off the island, and Roche was sent ashore to reconnoiter a suitable campsite for the Royal Marines during the following period of joint occupation of the island.

There is no indication when Roche began photographing, but the earliest work coincides with the trip from England, around South America to Vancouver Island. He joined the Coast Guard in 1868 with the rank of Commander and retired to the Isle of Wight in 1879 where he died in 1888. *AJB*

COLLECTIONS

PROVINCIAL ARCHIVES OF BRITISH COLUMBIA
The Francis Claudet Albums (Acc. No. 98201-79) contain approximately 9 original prints c. 1858-1860.
UNIVERSITY OF BRITISH COLUMBIA, SPECIAL COLLECTIONS
The Special Collections has approximately 4 original prints c. 1858-1860.
YALE UNIVERSITY LIBRARY, WESTERN AMERICANA COLLECTION
The James Alden Scrapbook contains approximately 20 original prints showing a number of South American Pacific coast cities and British Columbia, 1857-1860. They are all in poor condition.

ROSS, Bernard Rogan

(25 September 1827, Londonderry, Ireland — 21 June 1874, Toronto, Ontario)

Ross was born and educated in Londonderry, Ireland, the son of James Ross and Elizabeth Rogan. He joined the Hudson's Bay Company in June, 1843, as an apprentice clerk at Norway House. He served at a number of northern posts until he was appointed a Chief Trader in 1856. He served at Fort Simpson from 1858-1862. Following this he was at Moose Factory for several years and at Fort Garry during the Riel uprising. He retired from the company in 1871 and died during a visit to Toronto three years later.

Ross was a founding member of the Anthropological Society of London (1863) and a member of the Royal Geographical Society from 1864 in addition to other scientific groups. He was responsible for some notable donations of both natural history objects and meteorological information to the Smithsonian Institution through Robert Kennicott. While he was at Fort Simpson he undertook extensive observations and collected widely to illustrate the natural history and ethnology of the Mackenzie River region. It was probably about this time that he began to use photographs to support his scientific pursuits. Certainly he was the most active of the officers at Moose Factory while he was there. *AJB*

COLLECTIONS

PUBLIC ARCHIVES CANADA
Sandford Fleming Collection (Acc. No. 1936-272). 42 original prints primarily views of the forts of Moose Factory and Rupert's House taken by various Hudson's Bay Company employees including B.R. Ross.
ARCHIVES OF ONTARIO
H. Lionel Smith Collection (Acc. No. 2210) contains several dozen original prints by Ross including many *carte-de-visite* portraits of Inuit and Indians.

PAC, PA-113087

ROSS, John Wardrop

(23 January 1870, Montreal, Quebec — 11 August 1946, Montreal, Quebec)

John W. Ross was educated at Montreal High School and Montreal Business College before travelling extensively in Britain and Europe. In 1893, he became a partner in P.S. Ross & Sons, his father's chartered accounting firm. Elected to the Association of Accountants in 1896, he served as Secretary-Treasurer from 1899 to 1901 and as President in 1905 and 1906. Further professional distinction came with his election in 1902 as a Fellow of the Dominion Association of Accountants. During a business career which lasted 53 years, Ross also held directorships in a number of firms, and was President of the Montreal Board of Trade in 1923, 1932 and 1933. He was prominent in numerous charitable organizations, and received an LL.D. from McGill University in 1924.

Ross sought relaxation from public life with a number of hobbies, including golf, fishing, curling, and amateur photography. He was a founding member of the Montreal Y.M.C.A. Camera Club in 1898, serving as the first Vice-President. His photographs record the activities of his large family and of his wide circle of relatives and friends, often in a light-hearted and humorous way,

both in Montreal and at summer resorts like Cacouna. *PR*

COLLECTIONS

PUBLIC ARCHIVES CANADA
John W. Ross Collection (Acc. No. 1979-133) consists of 100 original prints, illustrating the daily life of the Ross family and friends at Montreal and Cacouna, Que., as well as various buildings at McGill University. Inclusive dates are c. 1885-1917.

PAC, 1982-247, 64-2949

SAUNDERS, Charles Edward

(2 February 1867, London, Ontario — 25 July 1937, Toronto, Ontario)

Charles Saunders made his reputation in agricultural science. With degrees from the University of Toronto (B.A., 1888) and Johns Hopkins University in Baltimore (Ph.D., 1891), he became Dominion Cerealist at Ottawa's Dominion Experimental Farm in 1903. Saunders followed through a research program begun by his father (Director, 1886-1911), ultimately creating the famous Marquis strain of wheat in 1906.

His hobbies included music as well as photography. He was a member of the Ottawa Camera Club from 1896 to 1921, including a term as President. Saunders was a leader of the elite eight who broke from the Ottawa Camera Club in 1904 to form the Ottawa Photographic Art Club. Two of his prints were chosen by Sidney Carter for inclusion in the landmark 1907 "Photo-Club of Canada" show

in Montreal. A regular exhibitor and active clubman, Saunders' membership ceased only with this club's apparent cessation because of the creation of a larger Ottawa Camera Club in 1921. Collections of Saunders family materials exist in the Library of the University of Western Ontario, Regional Collection, and in the Manuscript Division of the Public Archives Canada (MG 29 B19). *LK*

COLLECTIONS

PUBLIC ARCHIVES CANADA
Ottawa Camera Club Collection (Acc. No. 1971-161) contains 4 prints.
Canada. Department of Agriculture (Acc. No. 1982-247) contains an undetermined number of prints probably by Saunders.

SAUNDERS, Leslie Gale

(3 December 1895, London, England — 11 September 1968, Victoria, B.C.)

Soon after he moved to Nova Scotia at the age of sixteen, Leslie Saunders enrolled at Truro Agricultural College. He later attended Macdonald College, McGill University, and in 1925, earned his Ph.D. from the Molteno Institute for Medical Parasitology in Cambridge, England, before returning to Canada to take up a position in the Biology Department of the University of Saskatchewan. There he taught invertebrate zoology, entomology and parasitology for the next thirty-six years. During that time he conducted field research in South and Central America as well as in south-east Asia and the Philippines. Saunders returned from these travels with sketches for his watercolours, and negatives for many award-winning photographs.

Saunders began exhibiting pictorial photography in the late 1920s and continued his salon

work into the fifties. Working from 3 1/4" x 4 1/4" negatives, he manipulated his prints in a variety of ways, sometimes using an intermediate paper negative in the production of his bromide and chlorobromide prints. Saunders was one of the few Canadians to exhibit bromoils throughout the late twenties and into the thirties. His prints were shown at exhibitions in Canada, the United States and Great Britain, and in 1936, his work was hung by invitation at the Empire Exhibition in Johannesburg, South Africa. During the thirties, several of his prints won honourable mentions in the annual competitions of *American Photography*. Saunders also produced award-winning natural history photographs. About 1940, he became an Associate of the Royal Photographic Society. *JMS*

COLLECTIONS

MENDEL ART GALLERY, SASKATOON
Jessie S. Saunders Gift (Acc. No. 81:32-) contains approximately 85 watercolour paintings by Saunders and some 145 of his mounted salon prints.
NATIONAL GALLERY OF CANADA
L.G. Saunders Collection (on loan) includes 21 of Saunders' award-winning prints dating largely from the thirties.
PUBLIC ARCHIVES CANADA
Leslie G. Saunders Collection (1983-79) consists of copy negatives of three photographs of Saunders, c. 1930-1955.

SCOTT, Robert John Elliot
(fl. 1890-1920)

Robert Scott may have acquired an interest in watches as timekeeper for the Canadian Pacific Railway early in his career. He worked in Birks Jewellers in Montreal for perhaps twenty-five years, finally becoming a watchmaker and jeweller in Port Hope, Ontario. Reminiscences by a relative indicate his character was meticulous, austere and demanding. His only known photographs are largely

concerned with his relatives of the Scott, Rogers and Carss families of Montreal and Ottawa. *LK*

COLLECTIONS

PUBLIC ARCHIVES CANADA
Marion G. Rogers Collection (Acc. No. 1953-124) contains four albums with c. 500 prints, probably all by R.J.E. Scott.

PAC, PA-124026

SPEIRAN, Ralph Henry
(26 January 1910, Toronto, Ontario — 12 March 1974, London, Ontario)

Ralph Speiran was raised in London, Ontario, where he became a chef for Robert Simpson's for 37 years and then for the University of Western Ontario for another ten. Speiran was active as an amateur photographer during the late thirties and early forties. He was a member of FotoForum and served as the group's treasurer in 1939-40. Using a 2 1/4"-square twin-lens reflex camera, Speiran did some portraiture on a casual basis and occasionally sold photographs of local events to the newspaper. Though tempted at one stage to become a professional, Speiran gave up photography in 1944 to raise, train and ride horses. *JMS*

COLLECTIONS

PUBLIC ARCHIVES CANADA
Ralph H. Speiran Collection (Acc. No. 1980-97) contains 8 mounted salon prints, a half dozen snapshots, and 16 unidentified Dufaycolor transparencies. A large number of Speiran's b/w negatives

were destroyed by mould.
George A. Pearce Collection (Acc. No. 1979-235) Among Pearce's collection of photographs by London colleagues are five mounted salon prints by Ralph Speiran.

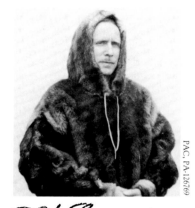

PAC, PA-126769

TWEEDLE, Arthur Herbert
(6 January 1900, Binbrook Twp., Wentworth Co., Ontario — 22 October 1976, Midland, Ontario)

Arthur Tweedle was an optometrist whose professional interest in precision optical instruments made him especially receptive to the Leica introduced to him by Leonard Davis in the early thirties. Tweedle became an active member of the Hamilton Camera Club, and although he exhibited little outside the salons of Southern Ontario, he participated in the monthly print competitions and assisted in the organization of the annual Canadian Salon. He travelled widely in Canada, filling snapshot albums with prints from these trips and later producing salon prints from the negatives. Described by Leonard Davis as "an absolute perfectionist with a sense of humour that made his eyes dance," Tweedle was most successful in his candid portrayals of people on the street or in the midst of their everyday activities. He was President of the Hamilton Camera Club in 1940, the same year that one of his prints was named "Canada's Print of the Year" at the Seventh Annual Canadian Salon. At this

time, Tweedle became an Associate of the Royal Photographic Society and shortly thereafter a Fellow of the Royal Society of Arts. In 1945, immediately after his discharge from the RCAF, and again in 1946, Tweedle went on trips sponsored by the Canadian National Institute for the Blind aboard the R.M.S. *Nascopie*, travelling throughout the eastern Arctic to examine the eyes of the Eskimos. During these voyages, he kept a journal and took black and white photographs and colour slides of the Inuit, their settlements and the landscapes of the Canadian Arctic, as well as the crew and activities aboard ship. *JMS*

COLLECTIONS

PUBLIC ARCHIVES CANADA
Arthur H. Tweedle Collection (Acc. No. 1978-162) consists of 890 celluloid negatives, 212 prints, 2,250 snapshots in 3 albums and 940 colour 35 mm slides. Included are a large number of mounted salon prints from the thirties and forties and photographic documentation of the "Eskimo Eye Survey, Eastern Canadian Arctic." Papers, pamphlets and maps which accompanied the collection are held by the Public Archives (MG 30 B114); several artifacts gathered in the Arctic were transferred to Ethnology Division, National Museum of Man.
Arthur H. Tweedle Collection (Acc. No. 1983-90) contains one portrait of Tweedle taken in 1969 by Leonard Davis.

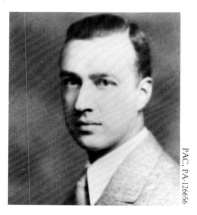

PAC, PA-126656

UPTON, Alfred Stephen
(b. 3 December 1898, Southport, Lancashire, England)

Alfred Upton came to Canada with his family in 1907, first to Toronto, then to Montreal. Upton began work as an agent for a life insurance firm in Montreal and, in 1927, joined Dominion Life, eventually becoming President in 1957. He retired in 1964, but remained on the Board until 1973. Throughout his long and demanding career, Upton cherished photography as a relaxing and absorbing hobby. For him, the darkroom provided an escape: "You can't think about business when you're concentrating on making a fine print, wondering how long to dodge here or burn there."

Upton began to take photographs at the age of 12 using an Ensign box camera given to him by his father. A few years later he graduated to a #4 folding pocket Kodak. Although the camera took roll film, Upton had a plate back made for it, finding that being able to compose a picture on ground glass overcame any possible snapshooting tendency. Upton's wife Ellen gave him a vest pocket Kodak in 1925 as he began to do more travelling, and, a few years later, a 9 x 12cm Recomar which took cut film or film pack or plates: this, Upton considered to be his "first real camera." Still later he acquired a Rolleicord 2 1/4''-square twin reflex, a 35mm Rolleiflex and, upon his retirement, a 4'' x 5'' view camera. With this succession of equipment, Upton has sustained a reputation as a salon exhibitor of international stature for almost fifty years.

Upton entered the international salon scene in 1934 after buying a home in Waterloo, Ontario, that allowed him darkroom facilities. Upton's work was shown every year at the Canadian Salon of Photography of the Hamilton Camera Club, from its inception in 1934 to the final exhibition in 1972. His work appeared at salons all over Europe, and in 1938 he was one of two Canadians exhibiting at The Commemorative Salon of Photography marking Australia's 150th anniversary celebrations and held in Sydney. A member of the Photographic Society of America in 1952 and of the National Association for Photographic Art in 1969, he received his Associateship in the Royal Photographic Society in 1972 and, four years later, became a Fellow of the Royal Society of Arts. Upton's work bears witness to a master printer whose commanding knowledge of techniques and printing papers produced photographs that are rich and luminous. *JMS*

COLLECTIONS

PUBLIC ARCHIVES CANADA
Alfred S. Upton Collection (Acc. No. 1982-238) consists of 4 mounted salon prints (1931-39). *Alfred S. Upton Collection* (Acc. No. 1983-53) contains 5 mounted salon prints (1934-46) including his well-known prints, *Saplings* and *Wayside Birches*, and an exquisite Gevaluxe print of Victoria Harbour, 1946. Also part of the collection are copies of two portraits of Upton, 1932 and 1958, and his Recomar camera, with which much of his pictorial work of the thirties was done.
PRIVATE COLLECTIONS

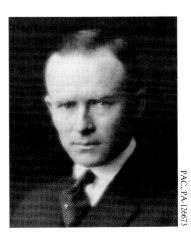

PAC. PA-126673

VANDEWIELE (VAN), Albert Robert (1881, Belgium — 3 January 1964, Toronto, Ontario)

Albert Van is said to have lived in order to photograph. He pursued photography as both a vocation and a recreation for over sixty years in North America, and had probably done so for a number of years before in Europe.

He either left home or became an orphan at the age of 17, and turned to photography to make a living. Around the turn of the century he was in North America, for he took a number of views of the San Francisco earthquake of 1906. He is also supposed to have studied photography in New York City. About the same time he took numerous publicity shots for the Canadian Pacific Railway, some of which were reputedly still being used in the mid-1960s. The date of his arrival in Toronto is unknown, but two of his photographs were accepted in the seventh Toronto International Salon held in 1910. By 1913 he was working for the City of Toronto works department, in the blueprinting section, under the direction of A.S. Goss. About 1922 he joined the Toronto *Telegram* newspaper as a press photographer. Here he remained for 41 years, until May 1963.

Van's amateur photography is on the whole easily distinguishable from his professional work. Both covered a large number of subjects, and went through several stylistic changes. Genre, portraits, and landscapes appear in Van's early work in abundance. During the period 1910-1920 he also kept several snapshot albums which contain photographs of all sizes, qualities, and subjects. He experimented with various printing methods, and often sought to obtain a charcoal-like effect. Later experiments involved toning, hand-colouring, and a variety of printing papers.

Until the beginning of the 1920s most of Van's photographs included people. However, his interests moved increasingly towards nature photography treated in a pictorialist manner. The most accomplished of his amateur work is represented by pictorial prints made before the Second World War. Subsequently he confined himself almost entirely to colour slides. Most of those still extant document vacation trips through Canada, the United States and Mexico.

Van did not exhibit a great deal in the salons, but he often received awards for his professional work. A large number of his photos were reproduced in international publications such as *National Geographic*, *Life*, and the *Encyclopaedia Britannica*. In his later years Van always carried a Leica in his pocket. A small man, he pioneered the use of smaller and lighter press equipment, being one of the first in Toronto to use sheet film, flashbulbs, and then miniature cameras for his work. *ACR*

COLLECTIONS

PUBLIC ARCHIVES CANADA
Albert Van Collections (Acc. Nos. 1980-236, 1980-237) Together the collections include several thousand negatives, slides and prints, mainly of wildlife, especially birds, covering Van's entire amateur career from the turn of the century until the late 1950s. Few of the items are identifiable as salon prints, although an album of mounted prints may include several.

WHITELAW, A. Brodie (b. 1910, Meaford, Ontario)
Brodie Whitelaw moved with his parents to Vancouver in 1919, and by the age of twelve he had acquired a Kodak Vest Pocket camera. By his later high school years he had set up a small portrait photography business, in which he was helped considerably by the internationally known photographer, John Vanderpant, whose style and outlook greatly influenced his photography at this time.

After a year at Vancouver

Technical High School, Whitelaw went to the University of British Columbia to study aeronautical engineering. He found this uncongenial and, as the Depression hit Vancouver with some force, came to Toronto in early 1931. After a short course at Shaw's Business Schools, Whitelaw worked briefly in the accounting department of Shell Oil, and shortly thereafter became a photographer in the commercial and advertising studio at Milne Studios. By the autumn of 1931 he had joined the Toronto Camera Club, and exhibited in the club's monthly competitions. His increasing involvement in professional photography, and his desire to obtain a pilot's licence, led him to give up the Club in 1935. In the mid 1930s he moved to Pringle and Booth in the agency, fashion, and catalogue fields. Here he remained until 1942, when he joined the British Commonwealth Air Training Plan as staff pilot at No. 9 Air Observers School, RCAF, St-Jean, Quebec, a navigation school. After the War he joined Brigden's Limited, a leading Toronto graphic arts house.

Brodie Whitelaw's early photography was mainly landscapes and portraits, done in soft or diffused focus. However, by the late 1920s, perhaps following his mentor Vanderpant, his interest in geometrical form and the massing of shapes had taken precedence over the earlier pictorialist style. After his move east he continued his concentration on line and form.

Whitelaw exhibited at the Toronto International and other Toronto area salons during the 1930s. After 1934 much of this photography was done with various colour methods, primarily three-colour carbon and wash-off relief; he gave these up when Kodachrome became readily available.

After the War Whitelaw became deeply involved in professional activities. He was one of the founding members of the Commercial and Press Photographers Association of Canada (CAPPAC), served on the Board of Directors for six years, and was elected president of the association in 1955. He continued at Brigden's until his retirement in 1980. *ACR*

COLLECTIONS

PUBLIC ARCHIVES CANADA
 A. Brodie Whitelaw Collection (Acc. No. 1983-25) includes c. 60 prints made from c. 1926 - c. 1935, some of which were exhibited at the Toronto Camera Club.

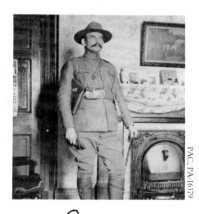

PAC. PA-16379

WOODSIDE, Henry Joseph (1858, Arkwright, Ontario — November 1929, Ottawa, Ontario)

Young Harry Woodside joined the Canadian Pacific Railway in Port Arthur as a telegraph operator. Later he moved on to Manitoba, where he opened a jewellery store at Portage la Prairie in 1880. With the outbreak of the Northwest Rebellion in 1885, he joined the militia with the rank of sergeant, and raised a company which formed part of the Winnipeg Battalion of Infantry assigned to duty around Qu'Appelle.

Woodside resumed his business activities in Portage after the rebellion. He also began a second career as a journalist with the weekly *Manitoba Liberal*. He continued to be active in the militia, winning promotion to the rank of captain and taking command of the local infantry company in 1891. About this time he took up photography in order to record his varied activities. His company became 'B' Squadron of the Manitoba Dragoons in 1893.

Promoted to major in 1898, Woodside went on the unattached list in order to visit the Yukon. As a special correspondent for a number of Canadian and American newspapers, he accompanied the Yukon Field Force over the Teslin Trail to Dawson. He remained there until 1901, not only as editor and manager of the Yukon *Sun* but also as Census Commissioner of the Yukon.

In the Boer War he volunteered for service with the Canadian contingent, reverting to the rank of lieutenant with the 2nd Canadian Mounted Rifles. Unfortunately, he did not reach South Africa until after the end of hostilities in 1902.

Returning to Canada, Woodside married and eventually settled in Ottawa, where he became manager of an insurance company in 1909. He was president of the Ottawa branch of the South African Veterans' Association in 1912 and 1913. In August 1914, Woodside once again volunteered for active service and raised a company which became part of the 14th Royal Montreal Regiment. After serving at depots in England, he was posted to France with the 5th Canadian Mounted Rifles. His tour was abruptly terminated by a shell which fell near Hooge in May 1915; Woodside was buried in a trench and suffered shellshock and ruptured eardrums. Partially deaf, he returned to Canada late in 1916 and retired from the service in February 1917. He served as both secretary and treasurer of the Ottawa branch of the Great War Veterans' Association. After the war he resumed his former job with the insurance company, and carried on until his death in November 1929. *PR*

COLLECTIONS

PUBLIC ARCHIVES CANADA
 H.J. Woodside Collections (Acc. Nos. 1967-25, 1970-157, 1974-432, 1980-123) consists of 3,042 prints and 5,004 negatives, documenting all aspects of the Klondike Gold Rush and of the participation of the 5th Canadian Mounted Rifles in the South African War, as well as views of such communities as Port Arthur, Ont., Portage la Prairie, Man., and Dawson City, Y.T., and aspects of Woodside's career as jeweller, military officer, public servant and journalist. Inclusive dates are c. 1890-1923.

Bibliography

A) Archival Sources

Many provincial, municipal and other archives contain both manuscript and photograph collections which, although not specified as the work of amateurs, can reveal themselves as such with some probing. Standard sources, available both in archives and libraries, are biographical dictionaries and handbooks, "who's who's" and "blue books," all containing valuable and specific name references, where "photography" appears as an individual's hobby or interest. Assessment rolls and telephone, criss-cross and city directories are useful for tracking down surviving relatives. A complete listing of all known city directories in Canada from 1790 to 1950 is provided by Dorothy E. Ryder's *Checklist of Canadian Directories, 1790-1950/Répertoire des annuaires canadiens, 1790-1950*, Ottawa: National Library of Canada, 1979.

Within the Public Archives Canada, the National Photography Collection has become a centre for research into the history of photography in Canada, both amateur and professional. During the course of this project the authors located and acquired the photography of many prominent Canadian amateurs, to supplement the already extensive representation of such work in our collections. In addition to vintage prints, the Public Archives Canada now holds correspondence, medals and other documentation. As a result of interviews and conversations, research files were created for dozens of photographers whose names do not appear in this book, and many hundreds of cards were added to a name index of Canadian photographers who, as yet, live on in name only.

Manuscript or photograph collections, not already mentioned in the biographies of photographers, of specific help to the authors:

Archives of Ontario, Toronto:
— M.O. Hammond Collection, Acc. 6355;
— C. Macnamara Collection, Acc. 3026, Acc. 2271;

City of Vancouver Archives, Vancouver;
— Vancouver Arts & Crafts Association Papers, Add. mss. 142;

Notman Photographic Archives, McCord Museum, Montreal:
— W. Hanson Boorne Papers;
— Alexander Henderson Papers;

Provincial Archives of British Columbia, Victoria:
— Francis G. Claudet Papers, A E C57 C57, Claudet to Mary Claudet, 20 June 1860;

Public Archives Canada, Ottawa:
— Joly de Lotbinière Family Papers, MG 24, I 117 (Microfilm Reel M-788);
— Montreal Amateur Athletic Association Papers, MG 28 I 128;
— Ottawa Camera Club Papers, MG 28 I 295;
— Professional Photographers of Canada Papers, MG 28 I 141;

— Toronto Camera Club Papers, MG 28 I 181;

Whyte Foundation, Banff:
— Vaux Collection.

B) Unpublished Research Manuscripts

Burant, Jim. *Photographers and Photographic Studios, St. John, New Brunswick, 1845-1865/Photographes et studios de photographie à Saint-Jean (Nouveau-Brunswick), 1845-1865.* PAC-NPC Finding Aid FA-35/APC-CNP Instrument de recherche FA-35, 1973.

Koltun, Lilly. *Pre-Confederation Photography in Toronto/La photographie avant la Confédération à Toronto.* PAC-NPC Finding Aid FA-40/APC-CNP Instrument de recherche FA-40, 1976.

_____ *Robert Reford Collection Report/Rapport sur la collection Robert Reford.* PAC-NPC Finding Aid FA-37/APC-CNP Instrument de recherche FA-37, 1977.

Mattison, David. *British Columbia Photographers Directory, 1858-1900.* A-Z Nov. 1982. (copy with author, Provincial Archives of British Columbia).

Robertson, Peter. "One of those 'Daft Birds': Clifford Johnston, F.R.P.S.," Unpublished manuscript, National Photography Collection, Public Archives Canada, 1977.

Rowat, Theresa. *Photography on Prince Edward Island, 1839-1873/La Photographie à l'île du Prince Edouard, 1839-1873.* PAC-NPC Finding Aid APC-CNP Instrument de recherche, 1983.

Schwartz, Joan Marsha. *Images of Early British Columbia: Landscape Photography, 1858-1888.* Master's thesis, University of British Columbia, 1977.

Thomas, Ann. *Painting and Photography in Canada, 1860-1900.* Master's thesis, Concordia University, 1976.

C) General Reference

Adams, W.I. Lincoln, ed. *Sunlight and Shadow: A Book for Photographers Amateur and Professional.* (New York: The Baker & Taylor Co.), 1897.

Bernard, Bruce. *Photodiscovery: Masterworks of Photography 1840-1940.* (New York: Harry N. Abrams Inc.), 1980.

Coe, Brian. *Cameras, From Daguerreotypes to Instant Pictures.* (London: Crown Publishers), 1978.

_____. *Colour Photography: The First Hundred Years, 1840-1940.* (London: Ash and Grant), 1978.

Coe, Brian, and Paul Gates. *The Snapshot Photograph: The Rise of Popular Photography 1888-1939.* (London: Ash and Grant), 1977.

Crawford, William. *The Keepers of Light, A History and Working Guide to Early Photographic Processes.* (Dobbs Ferry, N.Y.: Morgan & Morgan), 1979.

Davis, William S. *Practical Amateur Photography*, New Edition, (Garden City,

New York: Garden City Publishing Co., Inc.), 1937.

Eder, Josef Maria. *History of Photography,* translated by Edward Epstean. (New York: Columbia University Press), 1945, (reprinted by Dover Publications Inc., N.Y., in 1978).

Gamble, William. *Photography and its Applications.* (London: Sir Isaac Pitman & Sons, Ltd.), n.d.

Gernsheim, Helmut. *Creative Photography: Aesthetic Trends 1839-1960.* (New York: Bonanza Books), 1974.

Gernsheim, Helmut and Alison. *A Concise History of Photography.* (London: Thames and Hudson), 1965.

Gibson, Charles R. *The Romance of Modern Photography, Its Discovery & Its Achievements.* (London: Seeley, Service & Co. Limited), 1919.

Goldsmith, Arthur. *The Camera and Its Images.* (Ridge Press Book/Newsweek Books), 1979.

Henney, Keith and Dudley, Beverly, eds. *Handbook of Photography,* (New York and London: Whittlesey House, McGraw-Hill Book Company, Inc.), 1939.

Holmes, Edward. *An Age of Cameras.* (Kings Langley: Fountain Press), 1974.

Jones, Bernard E., ed. *Cassell's Cyclopaedia of Photography.* (London, New York, Toronto and Melbourne: Cassell and Company, Ltd.), 1911.

Marden, Luis. *Color Photography with the Miniature Camera.* (Canton, Ohio: The Fomo Publishing Company), 1934.

Naef, Weston J. *The Collection of Alfred Stieglitz, Fifty Pioneers of Modern Photography.* (New York: Metropolitan Museum of Art/The Viking Press), 1978.

Neblette, C.B. *Photography, Its Principles and Practice,* 4th edition. (New York: D. Van Nostrand Company, Inc.), 1942.

Newhall, Beaumont. *The History of Photography from 1839 to the Present Day.* (New York: Museum of Modern Art), 1964.

Panzer, Mary. *Philadelphia Naturalistic Photography 1865-1906.* (New Haven, Conn.: Yale University Art Gallery), 1982.

Photo Pictorialists of Buffalo. *Pictorial Landscape Photography.* (Boston: American Photographic Publishing Co.), 1921 (originally published 1909).

Pictorial Photographers of America. *Pictorial Photography in America.* Vol. 4. (New York: Pictorial Photographers of America), 1926.

Rice, Johnston and Gladwish Photographic Supplies. *Catalogue of Cameras, Kodaks, Plates, Films, Apparatus, Supplies and Sundries* (Montreal: Rice, Johnston & Gladwish Photographic Supplies), [1903].

Sandweiss, Martha A. *Masterworks of American Photography: the Amon Carter Museum Collection.* (Birmingham, Alabama: Oxmoor House), 1982.

Sipley, Louis Walton. *A Half Century of Color.* (New York: The Macmillan Company), 1951.

Taft, Robert. *Photography and the*

American Scene: a Social History, 1839-1889. (New York: Dover Publications Inc.), 1964.

Taylor, John. *Pictorial Photography in Britain 1900-1920,* (London: Arts Council of Great Britain in association with The Royal Photographic Society), 1978.

Trachtenberg, Alan, ed. *Classic Essays on Photography.* (New Haven: Leete's Island Books), 1980.

Travis, David and Kennedy, Anne. *Photography Rediscovered: American Photographs, 1900-1930.* (New York: Whitney Museum of American Art), 1979.

Wall, E.J. *Practical Color Photography.* (Boston: American Photographic Publishing Co.), 1928.

Wall, E.J. and Mortimer, F.J. (ed.). *The Dictionary of Photography and Reference Book for Amateur and Professional Photographers,* 11th edition. (London: Iliffe & Sons, Ltd.), 1926.

_____. *The Dictionary of Photography and Reference Book for Amateur and Professional Photographers,* 12th edition. (Boston: American Photographic Publishing Co.), 1931.

_____. *The Dictionary of Photography and Reference Book for Amateur and Professional Photographers,* 14th edition. (Boston: American Photographic Publishing Co.), 1938.

D) PERIODICALS

The titles listed are the last under which a magazine was published.

AMATEUR PHOTOGRAPHER. London. 1888-. 1888-1908 as *Photography;* 1908-1918 as *Photography and Focus;* 1918-1927 as *Amateur Photographer and Photography;* 1927-1939 as *Amateur Photographer and Cinematographer.*

AMATEUR PHOTOGRAPHER AND PHOTOGRAPHIC NEWS. London. 1884-1918. 1884-1906 as *Amateur Photographer.* Merged into *Amateur Photographer and Photography,* later *Amateur Photographer and Cinematographer.*

AMATEUR PHOTOGRAPHER'S WEEKLY. Cleveland. 1912-1919. Merged with *American Photography.*

AMERICAN AMATEUR PHOTOGRAPHER AND CAMERA AND DARKROOM. Brunswick, Me.; New York. 1889-1907. 1889-1906 as *American Amateur Photographer.* United with *Photobeacon* and *Camera Notes* to form *American Photography.*

AMERICAN ANNUAL OF PHOTOGRAPHY. Boston; New York. 1887-1953. Merged with *Photography Annual.*

AMERICAN PHOTOGRAPHY: A CONTINUATION OF AMERICAN AMATEUR PHOTOGRAPHER . . . CAMERA AND DARKROOM . . . PHOTO BEACON . . . CAMERA NOTES . . . POPULAR PHOTOGRAPHY. New York; Boston. 1907-1953. Merged with *Popular Photography.*

ANNUAL REPORT OF THE CANADIAN INSTITUTE. Toronto. 1887-1888.

ANTHONY'S PHOTOGRAPHIC BULLETIN. New York. 1870-1902. Merged with *Photographic Times.*

BETTER PHOTOGRAPHY. New York. 1938-1939. 1938 as *Practical Photographer Magazine.*

BRITISH JOURNAL OF PHOTOGRAPHY. Liverpool; London. 1854-. 1854-1856 as *Liverpool Photographic Journal;* 1857-1858 as *Liverpool and Manchester Photographic Journal;* 1859 as *Photographic Journal.*

THE BRITISH JOURNAL OF PHOTOGRAPHY ANNUAL. London. 1860-. 1860-1940 as *The British Journal Photographic Almanac and Photographer's Daily Companion.*

BULLETIN OF PHOTOGRAPHY. Philadelphia. 1907-1931. Merged with *Camera.*

CAMERA AND MINIATURE PHOTOGRAPHER. Dublin; London. 1921-1940. 1921-1929 as *The Camera — For the Advancement of Photography;* 1930-1937 as *Camera and Amateur Cinematographer for the Advancement of Photography.*

CAMERA: A PRACTICAL MAGAZINE FOR PHOTOGRAPHERS. Philadelphia 1897-1953. Merged with *Popular Photography.*

CAMERA CRAFT. San Francisco. 1900-1942. Merged into *American Photography.*

CAMERA WORLD. London. 1936-1941; 1947-1958. 1936-1941, 1947-1955 as *Miniature Camera World.*

CANADIAN COURIER. Toronto. 1906-1920.

CANADIAN KODAKERY. Toronto. 1914-1932.

CANADIAN PHOTOGRAPHIC JOURNAL ILLUSTRATED. Toronto. 1892-1897. Merged into *Professional Photographer,* later *Professional and Amateur Photographer* (Buffalo).

CANADIAN PHOTOGRAPHIC STANDARD. Montreal. 1893-1899.

CANADIAN PICTORIAL. Montreal. 1906-1916.

COLLEGE TIMES: A MAGAZINE DEVOTED TO THE INTERESTS OF ALL UPPER CANADA COLLEGE BOYS, PAST AND PRESENT. Toronto. 1895-1896; 1899-1900.

THE DOMINION ILLUSTRATED: A CANADIAN PICTORIAL WEEKLY. Montreal and Toronto. 1888-1891.

GALLERY OF INTERNATIONAL PHOTOGRAPHY. Kidderminster, England. 1933-1939. 1933-1938 as *Gallery: A Monthly Review of International Pictorial Photography.*

IDEA AND FORM. Kidderminster, England. 1938.

JOURNAL AND PROCEEDINGS OF THE HAMILTON ASSOCIATION FOR THE ADVANCEMENT OF LITERATURE, SCIENCE AND ART. Hamilton, 1892-1922.

MODERN PHOTOGRAPHY. Cincinnati; New York. 1937-. 1937-1940 as *Minicam;* 1940-1949 as *Minicam Photography.*

MODERN PHOTOGRAPHY: "THE STUDIO" PHOTOGRAPHY ANNUAL. London. 1931-.

NEW PHOTO-MINIATURE. New York;

London. 1899-1936. 1899-1936 as *Photo-Miniature.*

PHOTO-CRAFT. Ann Arbor, Mich. 1918-1920.

PHOTO-ERA MAGAZINE: THE AMERICAN JOURNAL OF PHOTOGRAPHY (American Federation of Photographic Societies). Wolfeboro, N.H.; Boston. 1898-1932. 1898-1920 as *Photo-era.* Merged into *American Photography.*

THE PHOTOGRAM. London. 1894-1905. Merged into *Photographic Monthly.*

PHOTOGRAMS OF THE YEAR. London. 1895-1960.

PHOTOGRAPHIC DIGEST. New York. 1936-1938. Merged into *Minicam,* later *Photography.*

PHOTOGRAPHIC JOURNAL. London. 1853-.

PHOTOGRAPHIC JOURNAL OF AMERICA. Philadelphia. 1864-1923. 1864-1888 as *Philadelphia Photographer;* 1889-1914 as *Wilson's Photographic Magazine.* Merged with *Camera* (Philadelphia).

PHOTOGRAPHIC TIMES; AN ILLUSTRATED MONTHLY MAGAZINE DEVOTED TO THE INTERESTS OF ARTISTIC AND SCIENTIFIC PHOTOGRAPHY. New York. 1871-1915. Merged into *Popular Photography.*

PHOTOGRAPHIC TOPICS; DEVOTED SOLELY TO PHOTOGRAPHY. New York. 1902-1911. 1902-1908 as *Down-Town Topics.* Merged into *Popular Photography.*

PHOTOGRAPHY YEAR BOOK. London. 1935-.

PHOTO POUR TOUS; REVUE MENSUELLE ILLUSTREE DE PHOTOGRAPHIE ET DE CINEMATOGRAPHIE D'AMATEURS. Paris. 1924-1939.

POPULAR PHOTOGRAPHY. Boston. 1912-1916. Merged with *American Photography.*

POPULAR PHOTOGRAPHY. Chicago. 1937-. 1948 incorporated *Photo Arts.* 1953 incorporated *American Photography* and *Camera.*

PRIZE PHOTOGRAPHY. New York. 1937-1941. 1937-1940 as *Everyday Photography Magazine.* Merged with *Popular Photography.*

PROFESSIONAL AND AMATEUR PHOTOGRAPHER. Buffalo. 1896-1911. 1896-1900 as *Professional Photographer.* Merged into *Abel's Photographic Weekly* later *Professional Photographer.*

SATURDAY NIGHT. Toronto. 1887-.

THE YEAR'S PHOTOGRAPHY; THE ROYAL PHOTOGRAPHIC SOCIETY EXHIBITION NUMBER OF THE PHOTOGRAPHIC JOURNAL. London. 1922-.

E) Newspapers

Halifax *Herald.* 1896-1900.

Hamilton *Spectator.* 1892-1900.

Manitoba *Morning Free Press.* 1893-1900.

Montreal *Gazette.* 1886-1900.

Ottawa *Evening Journal.* 1894-1900.

Quebec *Morning Chronicle.* 1887-1896.

Saint John *Globe.* 1893-1900.

Toronto *World.* 1886-1900.

Vancouver *Daily World.* 1897.

F) Books and Exhibition Catalogues

Camera Club of Ottawa. 75 Years of Photography, 1896-1970. Ottawa: The Camera Club of Ottawa, 1971.

Camera Studies of Ottawa From the Ottawa Journal. Ottawa: The Ottawa Journal, 1938.

Caron, Blossom. *History of the Montreal Camera Club, 1893-1981.* Montreal, privately published, 1982.

Caron, Fernand. *Fred C. Würtele Photographe,* Québec: Ministère des Affaires Culturelles, 1977.

Cavell, Edward, ed. and intro. *A Delicate Wilderness, the Photography of Elliott Barnes 1905-1913.* Banff: Altitude Publishing/Whyte Foundation, 1980.

Cavell, Edward. *Legacy in Ice: The Vaux Family and the Canadian Alps.* Banff: Whyte Foundation, 1983.

Charlottetown. The Beautiful City of Prince Edward Island. Published for Carter & Co. Ltd. (Charlottetown) by James Bayne Co., Grand Rapids, Mich., n.d. Photos by "W.S. Louson, the Amateur Photographer" of Prince Edward Island.

Collinson, Helen. *One Man's Mountains: Joe Weiss in Jasper.* Edmonton: The University of Alberta, 1979.

Conway, G.R.G. *Water Powers of Canada: Province of British Columbia.* Ottawa: Department of the Interior, Dominion Water Power Branch, 1915.

Costeloe, Michael P. *Mexico State Papers 1744-1843, A Descriptive Catalogue of the G.R.G. Conway Collection in the Institute of Historical Research, University of London.* London: University of London, The Athlone Press, 1976.

Dymond, J.R. and Toner, G.C. *Alfred Brooker Klugh, A Bibliography.* Supplement One, *Bulletin,* Gananoque: Eastern Ontario Fish and Game Protective Association, 1936.

Graham, Colin. *H. Mortimer-Lamb: Paintings.* in series: Collections of the Art Gallery of Greater Victoria/No. 10, published by the Art Gallery of Greater Victoria, 1978.

Grant, George Munro. *Ocean to Ocean, Sandford Fleming's Expedition Through Canada in 1872.* Toronto: James Campbell & Son, 1873.

Greenhill, Ralph, and Birrell, Andrew. *Canadian Photography: 1839-1920.* Toronto: The Coach House Press, 1979.

Harmon, Carole, and the Peter Whyte Foundation, eds. *Great Days in the Rockies, The Photographs of Byron Harmon, 1906-1934,* with a biography by Bart Robinson and an appreciation by Jon Whyte. Toronto: Oxford University Press, 1978.

Hart, E.J., ed. and intro. *A Hunter of Peace, Mary T.S. Schäffer's Old Indian Trails of the Canadian Rockies.* Banff, Alta: The Whyte Foundation, 1980

Hill, Charles C. *John Vanderpant, Photographs/Photographies.* Ottawa: The National Gallery of Canada, 1976.

Holloway, Robert E. *Through Newfoundland with the Camera.* St John's, Nfld.: Dicks and Co.; London, Eng.; Sach & Co., 1905, 2nd edition, Sach & Co. only, 1910.

Horetzky, Charles. *The North-West of Canada: Being a brief Sketch of the North-Western Regions, and a Treatise on the*

Future Resources of the Country. Ottawa: A.S. Woodburn, 1873.

_____. *Canada on the Pacific.* Montreal: Dawson Brothers, 1874.

_____. *Some Startling Facts Relating to the Canadian Pacific Railway and the North-West Lands.* Ottawa: Free Press Office, 1880.

"Jay" [Thomas George Jaycocks]. *Camera Conversations.* Toronto: Macmillan, 1936.

Photographs by L.G. Saunders, 1895-1968: A Memorial. Saskatoon: Mendel Art Gallery, 1970.

Reflections on a Capital: 12 Ottawa Photographers Selected from the National Photography Collection in the Public Archives of Canada. Ottawa: Information Canada, 1970.

Reid, Dennis, *"Our Own Country Canada" Being an Account of the National Aspirations of the Principal Landscape Artists in Montreal and Toronto 1860-1890.* Ottawa: National Gallery of Canada, 1979.

Robertson, Peter. *Relentless Verity: Canadian Military Photographers since 1885/Irréductible Vérité: les photographes militaires canadiens depuis 1885.* Toronto: University of Toronto Press; Quebec: Les Presses de l'université Laval, 1973.

Robideau, Henri. *The Photographs of /Les photographies de Mattie Gunterman.* Saskatoon: the Photographers Gallery, 1977.

Russell, Victor, and Linda G. Price. *Arthur S. Goss, Photographer.* Toronto, The City of Toronto Archives, 1980.

Sprange, Walter, ed. *The Blue Book for Amateur Photographers.* Beach Bluff, Mass: published by author, 1894-1895.

Sutnik, Maia-Mari. *E. Haanel Cassidy: Photographs 1933-1945.* Toronto: Art Gallery of Ontario, 1981.

Thomas, Ann. *Fact and Fiction: Canadian Painting and Photography 1860-1900/Le réel et l'imaginaire: peinture et photographie canadiennes 1860-1900.* Montréal: McCord Museum, McGill University/Musée McCord, Université McGill, 1979.

Triggs, Stanley G. *Alexander Henderson, Landscape Photographer.* Toronto: Coach House Press [publication pending]

G) Articles

Anon. "Life in the Old West: Boorne and May 1886-1889," *Farm and Ranch Review,* October pp. 18-19, and December, 1960, pp. 16-17.

_____. "Photographs Taken Under Fire," *The Canadian Militia Gazette,* Vol. 1, No. 32, 15 December 1885, p. 252.

_____. "Some Recent Pictures in Amateur Photography," *Massey's Magazine,* Vol. III, No. 3, March 1897, pp. 176-177; Vol. III, No. 4, April 1897, pp. 265-268; Vol. III, No. 5, May 1897, pp. 342-344; Vol. III, No. 6, June 1897, pp. 427-431.

_____. "The History of Kodak Canada Ltd.," *Photographic Canadiana,* Vol. 6, No. 2, July/August 1980, pp. 4-7.

_____. "The Winnipeg Camera Club," *The Great West Magazine,* Vol. XIII (New Series), No. 1, September 1898, pp. 3-6.

_____. "W. Hanson Boorne, Photographic Artist," *Alberta History,* Spring 1977, pp. 15-22.

(Archer, A. Staunton). "No. CCXXXV. Mr. A. Staunton Archer. How I make my Exhibition Pictures. Methods and Ideals of well-known Pictorial Workers." *The Amateur Photographer & Cinematographer*, 18 April 1934, p. 354.

Beals, C.S. "John Stanley Plaskett (1865-1941)," *List of Officers and Members and Minutes of Proceedings of the Royal Society of Canada*, (Ottawa, 1942), pp. 107-113.

Best, Walter H. "More About: 'Pictorializing Photographs,' " *Camera Craft*, May 1929, pp. 203-208.

Birrell, Andrew. "Fortunes of a Misfit; Charles Horetzky," *Alberta Historical Review*, Winter 1971, pp. 9-25.

_____. "Horetzky, the first CPR Photographer," *Canadian Photography*, vol. 5, no. 3 (March 1974), pp. 41-46, 54.

B-J-ite in the Northwest [pseud.]. "Some Business Methods in Canada," *British Journal of Photography*, 27 March 1908, pp. 241-42.

Boorne, W. Hanson. "A Trip to the Crow's Nest Pass," *The Calgary Herald*, 26 and 28 September 1886, p. 1.

Bowsfield, Hartwell. "Ross, Bernard Rogan," *Dictionary of Canadian Biography*, vol. X. (Toronto: University of Toronto Press), 1972.

Boyd, John. "Success with Instantaneous Exposures," *American Amateur Photographer*, Nov. 1906, pp. 520-526.

_____. "Photographing Birds and their Nests," *American Annual of Photography and Photographic Times Almanac for 1903*, 1902, pp. 211-214; "May Blossoms," *1904*, *1903*, pp. 254-257; "Children at the Seashore," *1905*, *1904*, pp. 203-207; "Photographing Children," *1906*, *1905*, pp. 119-122; "Hunting Portraits versus Sporting Pictures," *1907*, *1906*, pp. 175-178; "Photographing Footprints," *1908*, *1907*, pp. 87-89; "Twenty-five Years Ago," *1909*, *1908*, pp. 194-199; "Night Photography," *1910*, pp. 252-257; "Making Picture Postal Cards," *1912*, *1911*, pp. 68-74; "Some Conveniences in Photography," *1913*, *1912*, pp. 141-146; "The Use of Diaphragms or Stops," *1914*, *1913*, pp. 276-277; "An Inexpensive Portable Lens Shade," *1915*, *p. 56.* "A Portable and Practical Lens Shade," *1917*, *1916*, pp. 150-153; "A Practical Fixing Tank," *1918*, *1917*, p. 222; "Some Film Defects and their Cure," *1919*, *1918*, pp. 104-105; "Using a Ray Filter for Enlarging," *1921*, *1920*, p. 268.

Bull, C. George. "Copying Prints," *American Annual of Photography*, 1909, p. 172.

_____. "Some Practical Points on Enlarging," *American Amateur Photographer*, Aug. 1902, pp. 343-350.

Burant, James. "Pre-Confederation Photography in Halifax, Nova Scotia," *The Journal of Canadian Art History*, Vol. IV, No. 1 (Spring 1977), pp. 25-44.

Carrington, James B. "A Roundabout Journey in Acadia," *Photographic Times*, 1902, pp. 244-250.

Carter, Sidney. "Pictorial Photography in Canada," *Photograms of the Year 1908*, pp. 77-80. illus. p. 144.

_____. "Pictorial Work in Canada," *Photograms of the Year 1907*, pp. 78-80, illus. p. 81.

_____. "The Week's review of art," *Montreal Daily Star*, 13 January 1932.

Cotter, H.M.S. "Chief Factor and Photographer," *The Beaver*, Outfit 264, No. 3, (December, 1933), pp. 23-26.

Cotter, James L. "The Eskimos of Eastmain," *The Beaver*, Outfit 260, No. 3, (December, 1929) pp. 301-306 and Outfit 260, No. 4, (March 1930) pp. 362-365.

Cox, H.G. "Among the Exhibitions," *American Photography*, (Boston), February 1937, pp. 150-151; March 1938, pp. 226-227.

_____. "Impressions of the New Westminster Salon." *American Photography*, vol. 23, 1929, pp. 685-686.

Cyprian, Dr. Tadeuz. "Suggested By Ottawa." *American Photography*, vol. 22, 1928, pp. 666-668.

Deignan, H.G. "HBC and the Smithsonian," *The Beaver*, Outfit 278, (June, 1947), pp. 3-7.

Eaton, Otto J. "Beginnings," *Focus*, December 1972, pp. 37-38.

English, Henry W. "Lantern slides," *The Canadian Photographic Journal*, December 1892, pp. 258-259.

Errol, Constance. "Lens Revelations — The Story of a Camera Artist [John Vanderpant] Who is Revealing the Spirit of Canada." *Maclean's Magazine*, 1 Jan. 1927, pp. 11, 46-47.

Fitz, W.G. "The Toronto Salon." *The Camera*, vol. 22, 1918, pp. 369-373.

Fox, William W. "Bubbles," *The American Annual of Photography and Photographic Times Almanac for 1894*, 1893, pp. 141-142; "Flash-Light for Amateurs," 1896, 1895, pp. 173-175.

Gadsby, James. "The Progress of Photography, Abstract of Paper Compiled and Read by Jas. Gadsby, President of the Camera Section," *Journal and Proceedings of the Hamilton Scientific Association*, No. 22, 1906, pp. 75-83.

Gordon, Bertha F. "The Camera in Canada," *Photographic Times*, 1914, pp. 233-36.

Goss, A.L. [sic]. "Pictorial Photography in Canada," *Photograms of the Year 1920*, p. 16.

Goss, Arthur S. "Pictorial Photography in Canada," *Photograms of the Year 1921*, pp. 24-25.

Greene, J.E. "The Exposure Itself," *Professional and Amateur Photographer*, Vol. VIII, No. 3, Mar. 1902, pp. 75-78; "The Toronto Camera Club's Eleventh Annual Exhibition," 1902, pp. 176-182.

Greene, P.W. "Topography Surveying" (in Canada), *Photographic Times*, 1910, pp. 320-322.

Grzeskowiak-Matejko, Joanna. "Karol Horecki — Baacz Zachodnie Kanady," *Kultura I Spoleczenstwo*, vol. 18, no. 2 (1974)

Hall, Rod. "The John Bellamy Miller Photographs (1869-1906)," *East Georgian Bay Historical Journal*, Vol. 1 (1981), pp. 102-111.

Halliday, Frank A. "No. CDV. Mr. Frank A. Halliday. How I make my Exhibition Pictures. Methods and Ideals of well-known Pictorial Workers." *The Amateur Photographer & Cinematographer*, 29 Sept. 1937, p. 366.

Hammond, W.O. "With a Camera in French Canada," *American Annual of Photography and Photographic Times Almanac for 1907*, 1906, pp. 185-192.

Harrod, Stanley, F.R.P.S. "Canadian Letter," *The Gallery* (Kidderminster), Jan. 1938, pp. 15-16; March 1938, pp. 45-46; April 1938; pp. 62-63; June 1938, pp. 92-94; Sept. 1938, pp. 121-122; Oct. 1938, pp. 158-159; Jan. 1939, pp. 14-15; Mar. 1939, pp. 46-47.

_____. "[Photography in] Canada," *Photograms of the Year 1939*, p. 18; 1940, p. 17.

Haweis, L. "British Columbia as a Field for British Photographic Enterprise," *The British Journal of Photography*, 26 March, 1909, pp. 233-235, and *The British Journal of Photography*, 2 April 1909, pp. 263-265.

Helders, Johan. "No. XCV. Mr. Johan Helders. How I make my Exhibition Pictures. Methods and Ideals of well-known Pictorial Workers," *The Amateur Photographer & Cinematographer*, 21 Oct. 1931, p. 385.

Henderson, Alexander. "Intensification with Mercury," *The American Annual of Photography and Photographic Times Almanac for 1892*, 1891, pp. 137-138.

Howard, Alfred H. "Some Irresponsible Remarks by a Mere Draughtsman," *The Canadian Photographic Journal*, February 1894, pp. 40-41; March 1894, pp. 84-85; "Rambling Incoherencies," May 1894, pp. 162-164; June 1894, pp. 203-206; July 1894, pp. 240-242; August 1894, pp. 277-281; September 1894, pp. 324-329; October 1894, pp. 362-370; November 1894, pp. 415-417; January 1895, pp. 11-14; February 1895, pp. 33-35; March 1895, pp. 71-73; "Some More Irresponsible Remarks by a Mere Draughtsman," November 1894, pp. 420-422; March 1895, pp. 63-66.

Howell, David J. "Press Photography in Canada" *The British Journal of Photography*, 2 April, 1909, p. 265.

Ide, William. "Portrait of the Human Figure," *Photo-Era*, May 1911.

Imlah, William. "Experience with Bromide Paper," *The American Annual of Photography and Photographic Times Almanac for 1890*, 1889, pp. 195-196.

Johnston, C.M. "No LXV. Mr. C.M. Johnston (of Canada). How I make my Exhibition Pictures. Methods and Ideals of well-known Pictorial Workers." *The Amateur Photographer & Cinematographer*, 25 March 1931, p. 254.

_____. "[Photography in] Canada," *Photograms of the Year 1937*, p. 19; 1938, p. 19.

Johnson, Peter. "Early Photographs of an Ontario Community," *Canadian Collector*, September/October 1977, pp. 44-47.

Kells, H.F. "How It Was Done," *Camera Craft*, Dec. 1934, pp. 565-72.

_____. "The Science of Pictorial Composition," *American Photography*, Oct. 1933, pp. 577-90.

Klugh, Alfred Brooker. "Wild Life and The Camera," *The Amateur Photographer & Photography*, 7 May 1924, pp. 444-445; Colouring Prints," 27 Aug. 1924, pp. 200-201; "Landscape Photography in Canada," 29 April 1925, pp. 435-436.

_____. "Hunting With a Camera," *Forest and Stream*, vol. 84, 1923, pp. 302-303, 332; 366-367,400; 434-435; 452-456; 492-493, 510.

_____. "The Charm of the Sunset," *American Photography*, vol. XIV, May 1920, pp. 284, 286-287.

_____. "Nature and Wildlife," [a monthly column], *American Photography*, 1923-1932.

_____. "Photographing Plants in Their Haunts," *American Annual of Photography*, 1916, pp. 198-202; "Sunset Photography," 1917, pp. 58-62.

Kodar, Tiit. "Northern Lights: Canadian Photography Journals Past and Present," Karen McKenzie and Mary F. Williamson, eds. *The Art and Pictorial Press in Canada* (Toronto: Art Gallery of Ontario) 1979, pp. 50-60.

Koltun, Lilly. "Pre-Confederation Photography in Toronto," *History of Photography*, Vol. 2, No. 3, July 1978, pp. 249-263.

MacKay, J. Harold. "Photographic Art in Canada," *Light and Shade*, Feb. 1929, pp. 6-7. Also published in *The Camera*, Nov. 1929, p. 295.

_____. "Photography in Canada," *Photograms of the Year 1930*, p. 16.

_____. "Pictorial Photography in Canada," *Photograms of the Year 1924*, pp. 14-15; *1925*, p. 17; *1926*, pp. 15-16; *1927*, pp. 18-19; *1928*, p. 9; *1929*, p. 9.

Macnamara, Charles. "A Method of Restoring Cracked Negatives," *Amateur Photographer and Photographic News*, May 1909, p. 490; "The Colloid Toning Process," 1913, p. 544.

Marsh, D.B. "All Caribou," *The Beaver*, Outfit 273, Dec. 1942, pp. 18-21; "Action Camera," Outfit 274, Sept. 1943, pp. 38-39.

_____. "Arctic Darkroom," *Sports Afield*, Sept. 1943, pp. 44-45.

_____. "Camera in the Arctic," *Popular Photography*, Dec. 1943, pp. 36-37, 85-87.

Massey, Walter E.H. "Development of the Photographic Art," *The Canadian Photographic Journal*, February 1893, pp. 4-8; March 1893, pp. 31-35; "How I Made My Pictures at the World's Fair," September 1893, pp. 237-242; "The Dark Side of the Art," December 1893, pp. 393-396.

Metcalfe, Bruce. "Photography in Canada," *Photograms of the Year 1931*, p. 17.

_____. "[Photography in] Canada," *Photograms of the Year 1932*, p. 20; *1933*, p. 22; *1934-35*, p. 21; *1936*, p. 20.

Montefiore, W.S. "History of the Montreal Camera Club, 1893-1955," *Photographic Journal*, Sept. 1955, p. 192.

Mortimer-Lamb, Harold. "Photography as a Means of Artistic Expression," *Canadian Journal of Politics, Science, Art and Literature*, Vol. 39, No. 1, May 1912, pp. 35-46.

_____. "Photography at Night," *American Annual of Photography*, 1908, pp. 285-291.

_____. "Photography for Mining Engineers and Geologists," *Journal of the Canadian Mining Institute*, Part of Vol. XIV, pp. 105-112, and an abridgment: *Amateur Photographer and Photographic News*, Oct. 1911, pp. 429-430.

_____. "Pictorial Photography in British Columbia," *Photograms of the Year 1904*, pp. 15-18.

_____. "Pictorial Photography in

Canada," *Photograms of the Year 1905,* pp. 81-86; *1906,* pp. 10-12 illus. p. 46; *113,* pp. 34-35, illus. Plate XLIII; *1914,* pp. 23-25; *1915,* pp. 21-23; *1918,* p. 25.

Moss, W.H. "Halation and its Prevention," *The Canadian Photographic Journal,* Dec. 1893, pp. 389-390.

Pathfinder [pseud.]. "An Amateur and his Work," *The Great West Magazine,* Vol. XIII (New Series), No. 2, October 1898, pp. 88-91.

Plaskett, J.S. "Photography in Natural Colours," *Transactions of the Canadian Institute,* Vol. VII, Toronto, 1904, pp. 371-390.

Reid, J. Addison. "The Toronto Exhibition," *The Photographic Journal of America,* Vol. 58, 1921, pp. 416-418.

[Roberts, Alfred T.]. "You Really Mustn't Believe All You See." *Saturday Night,* 6 June 1936, p. 13.

Robertson, Peter. "The All-Penetrating X," *Archivaria,* No. 10, Summer 1980, pp. 258-260.

Roland, Charles G. "Priority of Clinical X-Ray Reports: A Classic Dethroned?" *Canadian Journal of Surgery,* Vol. 5, July 1962, pp. 247-251.

Sherk, J.M. "H.B.C. Pioneers. Bernard Rogan Ross (1827-1874)," *The Beaver,* Outfit 257, December, 1926, p. 25.

Sinclair, George L. "Some Advice to Beginners," *The American Annual of Photography and Photographic Times Almanac for 1887,* 1886, pp. 68-71; "Lantern Slides and Transparencies," *1888,* 1887, pp. 185-187; "Snow Pictures," *1890,* 1889. pp. 141-142.

Sise, Hazen. "The Seigneur of Lotbinière — His 'Excursions daguerriennes'," *Canadian Art,* Vol. IX, Oct. 1951, pp. 6-9.

(Smith, Norman P.) "No. CDXXXII. Mr. Norman P. Smith (Canada). How I make my Exhibition Pictures. Methods and Ideals of well-known Pictorial Workers." *The Amateur Photographer & Cinematographer,* 6 April 1938, p. 379.

Spencer, Percival L. "The Camera in the Mission Field," *The Canadian Photographic Journal,* June 1894, pp. 206-209; August 1894, pp. 283-287; February 1895, pp. 36-39; March 1895, pp. 68-70; April 1895, pp. 98-100; May 1895, pp. 121-123; June 1895, pp. 147-149; July 1895, pp. 178-180.

Stovel, Rex. "The Toronto Camera Club Exhibition," *American Amateur Photographer,* June 1906, pp. 296-97.

Street, J. "The G.R.G. Conway Collection in Cambridge University Library: A Checklist." *The Hispanic American Historical Review,* vol. 37, no. 1, Feb. 1957, pp. 60-70.

Taylor, John. "Pictorial Photography in the First World War." *History of Photography,* Vol. 6, No. 2, April 1982, pp. 119-141.

Todd, F. Dundas. "Gum-Bichromate," *American Photography,* Oct. 1907, pp. 171-176; "Talks with Professional Photographers," Jan. 1909, pp. 3-8. "Making Passe-Partouts," Jan. 1910, pp. 34-37.

(Tranter, Gordon M.) "No. CDLI. Mr. Gordon M. Tranter. How I make my Exhibition Pictures. Methods and Ideals of well-known Pictorial Workers." *The Amateur Photographer & Cinematographer* 17 Aug 1938, p. 192.

Triggs, Stanley G. "Alexander Henderson:

Nineteenth-Century Landscape Photographer," *Archivaria,* Number 5, Winter 1977-78, pp. 45-59.

'Uncle Jason' (Henry W. English). "The Afflictions of an Amateur," *The Canadian Photographic Journal,* August 1892, pp. 160-163; "That Camera O' Mine," October 1892, pp. 212-213; "Doin' the Fair," December 1893, pp. 376-380.

[Van, Albert.] "The Toronto Camera Club's One Man Show. The pictures this week are the work of A. Van," *Sunday World* (Toronto), 22 April 1923, p. 3.

Vanderpant, John. "Because of the Cause or Giving the Reason Why," *Camera Craft,* Dec. 1929, pp. 570-577; "The New Westminster Salon of Pictorial Photography," Dec. 1924, pp. 582-584; Jan. 1925, pp. 15-17.

Viewfinder [pseud.]. "The Amateur Photographer," *The Great West Magazine,* Vol. XIII (New Series), No. 3, Nov. 1898, pp. 170-172; "Possibilities of the Camera," Vol. XIII (New Series), No. 4, Dec. 1898, pp. 243-247.

H) Salon Catalogues

The catalogues that accompanied salons of photography are a rich source of names of Canadians active in the world of competitive exhibitions. Occasionally, they also offer reproductions of work long lost.

(Arts and Crafts Association, Vancouver, B.C.) *First Annual Exhibition of the Arts and Crafts Association* in the Theatre Royal, 25, 26, 27 September 1900. Vancouver, B.C.

(Academy of Science and Art, Photographic Section. Carnegie Institute, Pittsburgh, Pennsylvania) *Fifteenth Annual Pittsburgh Salon of Photographic Art,* 1928; *Sixteenth,* 1929; *Seventeenth,* 1930; *Twenty-Second,* 1935.

(Birkenhead Photographic Association) *Annual International Exhibition of Photographic Art,* Birkenhead, England, *1939.*

(Bishop Auckland Photographic Society) *Bishop Auckland Salon of Photographic Art,* Bishop Auckland, England, 1938, 1939.

(Bolton Camera Club) *Annual International Exhibition of Pictorial and Scientific Photography,* Bolton, England, 1934, 1935, 1938.

(Brantford Camera Club) *Third Annual Spring Salon,* Brantford, Ontario, 1940.

(Bristol Photographic Society) *Open Exhibition,* Bristol, England, 1935.

(Bristol Photographic Society/Western Counties Photographic Federation) *Western Salon of Photography,* Bristol, England, 1938.

(British Columbia, Royal Agricultural and Industrial Society of) *Ninth Annual International Salon of Pictorial Photography,* New Westminster, British Columbia, 1929.

(Buffalo Camera Club) *Ninth Annual Salon of Pictorial Photography,* Albright Art Gallery, Buffalo, New York, 1928; *Tenth,* 1929; *Thirteenth,* 1934.

(Canada, Photo-Club of) *Exhibition of Pictorial Photographs* arranged by The Photo-Club of Canada and held in the Galleries of the Art Association of Montreal, 23 November to 7 December, 1907.

(Canadian Society of Applied Art) *Second*

Exhibition held at the Galleries of the Ontario Society of Artists, 165 King St. West (Toronto), 9 December to 23 December, 1905.

(Cannes, Photo-Club de) *3e Salon International d'Art Photographique,* Cannes, France, 1935.

(Catalunya, Agrupacio Fotografica de) *III Salo International d'Art Fotografic,* Barcelona, Spain, 1935.

(Cedar Rapids Camera Club) *Third Annual Cedar Rapids Salon of Photographic Art,* Cedar Rapids, Iowa, 1938.

(Chicago Camera Club) *Century of Progress International Salon of Photography,* Chicago, Illinois, 1933.

(Derby Photographic Society) *Jubilee Exhibition,* Derby, England, 1934.

(Des Moines YMCA Camera Club) *International Salon of Photography,* Des Moines, Iowa, 1938, 1940.

(Detroit Institute of Arts) *Sixth Detroit International Salon of Photography,* Detroit, Michigan, 1937; *Seventh,* 1938.

(Edinburgh Photographic Society) *Seventy-Seventh Annual Open Exhibition,* Edinburgh, Scotland, 1939.

(Galashiels Camera Club/Scottish Photographic Federation) *Thirtieth Scottish National Photographic Salon,* Galashiels, Scotland, 1938.

(Hamilton Camera Club) *Canadian Salon of Photography,* Hamilton, Ontario, 1934; *Second Annual,* 1935; *Third,* 1936; *Fourth,* 1937; *Fifth,* 1938; *Sixth,* 1939; *Seventh,* 1940.

(Handsworth Photographic Society) *Annual International Exhibition,* Birmingham, England, 1938.

(Johannesburg Photographic Society) *Third South African Salon of Photography (International),* Johannesburg, South Africa, 1934.

(Leicester and Leicestershire Photographic Society) *International Exhibition of Pictorial Photography,* Leicester, England, 1935.

(London Camera Club) *First Western Ontario Salon of Photography,* London, Ontario, 1936; *Third,* 1938.

(Los Angeles, Camera Pictorialists of) *22nd Annual Salon,* Los Angeles, California, 1939.

(Mackenzie, Walter; Cutten, Fenwick; and Carter, Sidney) *Exhibition of Pictorial Photographs by Walter Mackenzie, Fenwick Cutten and Sidney Carter,* held in the Galleries of the Art Association of Montreal, from 15 October to 4 November, 1913.

(Manchester Amateur Photographic Society/Bradford Photographic Society) *Northern Photographic Exhibition International,* Manchester, England, 1934-35.

(Manitoba Camera Club) *Sixth Annual Western Canadian Salon of Photography,* Winnipeg, Manitoba, 1940.

(Midland Counties Photographic Federation) *Twelfth Midland Salon of Photography,* Wolverhampton, England, 1935; *Fifteenth,* Birmingham, 1938; *Sixteenth,* Leicester, 1939.

(Montreal Amateur Athletic Association) *Third Annual Exhibition,* Montreal, Quebec, 12 - 17 April, 1909.

(National Gallery of Canada) *Canadian International Salon of Photographic Art,* Ottawa, Ontario, 1934; *Second,* 1935;

Third, 1936; *Fourth,* 1937; *Fifth,* 1939; *Sixth,* 1940.

(Philadelphia, Miniature Camera Club of) *First Philadelphia Annual Salon* of the Miniature Camera, Philadelphia, Pennsylvania, 1935.

(Philadelphia, Photographic Society of) *Sixth Annual Exhibition* at the Galleries of the Pennsylvania Academy of Fine Arts, Philadelphia, Pennsylvania, 17 - 29 April 1893.

(Rhode Island, Camera Club of) *First Rhode Island International Salon of Photography,* Providence, Rhode Island, 1937.

Rochester International Salon of Photography, Memorial Art Gallery Rochester, New York, December 1929; *Third,* December 1931; *Sixth,* February 1941.

(Rotherham Photographic Society) *Forty-Fifth Exhibition,* Rotherham, England, 1934.

(San Antonio, Pictorial Camera Club of) *Third San Antonio National Salon of Photography,* San Antonio, Texas, 1938.

(Seattle Camera Club) *First Exhibition of Pictorial Photography,* Seattle, Washington, 1925; *Second,* 1926; *Third,* 1927; *Fourth,* 1928; *Fifth,* 1929.

(Société Français de Photographie) *XXVIIe Salon International d'Art Photographique de Paris,* Paris, France, 1932.

(South Shields Photographic Society) *Fourth South Shields International Exhibition,* South Shields, England, 1938; *Fifth,* 1939.

(Springfield, Photo-Pictorialists of) *First Annual Springfield International Salon of Photography,* Springfield, Massachusetts, 1939.

(Toledo Camera Club) *First Toledo International Photographic Salon,* Toledo, Ohio, 1940.

(Toronto Camera Club) *Ninth Annual Exhibition,* Toronto, Ontario, 1899; *Tenth,* 1900; *Eleventh,* 1902; *Sixth Salon/Eighteenth Annual Exhibition,* 1909; *Fortieth Annual Toronto Salon of Photography,* 1931; *Forty-First,* 1932; *Forty-Second,* 1933; *Forty-Third,* 1934; *Forty-Fourth,* 1935; *Forty-Fifth,* 1936; *Forty-Sixth,* 1937; *Forty-Seventh,* 1938; *Forty-Eighth,* 1939; *Forty-Ninth Annual International Toronto Salon of Photography,* 1940.

(Twin City Camera Club) *Fourth Annual Blossom Festival Salon of Photography,* Saint Joseph and Benton Harbor, Michigan, 1938.

Valley of the Sun Photographic Salon, Arizona, 1939.

(Vancouver Photographic Society) *First International Vancouver Salon of Pictorial Photography,* Vancouver, British Columbia, 1940; *Fourth,* 1943.

(Vanderpant Galleries) *Paintings, Etchings and Photographs* at the Opening Exhibition of the Vanderpant Galleries, 15 - 20 March, [1926], 1216 Robson Street, Vancouver.

(Weymouth and District Photographic Society) *The World's Camera Pictorialists: An Open Exhibition of International Photographic Art,* Weymouth, England, 1938.

(Windsor, Photo-Guild of) *Windsor International Salon of Photography,* Windsor, Ontario, 1941.

Index